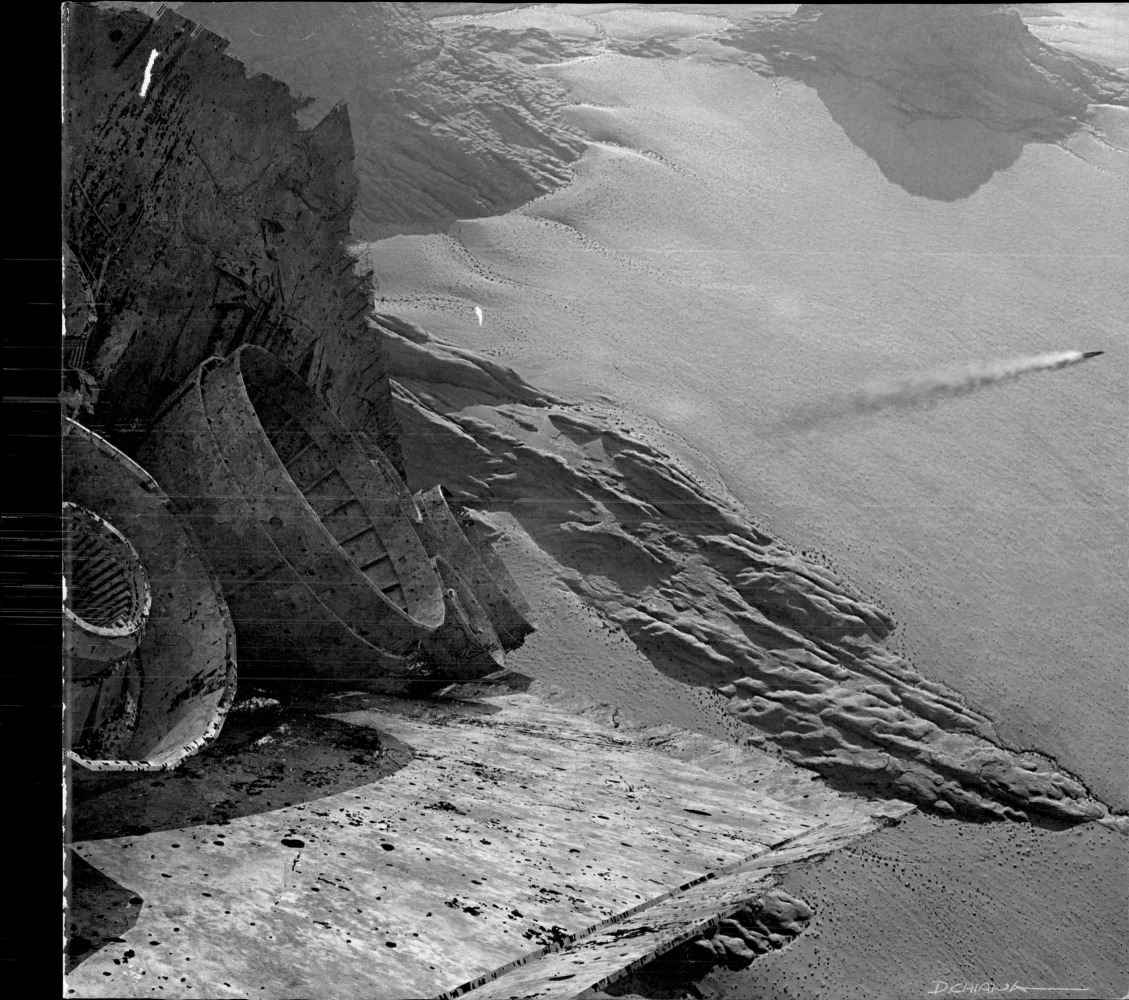

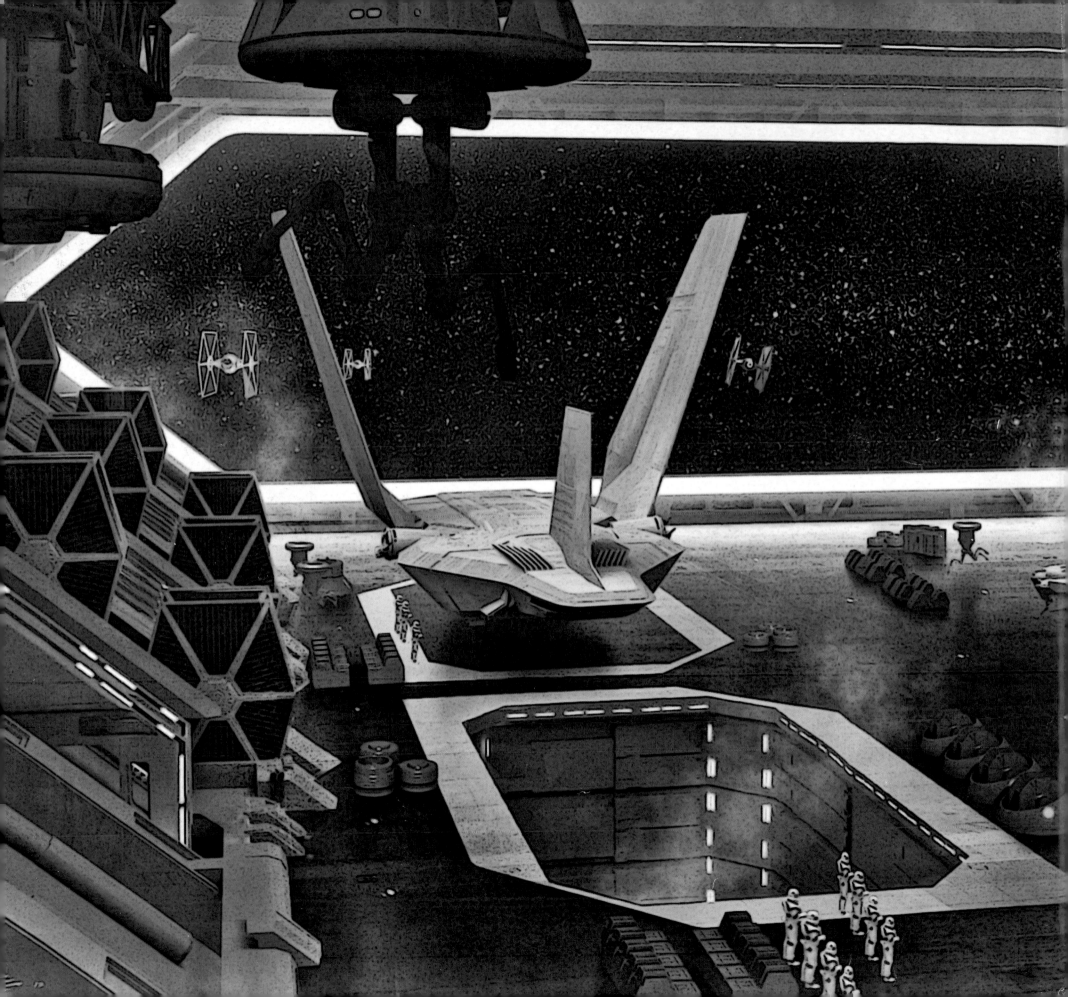

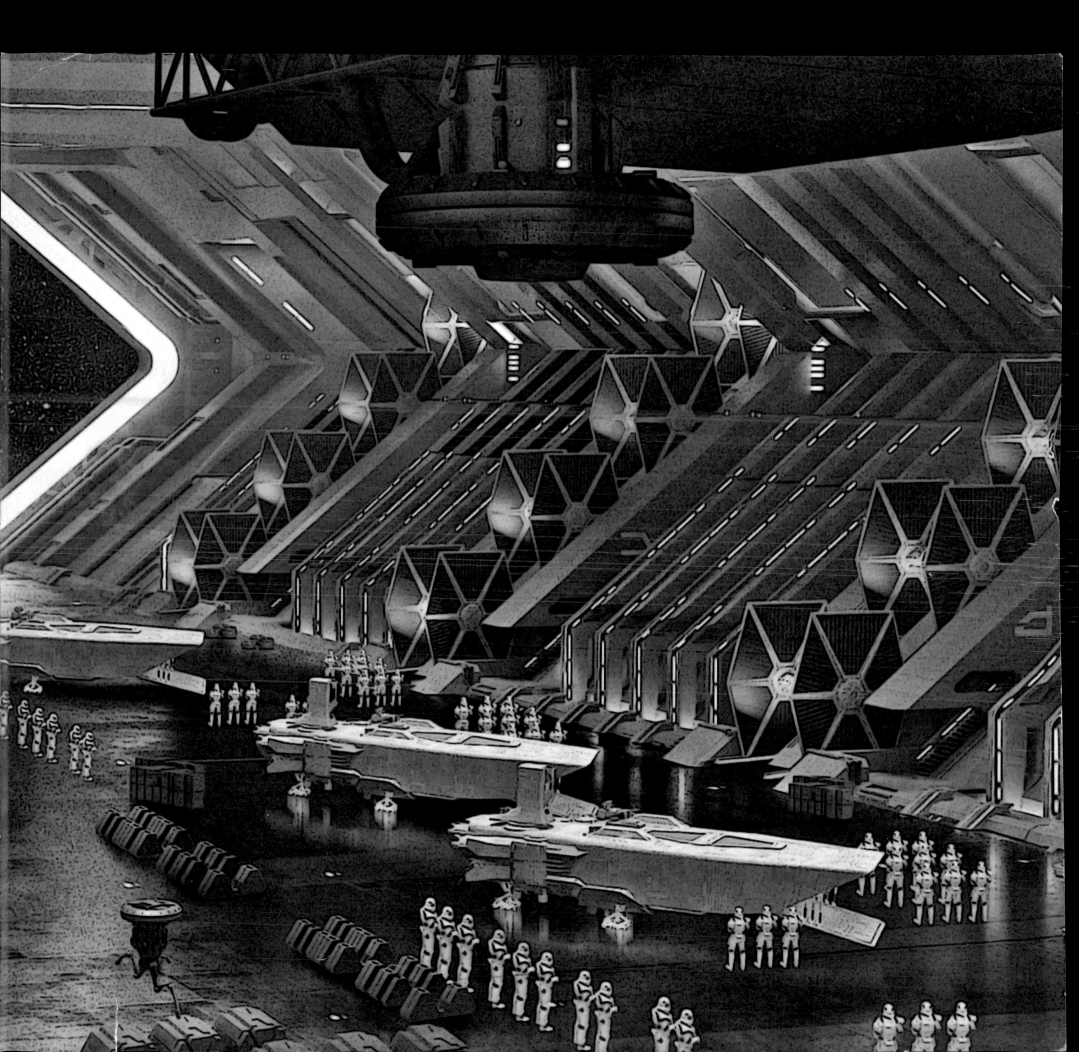

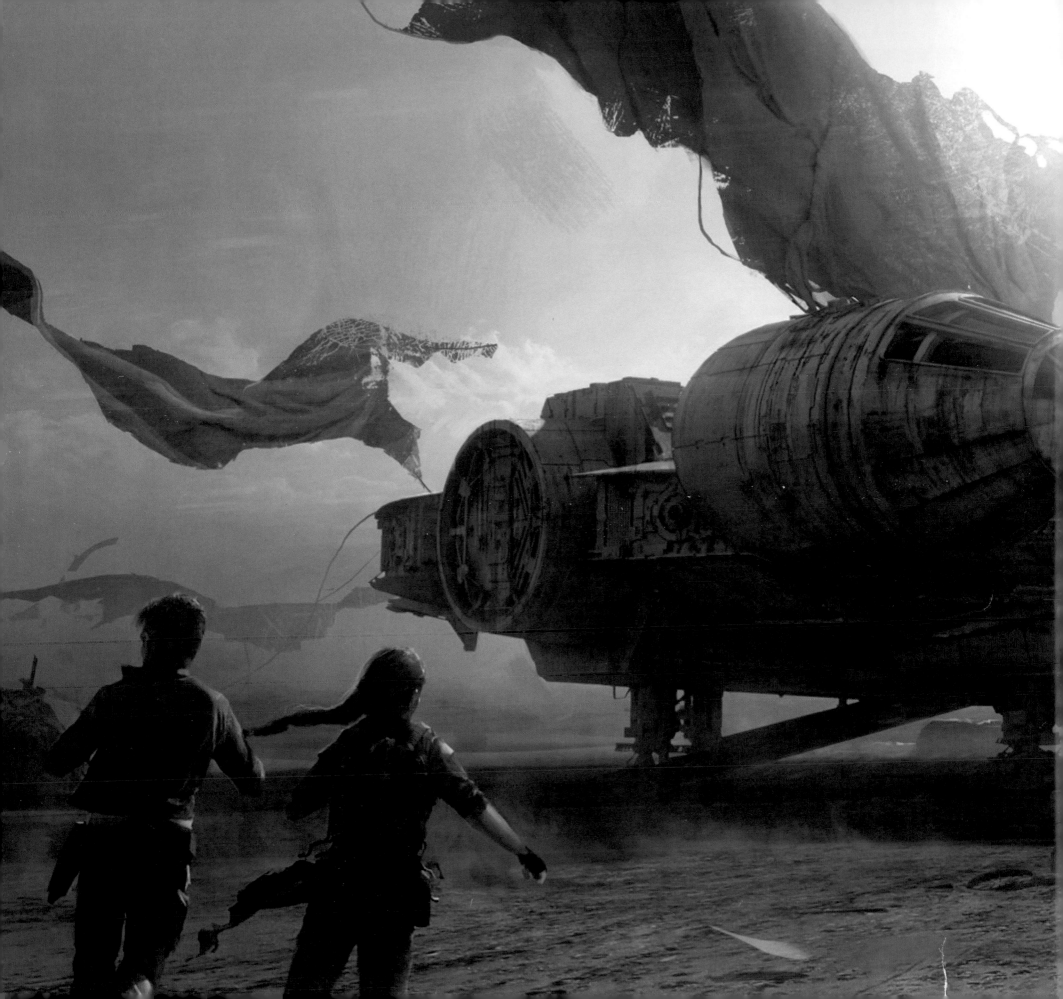

THE ART OF

STAR
WARS

THE FORCE AWAKENS

Written by PHIL SZOSTAK Foreword by RICK CARTER

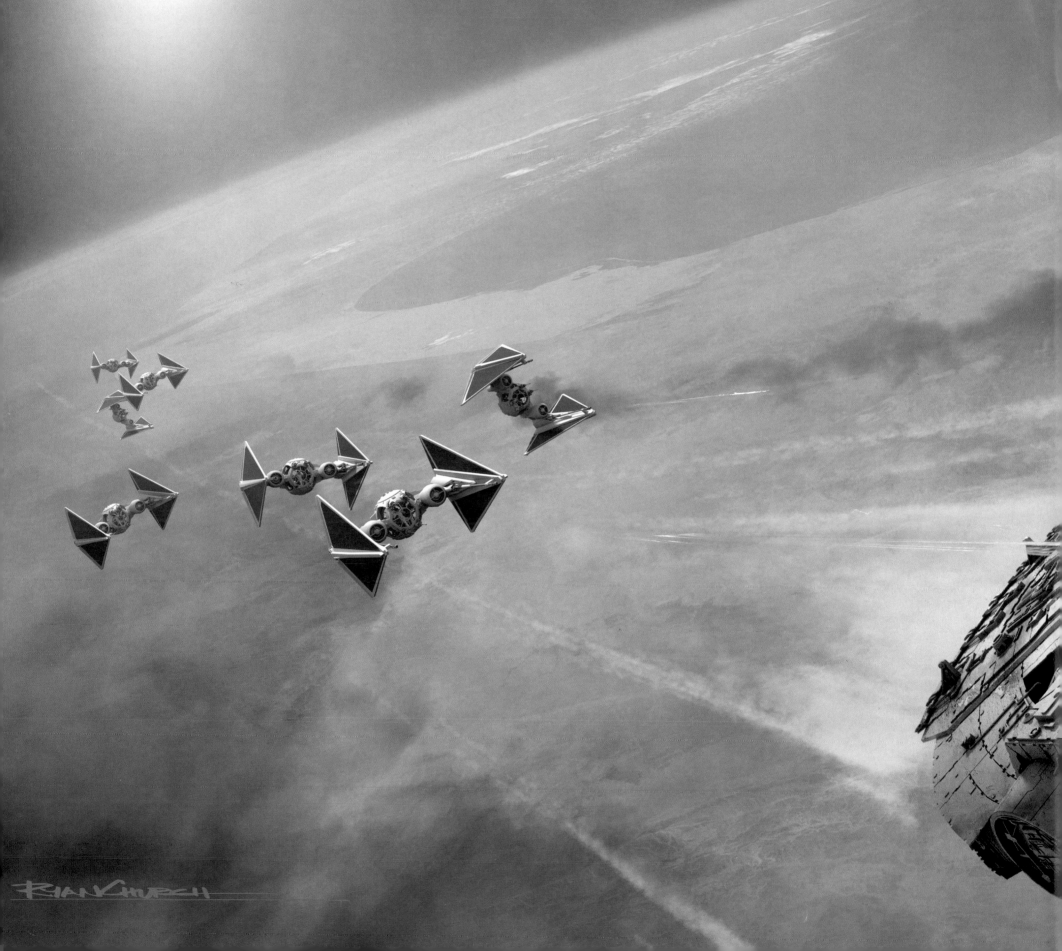

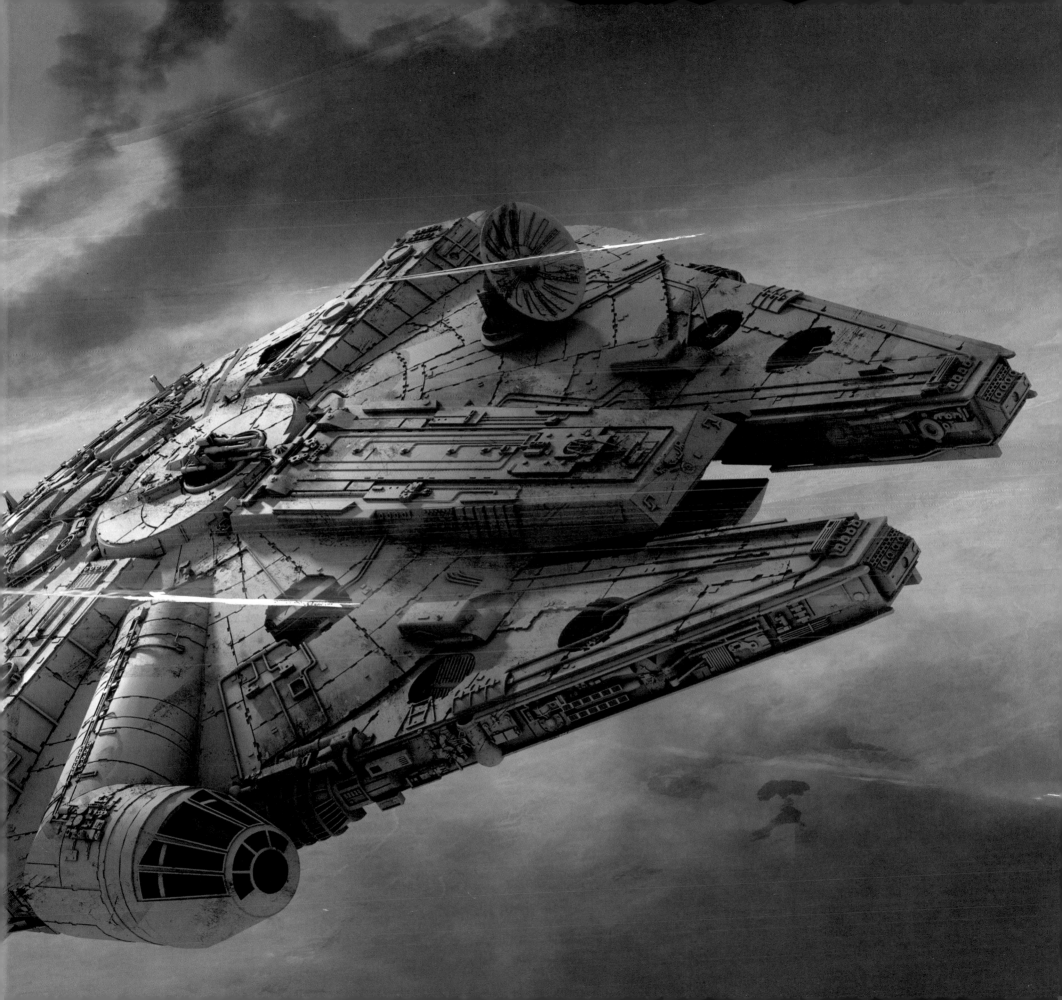

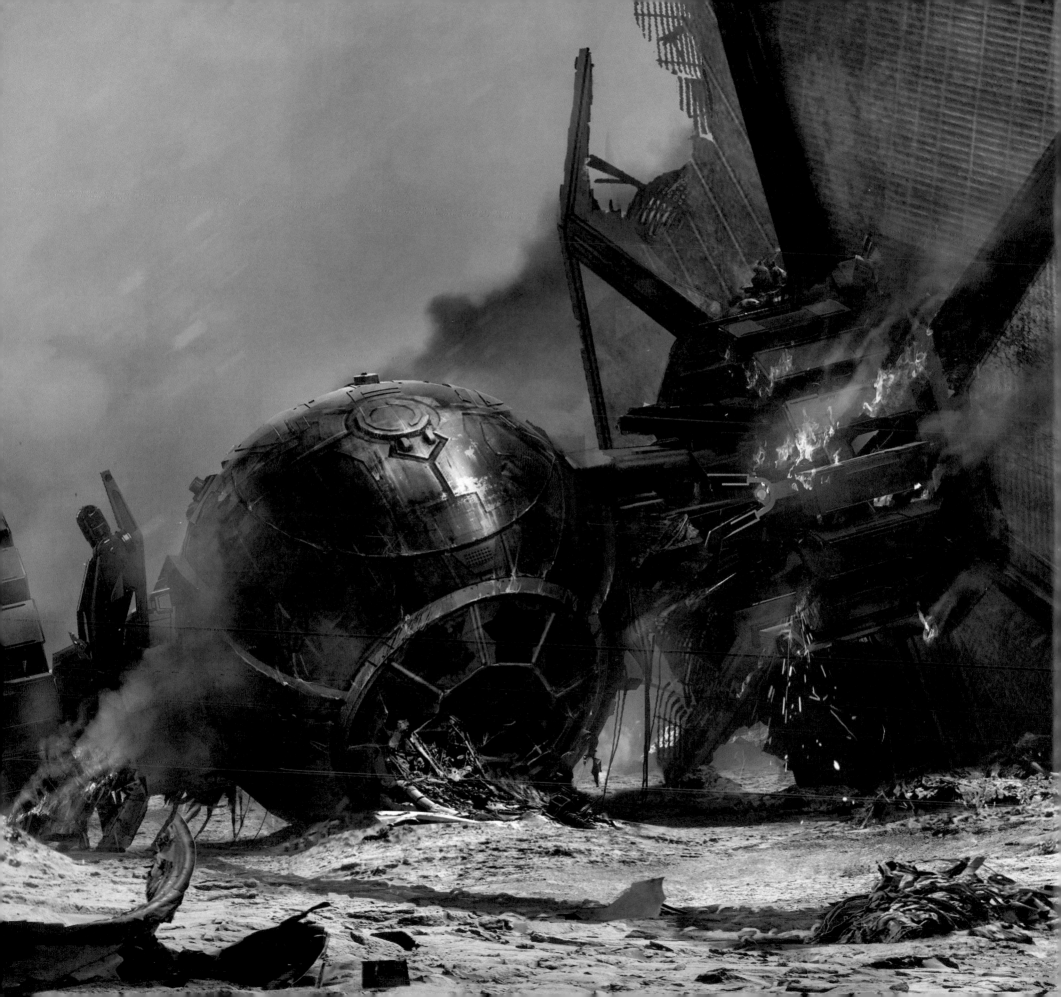

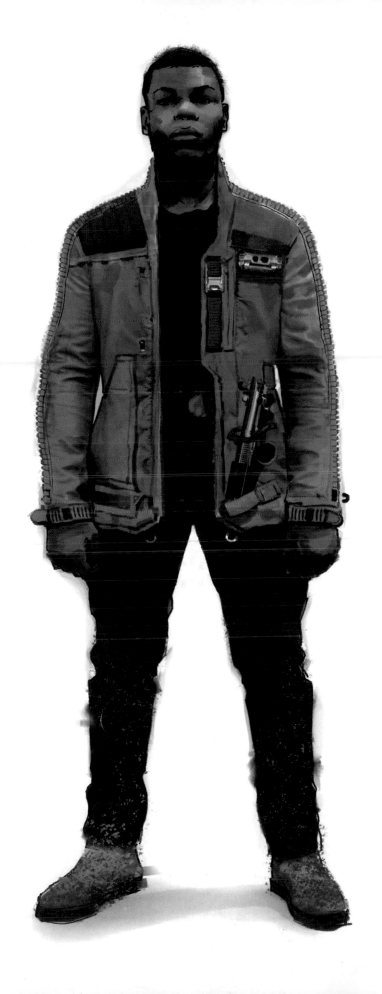

CONTENTS

▲ Page 1 DESERT DESTROYER Doug Chiang

▲ Pages 2–3 TIE LOADING WIDE James Clyne

▲ Pages 4–5 *MILLENNIUM FALCON* Andrée Wallin

▲ Pages 6–7 *FALCON* ESCAPE Ryan Church

◄◄ CRASH SITE ANGLE 2 (DETAIL) Wallin

◄ FLIGHT JACKET Glyn Dillon

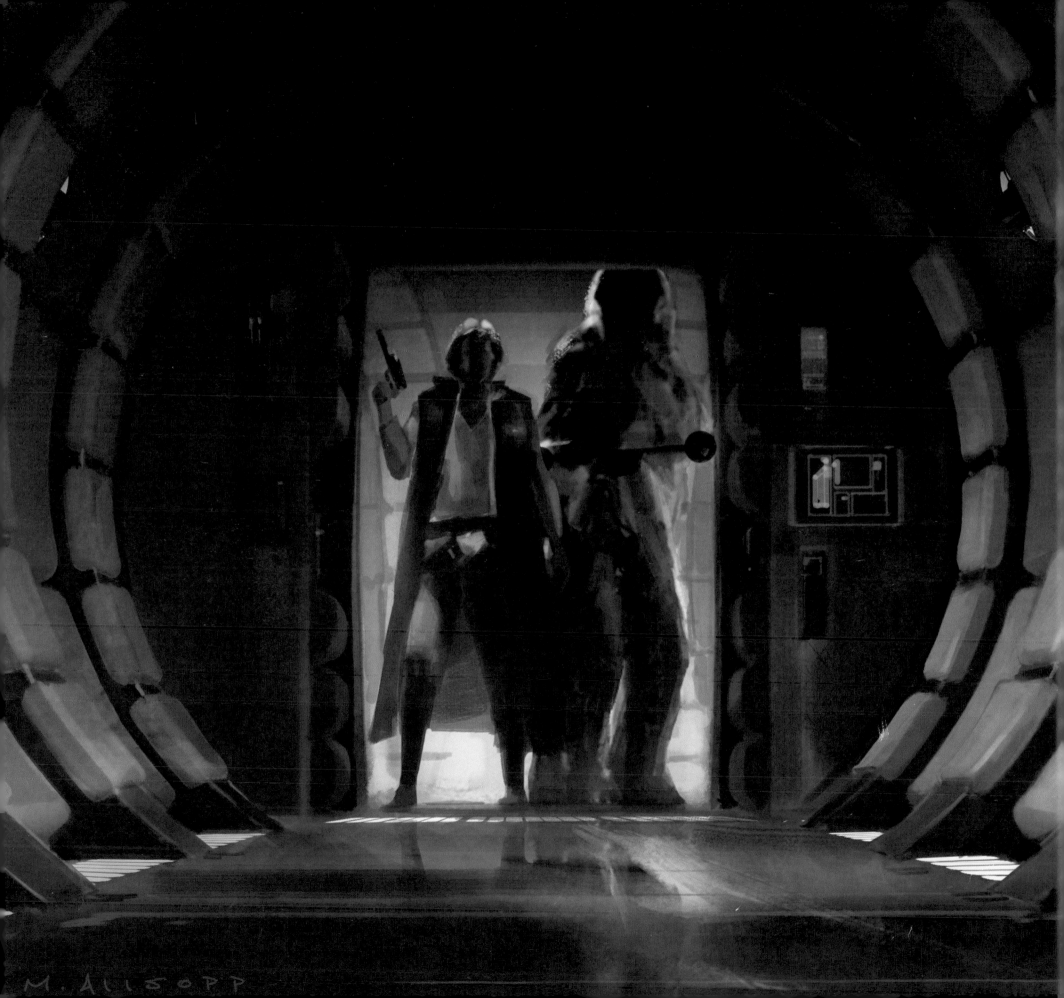

FOREWORD BY RICK CARTER

From the time *Star Wars* burst into our world in 1977 until today, its vision has evolved exponentially far beyond the cinema. Over the years, this galaxy from "a long time ago" and "far, far away" has remained accessible and become adaptable to multiple interpretations by each successive generation. Full of colorful visual wonders, populated with charming characters, peppered with rip-roaring quips and emotions, graced with a sublime spiritual philosophy, and elevated by a magnificently expansive sense of scale, it inspires our collective imagination. All of this forms the basis for the art of *Star Wars*.

This collection of art from *Star Wars: The Force Awakens* is more than a selection of paintings and drawings that illustrate the settings and visual effects of the movie. The images not only live and breathe in a dialogue with the movie's storyline and the characters they helped to inspire and create, but also with global culture over these past nearly four decades. As artists, we can now play in this *Star Wars* galaxy— we can explore it, and we can expound upon it, but it will always be about the mystery that George Lucas originated. He begot this time and place in our imaginations.

For many people, it all started with seeing the original movie, back when it was initially released to the public. If you are over forty, you most likely remember the theater you were sitting in when you were first transported to those faraway places. My personal introduction, at age twenty-seven, expanded my world of cinema and my view of the real world; although I had already worked on other Hollywood movies by that time and traveled around the world twice as a young man, the scope of George's *Star Wars* moviescape revealed what seemed like infinite new dimensions of what was possible to create as a cinematic artist. For younger people such as J.J. Abrams, who was eleven years old in 1977, seeing *Star Wars* for the first time was a life-altering event. From what he has told me, it was almost as real to him, at that age, as real life.

This set an adventurous path for J.J. to explore and pursue, both as a filmmaker and an artist. His vision emanates from the kid-at-heart who absorbed as much as he could, kept asking questions, and continued exploring, further and further. Now, as an adult and parent, all of these years later, he inspired us to bring forth our deepest visions. As much as he was inspired by George, it is J.J.'s fundamental aesthetic and soul that is reflected throughout *The Art of Star Wars: The Force Awakens*. Producer Kathleen Kennedy, to whom George entrusted his galactic legacy in 2012, orchestrated all of this. Through her guidance, a new generation of filmmakers, storytellers, and digital artists will continue into the future to explore and expand the boundaries of *Star Wars*.

As a co-production designer of *The Force Awakens*, I knew that for me to discover what *Star Wars* is and what it is not, I would have to meet with its creator. When I first met with George in December of 2012, it was clear that we would be embarking on an inter-generational hand-off. I was hoping for some guidance as to how he viewed the process of letting it all go and where to explore further. In a very Yoda-like manner, he mentioned something to me at the end of our talk that struck me as significant: When he was a younger filmmaker, images appeared to him as if he were looking through binoculars— very close and very vivid. Now that he was getting older, imagery appeared as if the binoculars were turned around and he was seeing it all from a greater distance, with a deeper perspective. I thought that this was a profound visual point of reference for him to express, and I think it represents why he's been able to let *Star Wars* go, to see if it has life beyond him. Of course, even in his movies, George has introduced the dimension of an afterlife. Before Obi-Wan Kenobi sacrifices himself to Darth Vader, he even predicts, "If you strike me down, I'll become more powerful than you can possibly imagine."

Those are very potent words, and that's quite a high level of spirituality to understand, especially for any artist coming in to make a new *Star Wars* movie. The first question that I therefore felt needed to be asked of the new artists we assembled was, "How strong is the Force?" Not just as we might think we have seen it demonstrated in previous *Star Wars* movies, but in the present day. What is the Force for us now? What does it mean? Not just what you say it means, but what does it truly mean to you?

Each artist began to explore his individual response, and collectively, we began to answer, with our words and art. Out of our brainstorming sessions emerged visual imagery of where we might want to go and what it would look like when we got there. Ultimately, *The Art of Star Wars: The Force Awakens* is about the power of the images and the ideas behind them. We were not merely illustrating scenes that already existed; we were initiating storytelling concepts through the visual images themselves.

As George has often stated, *Star Wars* is actually a period piece set "a long time ago, in a galaxy far, far away. . . ." The graphic quality of the movies is simple and clear. But where does that come from? It comes from the inaugural *Star Wars* artists with whom he created his

◄ *FALCON* CORRIDOR
(DETAIL) Matt Allsopp

cinematic vision. First and foremost is, of course, Ralph McQuarrie, who was the primary artist to define this saga. His paintings seem to have a past and define a vivid, present moment in the movie, but they also lead you to something yet to come.

Our new team of *Star Wars* artists dug into the Skywalker Ranch archives, where we had access to all sorts of rarely seen drawings and sketches by McQuarrie. Some are very small but have tremendous scale. They invoke something that is special about the personal, the majestic, the huge, and then, eventually, the breadth of the entire galaxy that we now think of as *Star Wars*.

Through this aesthetic pilgrimage, we discovered that we were going back in order to move forward; we began to grasp what it was that we wanted to bring into our new saga: a real, physical sense of time and place—of history, continuity, and future possibilities. With J.J. in the lead, we decided to film in real locations, and build many physical sets, in order to create actual places that wouldn't only exist in digital form or on a computer.

We wanted our *Star Wars* worlds to feel tangible, so that the actors, the crew, and the audience could believe that they *are* somewhere, in a real time period, in another galaxy . . . but one that is very close to ours. Our quest, thematically speaking, was about trusting in something that no other cinematic reality has: the Force. And it felt like an awakening.

Every generation has to face its own real-world challenges, and our cultural artifacts necessarily reflect those specific challenges. Visionary art, however, can also reflect larger, cross-generational archetypes and synchronicities. I think this is the secret that George Lucas has always understood intuitively, and intellectually, and it is why he went all the way back into the deep myths that writer and mythologist Joseph Campbell talked about to find a way to tell stories that recur with successive generations. *Star Wars* doesn't just exist in some "movie place," with no reference point to where we are and who we are right now. Our vision for *Star Wars: The Force Awakens* is a different vision than George's, and it is going somewhere that we can't predict, but it also reflects our life and times—while striving to be just as visionary.

This is how George Lucas, in letting us take over from him, is becoming "more powerful than" perhaps even he could once imagine. His binocular-lens vision of the *Star Wars* galaxy, which we are now continuing to express, does not show a place that is so "long ago" or "far, far away." It is as it has always been: right now, and very close.

▶ **FLAMES FRONT CHROME (DETAIL)** Dillon

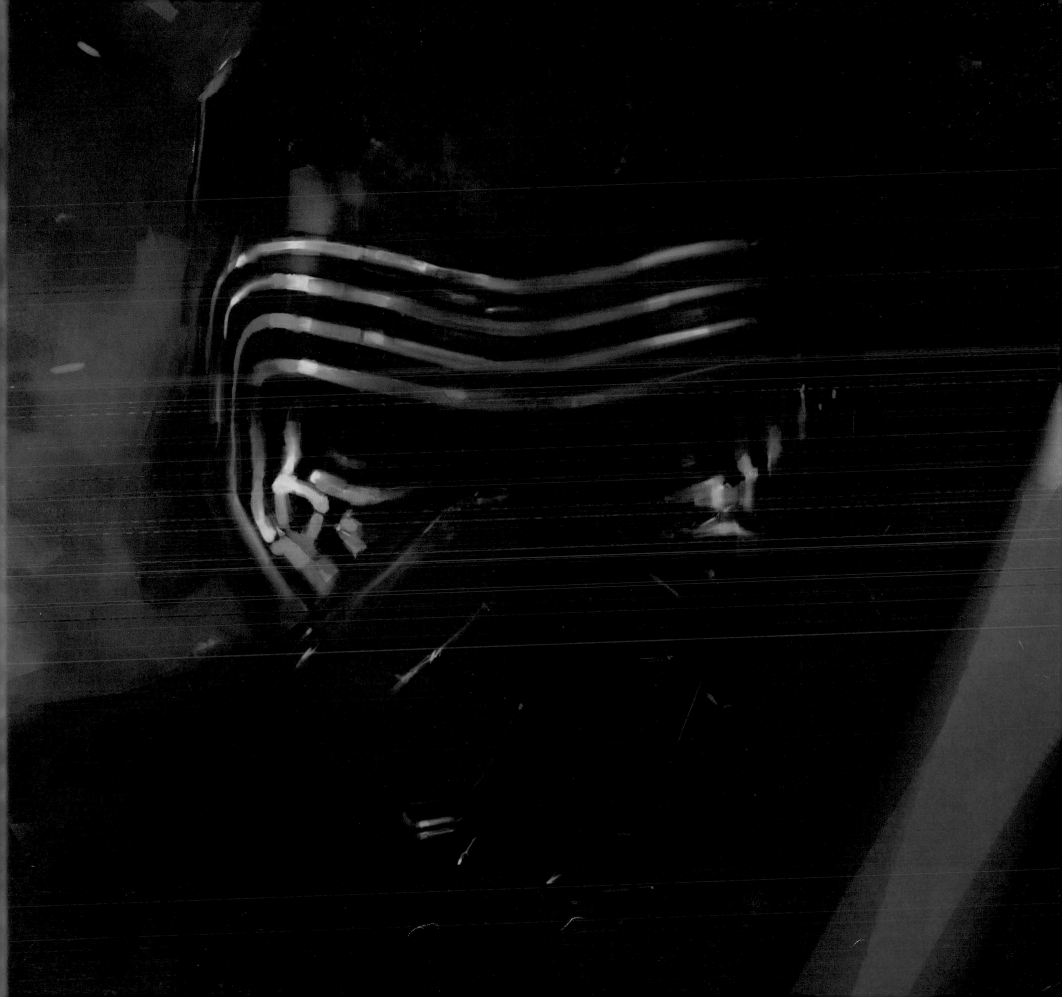

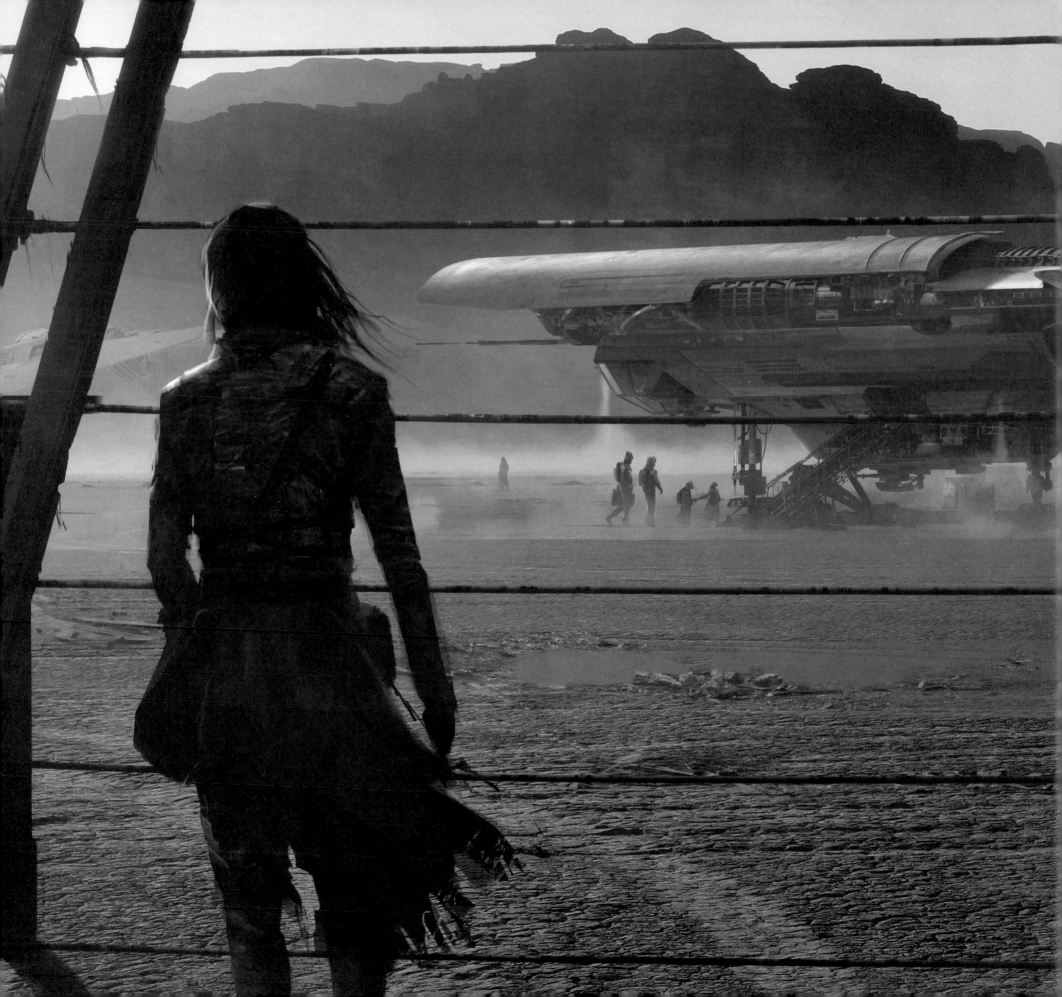

INTRODUCTION BY PHIL SZOSTAK

In the afternoon of September 6, 2012, a little more than three months after being appointed co-chairperson of Lucasfilm Ltd. by *Star Wars* creator George Lucas, Kathleen Kennedy met with the assembled divisions of Lucasfilm to state her intention to produce a new series of *Star Wars* films. Her announcement was met with cheers. *Star Wars: The Force Awakens* would be the first chapter of this series, to be released in 2015, a full decade after 2005's *Star Wars*: Episode III *Revenge of the Sith*. A few months later, following the October 30 sale of Lucasfilm to the Walt Disney Company, Kennedy was appointed the company's new president, and plans for the sequel trilogy were publically unveiled. Excitement over the news spread globally.

This latest slate of *Star Wars* movies would present incredible challenges to their creators, challenges unique both within the series' forty-year history and in comparison to any other film in cinematic history. First and foremost, what would *Star Wars* become without its creator, George Lucas? For the six prior *Star Wars* films and *The Clone Wars* animated TV series, Lucas synthesized an extraordinarily deep and diverse array of elements and influences, from classical mythology to cultural anthropology to Eastern spirituality, crafting a story, and an aesthetic, that appears simple but is exceedingly complex. It is that very complexity that, like the fully realized worlds of Frank Herbert's *Dune* or J.R.R. Tolkien's *Lord of the Rings* trilogy, gives the *Star Wars* universe its inherent richness and verisimilitude—the feeling that it exists, independent of the stories told of it. Would Lucas's world-building foundation be enough to sustain the next generation of *Star Wars* stories and storytellers?

In the process of conjuring *The Force Awakens*, the filmmakers would also confront fundamental questions about the very nature of *Star Wars*. Why does *Star Wars* resonate so strongly, across borders and through the ages? What is it that makes *Star Wars* a perennial pop-culture phenomenon? Is *Star Wars*'s appeal purely nostalgia-driven? What does *Star Wars* have to say to the youth of today, in a time both economically and sociopolitically similar to, but profoundly different from, 1977?

The Force Awakens's co-production designer Rick Carter recalls, "At the time, Lucas and Spielberg unleashed the power of not only classical storytelling, but optimism in the face of nihilism. The youth culture of the seventies was turning in on itself in a negative, almost cannibalistic way. *Chinatown*, *The Godfather*—these are great movies, but they're essentially nihilistic; there's no value that you can stand up for. Power was unleashed by identifying that there is something worth fighting for, that there is purpose. There is a good. There is evil. And there are complexities to it, but that's the scope of who we are. What we strive to be is worthy."

Star Wars shed a light into the darkness, bringing forward the counterculture youth movement of the sixties—which George Lucas and Rick Carter were both a part of—into the malaise of the post-Vietnam era of the late seventies. What's the story that the young people of 2015 are dying to hear, dying to be blown away by, as they were in 1977? Is that even possible? Can lightning strike twice?

Star Wars: The Force Awakens would inherently carry tremendous weight, as it was to be the first direct sequel to 1983's *Return of the Jedi* and would feature the original trilogy's beloved trio of central characters—Luke Skywalker, Princess Leia, and Han Solo. But Episode VII would also have to lay the groundwork for every film to follow: new characters, situations, starships, and worlds, including hints at more than three decades' worth of backstory bridging the trilogies. And the first film or story in any series is undoubtedly the most difficult.

Adding to that difficulty, the tale of Luke Skywalker seemed to have ended with *Return of the Jedi*. Joseph Campbell's "monomyth," which found elemental commonalities in religious and mythological storytelling throughout history, was a huge influence on Lucas. The hero's journey through the monomyth is the human journey through life: from childhood to adulthood, innocence to knowledge and acceptance—a story we all share. Luke Skywalker went from naïve farm boy to Jedi Knight, discovering terrible truths along the way, ultimately confronting and vanquishing his fears and obstacles. With the apparent destruction of the Galactic Empire, it truly seemed "happily ever after" for Skywalker, his friends, and the galaxy at large. But happily ever after is the end of conflict and therefore the end of the story. What more was there to say about these characters?

The Force Awakens director J.J. Abrams and screenwriters Michael Arndt and Lawrence Kasdan recognized that a new "nobody" was needed. Young film audiences would need fresh and relatable heroes to emulate—and those heroes would have their own paths to follow. Just as Obi-Wan Kenobi evolved from General of the Clone Wars to "Old Ben" Kenobi, wise father figure to young Luke Skywalker, so too would Luke, Han, and Leia now function as archetypal guides to the next generation.

Apart from the story challenges, the distinct design aesthetic of *Star Wars* would also need to be teased apart and reimagined for these new films. In a 1975 interview, George Lucas described his envisaged *Star Wars* look as "very real, with a nitty-gritty feel, which is hard to do in a film that is essentially a fantasy." Lucas loves cinema vérité, having employed documentary cinematographers for both *THX 1138* in 1971 and *American Graffiti* in 1973. He wanted *Star Wars* to feel as if you were watching a documentary filmed by a crew within the *Star Wars* universe, who would just observe without dwelling on anything in particular. The speed of the action and of the narrative would always supersede showing off anything "cool."

To that end, Lucas asked that every object, costume, vehicle, alien, and set designed for the film in 1975–76 be casual, asymmetrical, mismatched—as if it hadn't been designed at all. That aesthetic was clearly carried through in the designs of original trilogy artists Ralph McQuarrie and Joe Johnston, and it was enthusiastically adopted by J.J. Abrams, Rick Carter, and the entire *The Force Awakens* art department from the get-go.

Carter treated Lucas, McQuarrie, and Johnston's aesthetic as foundational to the work of *The Force Awakens*'s art department, who were, early on, nicknamed "Visualists." He would also serve as a mentor and spiritual advisor to the film, digging deep for a fundamental understanding of *Star Wars* and the Force. "I wasn't the only person in this role," he says. "If you care about the Force, you want to invoke the Force."

Carter would slowly draw out sparkling bits of inspiration from his Visualists in marathon two- to three-hour art department meetings, lulling his designers into deep creative mindsets where the walls between individuals would drop, allowing the group to function as a sort of collective unconscious. In many ways, much of the early design work on the film was a shared dream of the Visualists, with Carter picking up on the faint whispers of an idea that would otherwise be lost. "It's like charades," he recalls. "If somebody gets close and you get excited, you put your hand on your nose—'That's it, that's it!' I just encouraged them whenever I felt inspired by what they were saying."

Halfway through the first year of pre-production, *The Force Awakens* co-production designer Darren Gilford joined the team. Like director Abrams and most of the Visualists, Gilford was part of the first *Star Wars* generation who experienced the initial tidal wave of excitement around the franchise in the seventies and eighties. Gilford had more cause than most kids in 1977 to be inspired by the series. "I don't know how it happened, but my dad got the commission to do the illustration for the cover for the *Star Wars* issue of *Cinefantastique*, which came out in 1978," he says. "We went to go see *Star Wars* like nine times while he was doing all the drawings for the cover. Of course, I wanted to go see it as many times as I could—it just left an impression on me.

"So as soon as I got the job, the first thing I did was give the magazine to J.J. to look at, and he had such a strong reaction to it," Gilford continued. "J.J. was really clear very early on: He did not want the design to overpower the story. He wanted the design to support the story and bring viewers right back in that world."

Abrams and Gilford paid faithful homage to every nuance and detail of the first *Star Wars* films' aesthetic and design process, as spearheaded by production designer John Barry. Concurrently, Carter and Gilford naturally formed a sort of yin-and-yang production design tag team, each contributing strengths that innately supported the other.

Like Gilford, many of the Visualists who grew up in the seventies and eighties—Doug Chiang, Erik Tiemens, and Ryan Church, to name a few—were chiefly and profoundly inspired by McQuarrie, Johnston, and *Star Wars* generally to pursue careers in film and conceptual art. It was their work on the *Star Wars* prequel trilogy and other turn-of-the-millennium films that stirred the next wave of young artists, now in their twenties, to subsequently join the *The Force Awakens* team.

This three-generation ensemble of masters and apprentices, industry veterans and up-and-comers, is quite possibly the greatest collection of filmmakers and artisans ever assembled for a film. Their care and respect for cinema and for *Star Wars* remains deep and abiding. The dedication, intelligence, craft, and creativity they brought to their work on *The Force Awakens* in the face of formidable odds and intense deadlines is truly staggering—a testament to their passion for the medium and the film.

There can be no doubt that *Star Wars* is in good hands. J.J. Abrams's *The Force Awakens* is the proof. The foundation that Lucas, McQuarrie, Johnston, Barry, and the entire original trilogy cast and crew laid down three decades ago has been and will continue to be brilliantly built upon for decades to come.

More than ever, the world needs Lucas and *Star Wars*'s message of hope in the face of despair, the triumph of humanity over technology, spirit over matter, light dispelling the dark. These powerful messages will resonate just as strongly for the next generation of young filmgoers. Perhaps they will become the artists, writers, and directors of tomorrow, telling stories we cannot even begin to imagine.

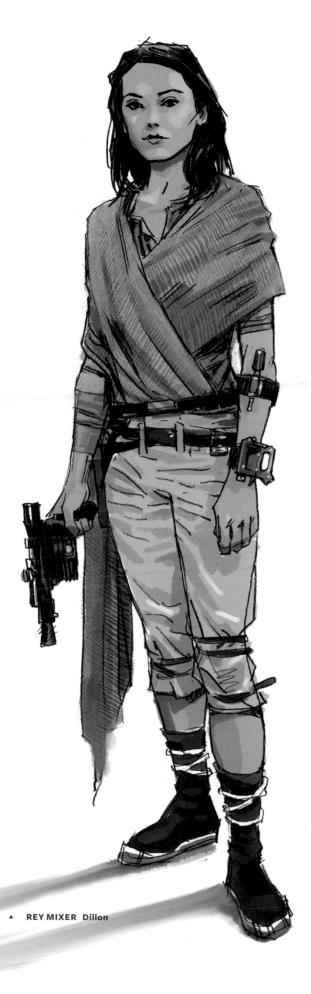

▲ REY MIXER Dillon

WHO'S WHO

J.J. Abrams
Writer/Director

Matt Allsopp
Concept artist

Christian Alzmann
Concept artist

Michael Arndt
Writer

Chris Bonura
Concept artist

Andrew Booth
Computer graphics
supervisor: BLIND LTD.

Luis Carrasco
Concept artist

Rick Carter
Co-production designer

Doug Chiang
Concept artist

Ryan Church
Concept artist

James Clyne
Concept artist

Jake Lunt Davies
Creature concept designer

Fausto De Martini
Concept illustrator

Glyn Dillon
Costume concept artist

Peter Dorme
Art director

Ryan Drue
Concept artist

Yanick Dusseault
Concept artist

Haley Easton-Street
Art director

Neil Ellis
Concept model maker

Landis Fields
Concept artist

Dave Filoni
Supervising director:
Star Wars Rebels

Jo Finkel
Art director

Luke Fisher
Senior sculptor

Colin Fix
Concept artist

Brian Flora
Concept artist

David Fogler
ILM CG artist

Lydia Fry
Assistant art director

Darren Gilford
Co-production designer

Roger Guyett
ILM VFX supervisor

Mark Harris
Art director—props

Kiri Hart
Lucasfilm vice president
of development

Will Houghton-Connell
Art department assistant

Colin Jackman
Creature sculptor

Kevin Jenkins
Art director

Michael Kaplan
Costume designer

Lawrence Kasdan
Writer

Kurt Kaufman
Concept artist

Kathleen Kennedy
Lucasfilm president

Magda Kusowska
Costume concept artist

Thang Le
Concept artist

Sam Leake
Draughtsman

Nicole Letaw
Art department coordinator

Karl Lindberg
Concept artist

Dela Longfish
Concept artist

George Lucas
Star Wars creator

Katrina Mackay
Assistant art director

Ivan Manzella
Senior sculptor

Iain McCaig
Concept artist

Timothy Mueller
ILM CG artist

Julian Murray
Creature concept designer

Brett Northcutt
Concept artist

Lee Oliver
Concept artist

Kimberley Pope
Costume concept artist

Dermot Power
Costume concept artist

Andrew Proctor
Draughtsman

Martin Rezard
Senior sculptor

Rayne Roberts
Lucasfilm creative executive

Stuart Rose
Art director—vehicles

Matt Savage
Concept artist

Erik Tiemens
Concept artist

Neal Scanlan
Creature creative supervisor

Tyler Scarlet
Art department assistant

Henrik Svensson
Creature paint finish
designer

Thom Tenery
Concept illustrator

Gary Tomkins
Senior art director—vehicles

Chris Vincent
Art department assistant

Dan Walker
Concept artist

Matt Walker
Scenic painter

Andrée Wallin
Concept artist

Sam Williams
Costume concept modeller

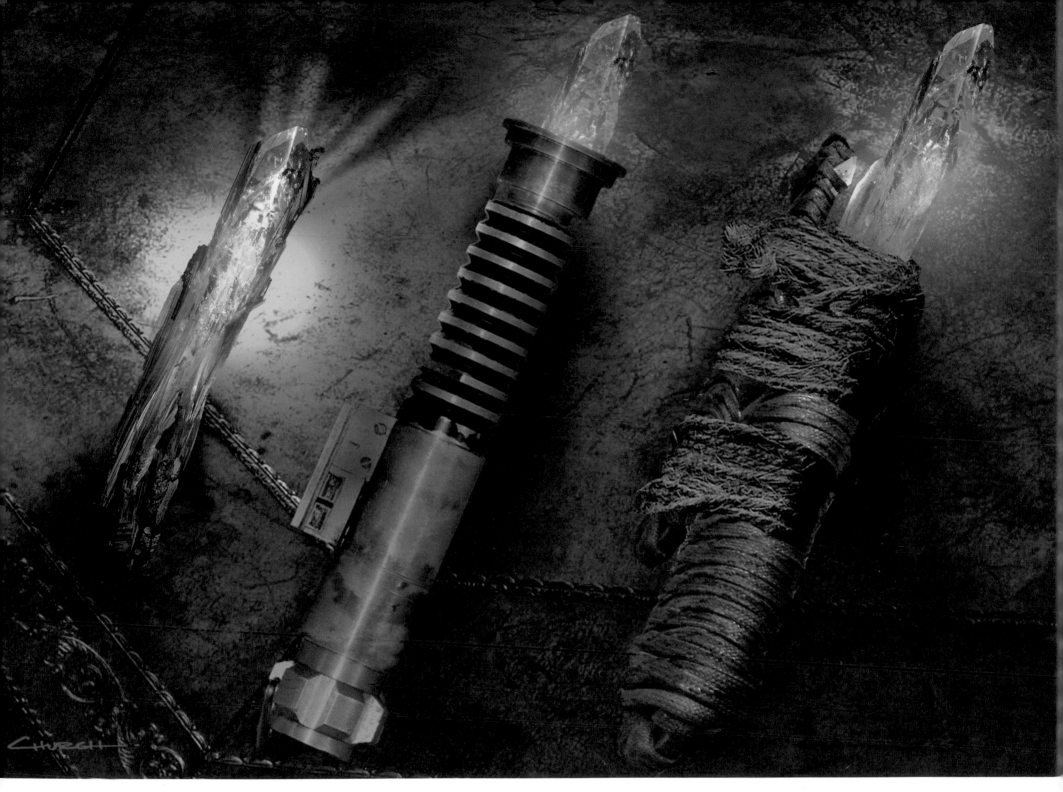

▲ **SABER STUDIES** *"You can see the little trigger crystal on the far right one—that's the most primitive lightsaber there is. All this aluminum-milled stuff, that's all just for safety and styling."* **Church**

"GUIDED IMAGERY" CONCEPT PHASE

"HOW STRONG IS THE FORCE?"

On October 31, 2012—Halloween—the day after Disney's acquisition of Lucasfilm and the public announcement of a new *Star Wars* trilogy, production designer Doug Chiang (*The Polar Express, War of the Worlds, A Christmas Carol*) reached out about Episode VII to several contacts close to Lucasfilm president Kathleen Kennedy, including his *The Polar Express* co-production designer Rick Carter (*Jurassic Park, Forrest Gump, Avatar*). "I heard about the new films like the rest of the world in late fall," Chiang recalls. "Of course, it was very exciting because *Star Wars* has been my passion for the longest time." Chiang was last affiliated with the franchise as concept-design supervisor for 2002's *Star Wars*: Episode II *Attack of the Clones*.

"Rick hadn't heard about it, either, until I told him," Chiang continues. "A couple days later, he came back and said, 'This is really interesting. I would like to throw my name into the hat.'" Carter contacted Kennedy shortly thereafter, offering to help in whatever capacity she needed. "I think roughly about a month after that, Kathleen reached out to Rick and said, 'Even though we don't have a script or a director yet, let's start this process.'"

Carter, Chiang, and David Nakabayashi, creative director of Industrial Light & Magic (ILM), convened at the Letterman Digital Arts Center in San Francisco on December 11 to handpick a "dream team" of designers for an Episode VII art department, to be inaugurated in January 2013, with plans for a full production design team to be up and running by March. The following day, Carter met *Star Wars* creator George Lucas for the first time in the Main House on Skywalker Ranch.

On January 9, 2013, Carter called the first meeting of his concept art department. Working in tandem with screenwriter Michael Arndt (*Little Miss Sunshine, Toy Story 3*), Lucasfilm Vice President of Development Kiri Hart, and soon-to-be-announced director J.J. Abrams (*Mission: Impossible III, Star Trek, Super 8*), the artists were encouraged to dig deep and create pieces that Carter calls "guided imagery."

"You're in a waking dream state and learn to say what comes to your mind. You pick up on little things and follow them, which is what allowed me to become a production designer," says Carter. Guided imagery is often purely symbolic, with little to no connection to the developing plot of the film, but the art can spark other ideas or stand as thematic milestones for the ongoing screenwriting and visual development process. Carter also posed fundamental, deeply challenging questions; "How strong is the Force?" and "Who is Luke Skywalker?" were most prominent among them. "What is the Force's relevance?" he wondered. "Does it mean anything now? Or is it just what is referred to in the movies, an archaic old wives' tale of days gone by and simpler times of ancient chivalry? Today, does anybody really care?" Translating the spiritual movement of the Force into compelling visuals would be their first, and possibly greatest, challenge.

Carter worked primarily out of Los Angeles, meeting with Abrams at Bad Robot Productions. He then relayed information to the gathered Visualists and art department coordinator Nicole Letaw via teleconferenced meetings on a weekly or bi-weekly basis, along with daily phone calls.

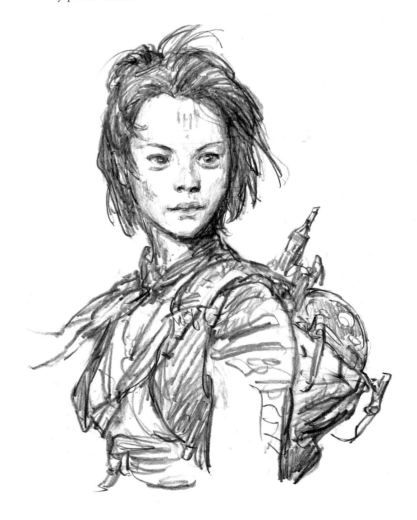

▲ **ALT KIRA (REY)** Iain McCaig

Rick Carter's concept art team hit the ground running. For the first meeting on January 9, 2013, Carter tapped leaders from across the company. This creative council included *Star Wars Rebels* supervising director Dave Filoni, Story Group's Kiri Hart and creative executive Rayne Roberts, chief technology officer Kim Libreri, senior vice president of physical production Jason McGatlin, and me, along with the initial group of accomplished ILM concept artists and *Star Wars* veterans: Doug Chiang, Iain McCaig, Erik Tiemens, Kurt Kaufman, Christian Alzmann, and Yanick Dusseault (James Clyne, who worked with Rick Carter on *Avatar* and *Lincoln*, contributed from Los Angeles starting on January 21). McCaig recalls: "We sat in the round, all the Knights of the Round Table, coming back to help on the latest quest."

"In Rick's mind, we're not just artists; we're 'Visualists,'" Chiang says. "And he was trying to develop that concept, where it's not just artists who can draw, but it's people like John Knoll, Dennis Muren, or Roger Guyett from ILM, story people like Kiri, Michael Arndt—all trying to collaborate and come up with what the film should look like."

On January 24, Carter and Chiang hosted an concept art presentation for Walt Disney Studio executives, including chairman and chief executive officer Bob Iger, chairman Alan Horn and president Alan Bergman, at Big Rock Ranch, just down the road from Skywalker Ranch. Chiang recollects, "We took what we knew of *Star Wars*, and what we would like to see of *Star Wars*, and we just blew it out." Work in January primarily focused on who Luke Skywalker, Han Solo, and Princess Leia have become in the thirty-plus years after the events of *Star Wars*: Episode VI *Return of the Jedi*. Two new characters, Kira and Sam (later renamed Rey and Finn), are also first realized. *Star Wars* creator George Lucas provided his Episode VII treatment to the project's creative team. And after months of Internet speculation, J.J. Abrams was officially announced as the director of Episode VII on January 25.

"I don't care what anything looks like. I really don't. I have total faith that it's going to look wonderful. I want it to be a great movie because it's infused with the spirit of the Force." **Rick Carter**

▸ **FELUCIA CANYON** Erik Tiemens

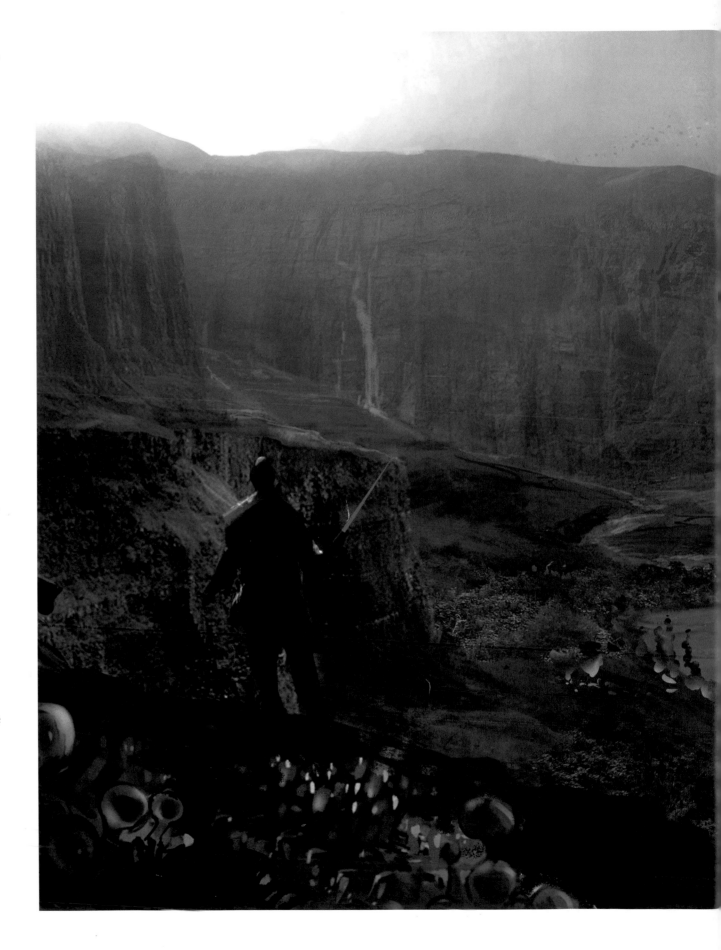

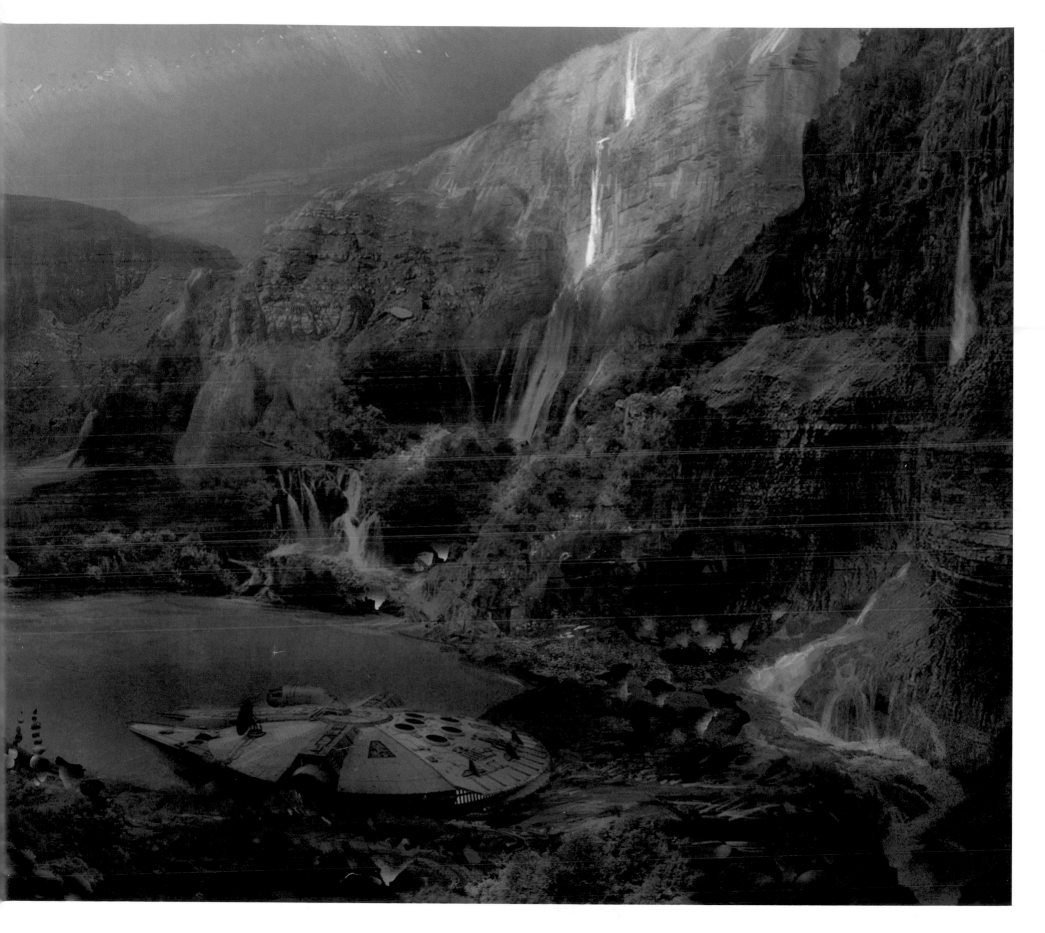

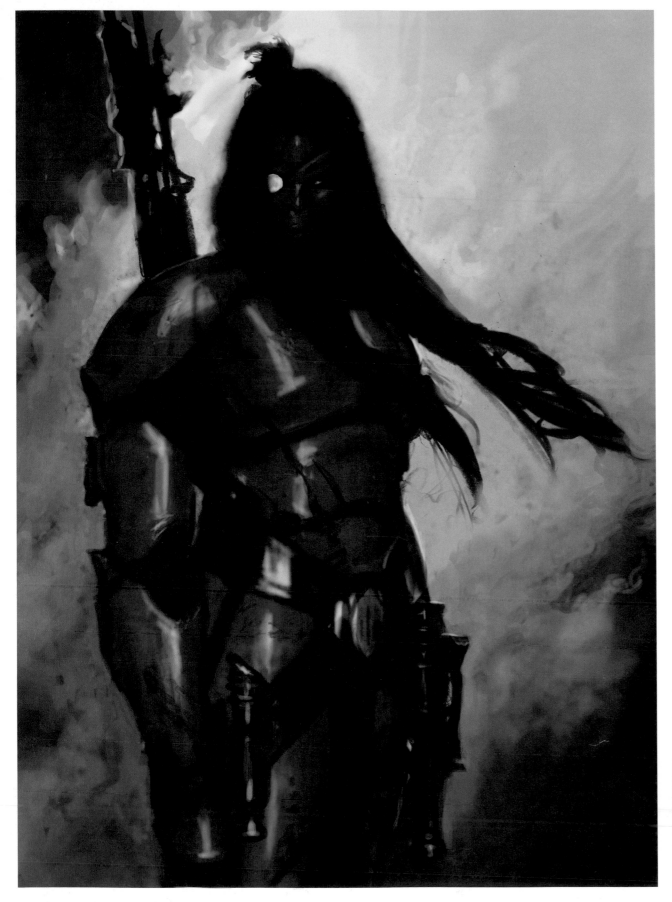

For the early Episode VII meetings in January, Rick Carter tacked up work—primarily pirate paintings—by the late nineteenth-century American illustrator Howard Pyle; nature photography and Zen Buddhist imagery that evoke both the wabi-sabi aesthetic and the Force; concept paintings from legendary *Star Wars* concept designer Ralph McQuarrie; images of mountain climbing; and stills from Akira Kurosawa's films—including 1958's *The Hidden Fortress*, which directly inspired Lucas's *Star Wars: Episode IV A New Hope*. At one point in the January 9 meeting, Carter handed a stack of random Kurosawa stills to Kiri Hart and asked her to use them to tell the story of Episode VII. The five chosen images, from films such as *Rashomon* and *The Hidden Fortress*, perfectly illustrated Kira's journey of self-discovery, from fearful Force-sensitive to master.

◄ **JEDI KILLER** McCaig

▼ **LUKE 13** Christian Alzmann

Screenwriter Michael Arndt would later describe these early versions of Episode VII's young heroes, Kira and Sam, as a "loner, hothead, gear-head, badass" and "pure charisma," respectively.

▸ **KIRA (REY) AND SAM (FINN)** McCaig, Lindberg, Tiemens, and Chiang

▾ **PRINCESS LEIA REVISED** *"The actress Sarah Bernhardt had a fantastic costume with a very high collar when she was getting older but still playing romantic leads. And it's such an attractive choice, because it really sculpts the face."* **McCaig**

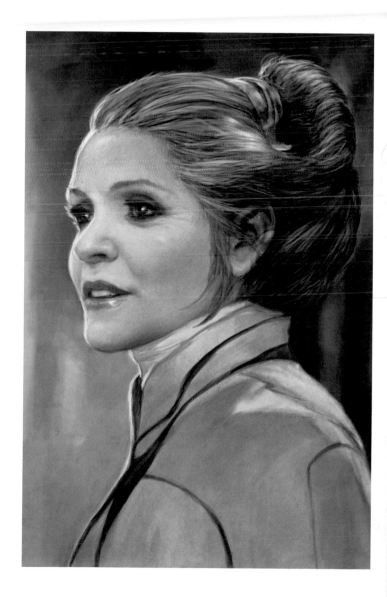

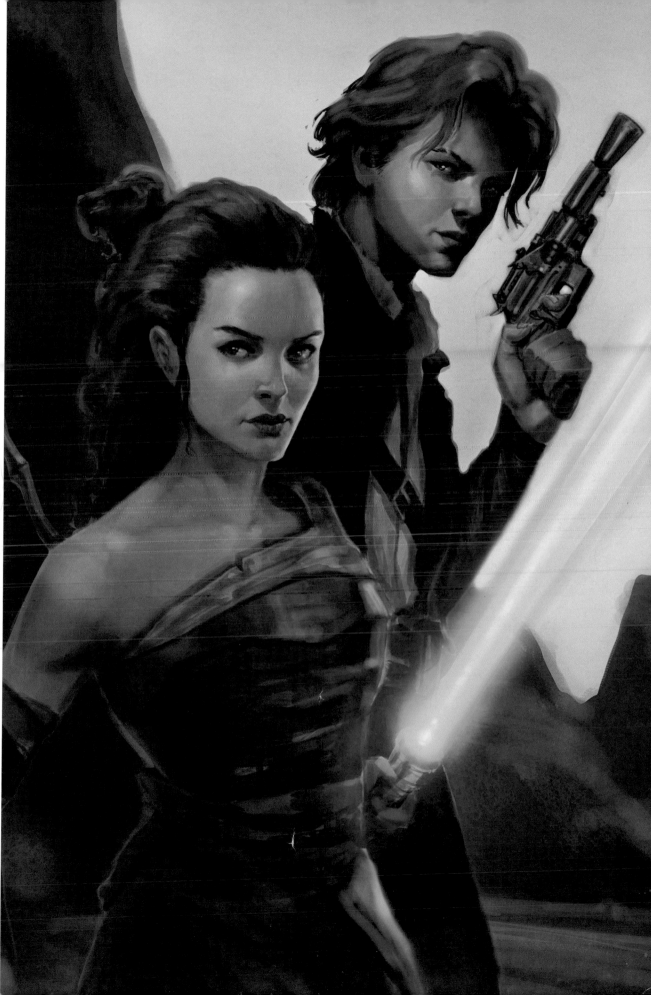

▲ **FELUCIA SPACE VERSION** Yanick Dusseault ▼ **FELUCIA UNDER** Dave Filoni

▲ **BANDITS** Dusseault ▼ **BLOB &** *MILLENNIUM FALCON* Kurt Kaufman

▲ **HAN SOLO** Alzmann and McCaig

"Iain and I were thinking about Jeff Bridges in True Grit [2010]. Everyone loved the idea of a duster and the long combed-back hair with the beard. They wanted it to look like the old Sergio Leone–style posters." **Alzmann**

The seeds of a junk planet concept were born out of the very first Visualist meeting on January 9, in which a crashed Imperial space station was discussed. Not long after, they proposed the idea of a wrecked Imperial Star Destroyer. Reference imagery of the shipbreaking yards of the modern-day Indian subcontinent were combined with these ideas, and the planet of Jakku began to take shape.

"In the beginning, Michael Arndt would have ideas about types of planets—environments that he was looking to explore, such as a planet that had all the wreckage from the previous Star Wars movies." **Carter**

▶ **JUNK PLANET CONCEPT SKETCH** Tiemens

▼ **JUNK PLANET** Kaufman

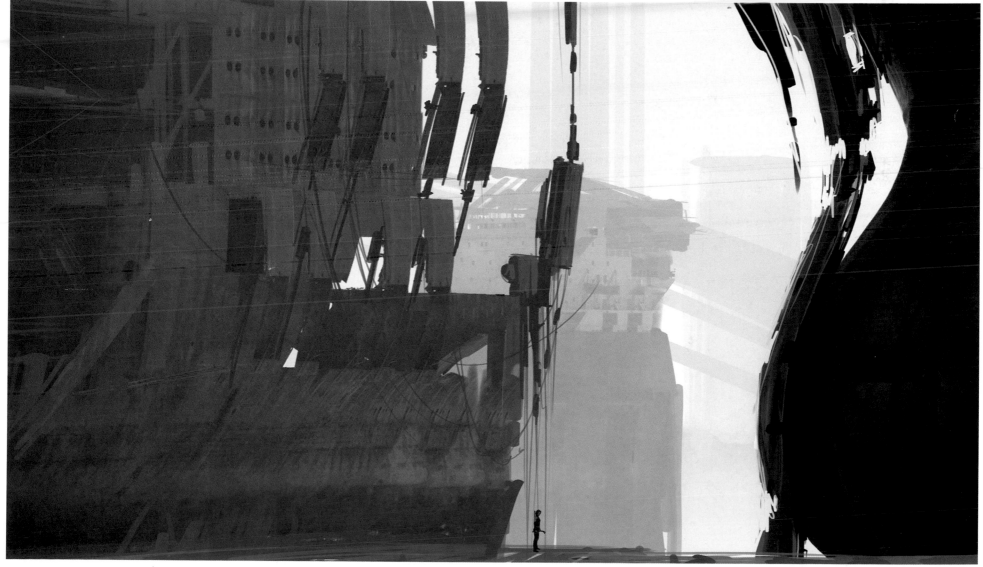

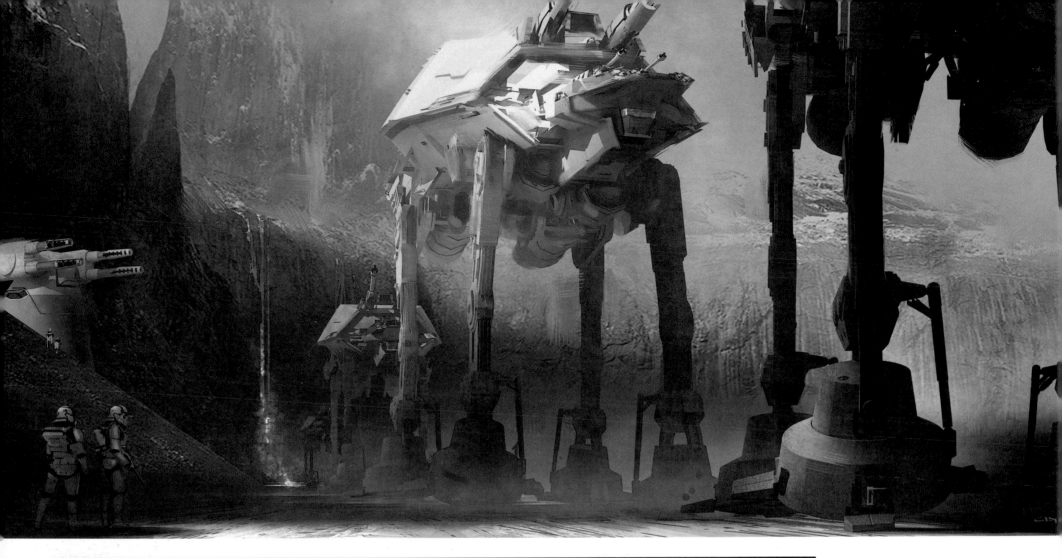

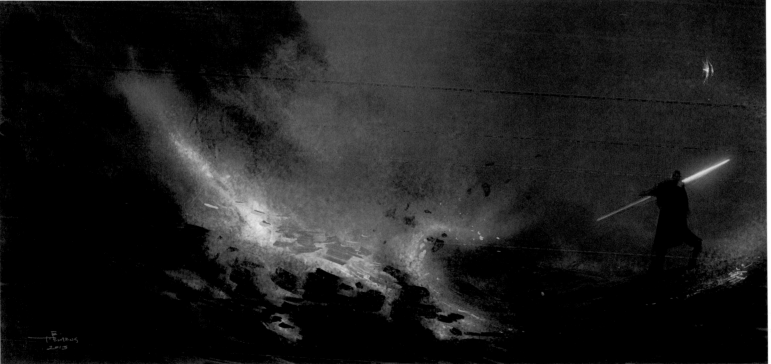

▲ **WALKER LAVA SNOW** Clyne

◄ **FIRE & ICE CONCEPT** "Early on, Rick was really keen on bringing this concept of fire and ice together visually. He suggested, because I had one lightsaber that was blue, 'Why don't we make it a double lightsaber?'" **Tiemens**

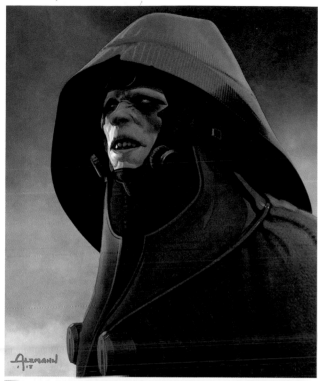

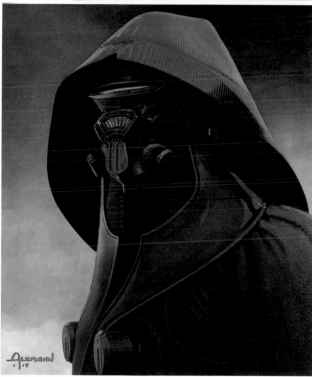

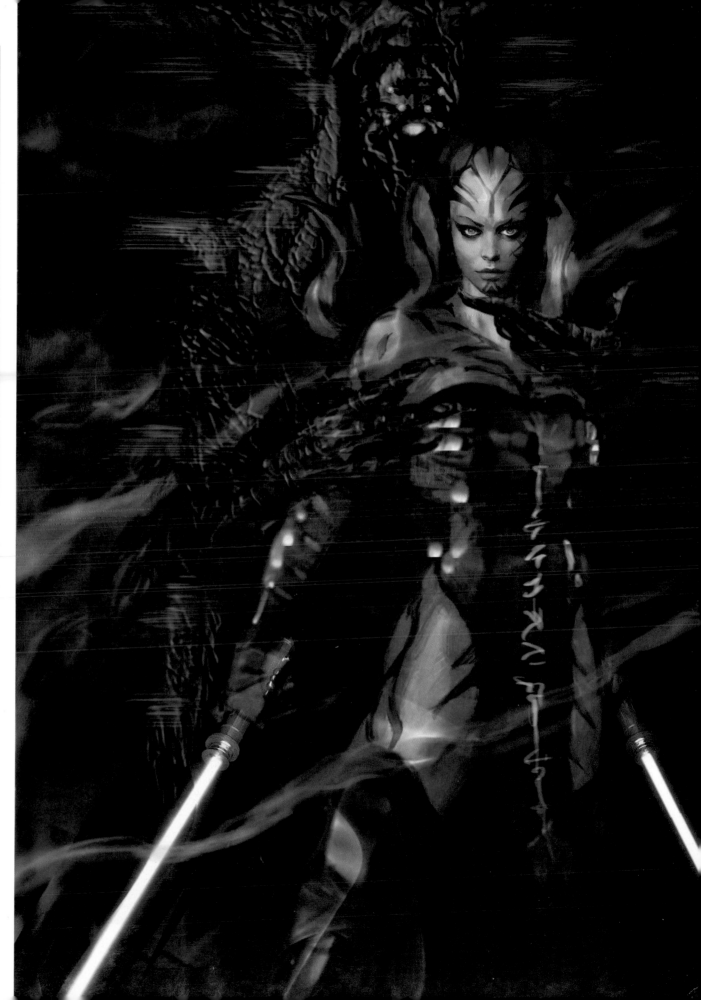

▲ **VILLAINS 03 & 06** *"These were actually the first images that I did of a Sith. Even there, I was going with a brown cape, making him a little more rustic. Because this concept did well, I became the 'villain guy' for a long time."* **Alzmann**

▶ **DARTH TALON, DARK SIDE OF THE FORCE** *"The tattoos are a lot simpler. They follow a rhythm and they flow. And that's the evil thing puppeteering her from behind."* **McCaig**

Taking a break from *Star Trek Into Darkness* post-production, director J.J. Abrams and his Bad Robot Productions team visited Lucasfilm on February 13 for an art presentation led by Kathleen Kennedy and Rick Carter. Kiri Hart, Jason McGatlin, ILM chief creative officer John Knoll, Doug Chiang, and screenwriters Michael Arndt and Episode VII story consultant Simon Kinberg were also in attendance. "How *Star Wars* relates to our lives is everything," Abrams said. "What's my place in the world? How am I connected to everyone else? The light and dark—the Force is a critically important component in this. I love how, in the first film, Han Solo is debating if the Force even exists, like it's some sort of an ancient religion or joke. It's about belief on some level—and the ability to be aware of your place in the world."

Darth Vader's castle, as illustrated by Ralph McQuarrie in the early development of *Star Wars: Episode V The Empire Strikes Back*, was mentioned. The junk planet, Luke's hovel, and the nature of the Force were all discussed in the meeting and continued to be developed in February, as well. February also saw the return of concept artist Ryan Church, who worked with Carter on *Avatar* and Abrams on both *Star Trek* reboot films, to the *Star Wars* art department.

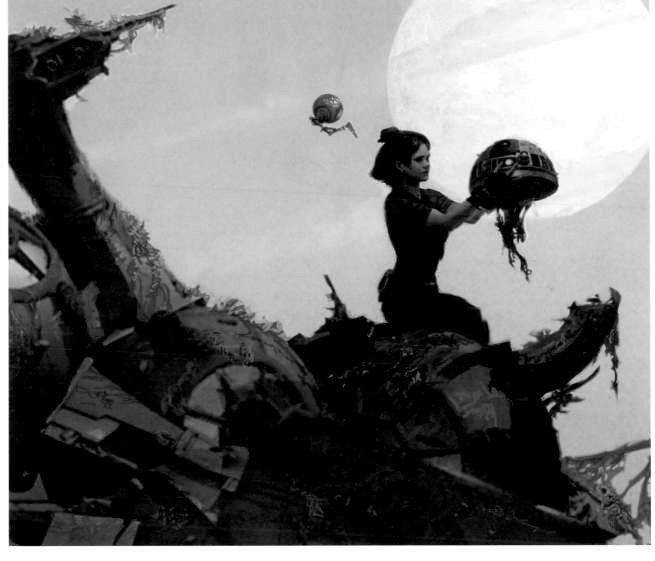

▲ KIRA (REY) IN THE JUNKPILE McCaig

▼ DROID JETSAM McCaig

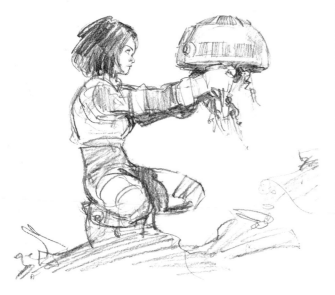

▼ JUNK BARGE Chiang

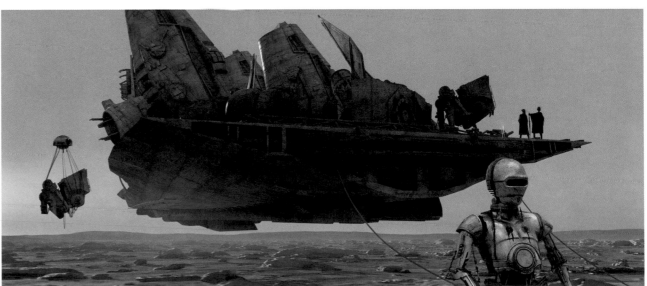

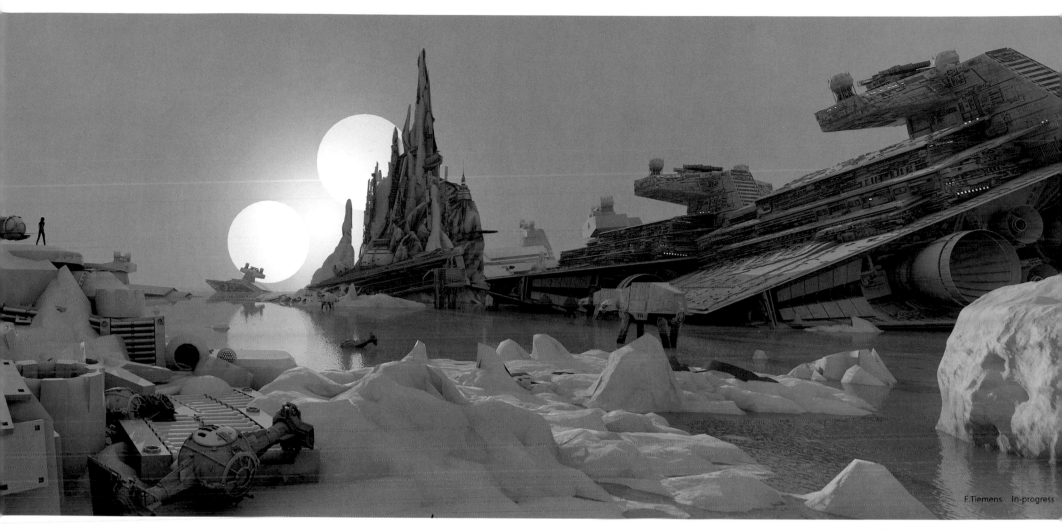

▲ JUNK CASTLE LANDSCAPE Tiemens ▼ KIRA'S (REY'S) CASTLE/STAR DESTROYER CANAL SKETCH Tiemens ▼ KIRA (REY) JUNKYARD McCaig

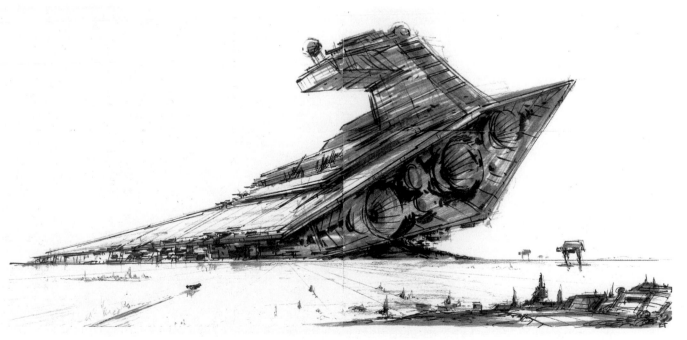

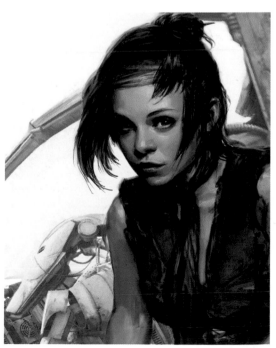

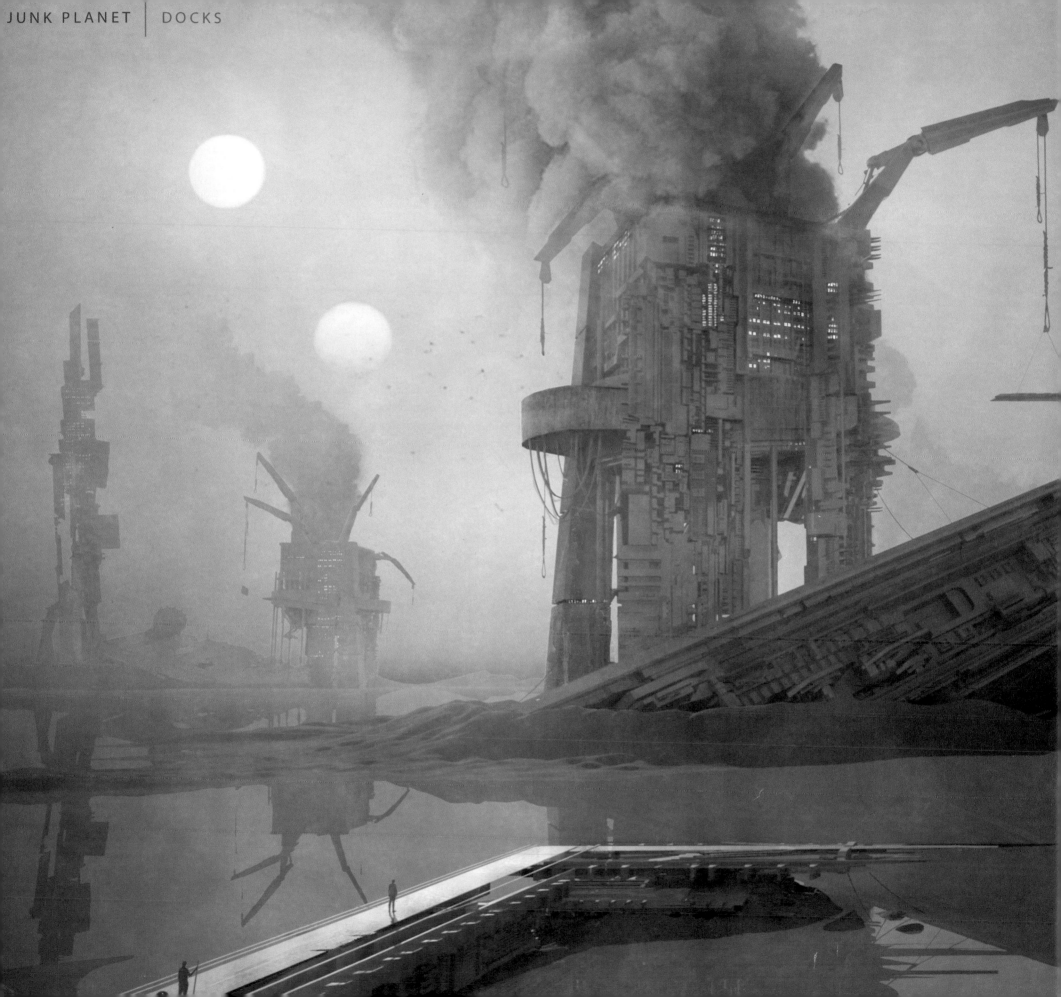

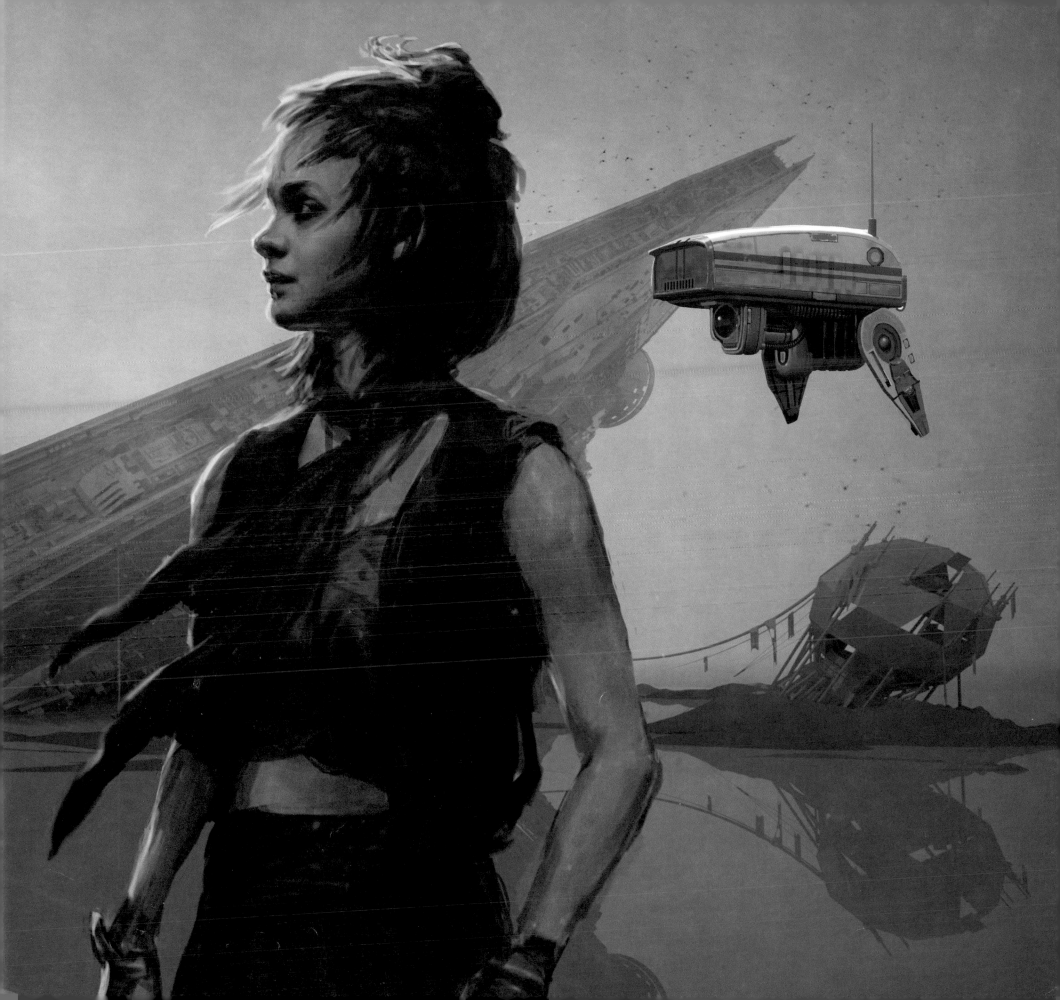

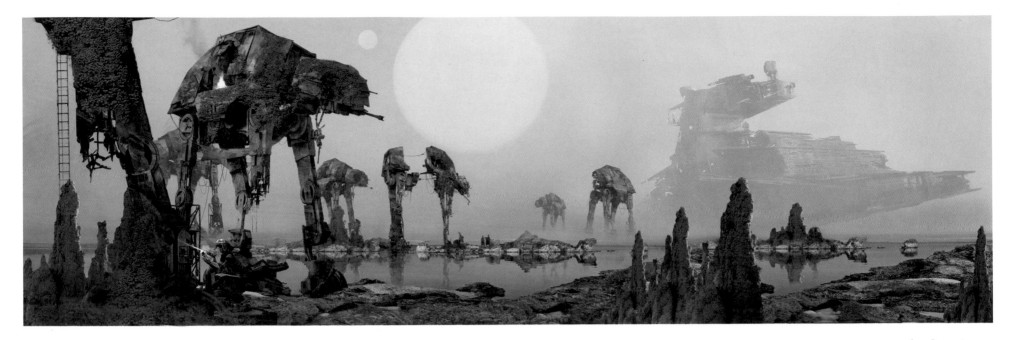

▲ JUNK WALKER DWELLING Chiang

▼ KIRA (REY) 1B Alzmann

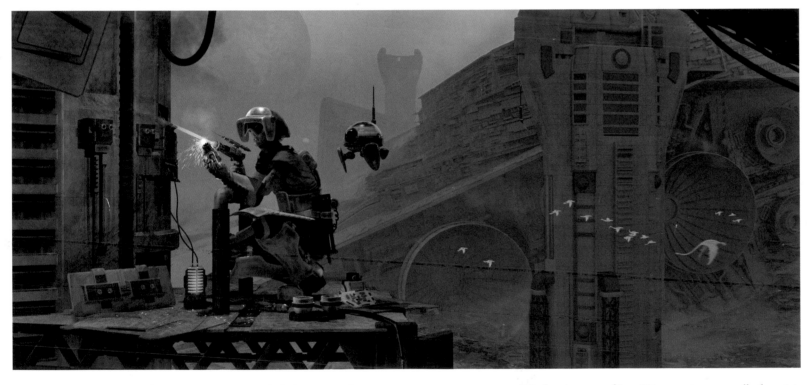

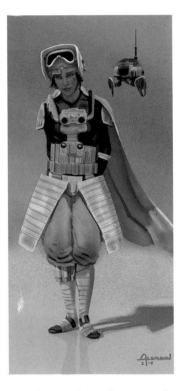

◄◄ JUNK PLANET McCaig, Tiemens, Alzmann, and Landis Fields
"When you have a great band, you just play together. So this is Erik Tiemens's background, Christian Alzmann's droid, and my Kira." **McCaig**

▲ KIRA (REY) 2C "My favorite parts of Star Wars movies are usually the quiet moments, because that's when you really get into the heart of a character. The twin suns moment is absolutely perfect. Even just Luke poking at his food while having a light argument with his aunt and uncle—that's where you actually get pulled in as a viewer." **Alzmann**

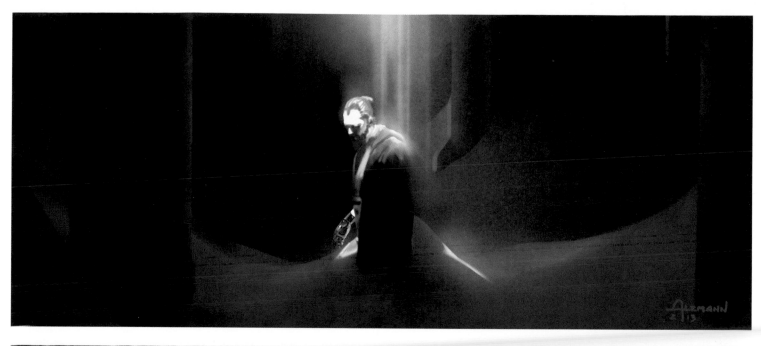

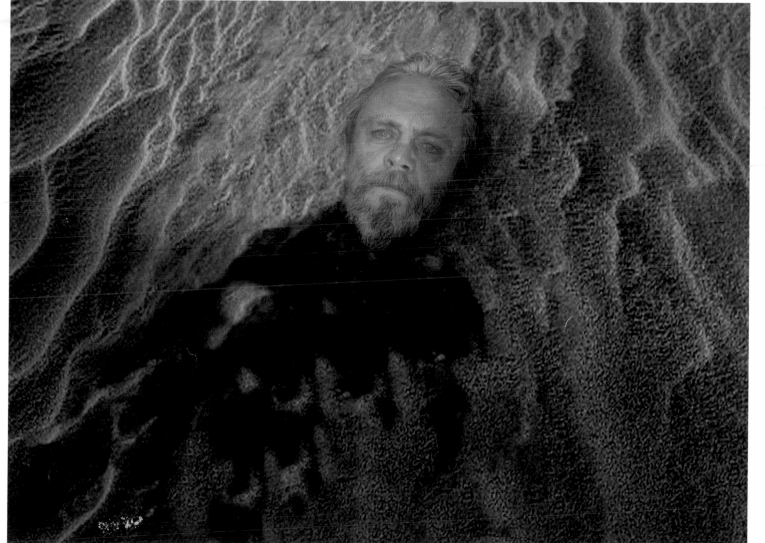

◂ **LUKE TRAPPED** *"Kathy would have an idea for an image or something she read about on the Internet that would make an interesting scene. My image of Luke in the sand was one. It was almost like illustrating a dream, in a way."* **Alzmann**

▲ **LUKE STAGE 2C, 2D & 2E** **Alzmann**

◂ **LUKE SKYWALKER IN THE SAND**
 McCaig and Chiang
 "The sand is pouring in on top of him, and he doesn't care. At one point, he suddenly just opens his eyes." **McCaig**

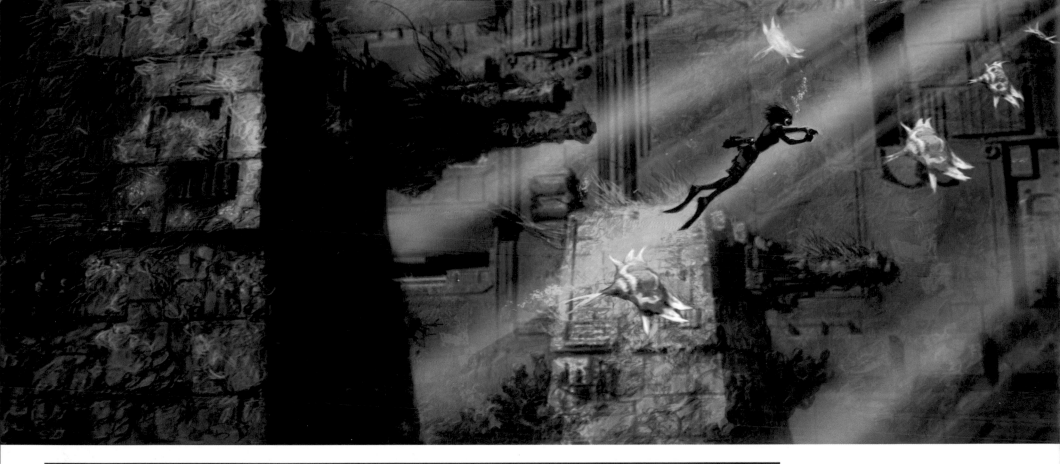

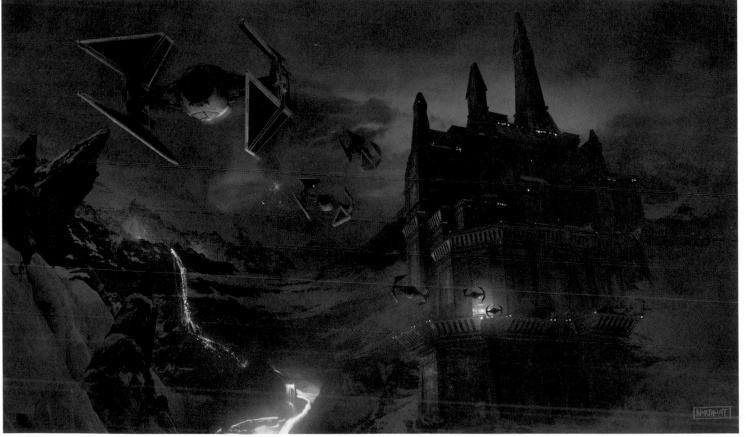

▲ **DEATH STAR TRENCH UNDERWATER**
 McCaig and Chiang
 "So when the adventure's over, Kira finds a hidden map inside the Emperor's tower of the second Death Star. And the map tells you where the Jedi are and where Luke is hiding." **McCaig**

◄ **VADER CASTLE** Northcutt (after Tiemens)

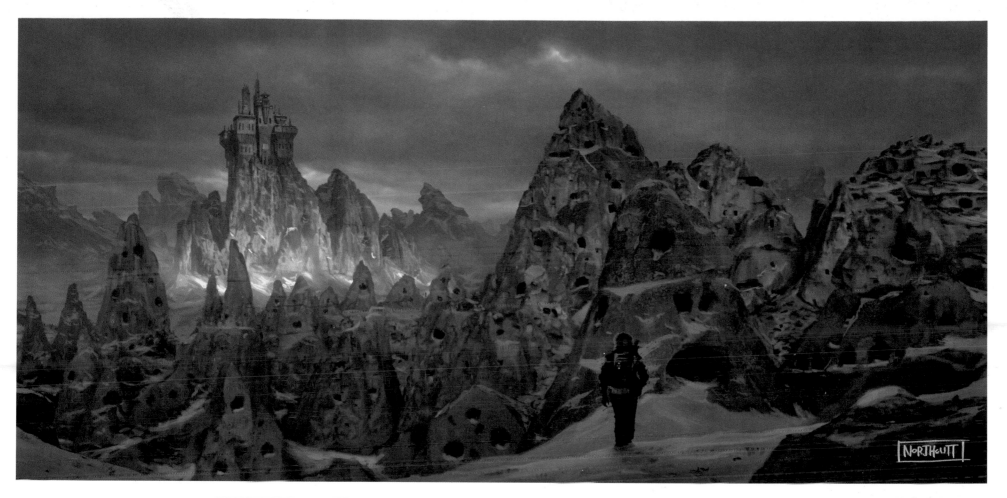

▲ **VILLAIN CASTLE** Northcutt

▶ **SEDUCTION** 001, 002, 003 & 005
McCaig

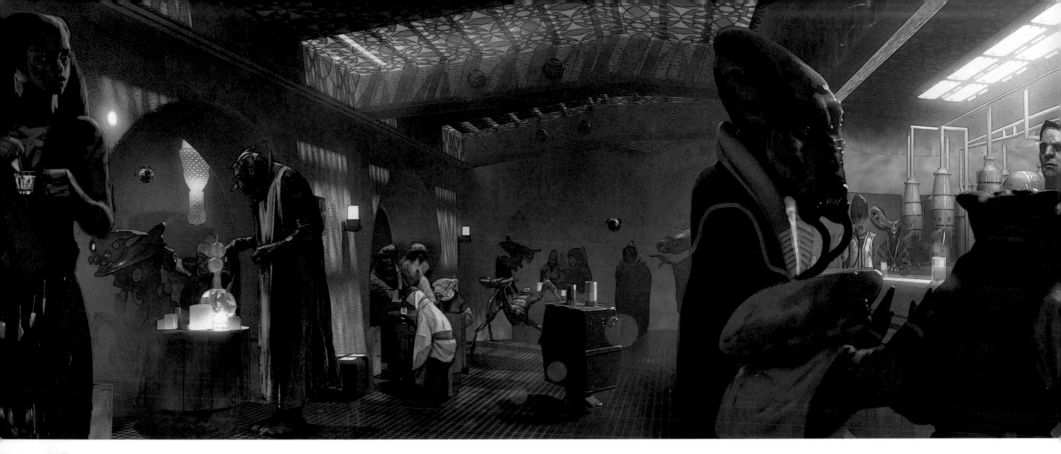

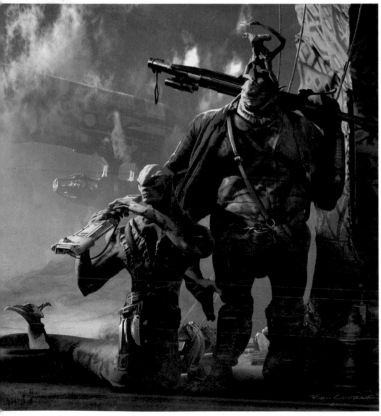

▲ **ROGUES: SNAKE & SYMBIOTE** Church

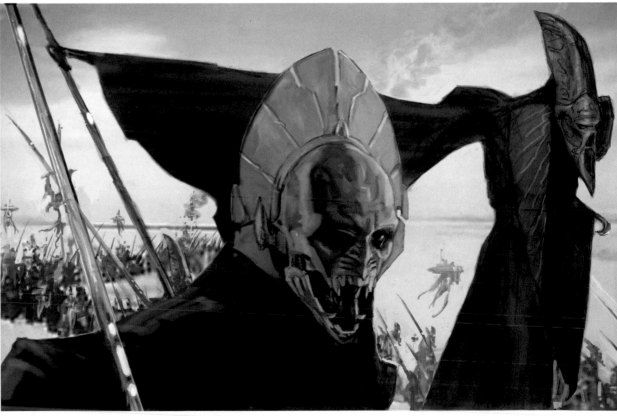

▲ **SITH LORDS** *"Rick came in with a bunch of photographs, and one was from Ivan the Terrible [1945]. I did an Ivan the Terrible–esque villain in mid-ground. Then in the foreground I thought, 'How fun if the villain were half-machine, half-flesh together?'"* **McCaig**

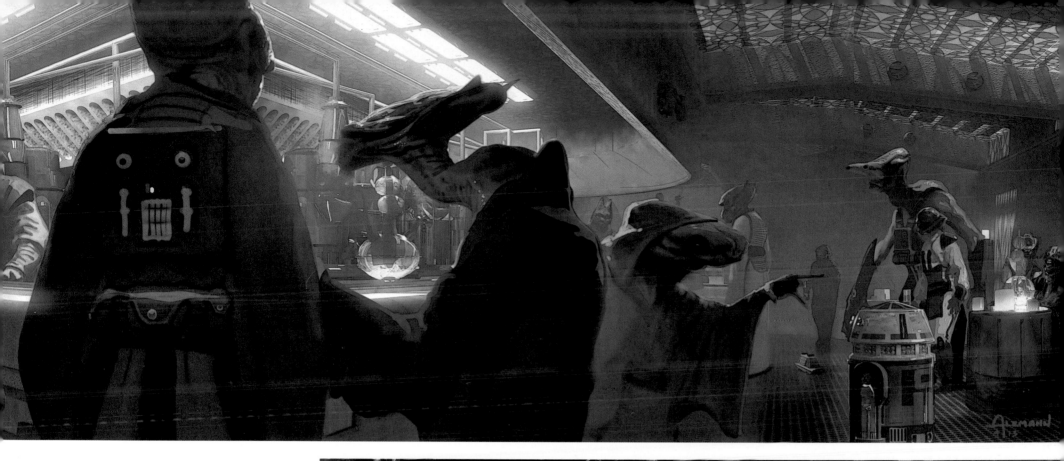

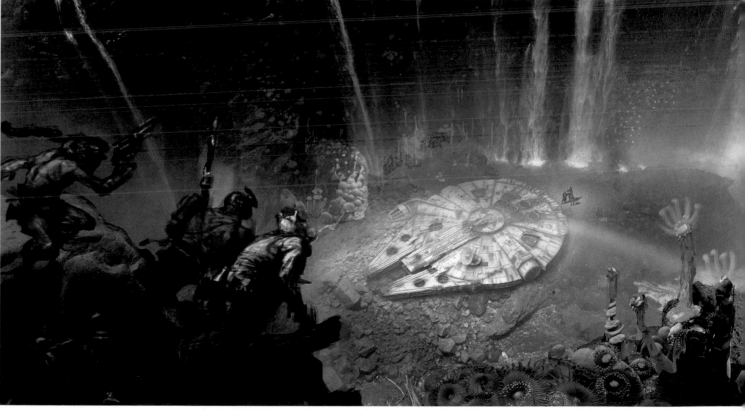

▲ **SPACE PIRATE** *"This was my version of what I thought a space pirate would look like in Star Wars. It definitely feels more bounty hunter–esque, but you can add a little bit of flair with a red body sash."* **Alzmann**

▲ *FALCON* **PIRATES** Brian Flora ▲▲ **BAR** Alzmann

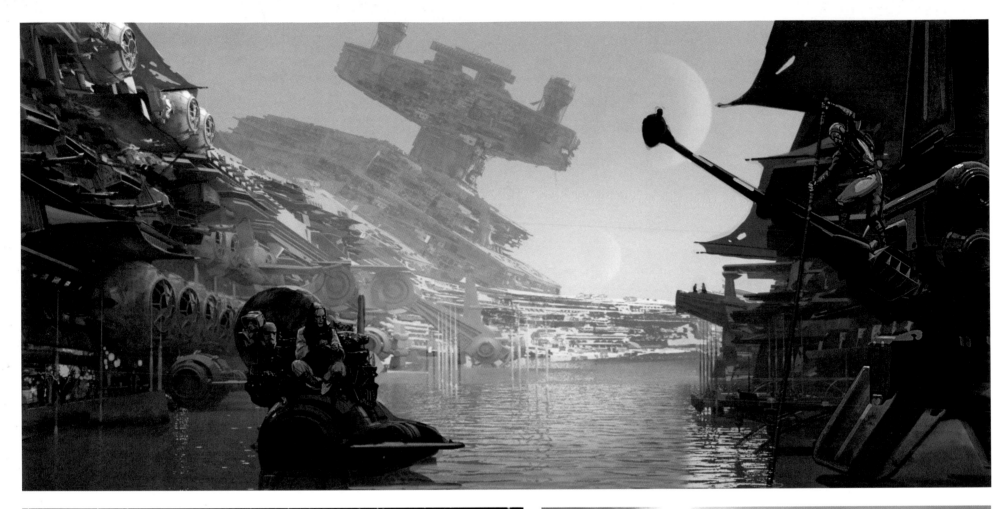

▲▲ JUNK CITY Alzmann, Kaufman, and McCaig ▲ KIRA (REY) SPEED Kaufman ▲ KIRA (REY) SHIP Chiang

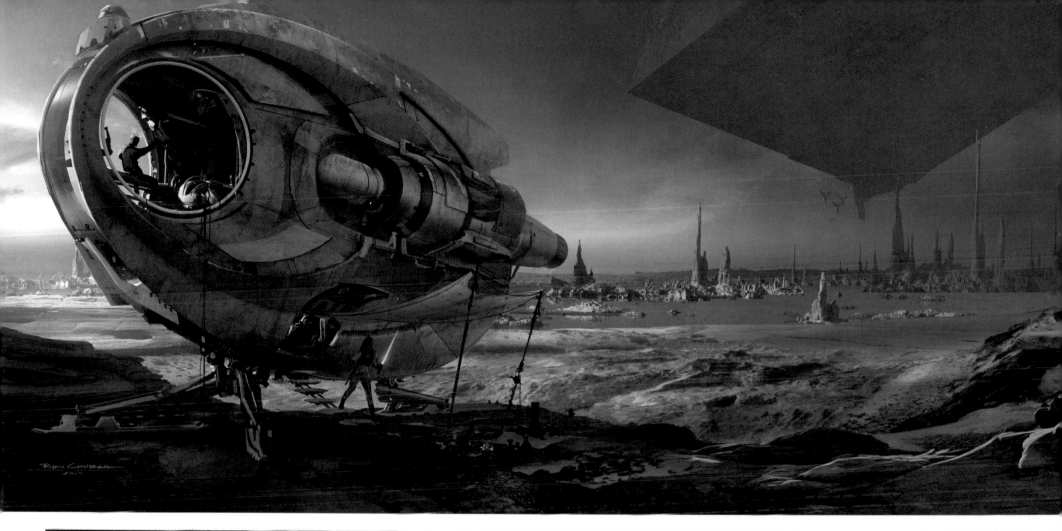

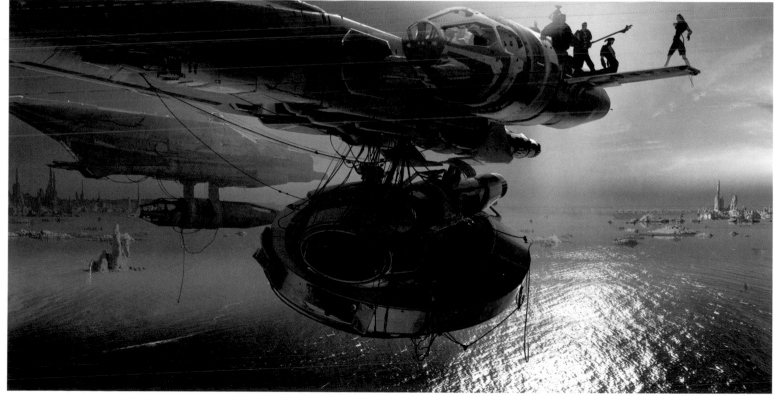

▲ **OVAL SHIP LANDED** *"I was just thinking, 'Well, they probably want to do some iconic shapes for a ship.' Slave I is a favorite ship theme— one that changes configuration once it's taken off."* **Church**

◄ **WALK THE PLANK** **Church**

As Michael Arndt's outline for Episode VII continued to take shape, designs for the newly christened but still origin-less "Jedi Killer" villain, Luke's homestead, and Kira's home planet saw further development. The junk planet town also picked up new design influences: Spaghetti Westerns of the 1960s, and the Afghani short film *Buzkashi Boys* (2011), slowly moved the outpost into something more Old West.

Several new story beats were first explored in March, including a daylight attack on the outpost by the Jedi Killer and his hooligans—first a band of pirate-mercenaries, then stormtroopers—which cemented the Jedi Killer's alignment with Neo-Imperial forces. Arndt met with the art department on March 5, and the very first inklings of a Neo-Imperial superweapon emanating from a planet were sketched out, then further developed in April. A climactic battle on an ice planet and a Yoda-like mentor figure for our young protagonists were also realized. Lastly, the enigmatic (and temporarily named) "John Doe," later named Poe, rounded out the trio of lead characters.

Kathleen Kennedy, Rick Carter, ILM senior visual effects supervisor Dennis Muren, and the Visualists journeyed to Skywalker Ranch on March 14 for a deep dive into the archives. "That, to me, was one of the most amazing highlights, because I hadn't seen the majority of the artwork that Joe Johnston and Ralph McQuarrie had worked on," Erik Tiemens remembers. "We were going through it, and there was something so tangible about the physical presence of the originals. That was our spiritual launching point."

▲ **LUKE & VADER** Alzmann
"One of the primary entry points for J.J. was the question: 'Who is Luke Skywalker?'—as if being asked by somebody in the movie who doesn't know. And that gets right to the point of, what is Star Wars now? Who is Luke Skywalker? Is he still in the game? Is he still with the Force? What's his role? What's happened since then?" **Carter**

▶ **VILLAIN** *"This one was 'it' for a while. J.J. saw this, and that's when he got the idea that this guy would be an imposter of Darth Vader, in order to mess with Luke's head."* **Alzmann**

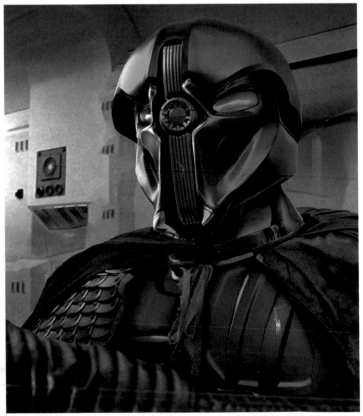

▲ **DARTH FULL HEAD** Church

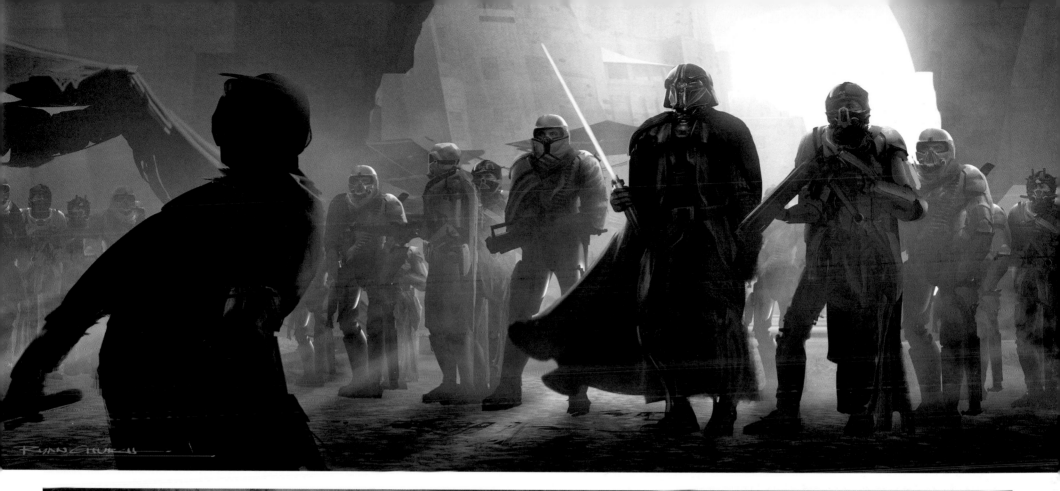

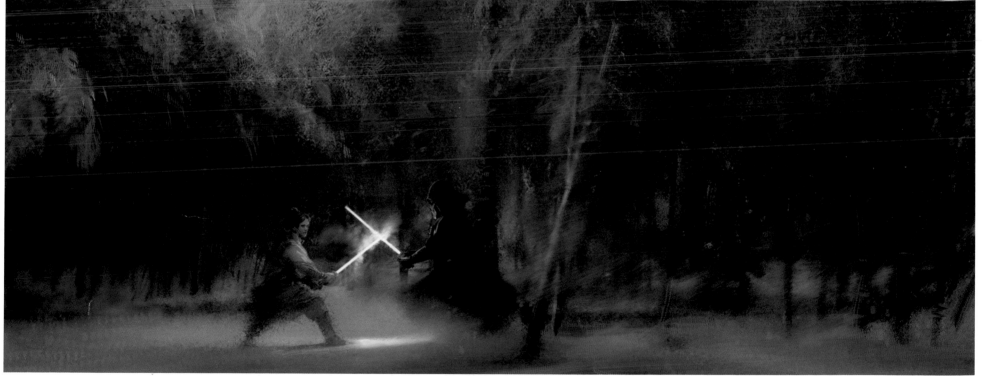

▲▲ **MARKET BAD GUYS** Church

▲ **SNOW FIGHT** Tiemens and McCaig

"It's dramatic, but it's beautiful. And there's silence in the piece.
But then there's this sort of quiet violence in the lights." **Tiemens**

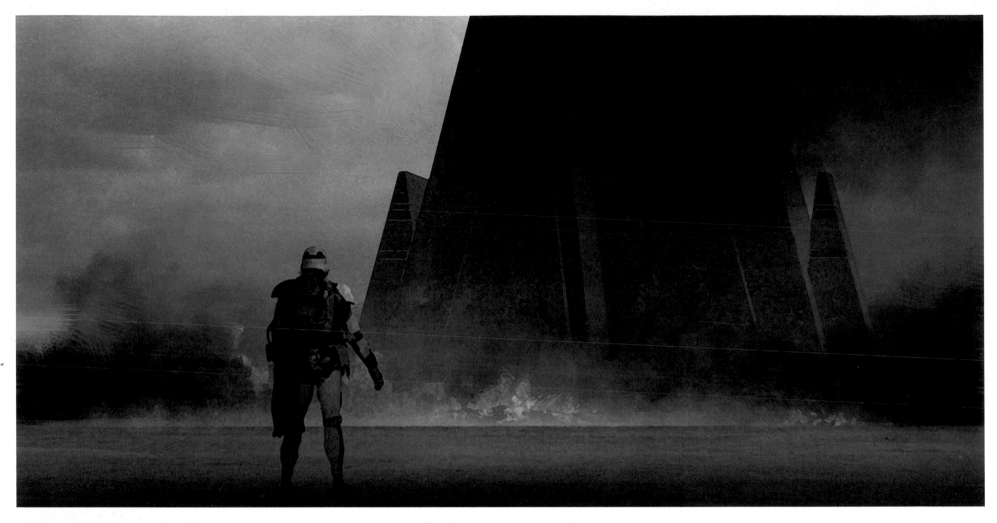

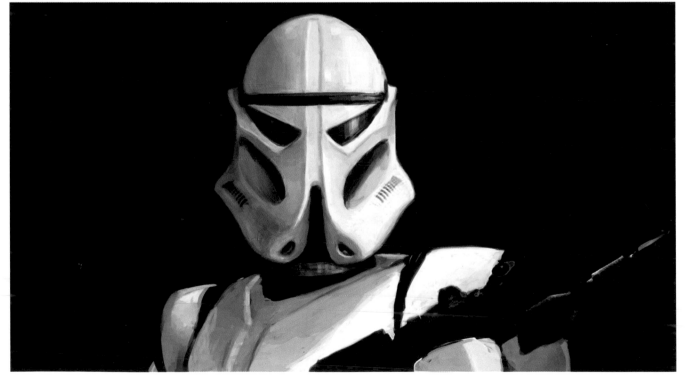

▲ BURNING Clyne

◄ NEW STORMTROOPER CLOSE-UP McCaig

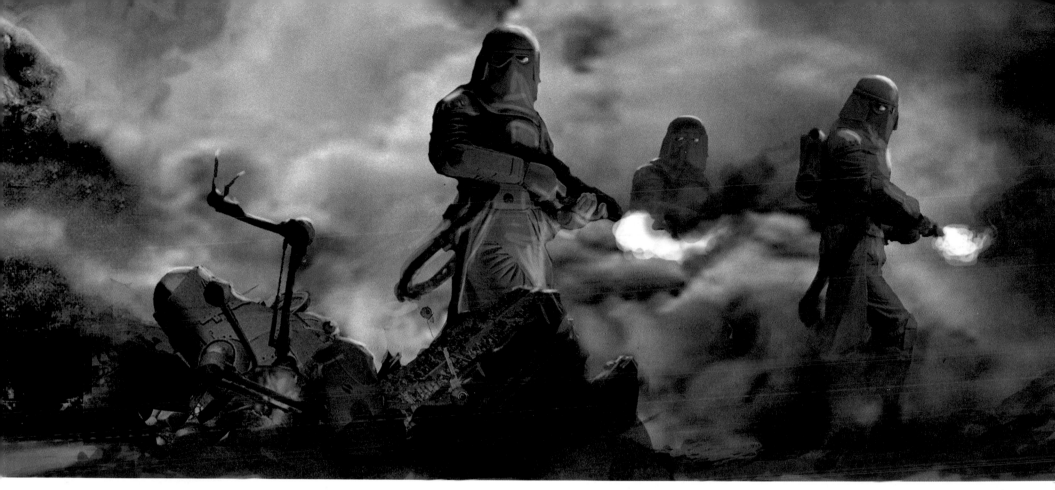

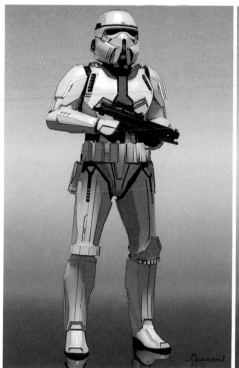
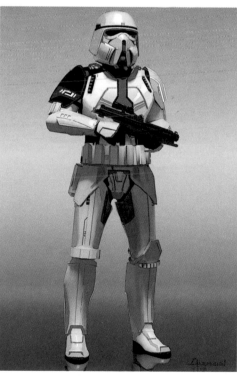
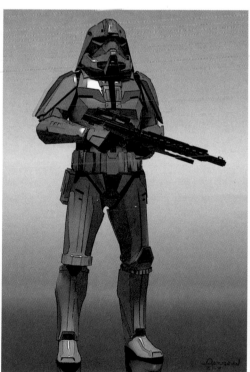
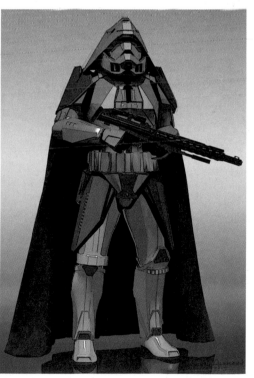

▲▲ **FIRETROOPERS** McCaig

▲ **STORMTROOPER B, B VERSION 3, C & G** *"We just updated the stormtrooper and gave it some edges. Things today have smaller radii, tighter lines. And they're more lightly faceted, as opposed to smooth and windswept like the stuff was in the seventies."* **Alzmann**

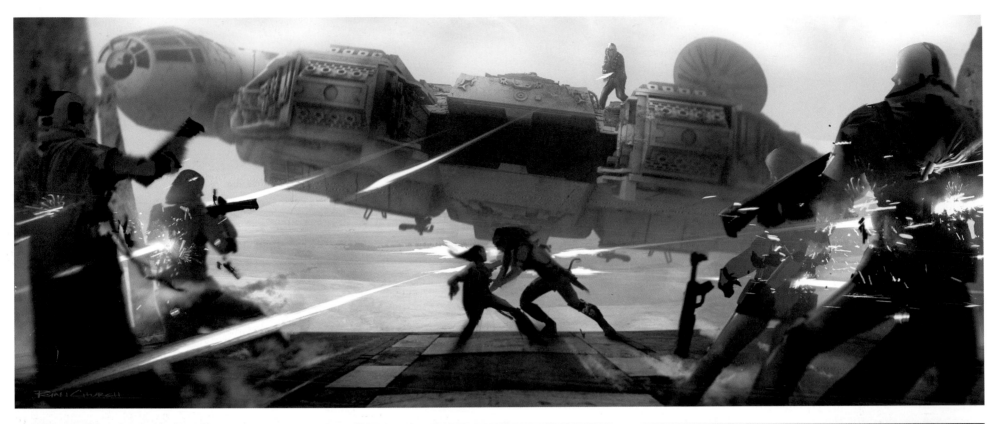

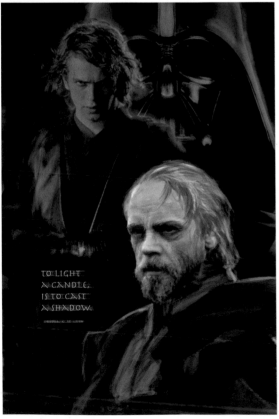

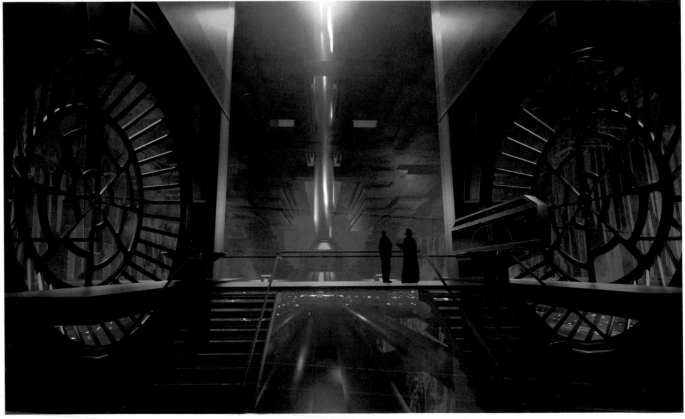

▲ **LUKE & ANAKIN EPIPHANY** *"I love that quote from A Wizard of Earthsea, the fantasy novel by Ursula K. Le Guin: 'When you light a candle, you also cast a shadow.' That inspired me to propose, for the first time, that Anakin's ghost could come back."* **McCaig**

▲ **SUPERGUN CONTROL CENTER** Church

▲▲ *MILLENNIUM* **SURPRISE** Church

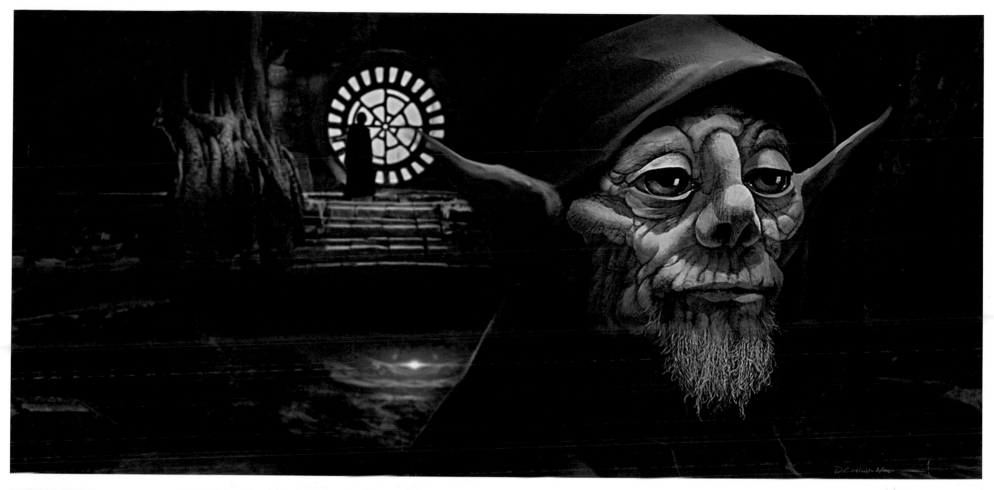

GOOD YODA Chiang and Ralph McQuarrie

"Ralph had created this really loose pencil sketch of a Yoda-like character. So I literally just did my version, painting over his, using his proportions, just to see if it could be something." **Chiang**

▶▶ **SNOW BATTLE, DESTROYER DOWN SHOT**

"This was when I was working at home, and I don't even think Rick had said 'ice planet' or anything. There's a million tiny little red lightsabers going up toward the structure. And there's a line of blue lightsabers defending it." **Church**

◀ **FOREST HOMESTEAD** Chiang

▲ **SABER TOTEM** Church

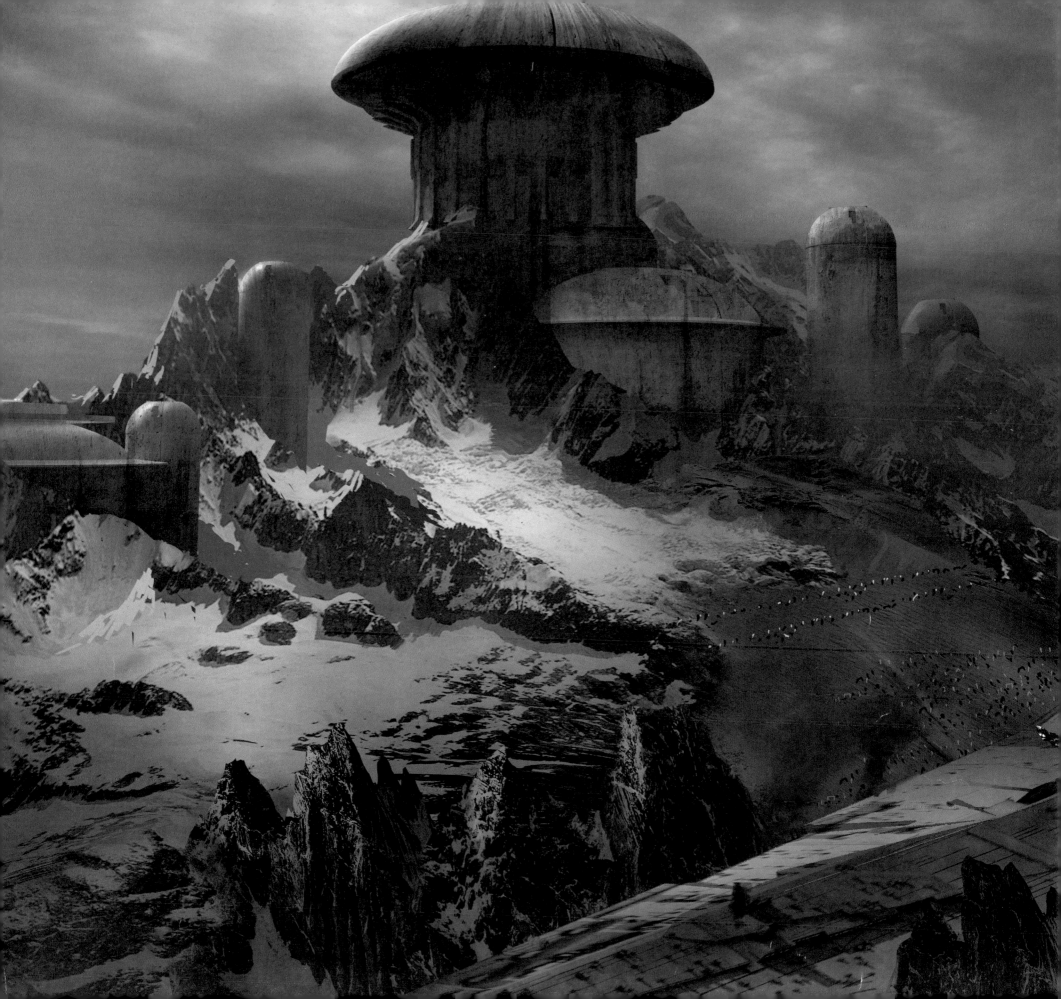

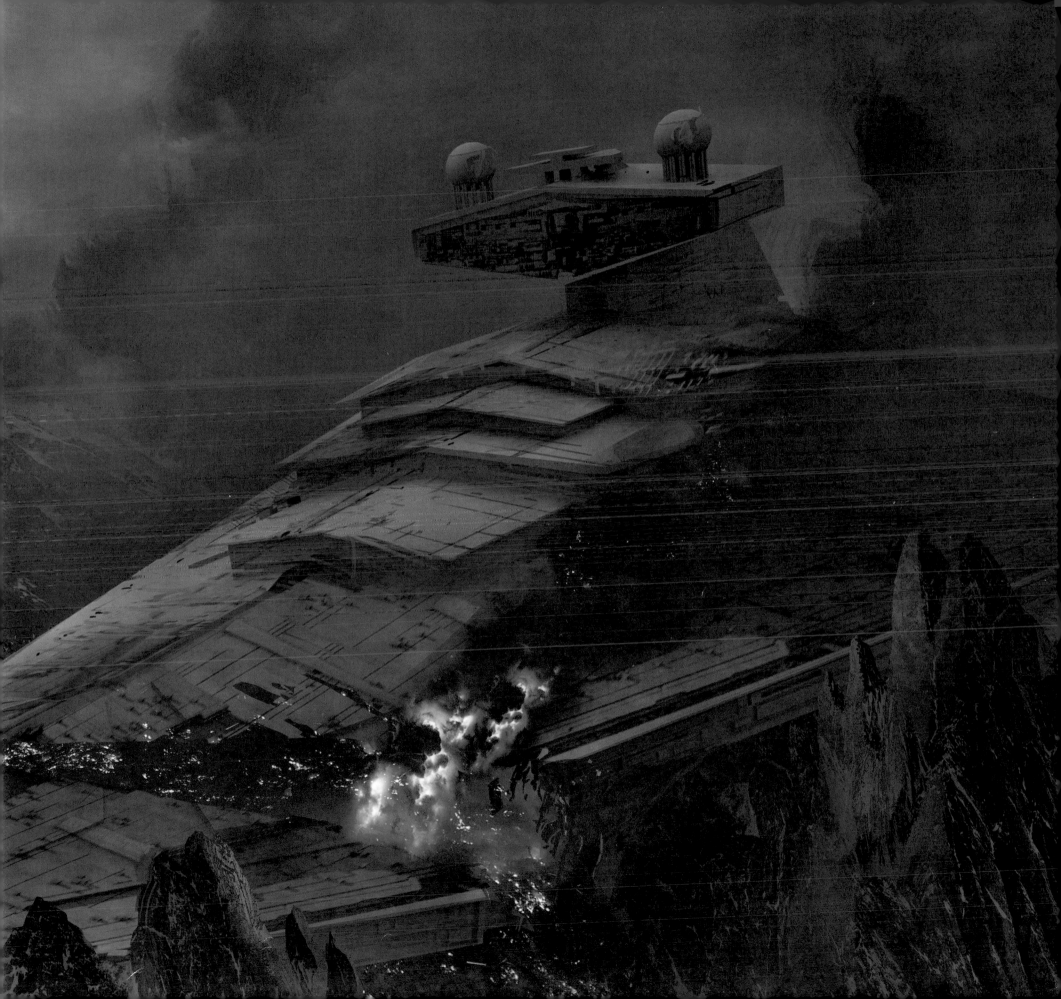

▲ **ALTERNATE YODA 001** McCaig

▶ **YODA** Alzmann

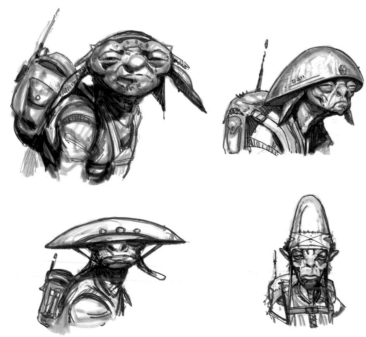

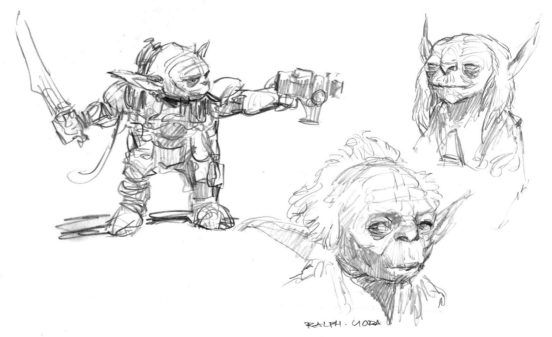

▲ **YODA SKETCHES** Alzmann

▲ **RALPH YODA** McCaig

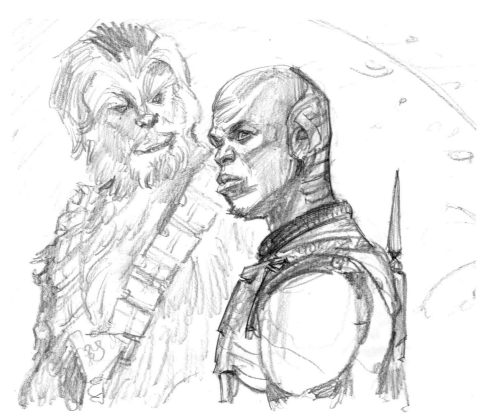

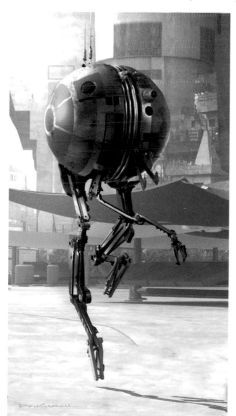

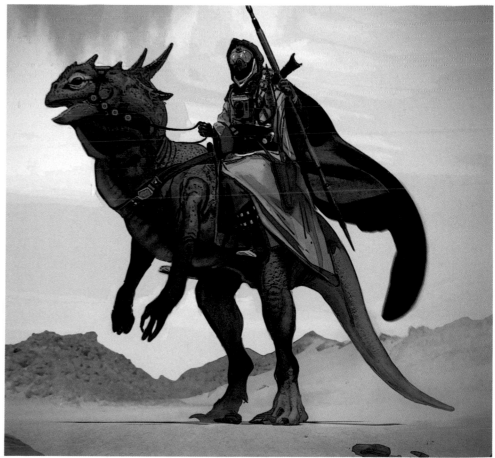

▲ **KIRA'S (REY'S) PARTNER** *"At one point, John Doe was almost a Jedi, and then he was a bounty hunter. I thought, 'Well okay, let's give him a Wookiee!'"* **McCalg**

▲ **SAM (FINN) DROID** Church

▲ **EXOTIC VILLAGER** Tyler Scarlet

▲▲ *STAR WARS* **CHARACTERS** McCaig

▲ **DESERT BEAST** Alzmann

An early Episode VII opening sequence con- sciously mirrored the start of *A New Hope*, with a rebel frigate pursued and swallowed up by a pirate ship, whose design echoes the classic Star Destroyer.

"Part of J.J.'s whole riff on this is that he wanted the opening of Episode VII to be very familiar—familiar to the point where it actually mimics the beginning of Episode IV. The setup is that they were parallel, but then you would quickly realize that these are new ships and new villains." **Chiang**

Begin TITLE SCROLL for 'STAR WARS: EPISODE VII'

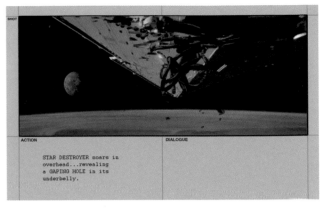

STAR DESTROYER soars in overhead...revealing a GAPING HOLE in its underbelly.

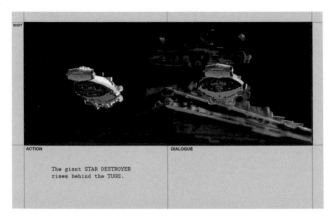

The giant STAR DESTROYER rises behind the TUGS.

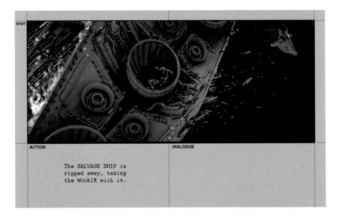

Inside the COCKPIT, a YOUNG MAN (SKYLAR), a WOOKIE and an R2 UNIT.

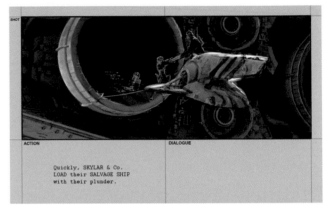

Quickly, SKYLAR & Co. LOAD their SALVAGE SHIP with their plunder.

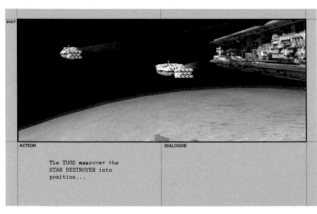

The TUGS maneuver the STAR DESTROYER into position...

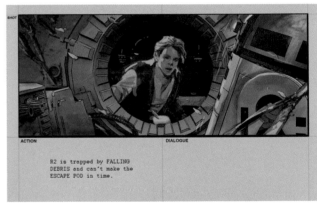

The SALVAGE SHIP is ripped away, taking the WOOKIE with it.

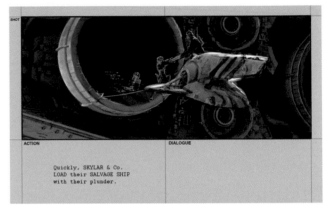

R2 is trapped by FALLING DEBRIS and can't make the ESCAPE POD in time.

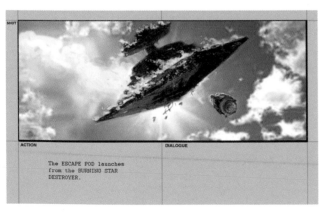

The ESCAPE POD launches from the BURNING STAR DESTROYER.

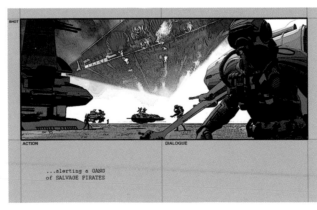

...alerting a GANG of SALVAGE PIRATES

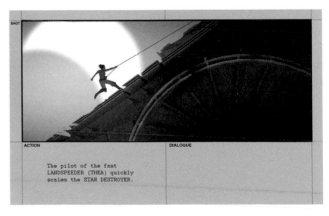

The pilot of the fast LANDSPEEDER (THEA) quickly scales the STAR DESTROYER.

▲ **STORYBOARDS** McCaig, with Alzmann (bottom middle only)

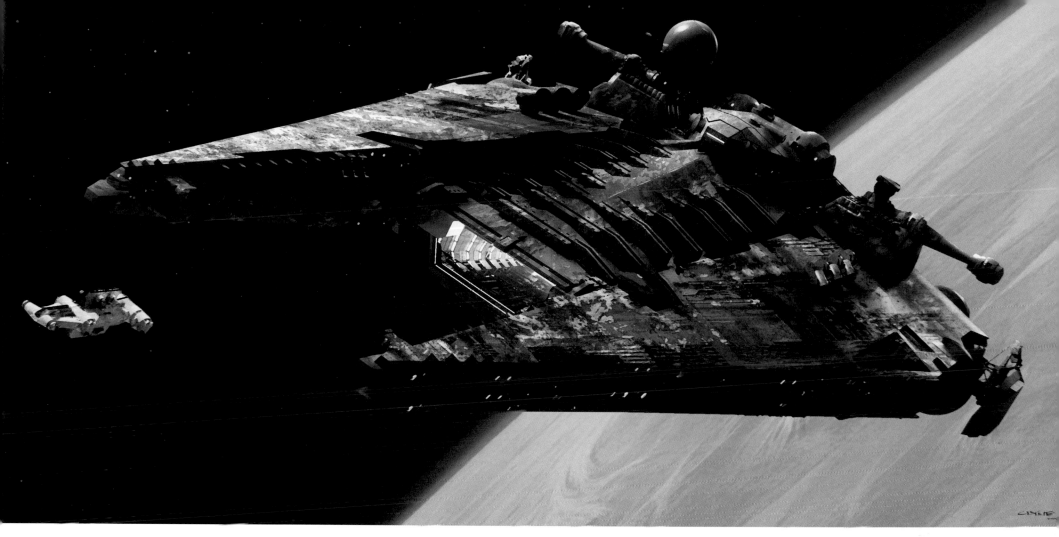

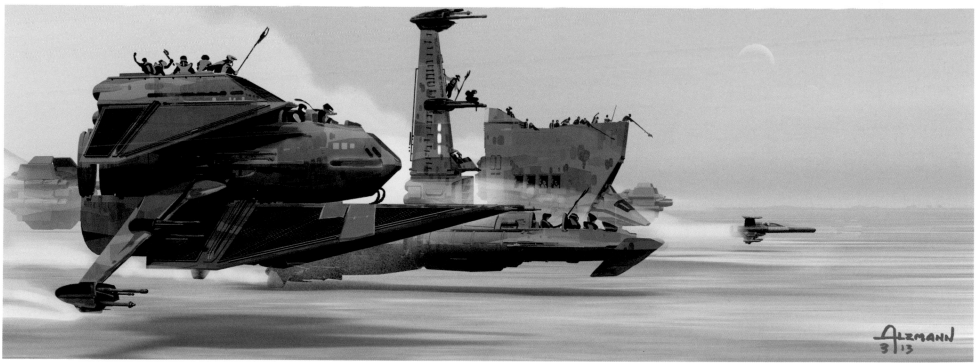

▲▲ **PIRATE SHIP** Clyne

▲ **RACE** Alzmann

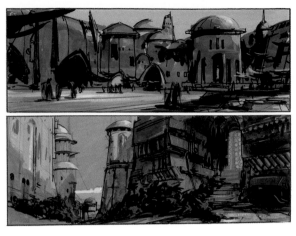

◄ **WEST** *"I started referencing* Once Upon a Time in the West, *a Sergio Leone movie. This started to create the discussion of 'Well, maybe this town is more like the Old West. An old outpost town.'"* **Clyne**

◄ **BUZKASHI BOYS** Thang Le

▼ **JUNK CASTLE LANDSCAPE** Tiemens

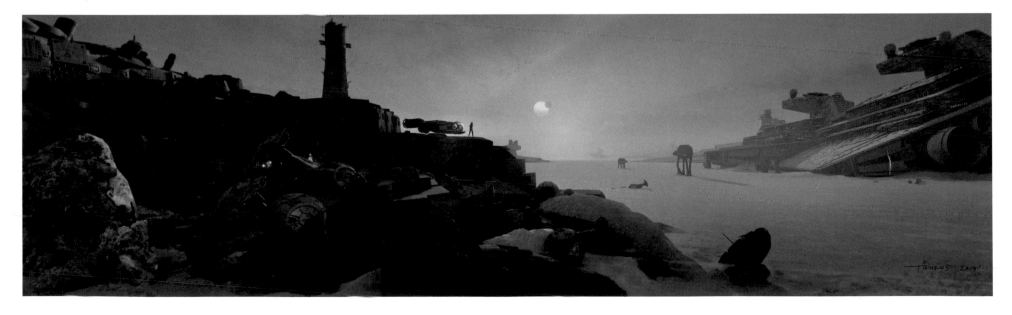

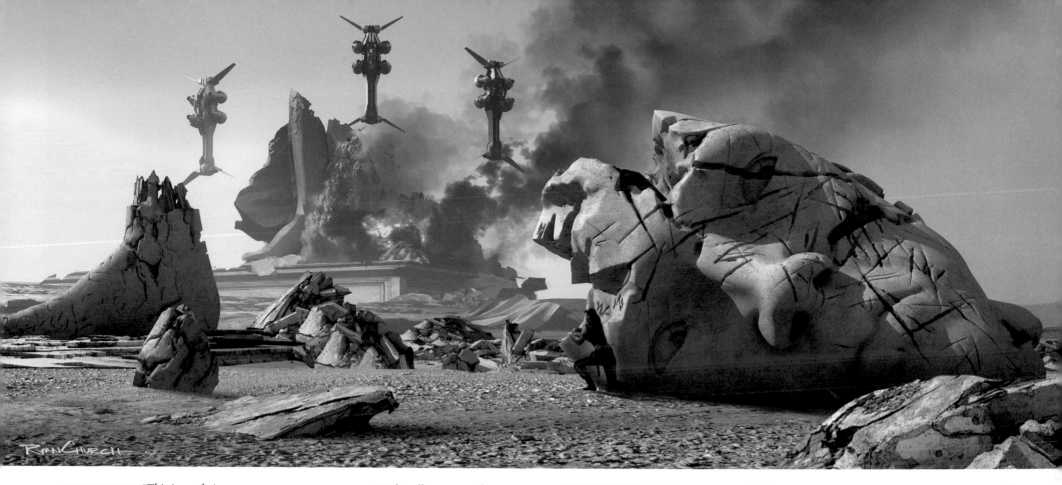

STATUE RUINED *"This is an obviously lightsaber-scarred face. Destroying Jedi relics was a theme that was with us early on."* **Church**

DESERT OCTUPED **Church**

DEATH STAR RISING *"Rick really encouraged us to go way out there. But I just thought it was a stunning image, seeing the Death Star emerging from the planet for some crazy reason. I felt compelled to put it down."* **Chiang**

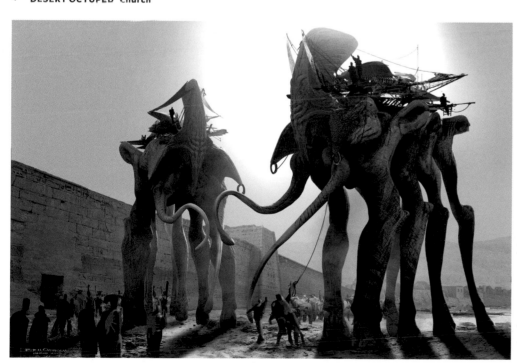

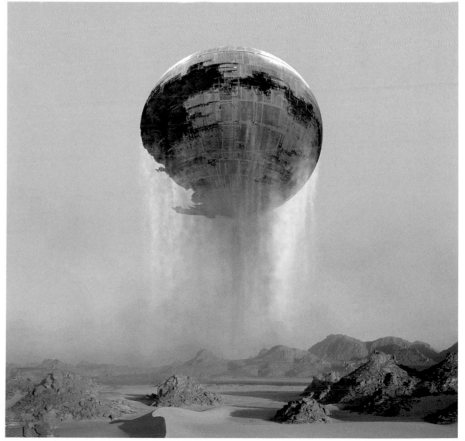

An April 17 story and design meeting between Michael Arndt, Rick Carter, and J.J. Abrams at Bad Robot Productions revealed an exciting new direction for a major Episode VII character. The male lead, Sam, would now start the film as a stormtrooper. One of his stormtrooper buddies is shot and marks Sam's helmet with bloody fingerprints. John Doe was also re-cast as a Republic military man with a droid companion carrying vital information, consciously reflecting R2-D2 in Episode IV: *A New Hope*. Doe must team up with Sam in order to complete his mission.

Kira was cast as a scavenger on the junk planet. An alien junk dealer was introduced into the mix, but Kira initially works in a used car lot of sorts for an elderly father figure, a former Republic pilot. Watching spaceships coming and going all day long, Kira daydreams of leaving her dusty backwater planet. A mothballed *Millennium Falcon* is among the ships on the lot. As the first act of the plot started to come into focus, the Visualists' guided imagery continued to generate story ideas for the rest of the film, particularly the Neo-Imperial forces and base.

▶ **VILLAIN HUNTER** *"They asked me if we could 'Boba' up the Jedi Killer—make him look like more of a bounty hunter. A little bit shorter cape, so he looks a little less regal and a little more like a man of action, so to speak."* **Alzmann**

▼ *FALCON* **SNOW Northcutt**

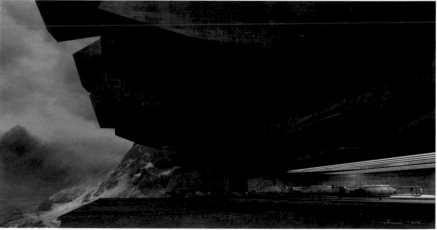

▲▲ **IMPERIAL RALLY** *"I just took Olympic Third Reich photos, put them on my computer screen, modeled them in 3-D, and put in little TIE fighters instead of guys. And I switched the flag logo to the Empire logo."* **Dusseault**

▲ **DANTOOINE WIDE SHOT EXTERIOR** *"This is a very early pass at an Imperial snow base, which was Dantooine at the time. The ruins that we hear about on Dantooine in A New Hope had indeed been picked up and retrofitted by the Empire."* **Church**

▲ **BRUTALIST BUILDING STUDY** *"This was a 3-D thing I was dabbling with; building architecture in this Brutalist style. It has a power to it that conveys the Empire."* **Tiemens**

▶▶ **X-WING VERSUS SUPERGUN BARREL** **Church**

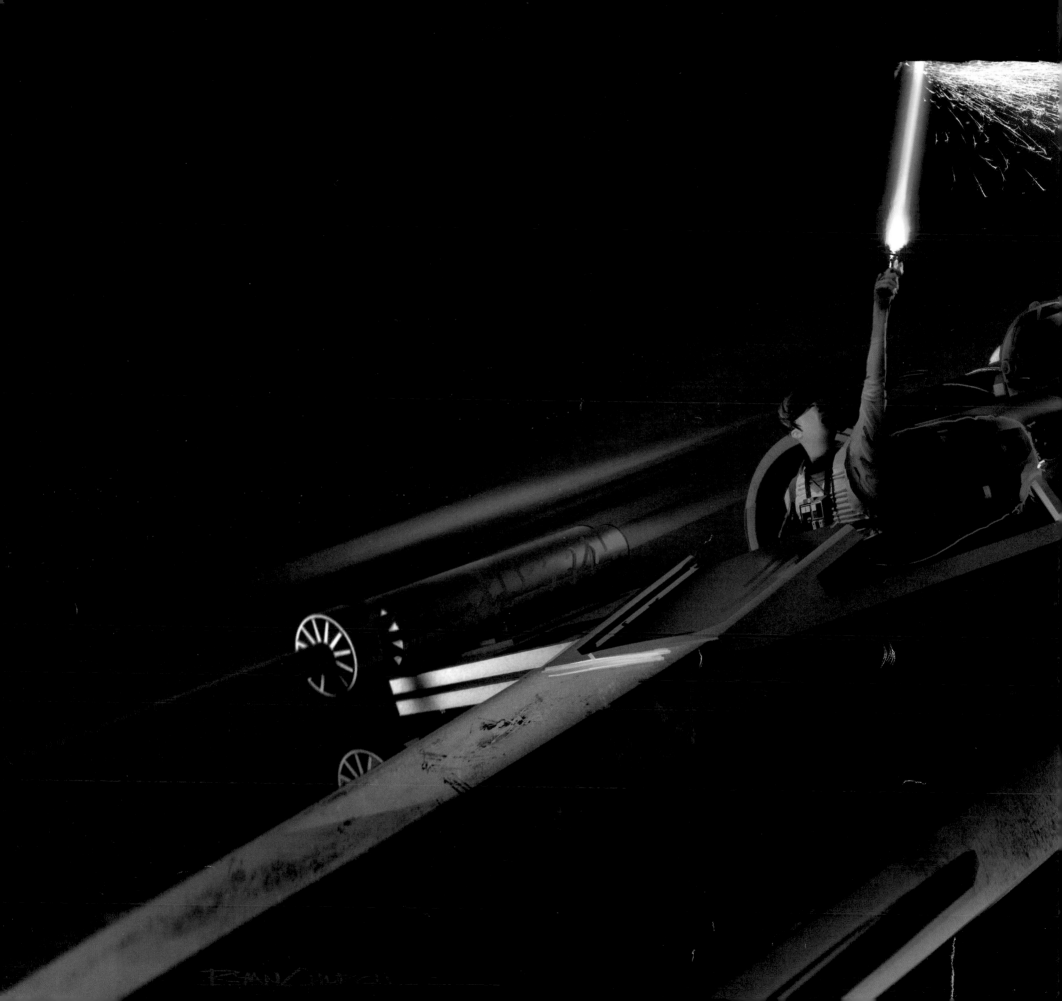

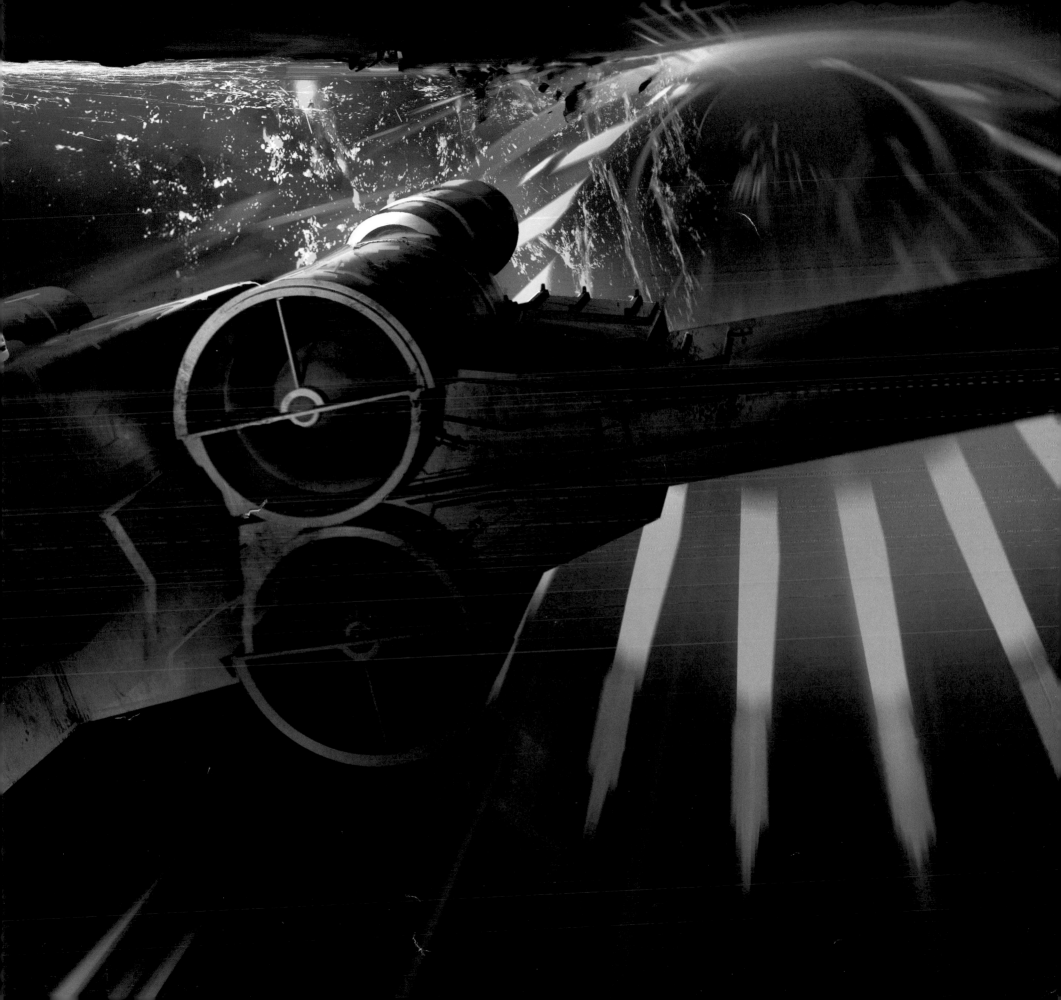

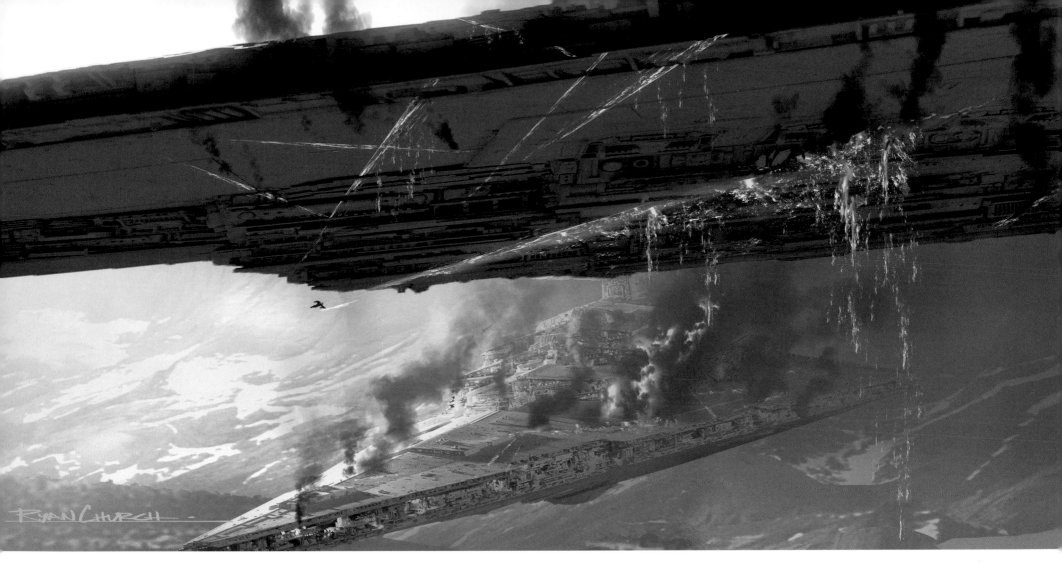

▲ **KIRA (REY) VERSUS STAR DESTROYERS** Church

▶ **NEW DEATH STAR** Chiang

▼ **SUPERGUN FIRE** "*I set it inside this volcano, so you wouldn't really see it. And so part of the third act was to have the Republic army using X-wings to go in and dive-bomb this, not unlike the trench run attack on the Death Star, to try to take out the gun.*" **Chiang**

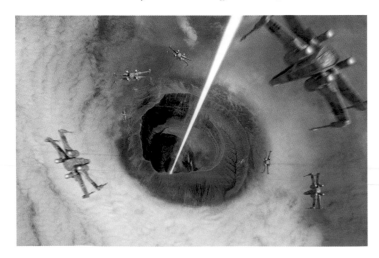

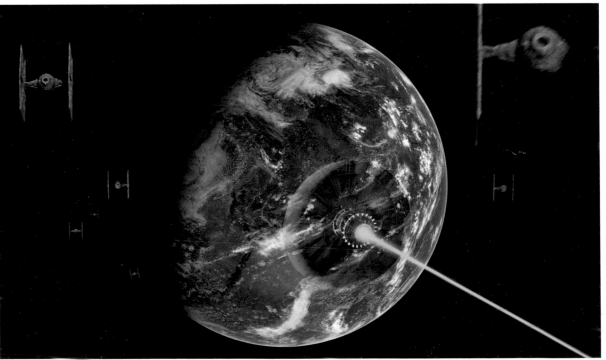

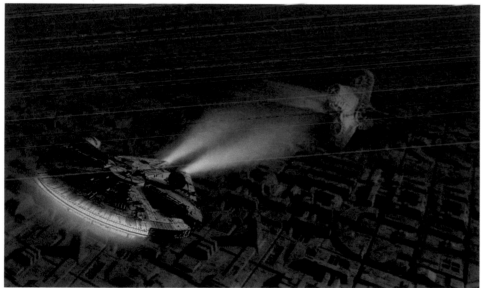

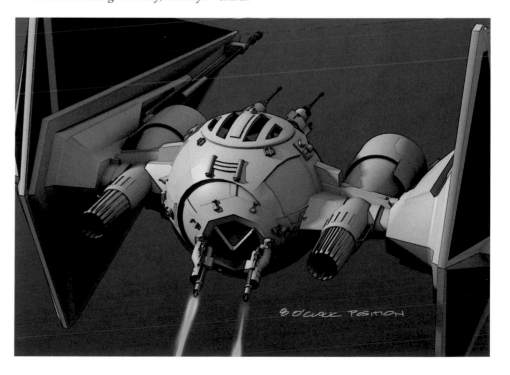

▲ **UNDERWATER EMPEROR ROOM** *"Rick said, 'What if the Emperor's chamber had crash-landed after the second Death Star explosion?' That doesn't make any sense, but that's when Rick knows he has something. He'll say, 'Exactly!'"* **Church**

▲ *FALCON* **UNDERWATER** *"Part of the journey of the story is that they take the Falcon, go underwater, and find the Emperor's tower [laughs]. The Falcon is watertight, because it's airtight, so it can go underwater, right?"* **Chiang**

▶ **OCULAR TURRET ROTATION** *"There was talk at one point of a four-person TIE fighter, called the 'quad-fighter.' I had this idea of this ocular gunner in the back, evoking some of the World War II– and Vietnam–era aircraft, which also had ball gunners on the back."* **Clyne**

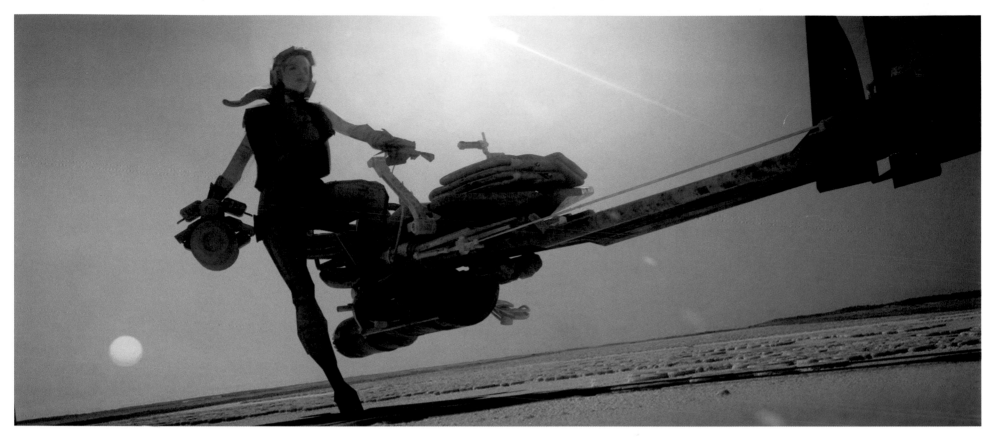

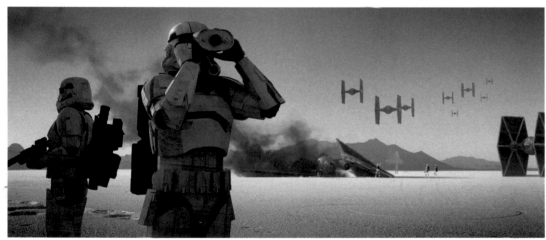

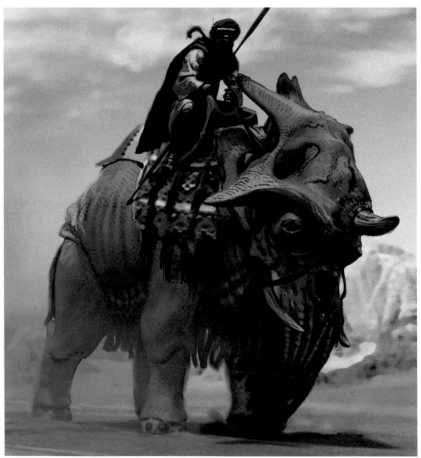

▲▲ **KIRA (REY) BIKE** Dusseault and McCaig

▲ **CRASH RECON** Dusseault

▶ **ELEPHANT** *"Let's try to redress an elephant again, as they did for the banthas in A New Hope. That was literally the framework: Let's have some new updated versions of old creatures."* **Alzmann**

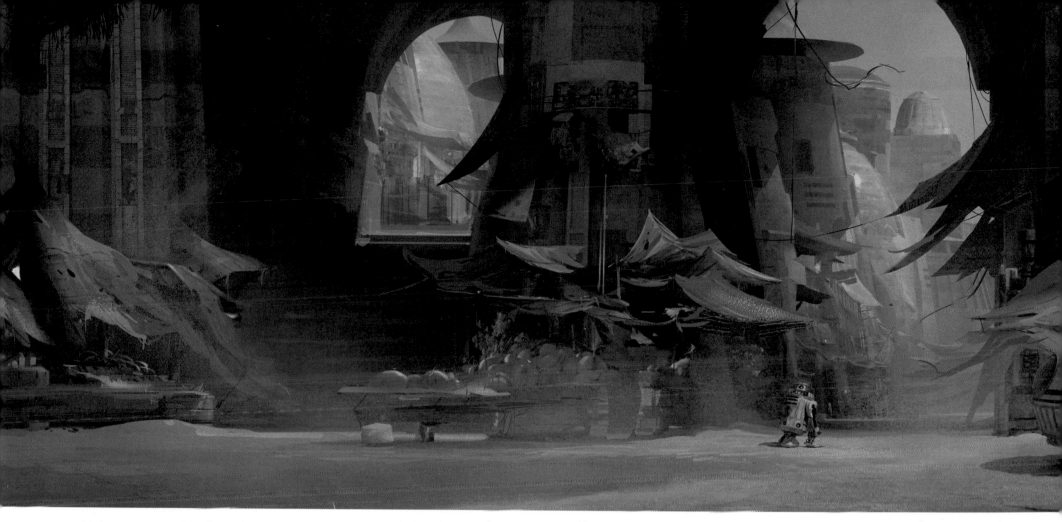

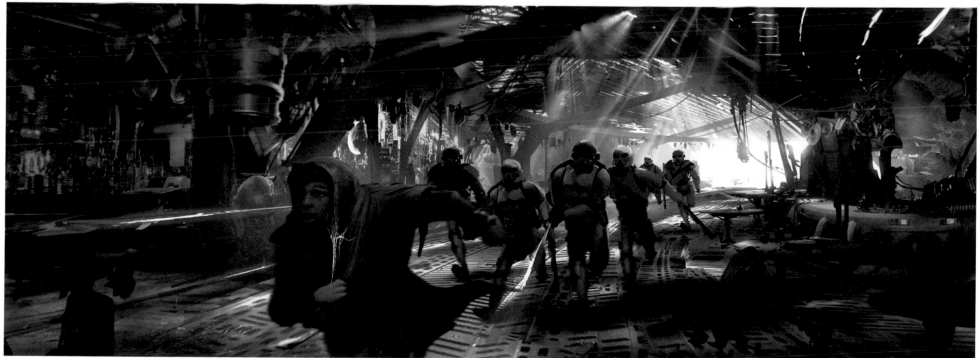

▲▲ **MARKET BAZAAR** *"Rick was suggesting, 'Well, maybe it could be more like an Orientalist or North African look, this desert town. Middle Eastern, harkening back to nineteenth-century paintings."* **Tiemens**

▲ **SOUK INTERIOR** Church

▲ **DEATH STAR** *"Originally, there was going to be wreckage on this new planet where we meet Leia—a lush green planet. Ultimately, that idea went away, because it was better to see the Star Destroyer's wreck on one planet so we are not confusing things."* **Chiang**

▼ **DESERT CAVE** *"This was inspired by a Mali location where they have mud huts and cliff dwellings."* **Tiemens**

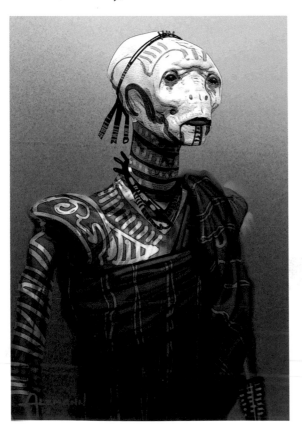

▲ **SHAMAN Alzmann**

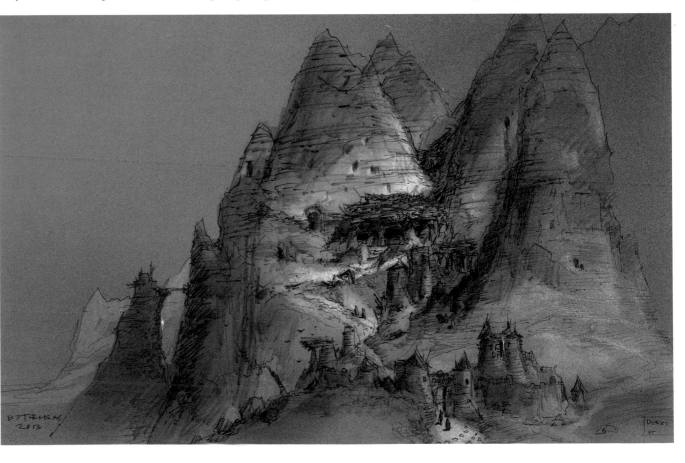

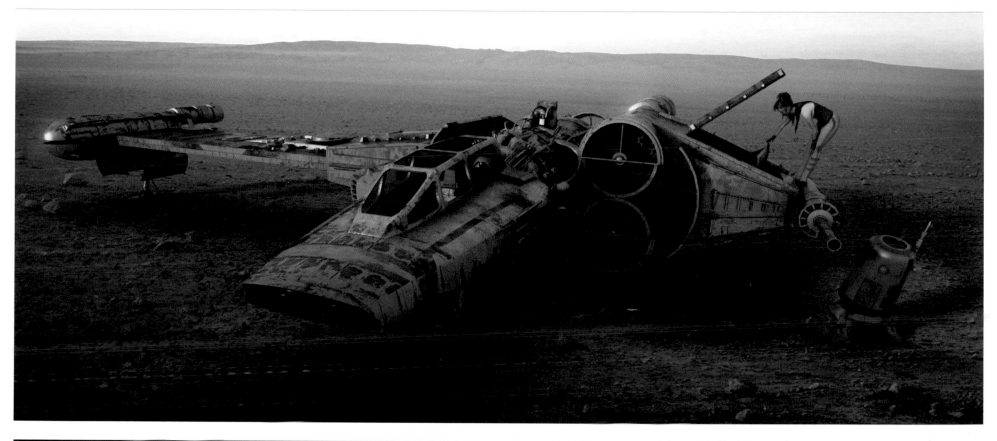

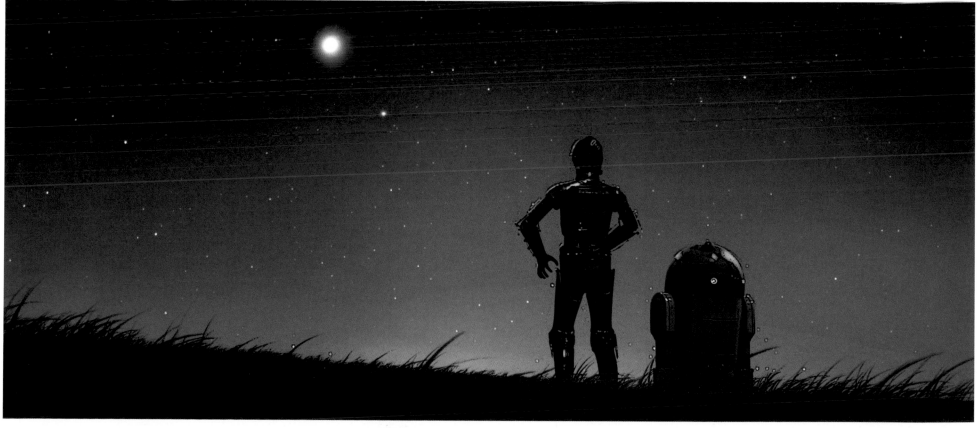

▲▲ KIRA (REY) SHIP Dusseault ▲ C-3PO & R2-D2 Alzmann ▶▶ TIE BASE Dusseault

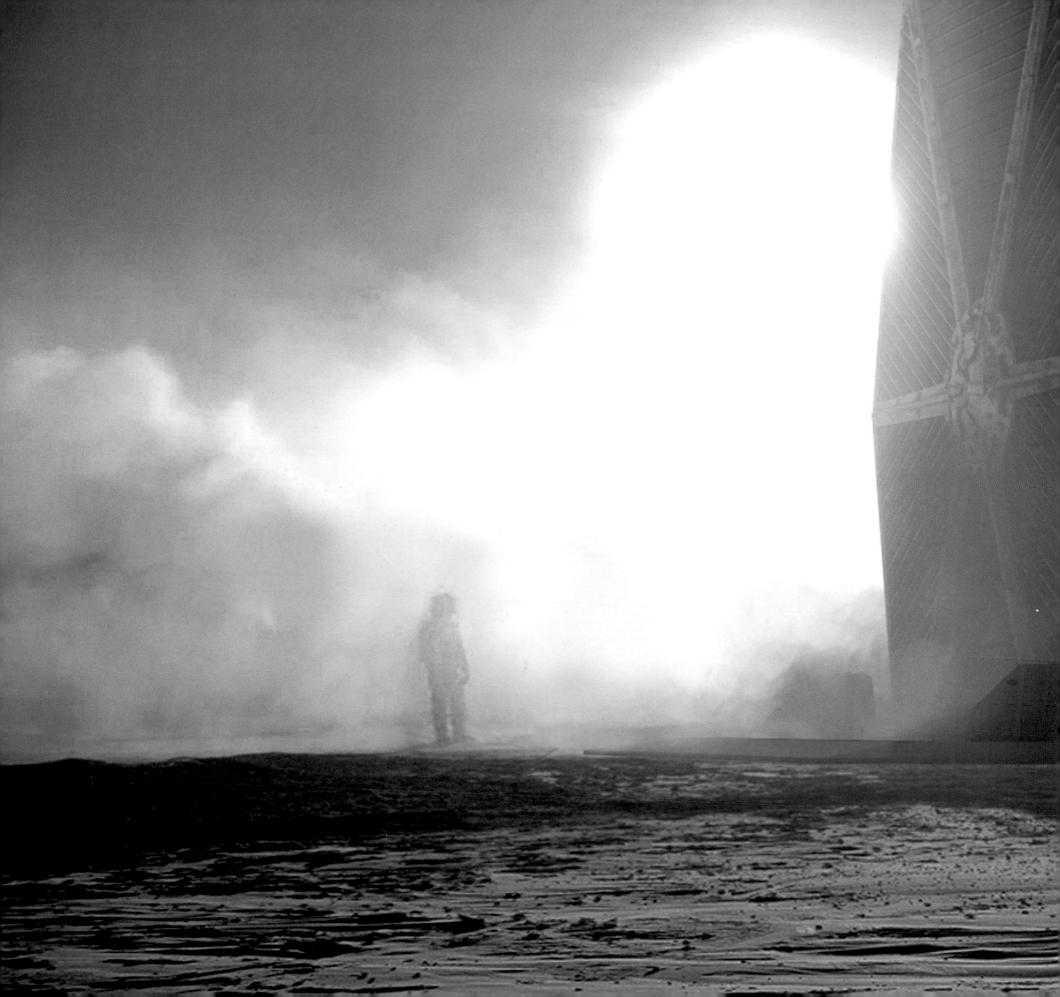

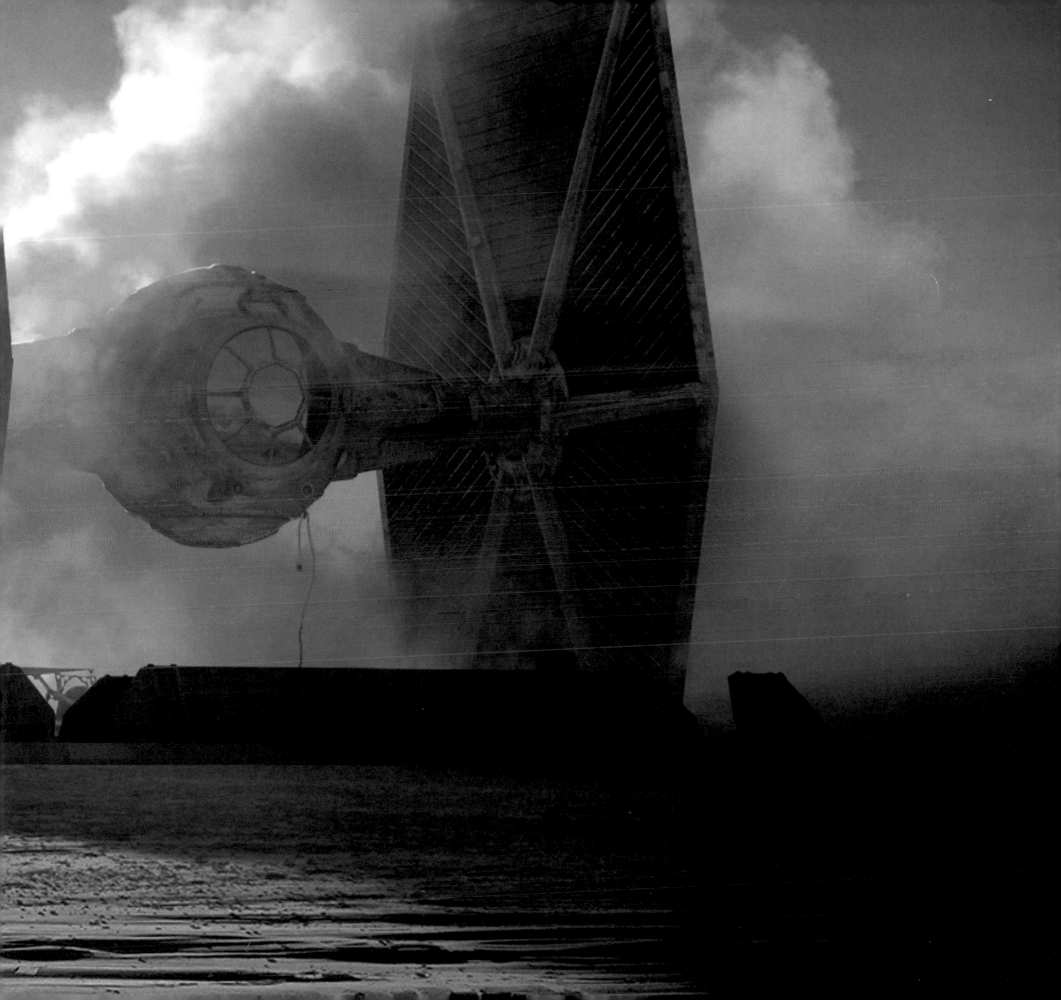

As the Episode VII story progressed, a pro-duction crew started to take shape. In Los Angeles, Rick Carter considered co-production designer candidates. Michael Kaplan (*Blade Runner*, *Fight Club*) was hired as costume designer for Episode VII, dovetailing with his J.J. Abrams collaboration on the *Star Trek* reboot films. Neal Scanlan (Jim Henson's Creature Shop, *Babe*, *Prometheus*) was once again tempted out of semi-retirement to become creature effects creative supervisor.

Following a promotional world tour for the May 16 release of *Star Trek Into Darkness*, Abrams was now able to turn his full attention to Episode VII. Two new locations were proposed in May: a "Crime City" or "Exotic City," where our young heroes first encounter a down-and-out Han Solo, and a new rebel base.

John Knoll, Roger Guyett (ILM VFX supervisor for Episode VII), and Dennis Muren frequently sat in on art department meetings with Carter. In a pivotal meeting on May 30, Carter picked the brains of his collective Visualists for Neo-Imperial schemes and motivations. James Clyne recalls, "Dennis said, 'Well, it's called *Star Wars*—where is our big thematic war in space?' And Dennis mentioned something like, 'What if they had the ability to take the energy of a star?'"

The Force's dark side feeds off of fear. And there is no more base human fear than fear of the dark. Muren wondered what if the Neo-Imperials found a way to plunge the galaxy into darkness, metaphorically and actually, by winking stars out of existence, one by one. The Starkiller "sun-crushing" super-weapon concept was born.

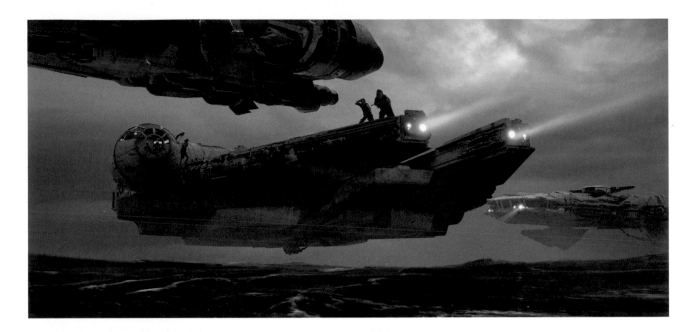

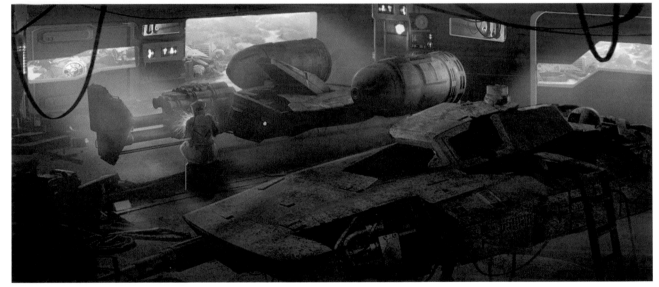

▲▲ *FALCON* ON WATER Church ▲ KIRA (REY) GARAGE Luis Carrasco ▼ JUNK WALKER DWELLING Chiang

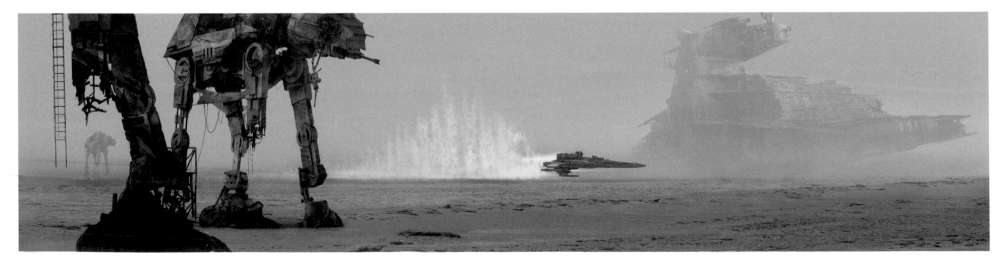

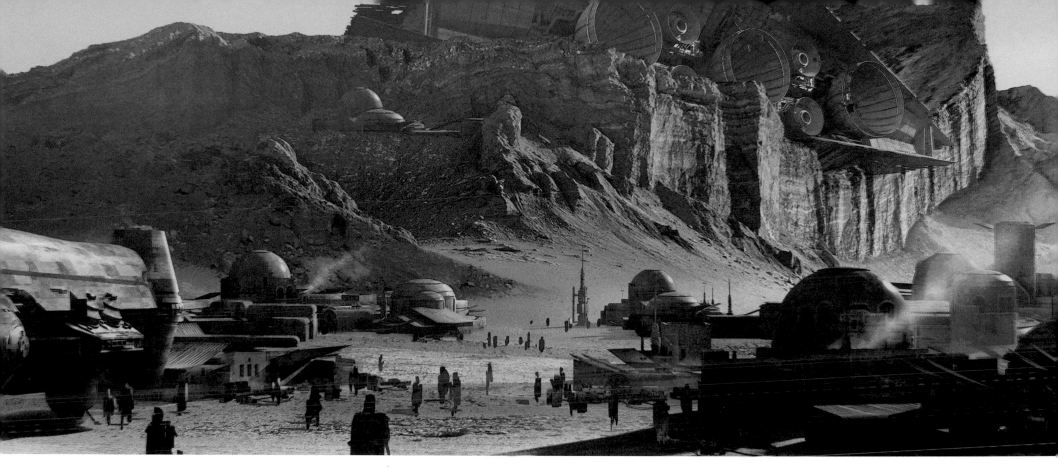

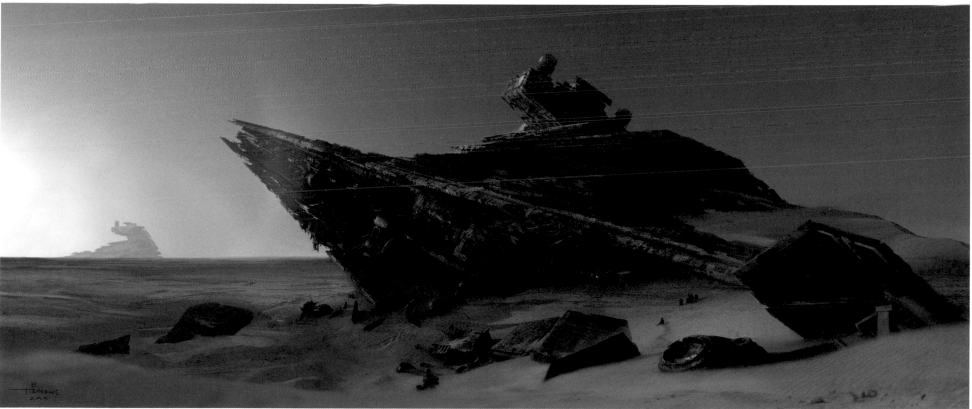

▲▲ **VILLAGE RIDGE SHOT** Clyne

▲ **STAR DESTROYER DUNES** *"There'd be elements of things that have dribbled out of this destroyed Star Destroyer. It's become a little whiter, with minimal rust."* **Tiemens**

The following two pages of concept
paintings illustrate Sam's "hero's journey"—
his transformation from anonymous storm-
trooper to valiant rebel. Sam bears witness
to either a firing squad or airlock ejection
of a captured rebel crew, compelling him to
desert the Neo-Empire and escape with rebel
agent John Doe in a two-seater TIE fighter.

▸ **AIRLOCK** Alzmann

▲ **STORMTROOPER EXECUTION** Dela Longfish

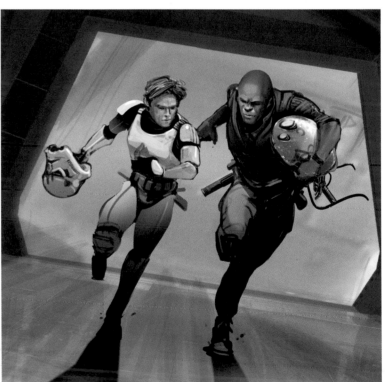

▲ **RUNNING FOR THE HANGAR BAY** Longfish

The fugitives crash-land on the desert junk planet. John Doe abandons Sam at the crash site, but he is soon rescued by members of an indigenous alien tribe who take him back to their village and perform a healing ritual. Sam is reborn a hero.

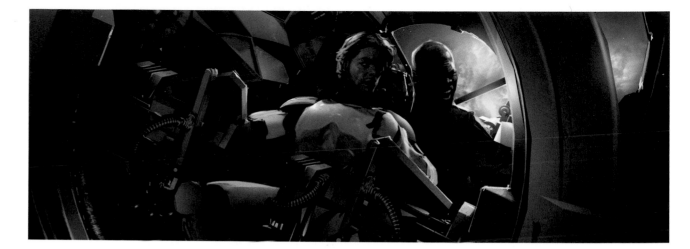

▶ **KEYFRAME 230 McCaig**

▼ **PARTING WAYS Colin Fix**

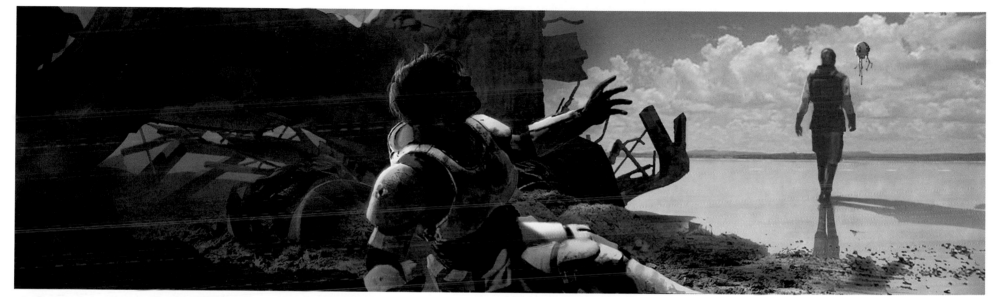

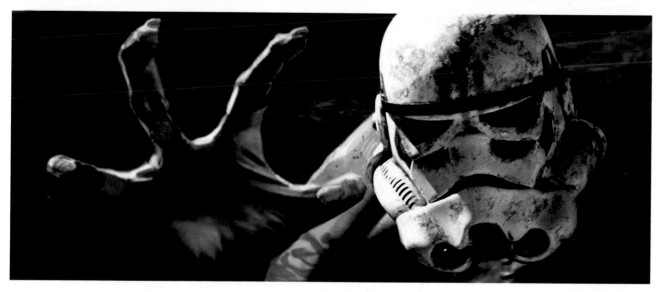

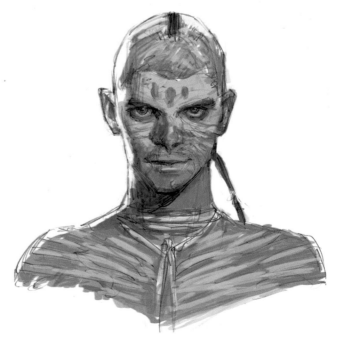

▲ **SHAMAN** *"The helmet that Sam has—marked with the bloodstained fingertips of his dying friend—that's really what freaked him out. So he's still got that helmet, and when he wakes up, this weird alien's wearing it."* **McCaig**

▶ **SAM (FINN) McCaig**

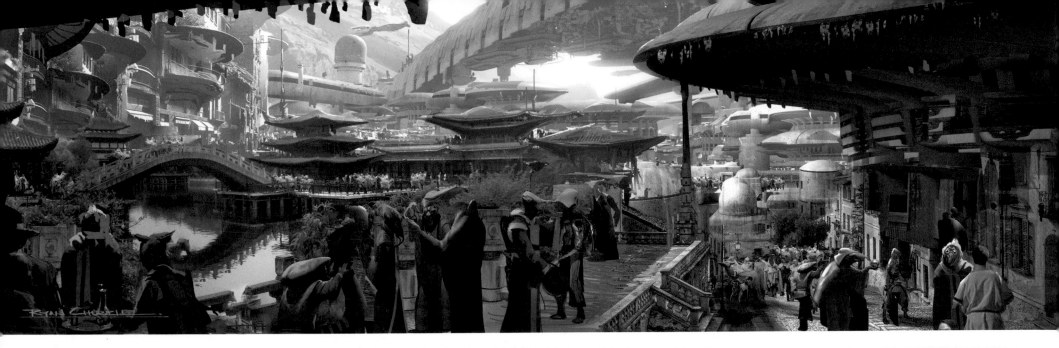

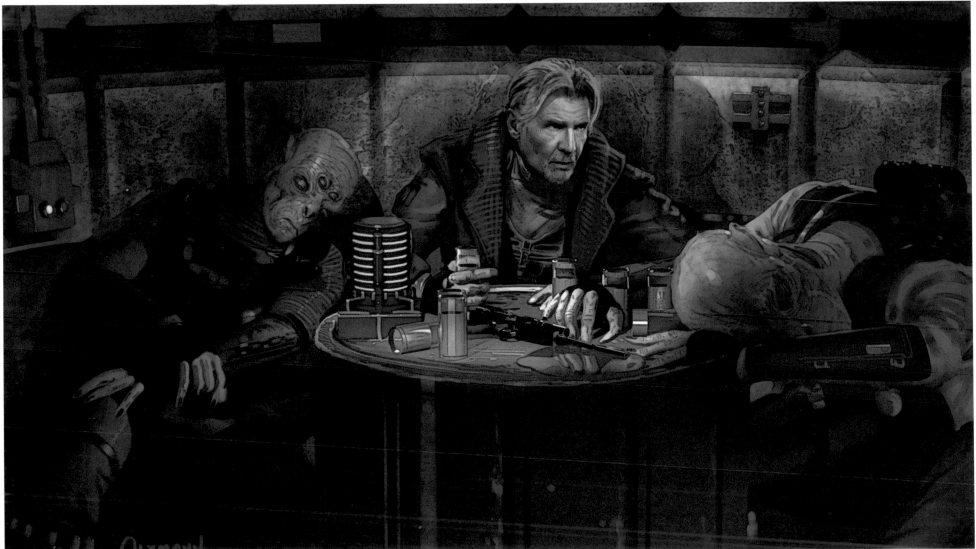

▲▲ **CRIME CITY** Church

▲ **SOLO** Alzmann

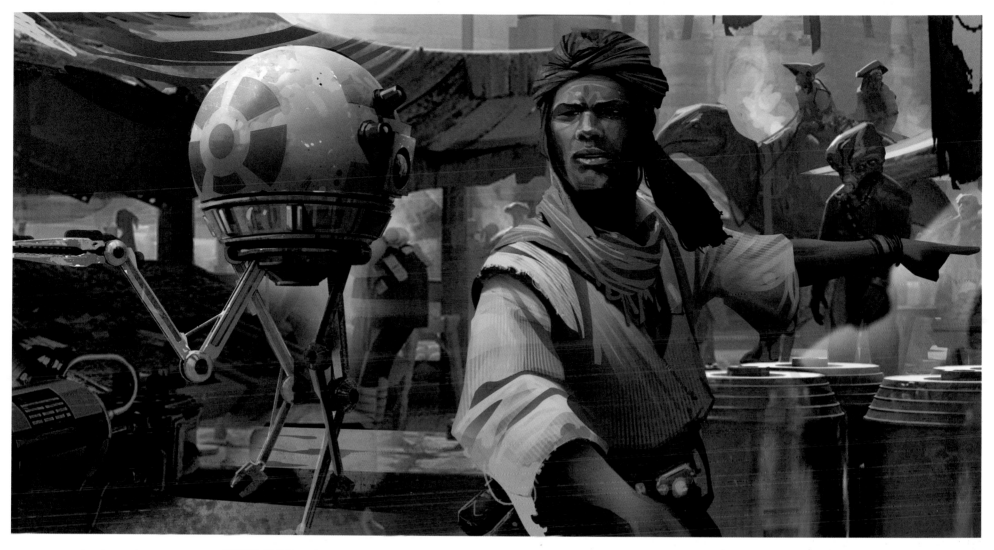

▲ JOHN DOE (POE) ARGUING Longfish

▶ KIRA (REY) IN JUNK LINE Fix

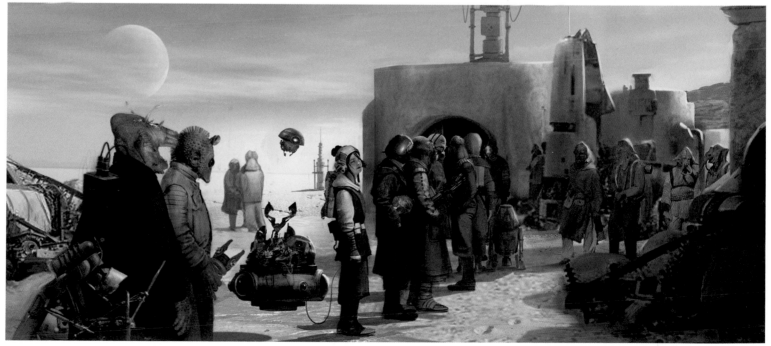

▶ JEDI KILLER CONCEPTS 03 & 04 *"The conceit was that Vader wasn't just a one-off, he was a Lord of the Sith and he has a specific title and a specific look that goes with that title. Even though the mask was helping him breathe, there still was a certain look to it."* **Alzmann**

▼ JEDI KILLER SKETCHES 06 & 07 **Alzmann**

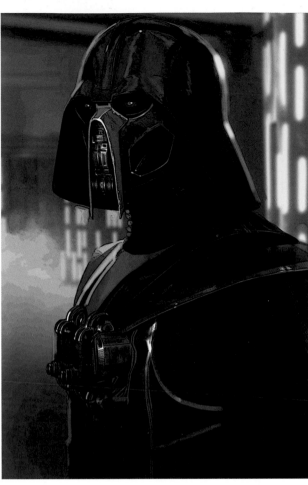
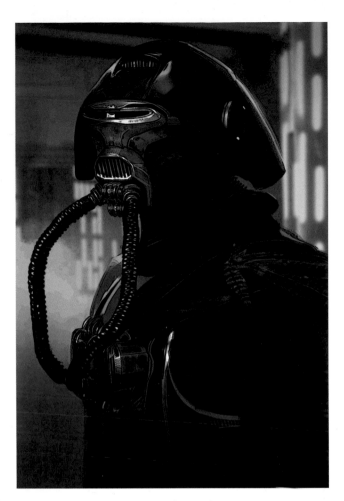

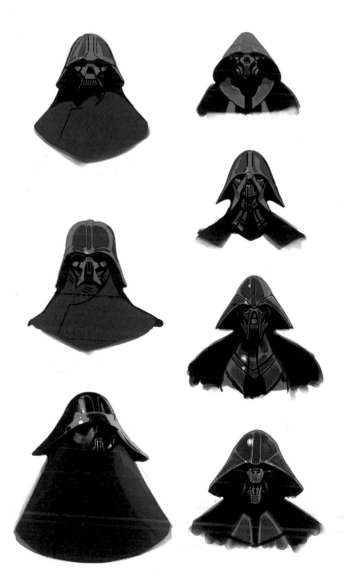

▶ JEDI KILLER MEDITATION CHAMBER **Alzmann**

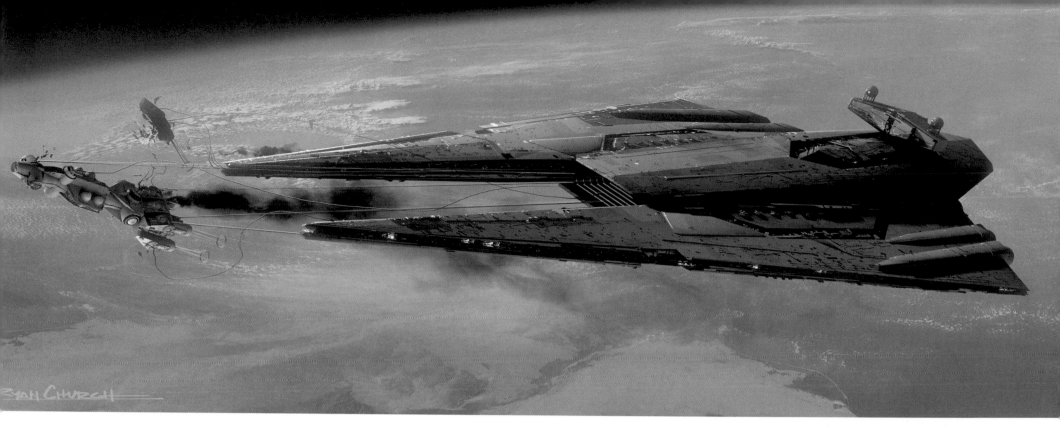

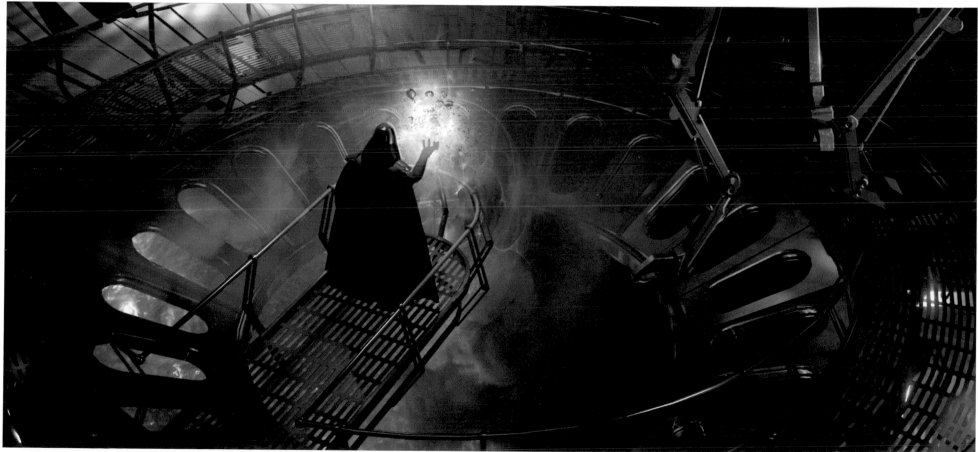

▲▲ **STAR DESTROYER GRAPPLING** Church

▲ **BRIDGE** *"The Jedi Killer eats sun matter. He's in his meditation chamber, the sun energy comes into the room, and he grasps and eats whatever power that is."* **Dusseault**

▶▶ **MAZ CHAMBER CONCEPT** Alzmann

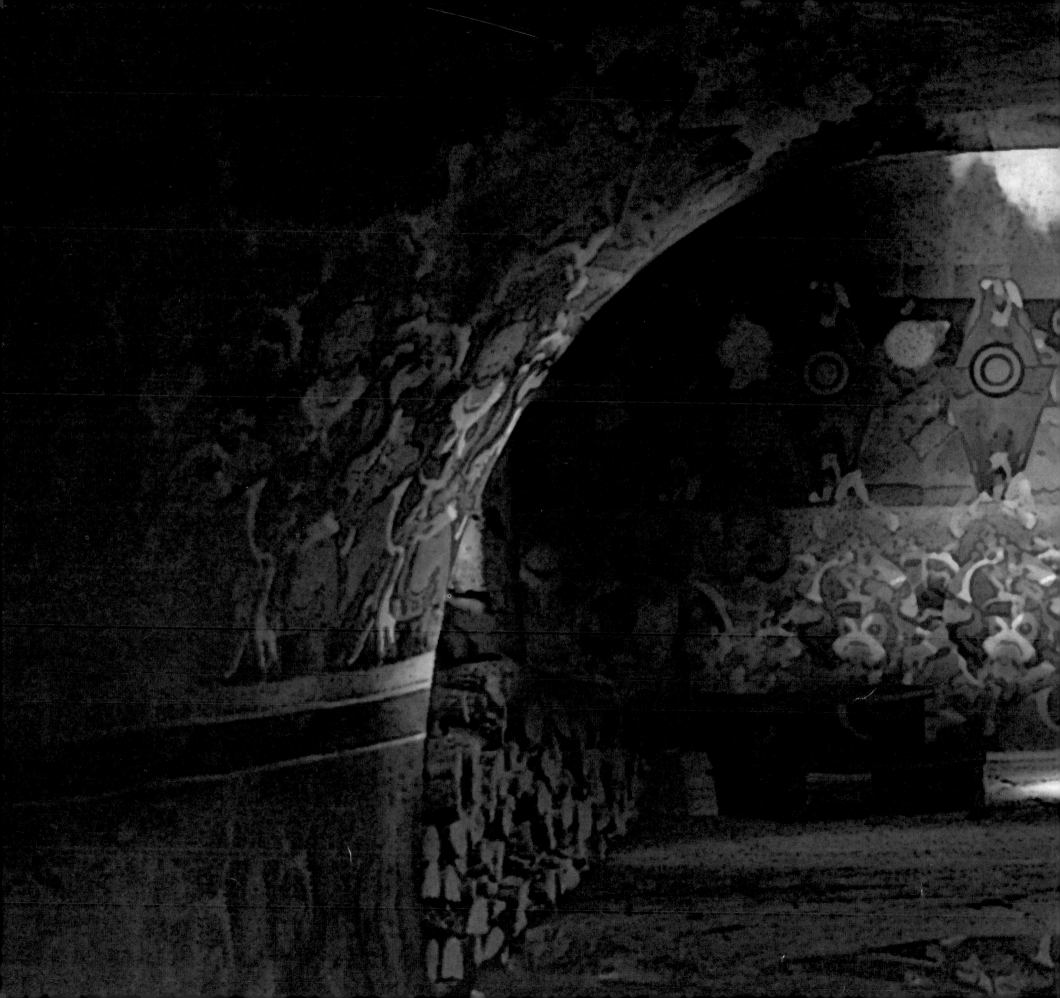

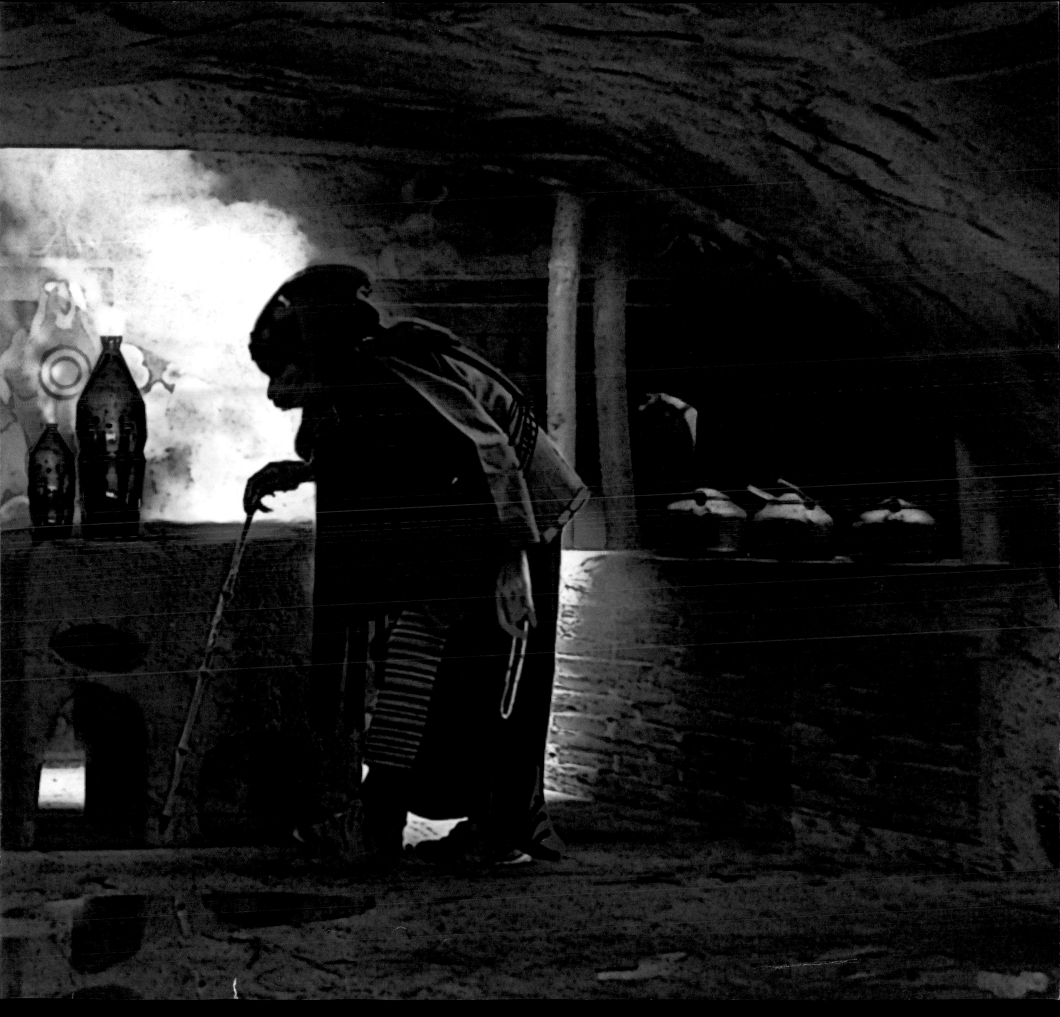

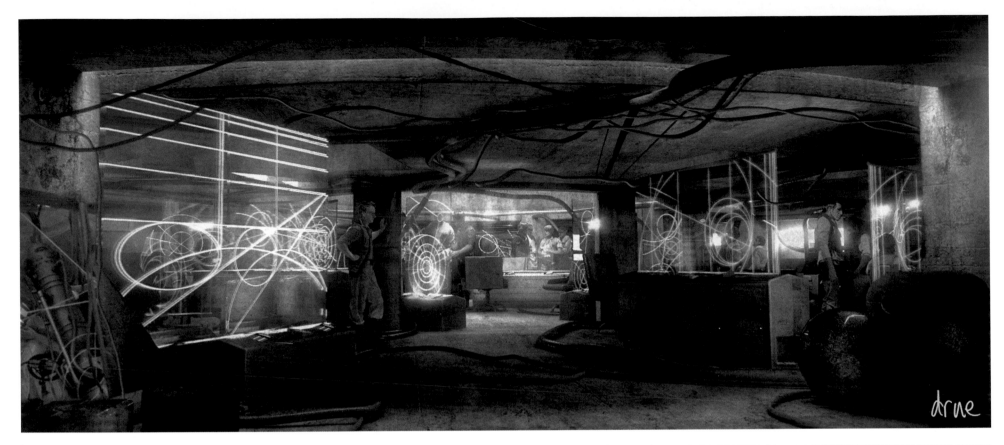

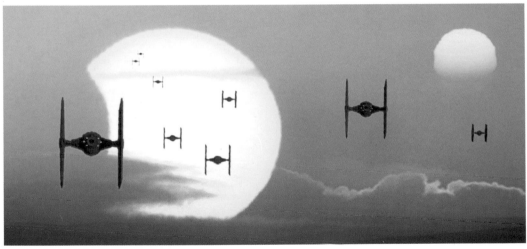

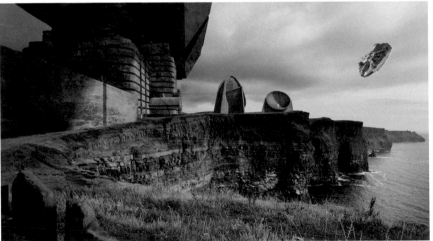

▲▲ BUNKER Ryan Drue

▲ TIE SUNSET "This is a moment of TIE fighters coming in—our riff on Apocalypse Now. Some of those moments are so powerful that all we have to do is put in something different like TIE fighters, and it totally works." **Chiang**

▲ MOHER BUNKER "These structures were actually sound dishes in England. Leia's base was really a hidden fortress, like in The Guns of Navarone, hidden in the cliff walls at the Cliffs of Moher." **Chiang**

▲ **MOHER BUNKER** Chiang

▼ **TIE GRAVE** *"This was a dump somewhere in Somalia. I just replaced it with a bunch of TIE fighters."* **Dusseault**

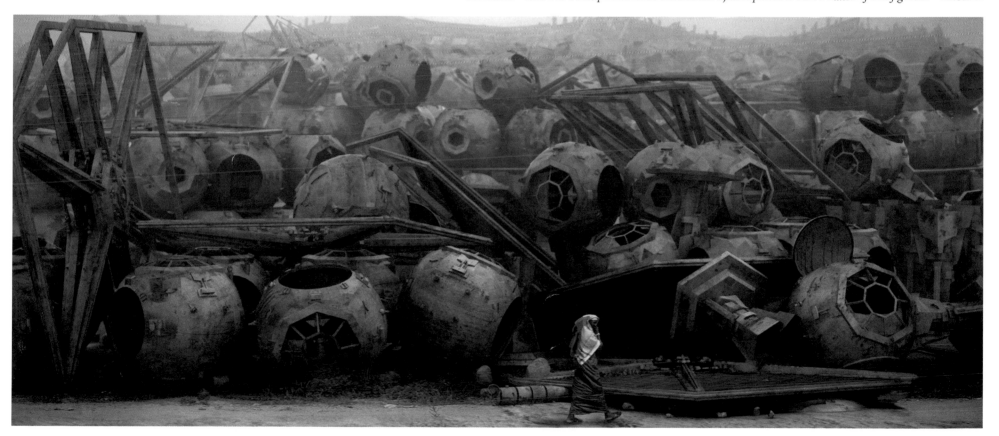

On June 20, Darren Gilford (*TRON: Legacy,*
Oblivion) was introduced to the art department as
the new co-production designer on the project. Rick
Carter said, "I'm going to try to guide it to where I
think it can go. But I can't be taking up a lightsaber
and fighting a duel with a bunch of young Jedi.
They're young, they're talented. It's their time."

"So I answered the phone, he basically said, 'Hey,
this is Rick. Am I catching you at a bad time?'" Gilford
remembers. "'Well, actually, I'm coaching my son's
Little League game. Can I call you back?' He goes, 'Yes,
call me back when you are done. I just want to see if
you would be interested in co-production designing
Star Wars.' I thought it was a practical joke. But then
I called him back, we chatted, and I couldn't believe
the opportunity and that I was even in the realm of
people who were being considered.

"It was the best of both worlds. I had all of his
experience and all of his knowledge, which is huge—
this massive amount of clout that Rick brings to
the project. What I can bring to it is the generation
that grew up really loving it. The fabric of my whole
existence is woven into *Star Wars*—who I am and
what I do."

The interior of a decaying Star Destroyer, the
collapsed AT-AT that Kira coopts as her dwelling, a
Neo-Imperial Star Destroyer, and the new archetypal
mentor character of "Maz Kanata" were all first tack-
led in June. The depot town, Exotic City, Starkiller
planet—occasionally known as the "Doom Star" at
this time—and Leia's rebel base saw further develop-
ment as well.

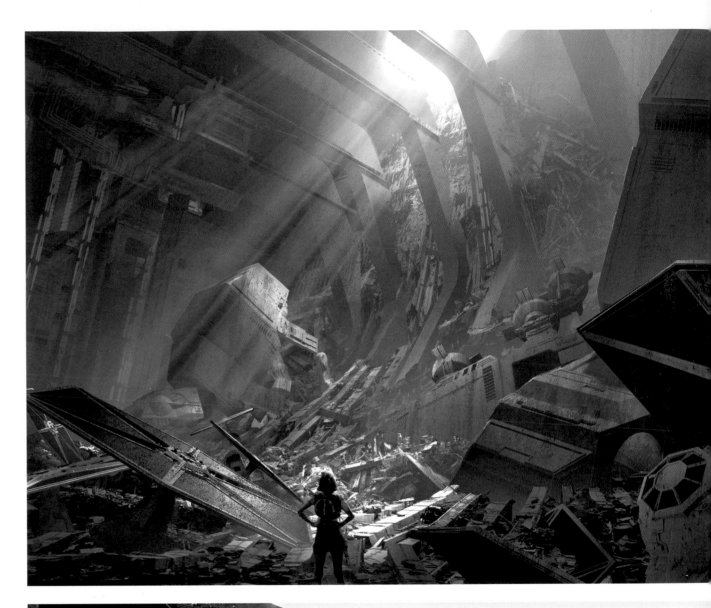

▲▲ **STAR DESTROYER INTERIOR CLIMB** Church ▲ **DESERT** Chiang

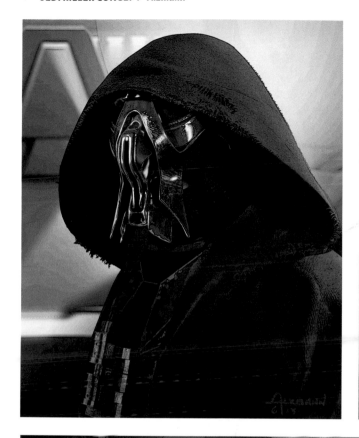

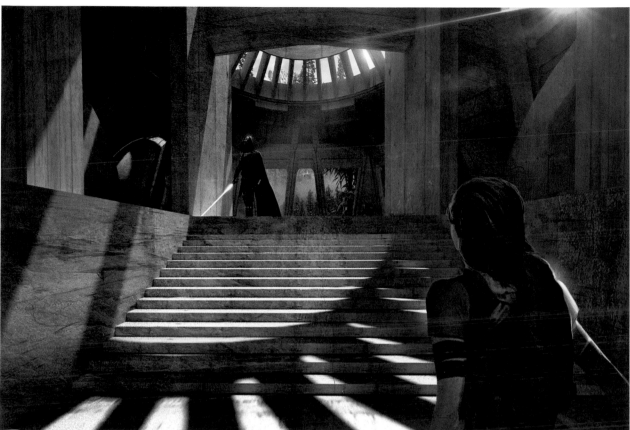

▲ **SNOW PLANET THRONE ROOM** *"What would the Jedi Killer's fortress be like? I was again taking iconic shapes that we know from Star Wars but putting a different material on them—in this case turning them into concrete instead of that slick painted metal."* **Chiang**

◄ **JEDI KILLER CONTEMPLATION** *"This was back when the MacGuffin was the melted helmet of Vader. I did a few passes at designing what a new meditation chamber might look like."* **Alzmann**

▼ **ECLIPSE TIE FIGHTER** Chiang

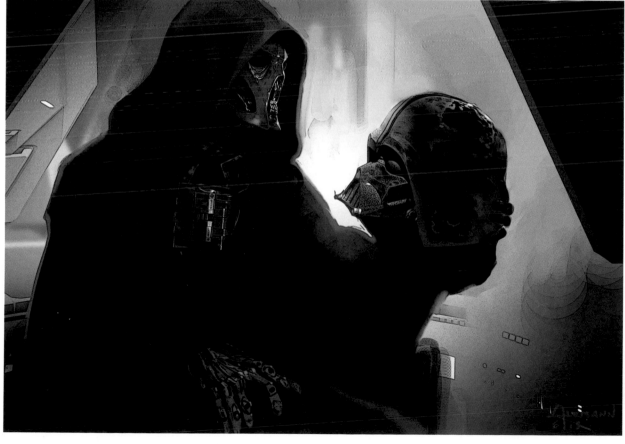

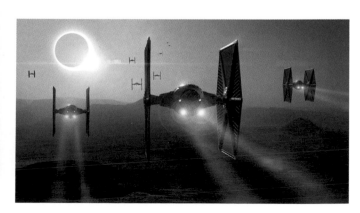

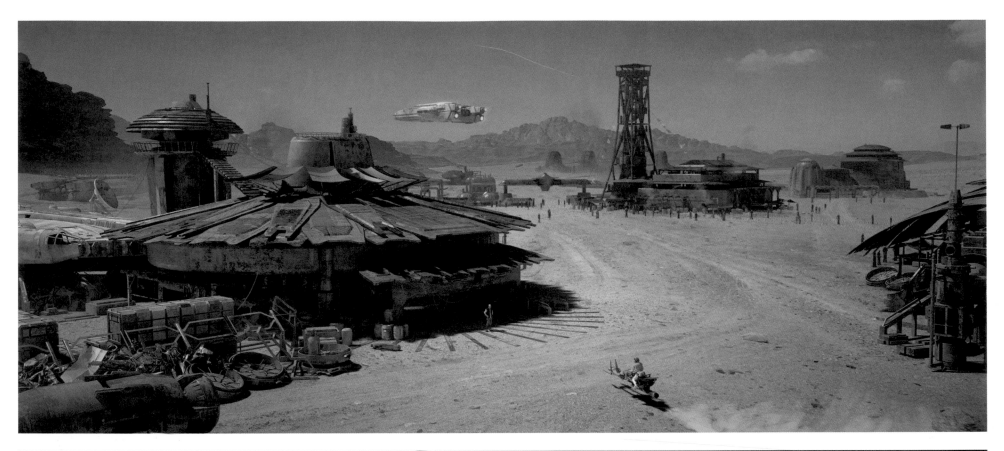

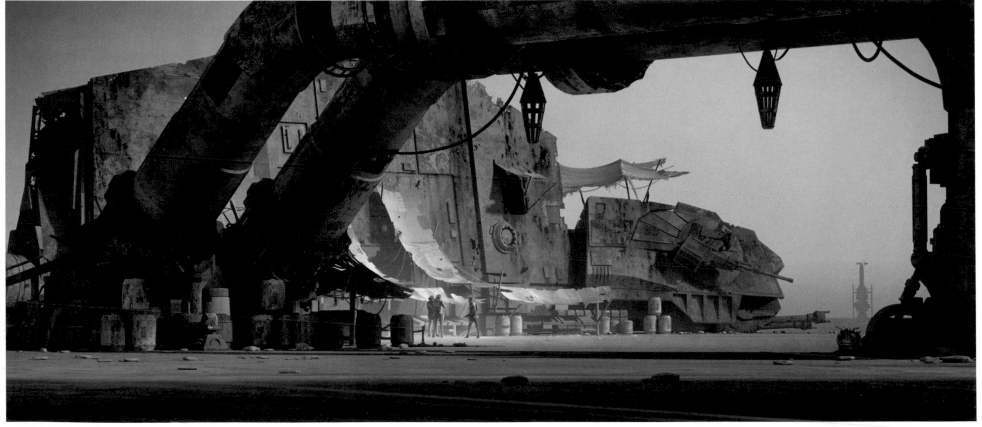

▲▲ **WESTERN TOWN** Dusseault ▲ **PIPES** *"That's that AT-AT house, a little market thing. There might be a chance that's where Kira will reside."* Dusseault

80 THE ART OF STAR WARS: THE FORCE AWAKENS

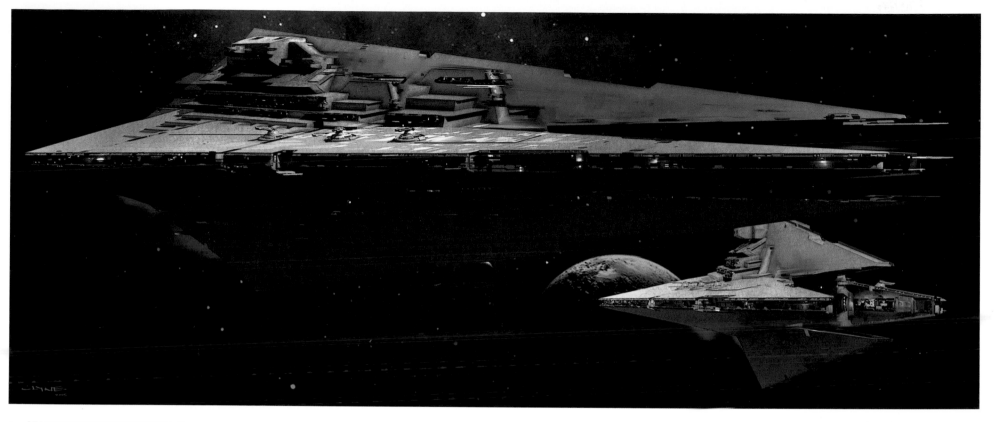

▲ **STAR DESTROYER FOUR PRONG** Clyne

▼ **STAR DESTROYER BRUTAL ANGLE** Church

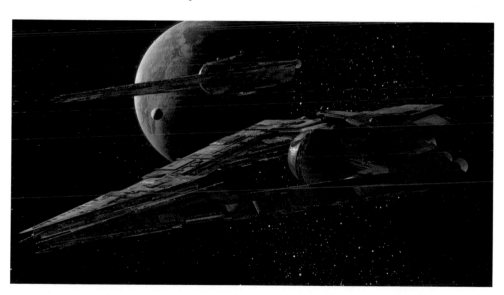

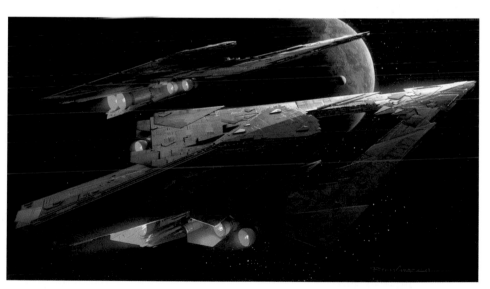

▲ **RED STAR DESTROYER EXTERIOR** *"Rick is the guy who started saying, 'Put a red ship in there. Put a red ship in there.' I think J.J. had asked for a red Star Destroyer at one point, just to see, on a whim, what that looks like."* **Church**

▸▸ **SUNSET WATER TOWER** Clyne and McCaig
"I did this to mirror Luke's moment looking at the double sun. You understand who he is. It's such a magical moment." **Clyne**

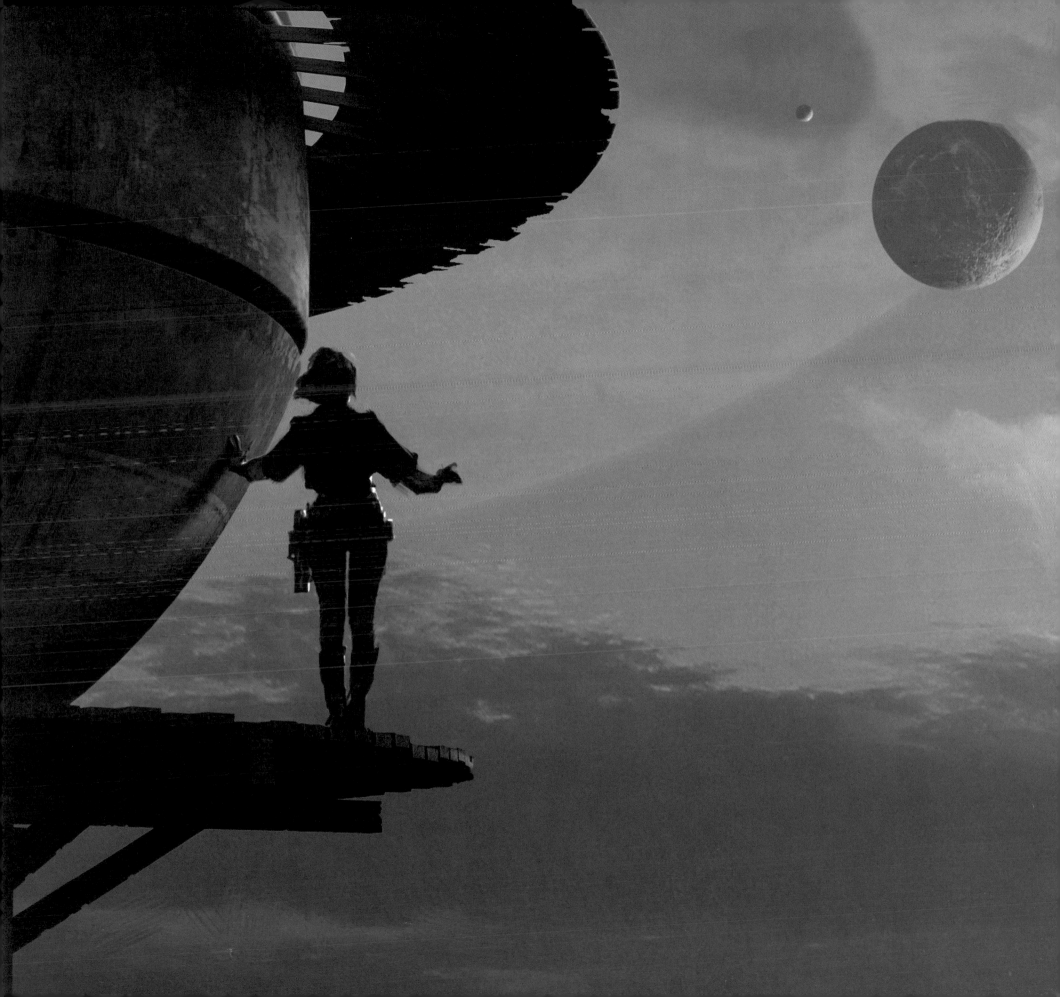

Early in Episode VII's development, Rick Carter and J.J. Abrams discovered that they both had a common mentor: award-winning and adored Palisades High School English teacher Rose Gilbert, who retired at the age of 94 in early 2013 (she subsequently passed away in December of the same year). In tribute to Gilbert, character concept artists Christian Alzmann and Iain McCaig were tasked with creating "Maz," whom our heroes first encounter at an Exotic City bar that she runs.

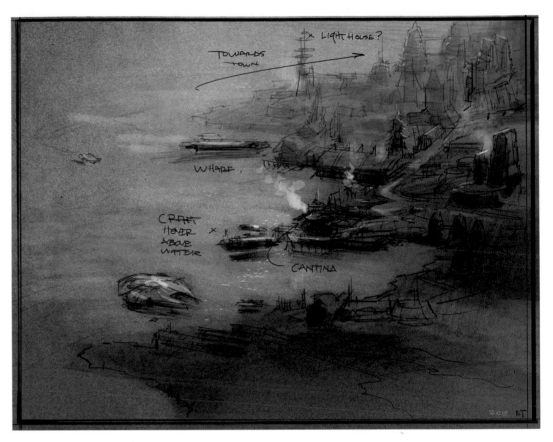

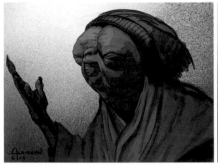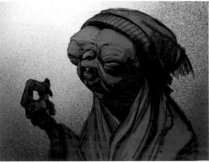

▲ **MAZ CONCEPT** Alzmann

▶ **CRIME CITY HARBOR ROUGH SKETCH** *"Then there was this idea for this Exotic City area: Crime City. And maybe it would have a wharf, where ships would come and land."* **Tiemens**

▼ **CRIME PLANET PARKING SPOT SHIP DOCK** Church

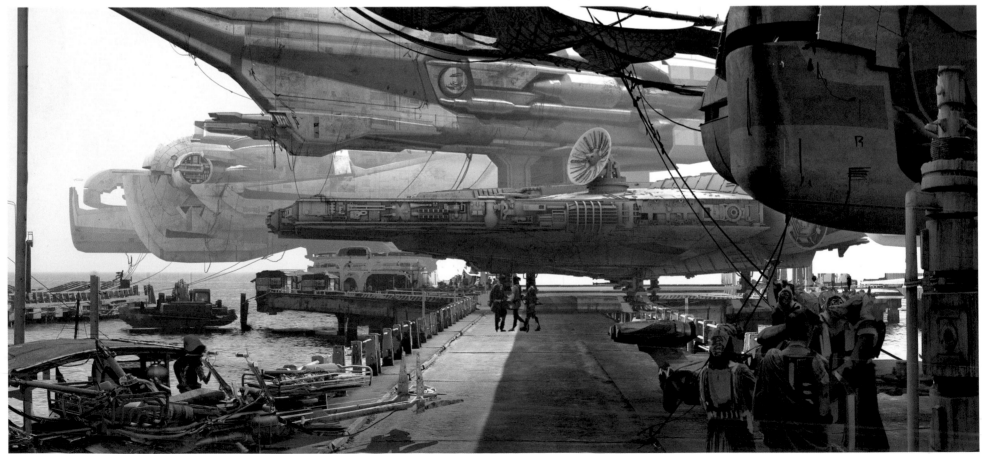

▲▲ **KIRA (REY) WRECK HALLWAY** Chiang

▲ **STAR DESTROYER RUBBLE** Clyne

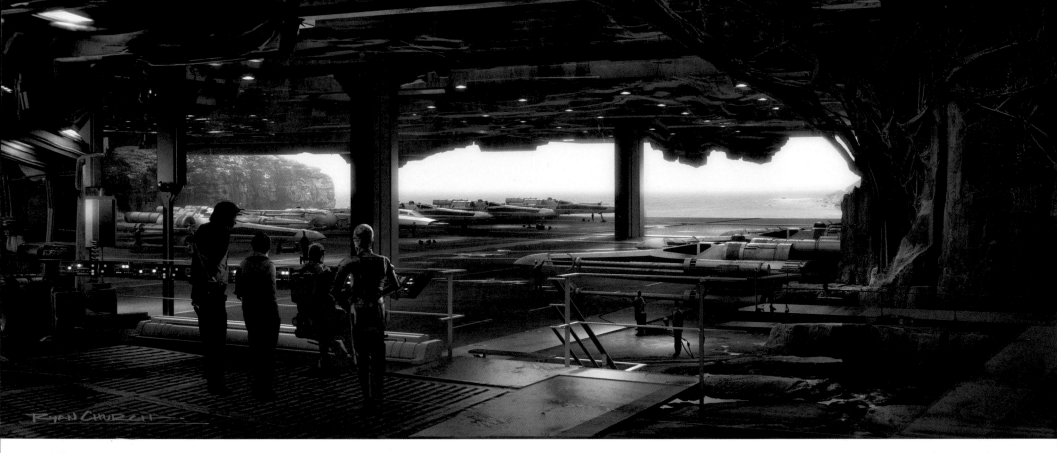

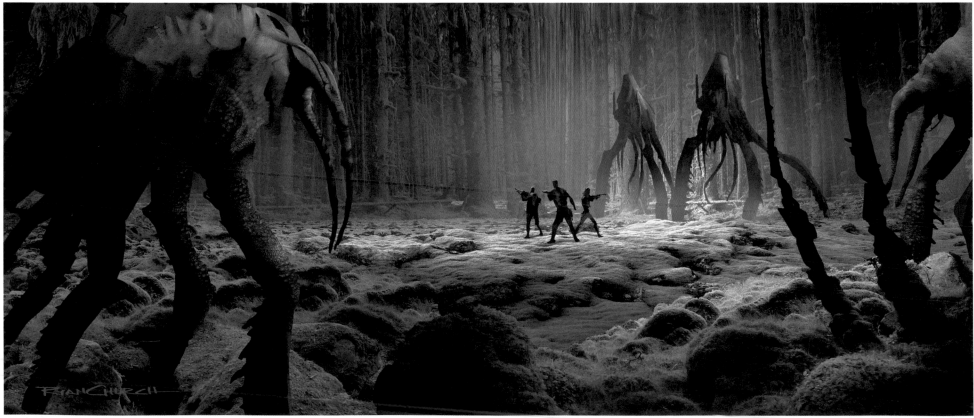

▲▲ **REBEL HANGAR WIDE** Church

▲ **FOREST BASE** *"This is when the octopus monsters were on the surface of the planet, not up on Han's freighter. It's like J.J. knew what imagery he wanted in the movie—the designs just had to find their way."* **Church**

▲▲ **SNOW BASE WIDE** *"J.J. did this really quick sketch of a ball with circles in it. So I adapted that quick little sketch and made these big ports. I like the idea of a belt of asteroids, not actually asteroids; they're chunks of this planet that they've Chunnel-ed out and discarded into space."* **Clyne**

▲ **DOOM STAR FRONT SHIPS** *"This was Rick saying, 'A red ship, not a Star Destroyer. Something weird and red.'"* **Church**

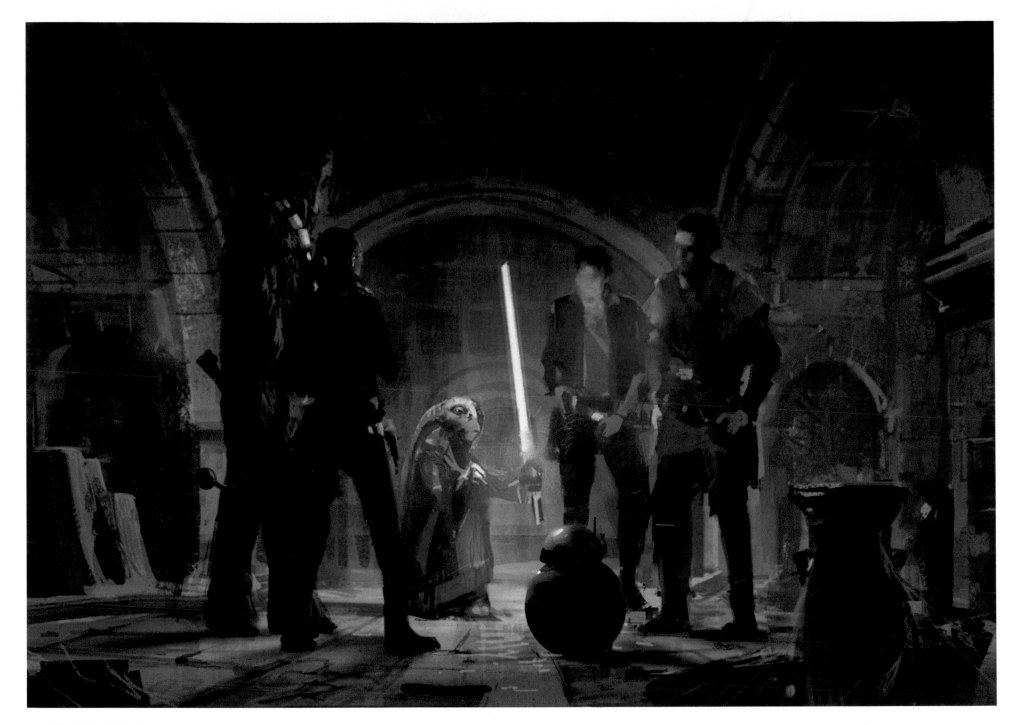

▲ **CATACOMBS MAZ Allsopp**
"Both the interior and exterior of Maz's castle were much less challenging for the construction team. The plaster and stonework are the sort of projects they do regularly." **Gilford**

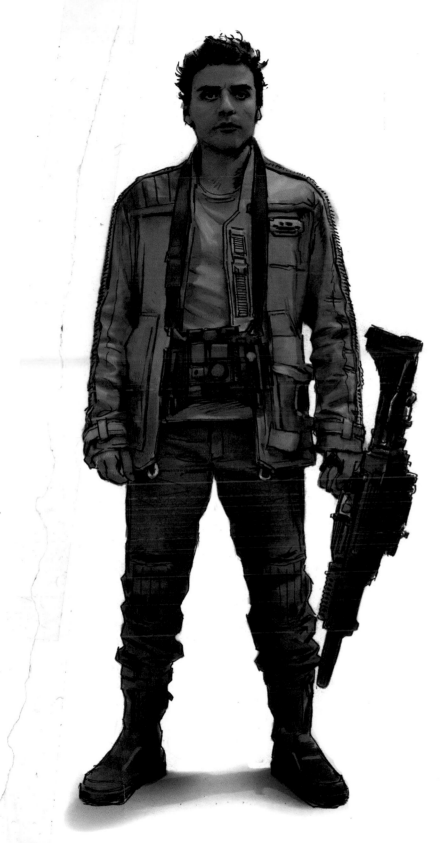

VILLAGE OUTFIT *"Finn, formerly 'Sam,' would obviously have to lose his stormtrooper armor, but what would be under the armor? I remember J.J. saying, 'There's got to be a way that he picks up Poe's coat.' So we had to do a jacket that would be a bit pilot-like that then John Boyega could wear."* **Dillon**

PRE-PRODUCTION

The pre-production design phase began in earnest in July 2013 at Pinewood Studios, Buckinghamshire, with the inception of the UK production art department, Neal Scanlan's creature effects department, and, following a visit to Lucasfilm on July 12, Michael Kaplan's costume department. Unlike previous *Star Wars* productions, all three departments would have their own handpicked design teams, including veteran creature designer/sculptors Jake Lunt Davies, Luke Fisher, Ivan Manzella, and Martin Rezard and costume concept artists Glyn Dillon and Magda Kusowska. "I don't think Neal's necessarily been in a position to offer up an art position," creature concept designer Jake Lunt Davies says. "It's great because, lots of times, within the industry, you can get a lot of art, which perhaps dilutes or changes things between concept art and the final puppet or model or creature." Concept artist Andrée Wallin, who worked with Darren Gilford on *Oblivion*, also joined the UK production art department in July.

Co-production designer Gilford relocated to Pinewood to oversee all three UK art departments and synthesize work from both sides of the Atlantic Ocean, while Rick Carter continued his work with J.J. Abrams and the US art teams from Los Angeles. "We could get notes from J.J., and basically be working 24/7," Gilford recalls. "While we were sleeping in London, the guys in LA would be working. So it was a constant 24-hour process of pumping out as much artwork as we could."

Principal photography was slated to begin in Abu Dhabi, capital of the United Arab Emirates, with the two-week Jakku desert location shoot.

In anticipation of the main shooting unit's arrival in the UK, the first *The Force Awakens* sets were constructed on the Pinewood lot in early 2014, including the soundstage-filling Star Destroyer hangar, *Millennium Falcon* exterior, and backlot Jakku village. Nine of Pinewood's stages would ultimately be utilized, most for several sets, as well as the outdoor backlot and paddock areas. But the colossal push to design, build, and deliver all of the sets, props, set decorating, costumes, and creatures for the Jakku location shoot would come to dominate pre-production.

Gilford remembers, "We were working in an environment that is incredibly hostile, with incredibly strong winds, sandstorms, 120 degree temperatures. And we were building big stuff, so Abu Dhabi was very challenging."

As the UK departments got up to speed, stateside designs continued on several fronts. The Starkiller planet, home base of the Neo-Empire, and their new TIE fighter saw further refinement. Designs for guru character Maz, her gambling den/canteen, and John Doe's droid companion inched ever forward. Leia's rebel headquarters were temporarily relocated from their previous cliff face to a dense jungle setting.

James Clyne's concepts for a Star Destroyer hangar and new stormtrooper transport vehicles were among the very first J.J. Abrams–approved designs on the project, although they wouldn't begin construction for many months.

And the story beats of two thrilling action set pieces, the Neo-Empire's attack on a Jakku village and the subsequent "graveyard" chase between several TIE fighters and the *Millennium Falcon*, started to come into focus.

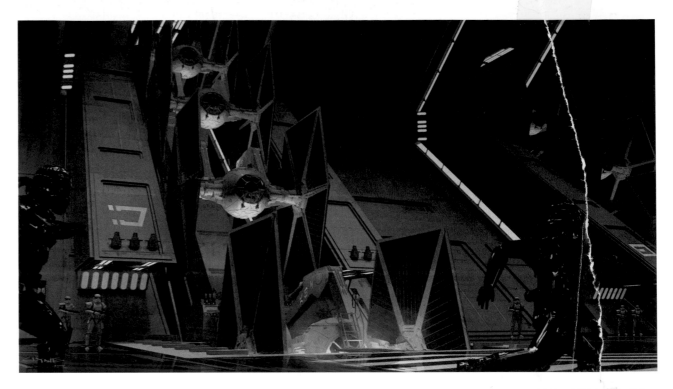

▲ **TIE LOADER** Clyne

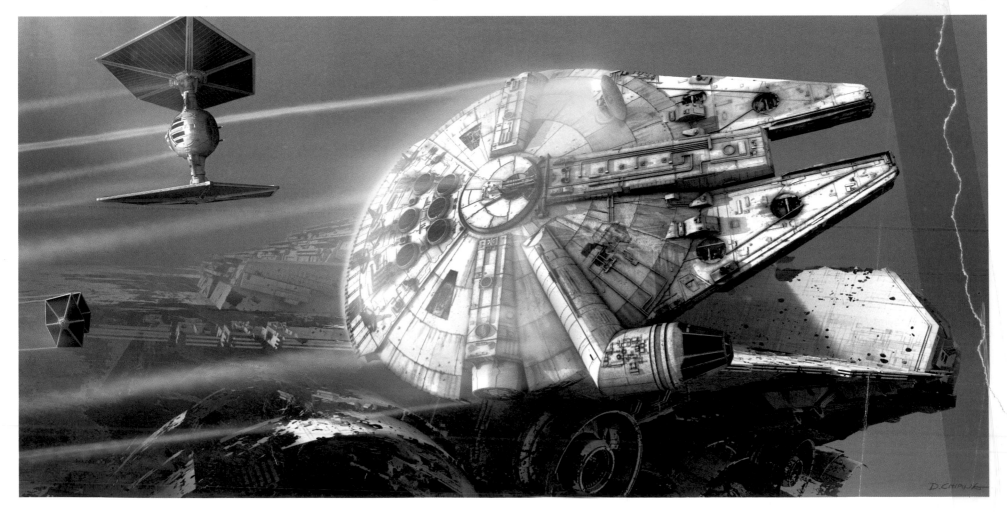

▼ **CHASE VERSION 02** Chiang

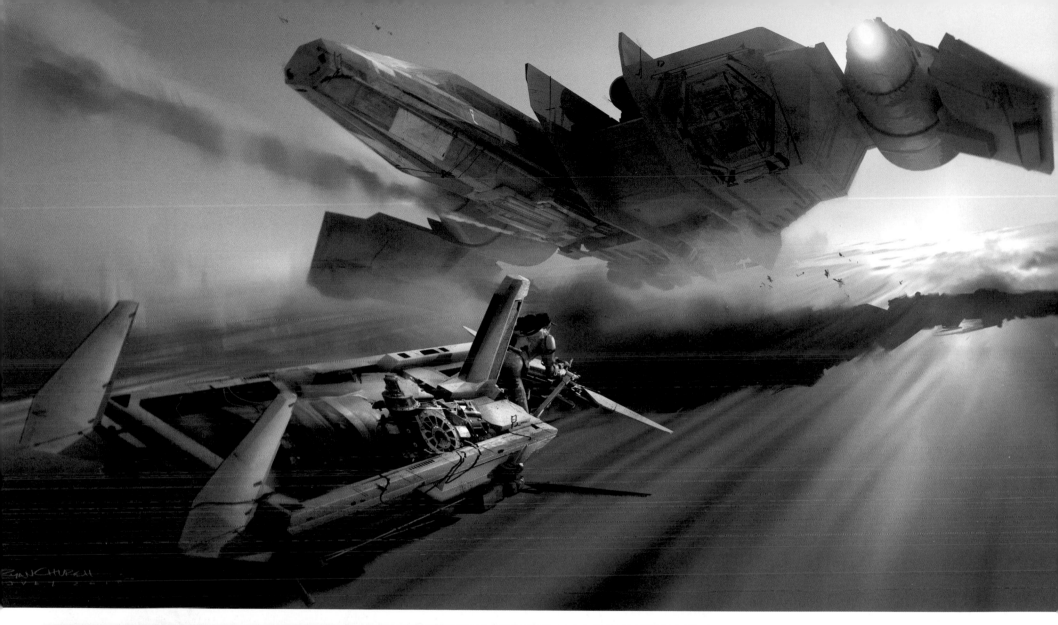

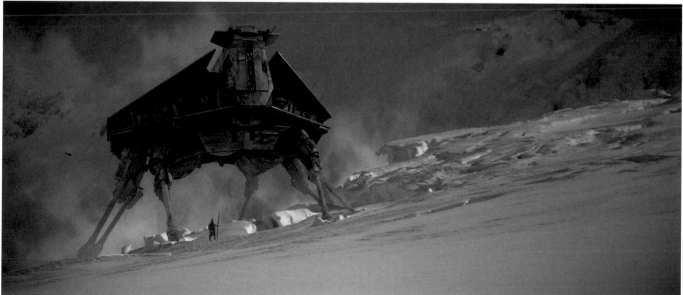

KIRA (REY) SHIP & SPEEDER *"It's her hero ship. It tells us a lot about Kira and is something that she's made from a lot of different parts, in her eclectic way."* **Church**

◄ **STEAM POD** Dusseault

► **KIRA (REY)** McCaig

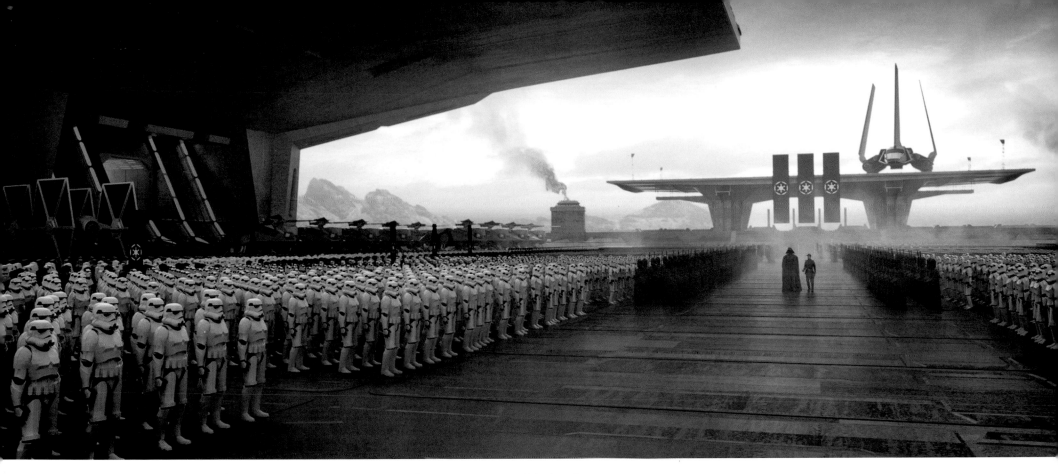

▲ **ICE PLANET EXTERIOR 8.2** *"A whole Brutalist architecture came on—sort of German, massive, weird-looking, heavy concrete structure stuff. It's definitely been informing what the Imperial third-act planet's going to be."* **Dusseault**

▼ **ICE PLANET EXTERIOR 10.1** **Dusseault**

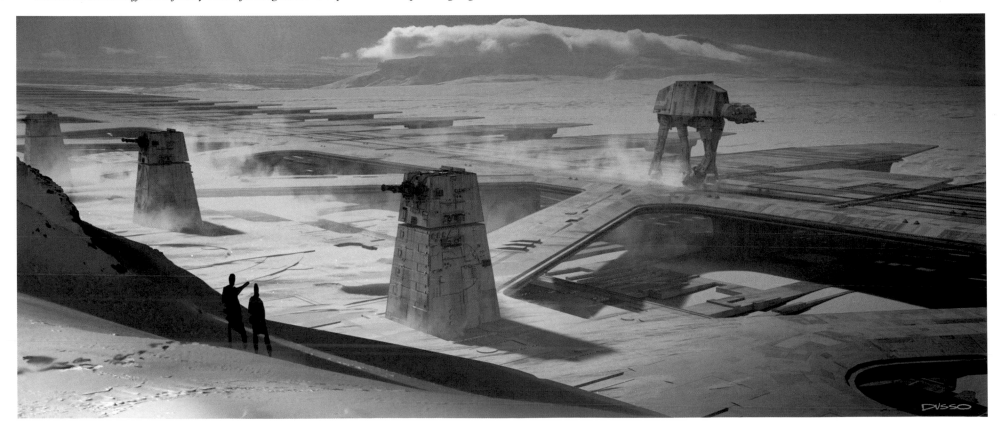

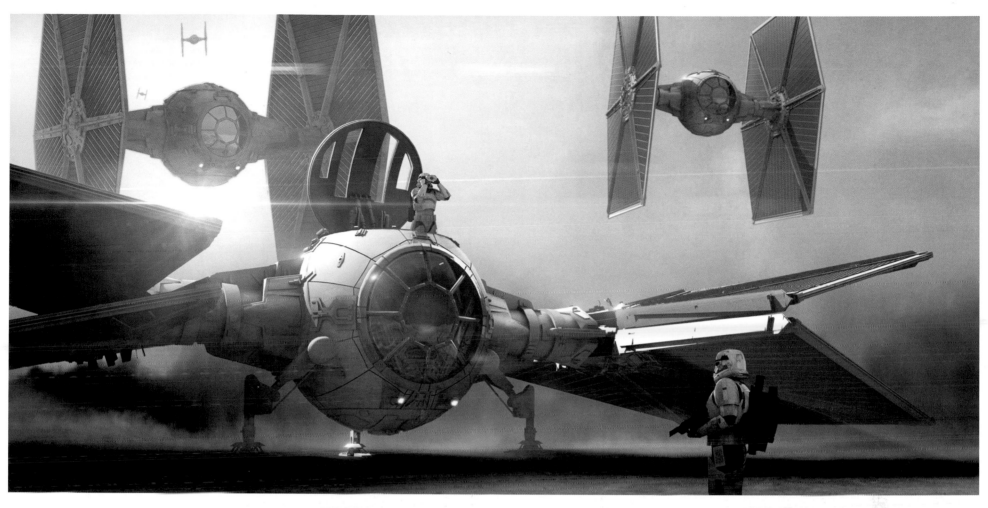

▲ **TIE LANDING** Chiang

▶ **TIE LANDING** *"We did a lot of exploration of how this TIE fighter could land. But of course we had to ask: 'How the hell do you get out?' My answer was you go to Home Depot, and you get the cheapest ladder you can buy [laughs], and you throw it out the back."* **Clyne**

▶▶ **JUNGLE** Tiemens

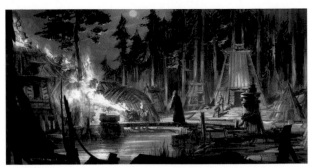

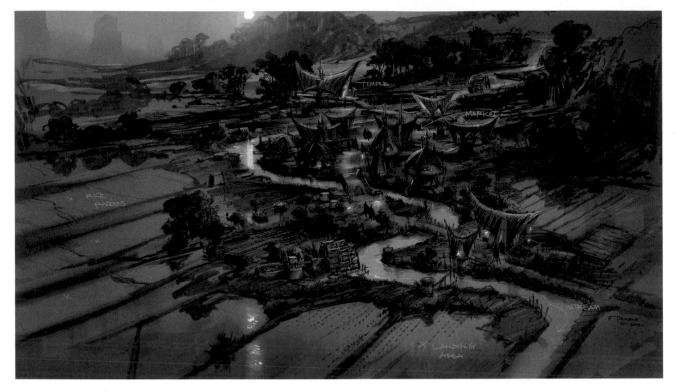

▲ **VILLAGE FIRE WITH BRIDGE** Tiemens

▲ **VILLAGE OVERVIEW** *"I spent a month or so on village design concepts. Production wanted to basically flood a somewhat level area outside, and then green it up like a rice field and make these structures."* **Tiemens**

▲ **LANDING SHIP ATTACK** Chiang ▼ **VILLAGE FIRE** Church

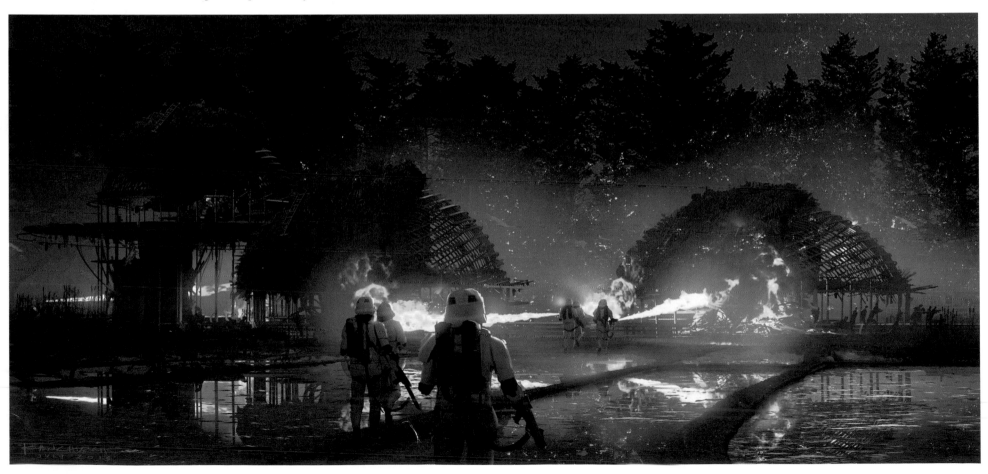

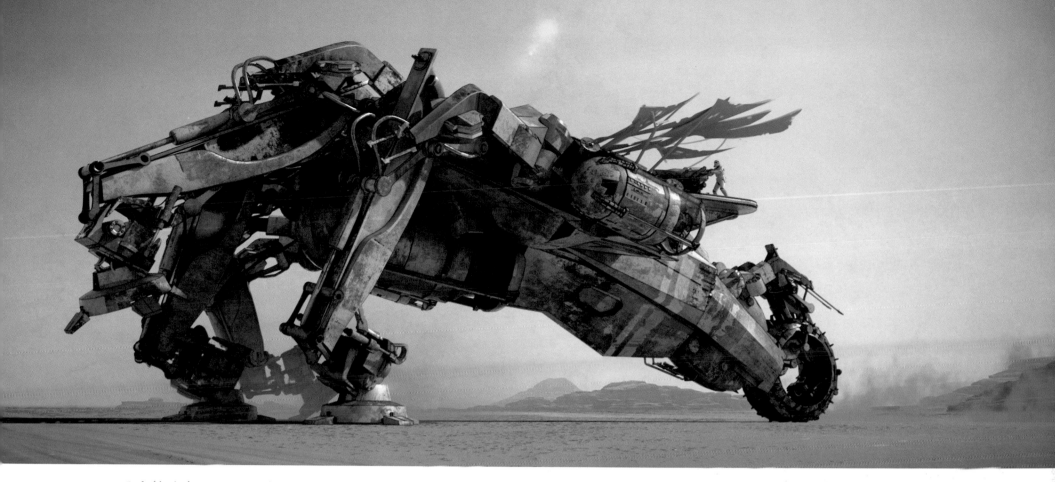

▲ **STEAM POD** *"Probably the least Star Wars thing I've done [laughs] for this film: a very first piece on an Empire land vehicle. It's too much—it's too complex—but people still like it."* **Dusseault**

▼ **KIRA (REY) SHIP** Church

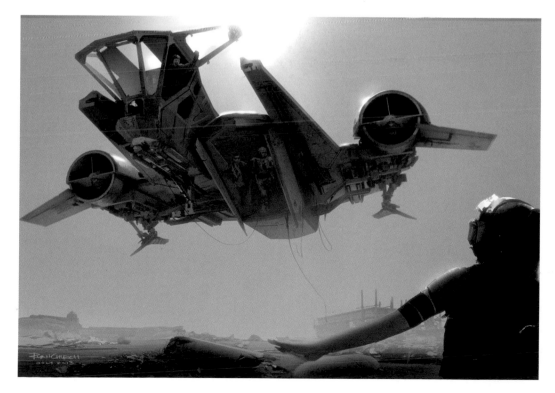

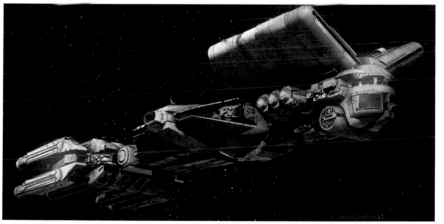

▲ **FRIGATE V HEAD** Church ▼ **IMPERIAL BOARDING CRAFT EXTERIOR WIDE** Church

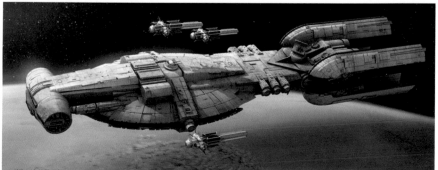

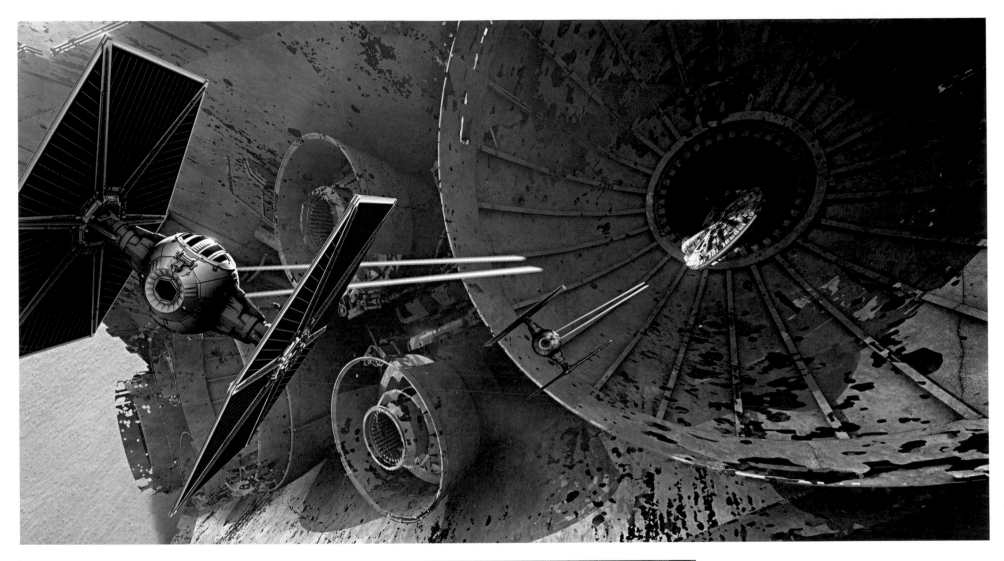

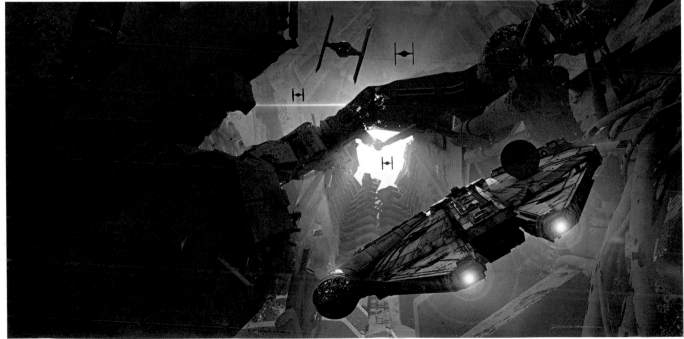

▲ *FALCON* CHASE VERSION 01 **Chiang**

◄ *FALCON* CHASE VERSION 03 *"I love the idea of just mixing the two—where you put something that's so iconic, like a Star Destroyer, into a new context, into a desert. As ridiculous as that is, it's what I think is part of the amazement and charm of Star Wars."* **Chiang**

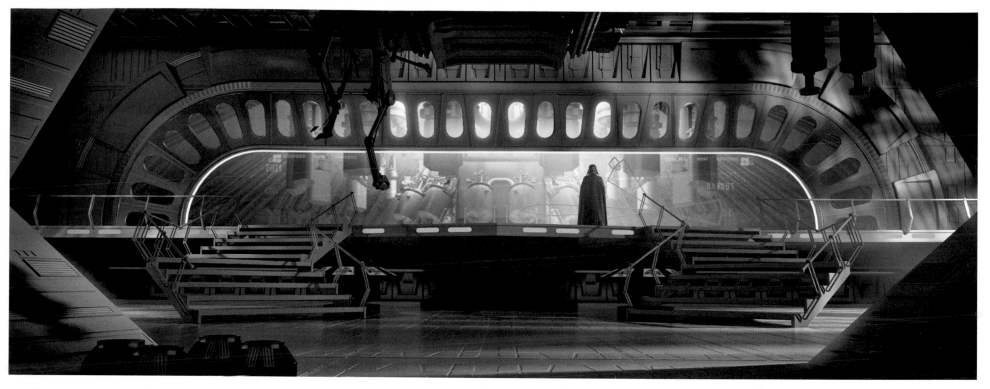

BRIDGE 3.1 "In everything I do, I really make an effort to look at legacy architecture, little details production would use and try to use them in the same percentage. And I imitated some of the lighting as well—particularly the amount of little red lights." **Dusseault**

DOOM STAR SURFACE Church

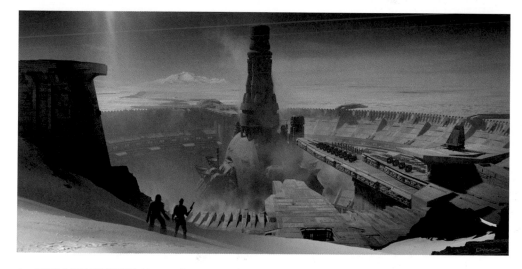

ICE PLANET EXTERIOR Dusseault

HIGGINS INTERIOR Clyne

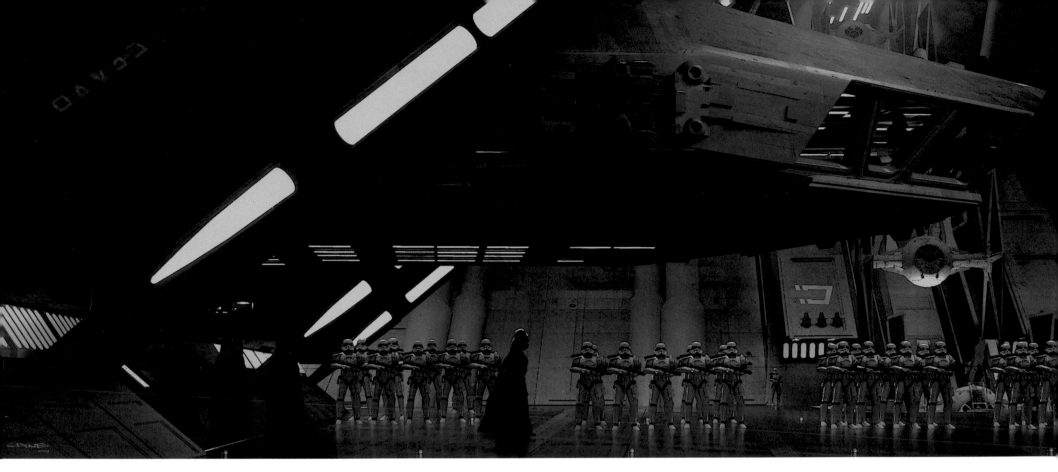

▲ **LOADING BAY CONTROL** *"Instead of a square, I chose a hexagonal hangar aperture. It seems really simple, but it took so much effort to arrive at that. Angling those walls, the initial intention wasn't the TIE fighter dispenser. But I think Darren was like, 'Well, what if it's more of a Pez dispenser kind of thing?'"* **Clyne**

▼ **HIGGINS** Clyne

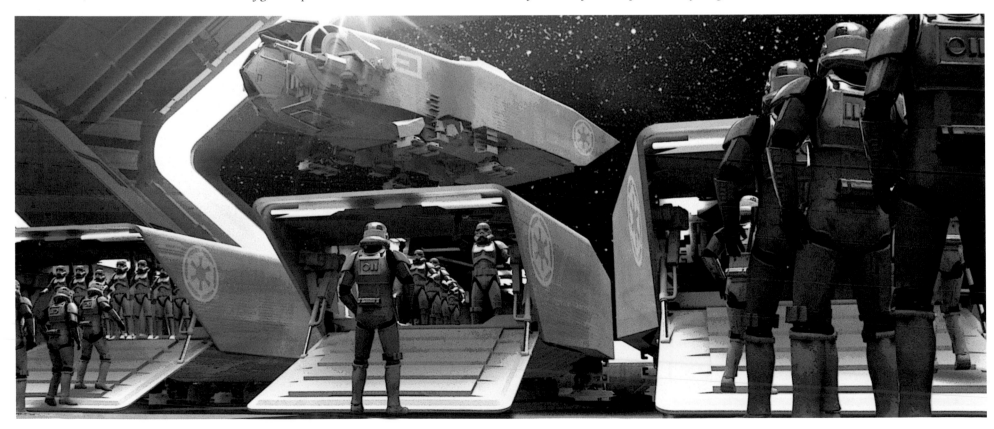

- **CHESS GAME** McCaig
- **DROID COCK-FIGHT** *"So if you're going to have a cock fight, don't have big monsters fighting. Have two dorky little droids duking it out like Robot Wars, and everybody gambling on it."* **McCaig**

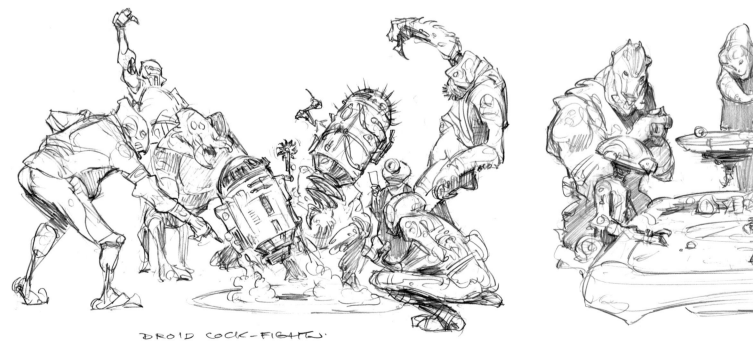

DROID COCK-FIGHT

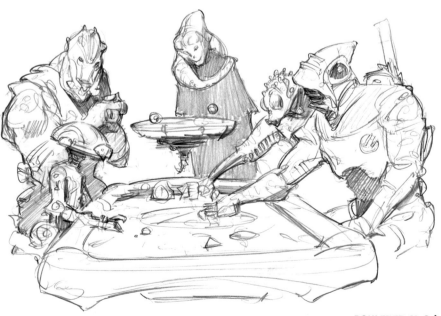

▲ **ROULETTE** McCaig

AUGUST 2013

August started on a fun note for the San Francisco–based Visualists, with a visit from Mark Hamill, who returns as Luke Skywalker in Episode VII. Hamill arrived with his wife, Marilou, and son Nathan. He generously spent an entire Saturday afternoon with the designers, in which he told hilarious story after story from the set of the original trilogy.

Michael Arndt turned in his outline for Episode VII in August, quickly followed by a work-in-progress script draft. Neo-Imperial interior sets, including the Star Destroyer's torture room and "cobra-head" bridge overlooking the hanger, and the form and function of their ice planet base were further developed. The Visualists also continued to fine-tune the junk world of Jakku, specifically the starship graveyard and sacred village. Pushed into even further contrast from Jakku, Exotic City picked up specific design influences from original trilogy concept art legend Ralph McQuarrie. Across the Atlantic, the creature department saw its first round of approvals for alien characters later populating the outpost and Maz's saloon.

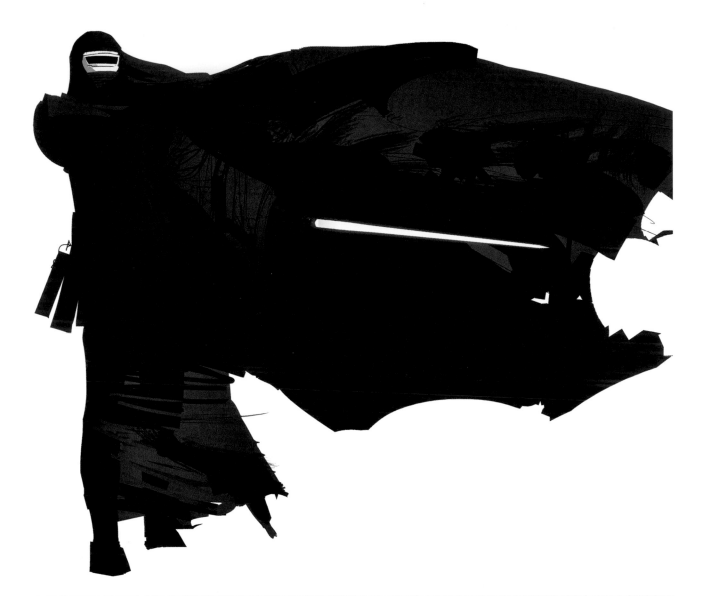

▶ **BILLOWING CLOAK AND HOOD** Dermot Power

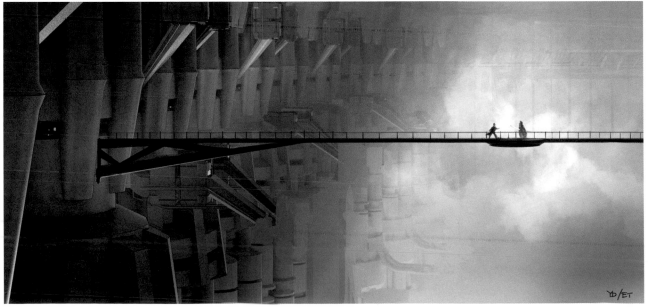

▶ **GUN BRIDGE FIGHT** Dusseault and Tiemens
"Ultimately, for Obi-Wan Kenobi, halfway through Star Wars, to realize that if he sacrifices himself and makes his own death of his making as much as the person who's causing his death, he's making himself more powerful than anybody can imagine. And it's witnessed by a third person, that young man. It's been in front of everybody for all these years. But you don't see Obi-Wan Kenobi everywhere. You see Darth Vader, you see Yoda, and you see Luke. But Obi-Wan's the one who made it all happen." **Carter**

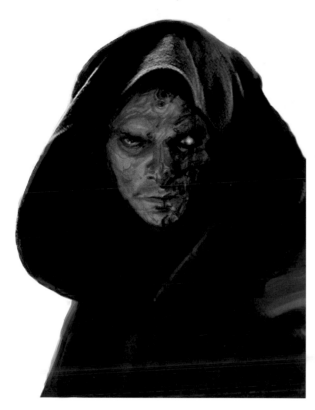

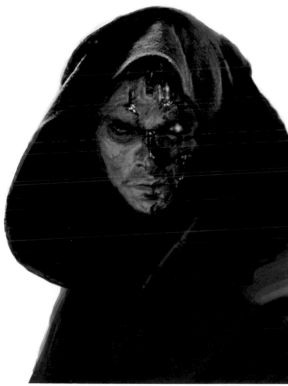

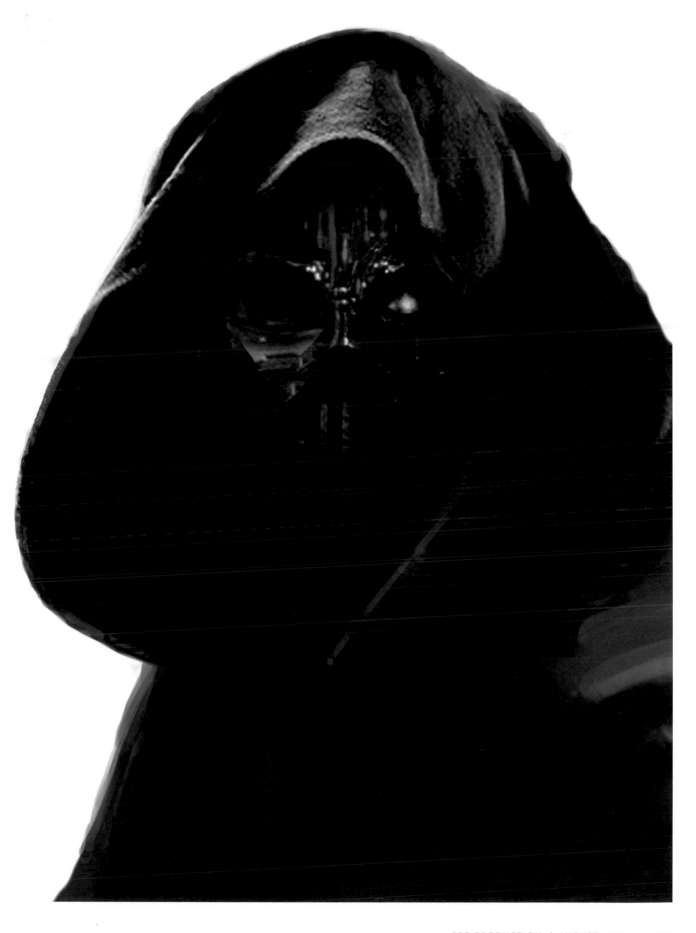

▲ **ANAKIN/VADER GHOST 01, 02 & 03** *"If we see Anakin Skywalker, because he does flow back and forth between Darth Vader and Anakin, let's see him as a character with a dark and light side. The reason Luke is this whole new entity is because he was the first to acknowledge his own dark side—that it was not separate from him."* **McCaig**

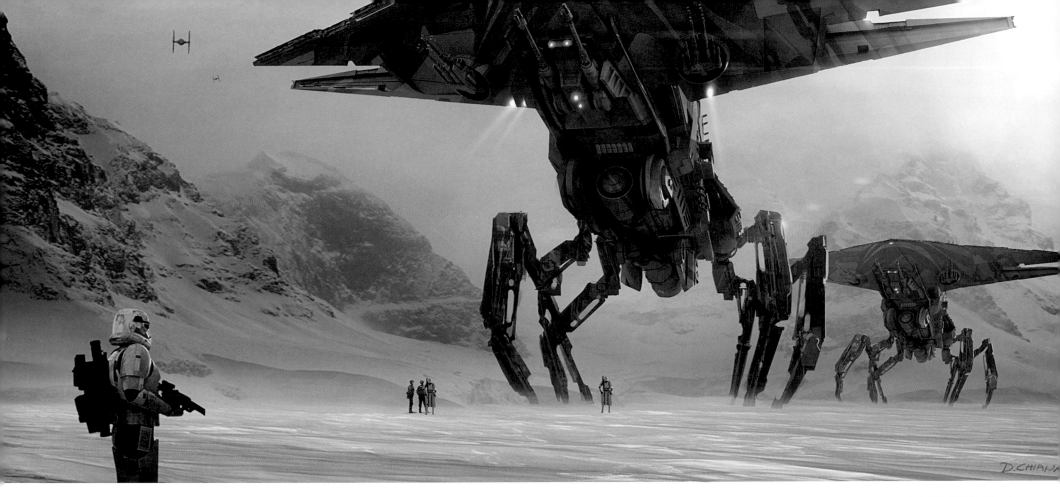

▲ NEO AT-AT Chiang

▼ TUNNEL CHASE Church

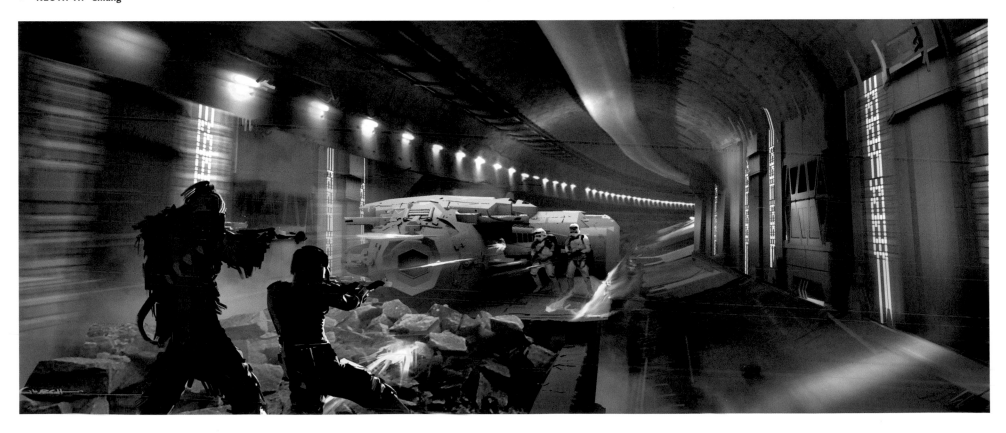

THE ART OF STAR WARS: THE FORCE AWAKENS

▲ **JEDI KILLER LIMO TIE** Church

▲ **BIG SCOUT** Clyne

▶ **FOLLOW THE PRINTS** Alzmann

▶▶ *FALCON CRASH* "*The goal was to come up with an image that's really provocative, in terms of lighting, to create mystery, power, and drama. So that when you look at it, without even knowing what the story is, you begin to ask yourself questions.*" **Chiang**

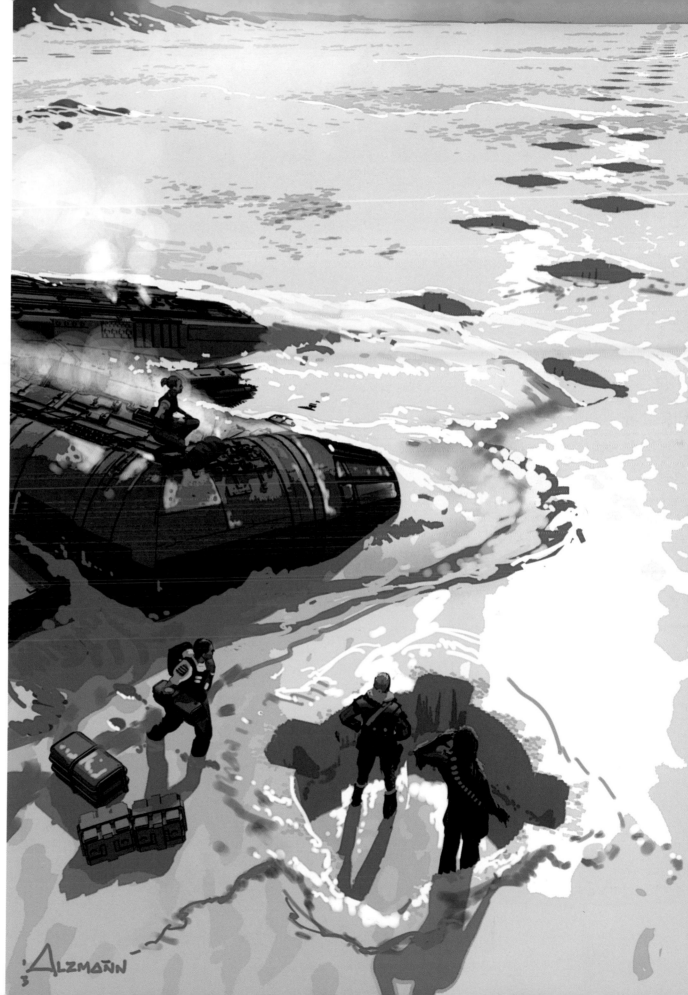

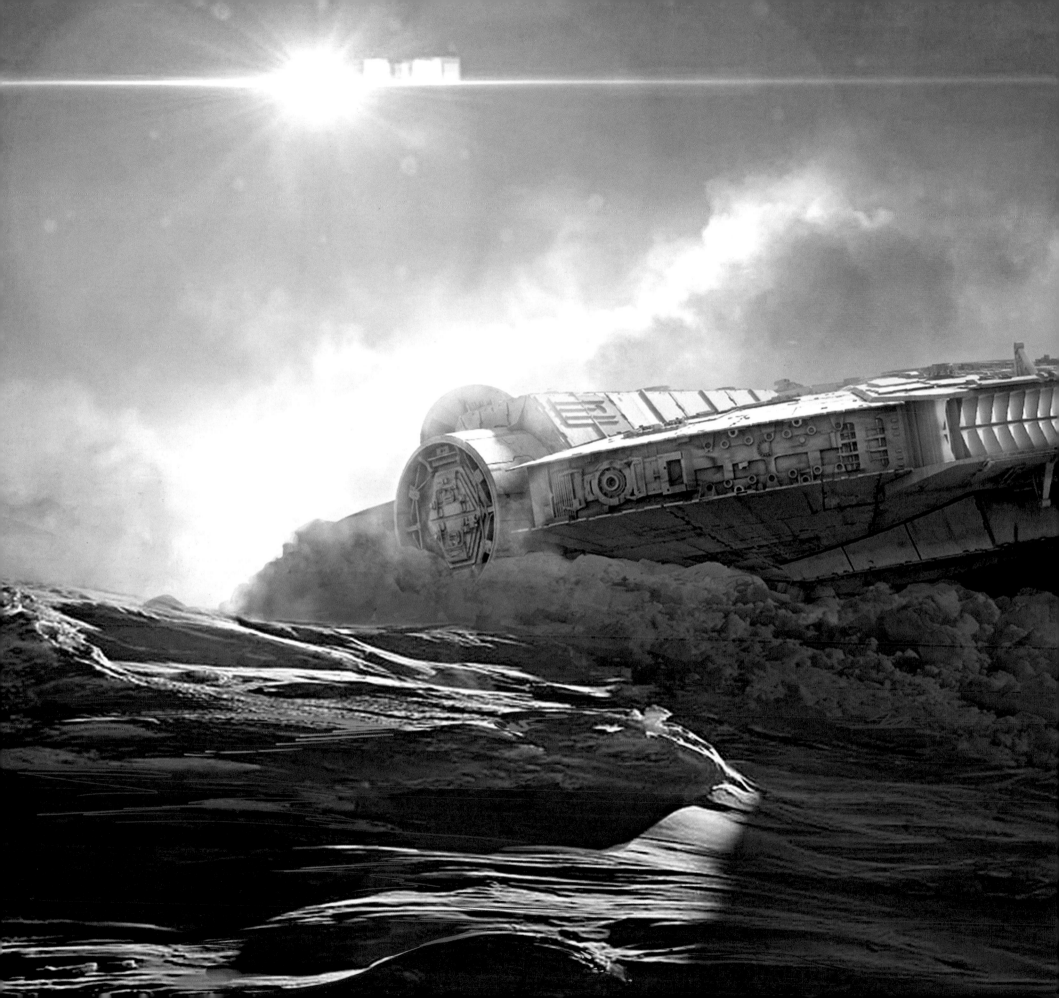

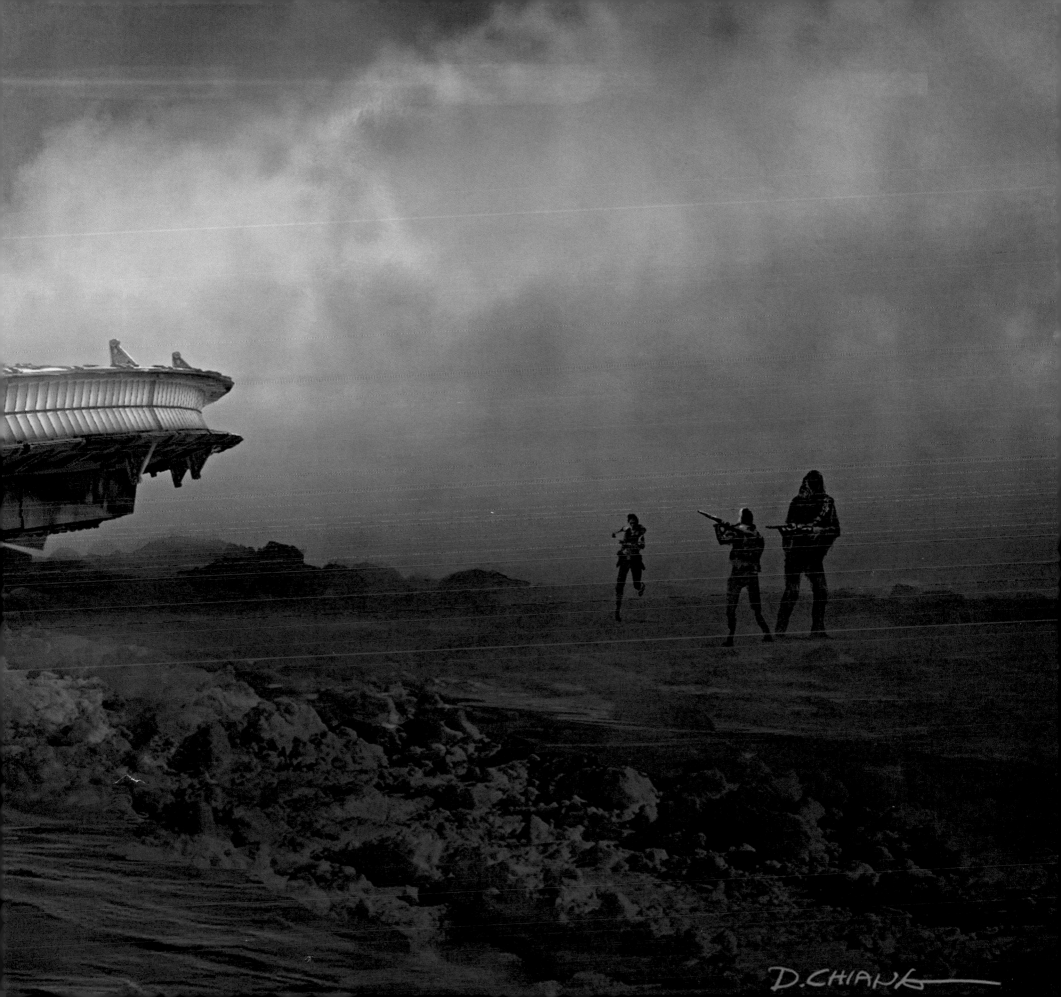

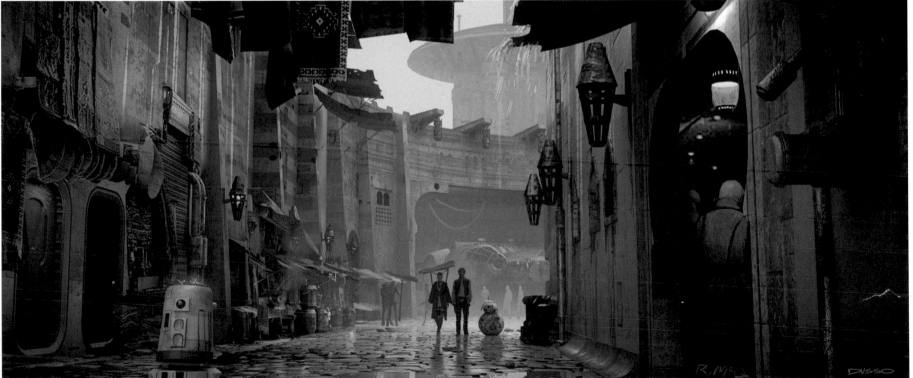

▲▲ **EXOTIC CITY 4.5** Dusseault

▲ **EXOTIC CITY RAIN BREAKDOWN** Dusseault and McQuarrie

"*The rain; Middle Eastern, rich colors—that was the process. Initially, Rick was saying Casablanca. There was a simpler version of this that I created, which was based on one of Ralph McQuarrie's paintings that Rick really liked because it was so simple.*" **Dusseault**

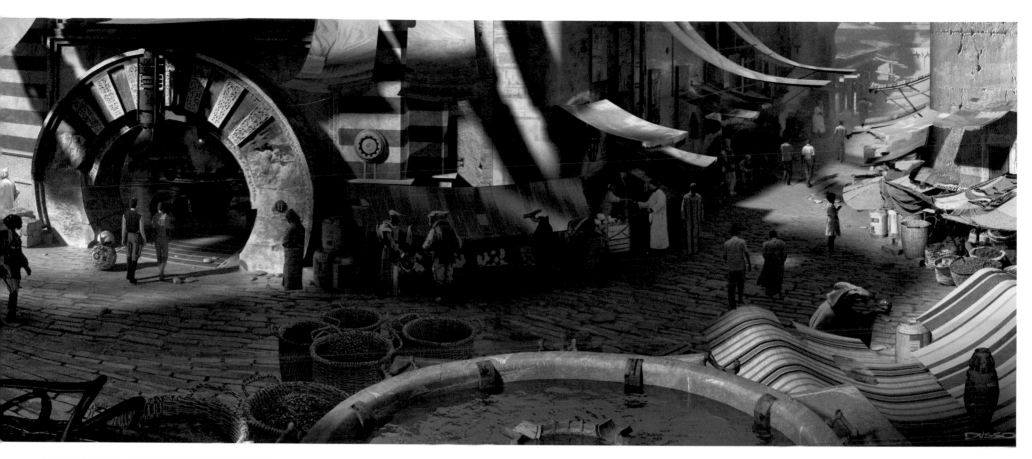

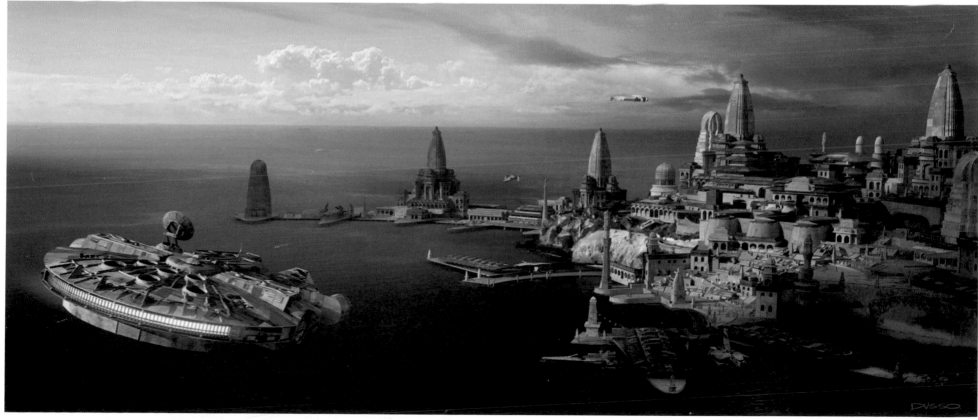

▲ **EXOTIC PORT** Dusseault

Starting with a simple sketch from J.J. Abrams, the ball droid companion of John Doe, nicknamed "Surly," was first conceptualized in mid-July 2013 by concept artist Christian Alzmann.

▸ **ROLLING DROID VERSION 01** Alzmann

▾ **SURLY STICKY NOTE** J.J. Abrams
"*There's a little Post-It drawing that J.J. did of the exact shapes he wanted: two circles and a head magnetically floating above the sphere. He even did a dash and dot for the eyes and a smile, and I tried to build that into the old droid aesthetic.*" **Alzmann**

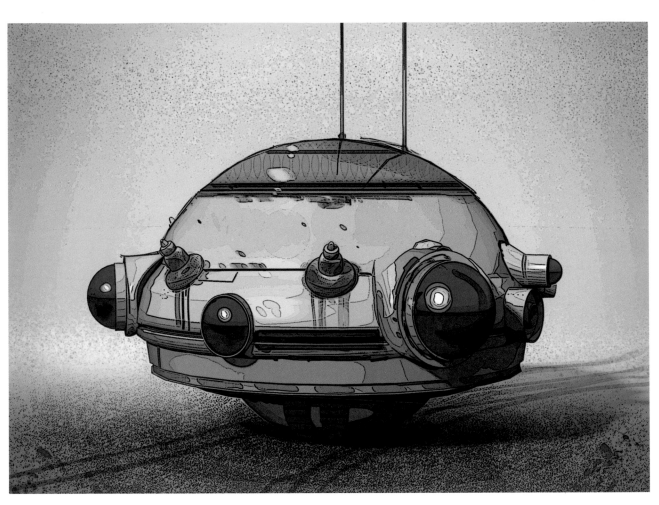

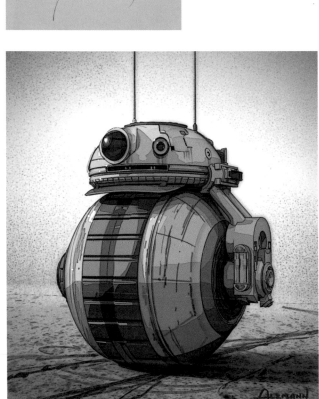

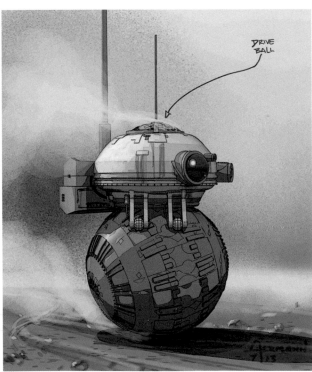

DRIVE BALL

▲ **ROLLING DROID VERSION 03** Alzmann

▲ **SURLY VERSION 04** Alzmann

▲ **SURLY VERSION 05** Alzmann

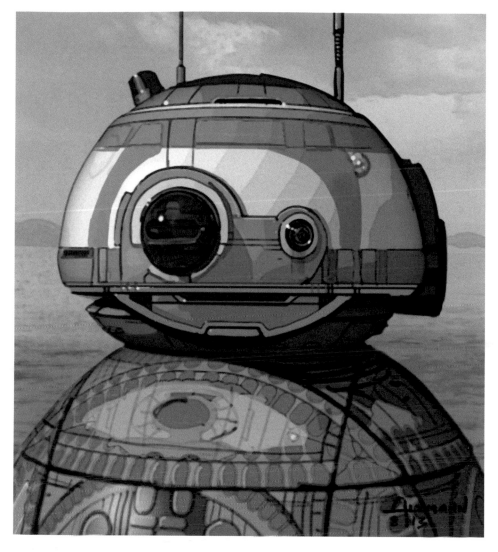

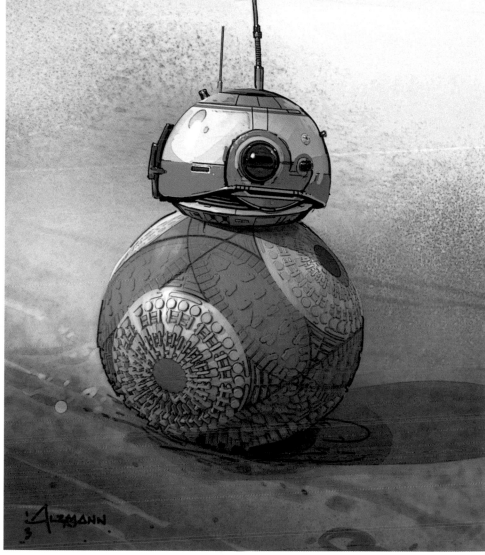

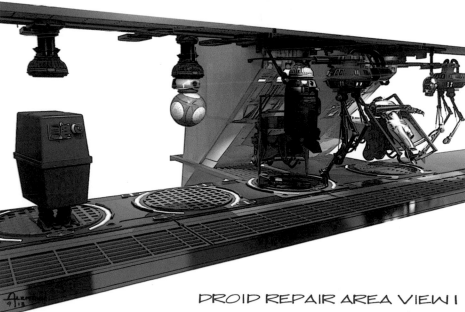

▼ **DROID ASSEMBLY 01** *"At the time, the first place we saw Surly was a droid repair area on a Star Destroyer. If you can't be repaired, they just toss you in the furnace."* **Alzmann**

DROID REPAIR AREA VIEW I

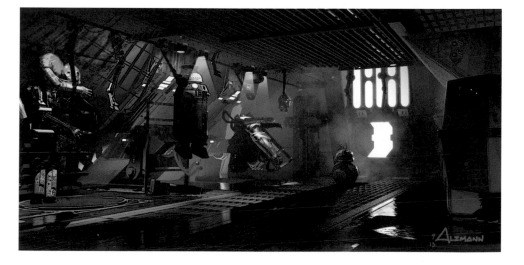

▲▲ **FACE** Alzmann ▲ **DROID REPAIR AREA** Alzmann

▲ **AERIAL APERTURES** Church

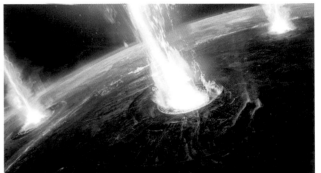

▲ **CAVE ENTRANCE** *"Early on, Rick said, 'Desert, forest, snow: That's where we'll start. I think if we go with those three planets, that will create a Star Wars feel and bring just enough color to the movie.' This was more of a bunker idea—the entrance to a mountain fortress."* **Alzmann**

▶ **STARKILLER SEQUENCE 08** **Chiang and Wallin**

▼ **STARKILLER SEQUENCE 03** **Chiang**

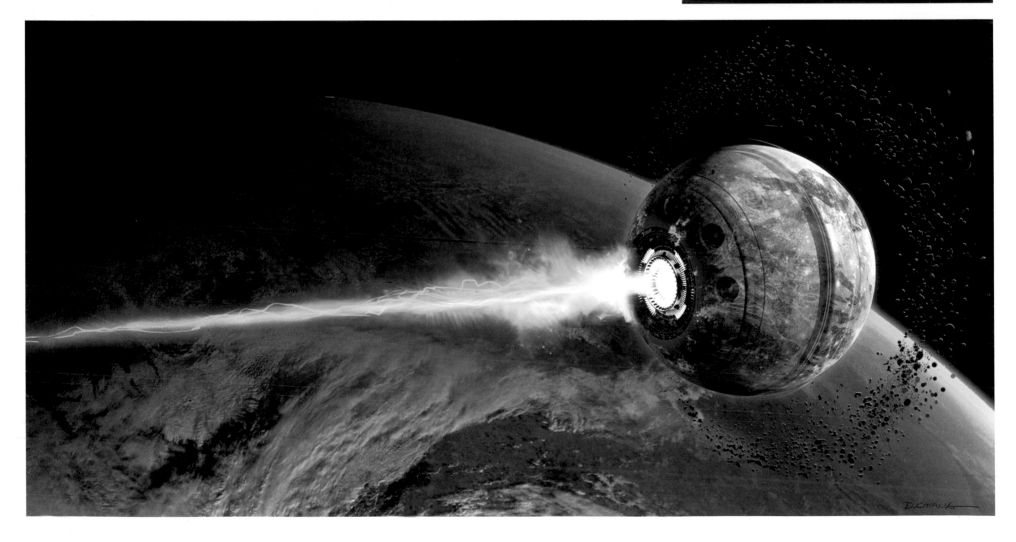

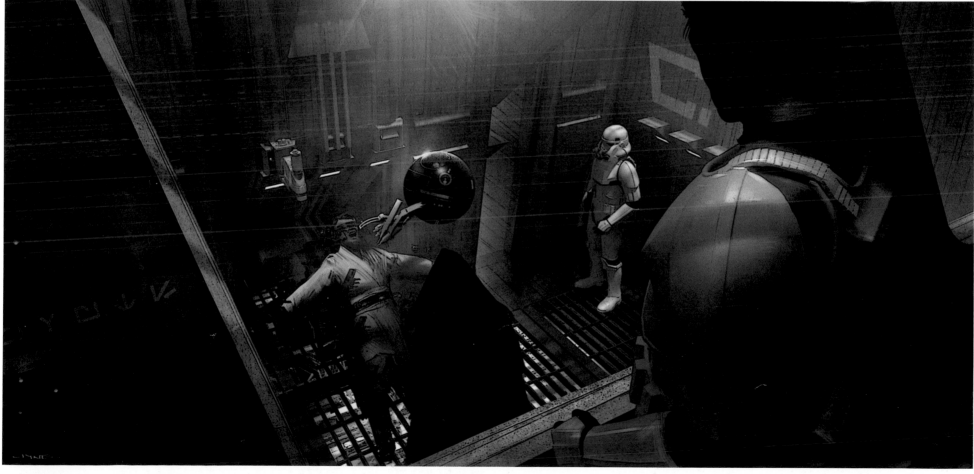

▲▲ **CONTROL ROOM MEDIUM SHOT** Clyne

▲ **INTERROGATION ROOM WIDE** Clyne

September marked a personnel shift in the California-based concept art teams, with Iain McCaig and Erik Tiemens moving on to other jobs, and Thom Tenery, who worked with Darren Gilford on *Oblivion*, Fausto De Martini (*RoboCop* [2014], *Transformers: Age of Extinction*) and Matt Allsopp (*Godzilla* [2014]) coming on board. "Adding them on didn't come about until a little bit deeper into the project when we saw a window," Gilford recounts, "and I said, 'Hey, there's a couple guys I'd like to bring into this fold who I think are super talented.'"

Tenery and De Martini, who primarily focused on vehicles, were stationed at Bad Robot Productions in Los Angeles, where they could immediately address design issues with J.J. Abrams and Rick Carter. Allsopp joined Gilford's Pinewood-based art department.

The costume department's stormtrooper, snowtrooper, and flametrooper armor and weapon designs got their initial director approvals in September. Simultaneously, approved alien and droid concepts continued to pour out of the creature department. Starkiller base and crashed Star Destroyer designs saw further refinement. And Tiemens's design and lighting concept for the trading post at the center of the outpost defined the structure, until it was raised on the salt flats outside of Abu Dhabi.

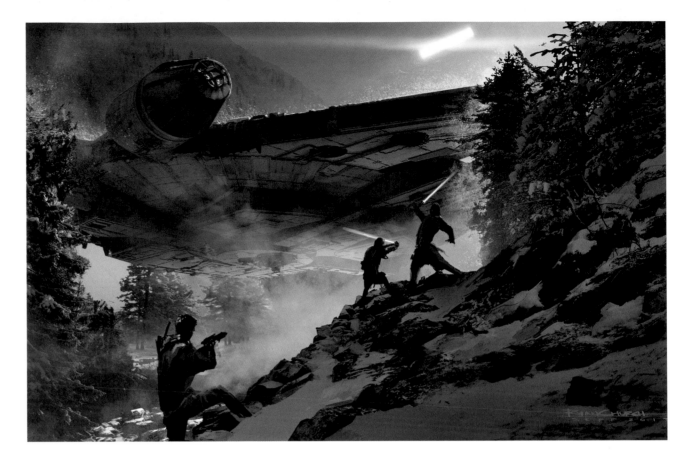

▲ *FALCON* APPEARS Church

▼ HANGAR BAY WIDE *"The questions were: 'How do we reuse the neo-Star Destroyer hangar?' and 'Is there another way we can use it on the Starkiller base?' Initially, this was going to be the location where Kira could steal a TIE fighter and get out. That whole buttress rock area was riffing off an idea that Erik Tiemens had. So we thought, let's try to keep it alive."* **Clyne**

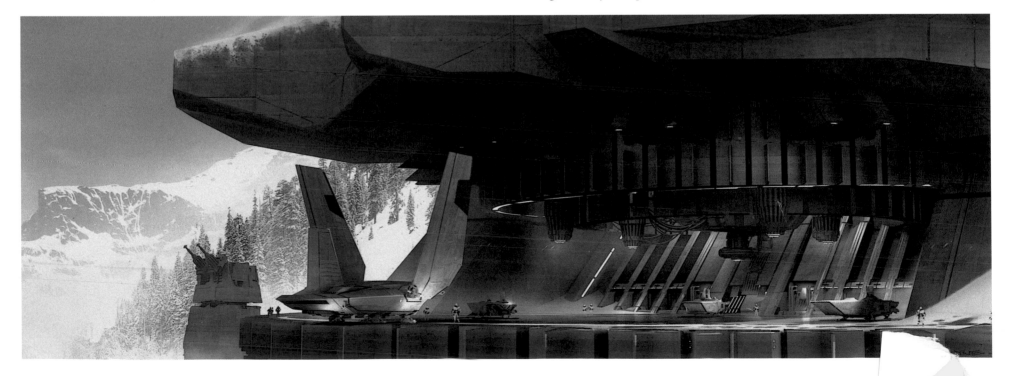

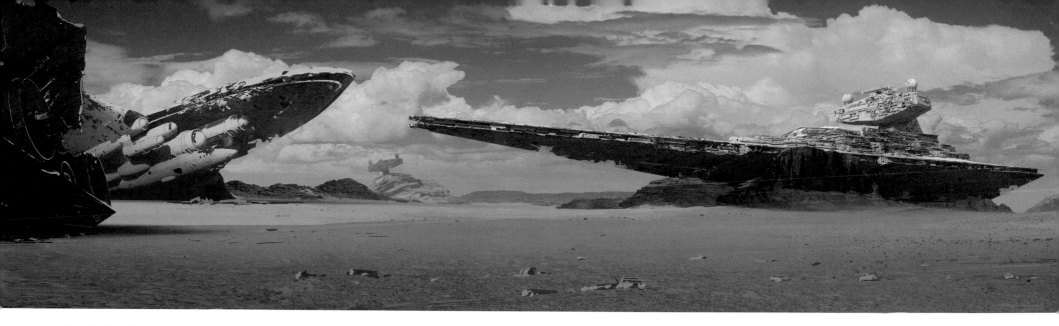

▲ **GRAVEYARD** Chiang

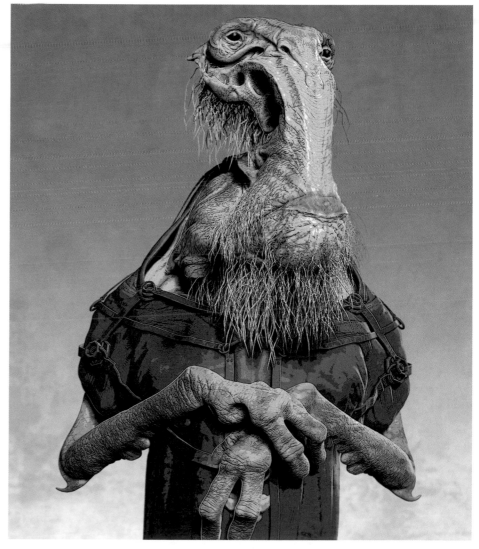

▲ **SAND PEOPLE HEAD** *"Sarco Plank came up when we were doing research and producing designs with the idea of creating Sand People. One of the drafts I created got picked up, which had a little bit of a lobster feel about it, especially in the face."* **Rezard**

▲ **OLD PRIEST** *"I started to develop a backstory with him, that he was this kind of . . . not a monk or a Jedi, but the creature has this gravitas about him. One of the things that really inspires me is getting away from the human shape while retaining expressivity."* **Rezard**

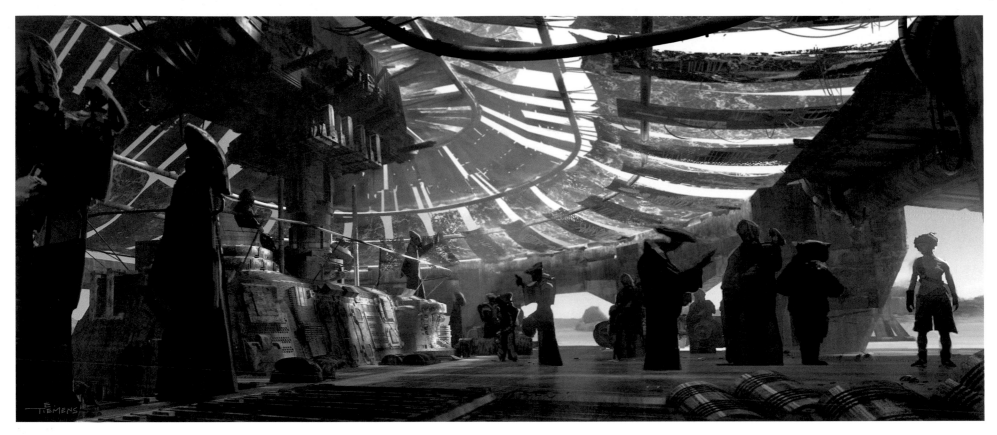

▲ INTERIOR VIEW Tiemens and Dusseault

▼ DEPOT Dusseault

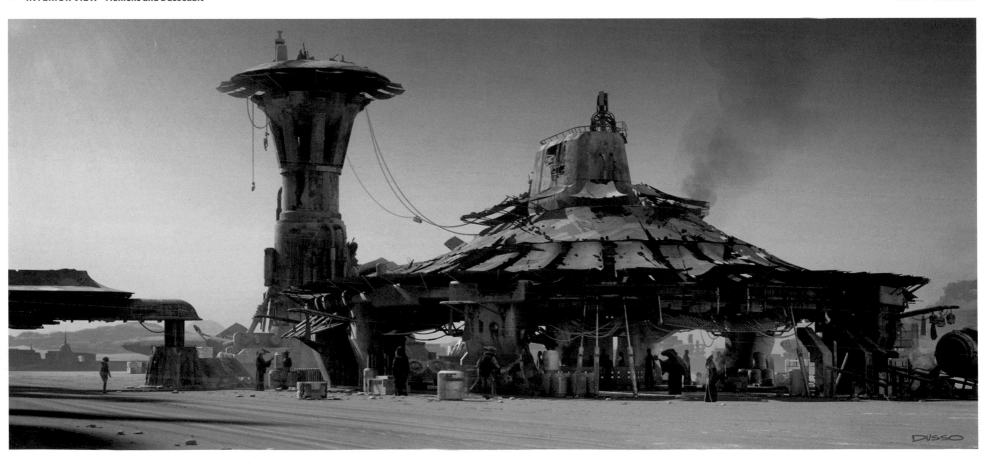

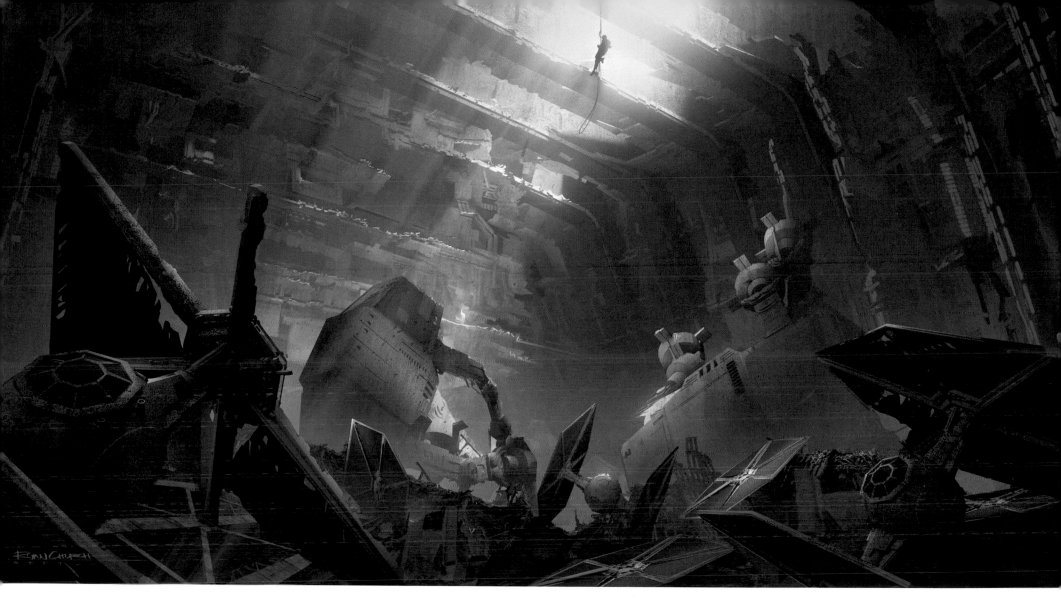

▲ **HANGAR BAY** *"This Star Destroyer hangar has to look decrepit and huge and old, which was challenging. We went back through the classic trilogy, and the hangar is one of the only Star Destroyer sets you see, the only set that can conjure specific, iconic imagery."* **Church**

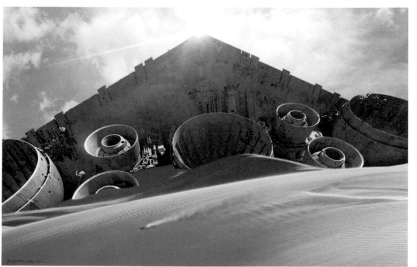

▲ **KIRA (REY) DROPS INTO WIDER COMPARTMENT**
Chiang and Wallin

▲ **ENGINE ROOM JUMP** Clyne

▲ **KIRA (REY) RACES OFF ON HER SPEEDER** Chiang

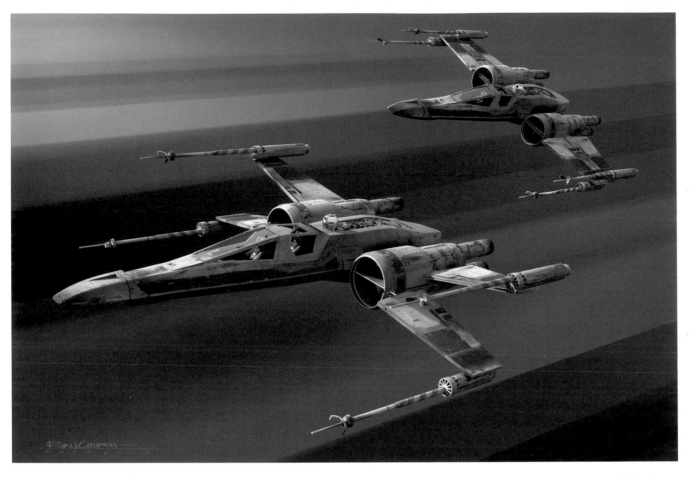

▲ **SCISSOR WING** Church

▶ **SHIP** Allsopp

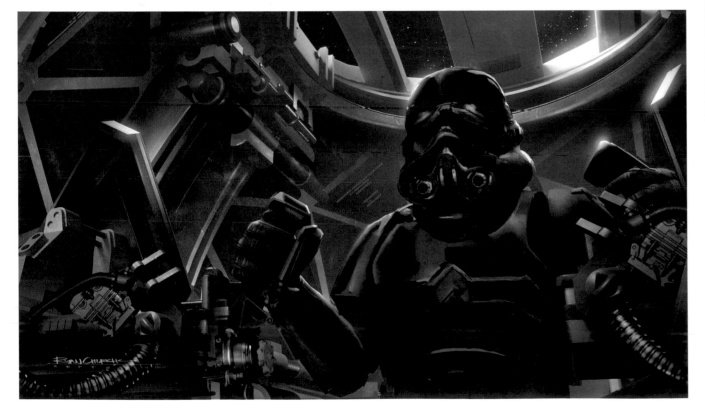

◀ **INTERIOR AFT** *"The classic TIE fighter interior looked good in the movie. But when you see the set photography, it isn't great. What it did have is an aesthetic that it was easy to extrapolate."* **Church**

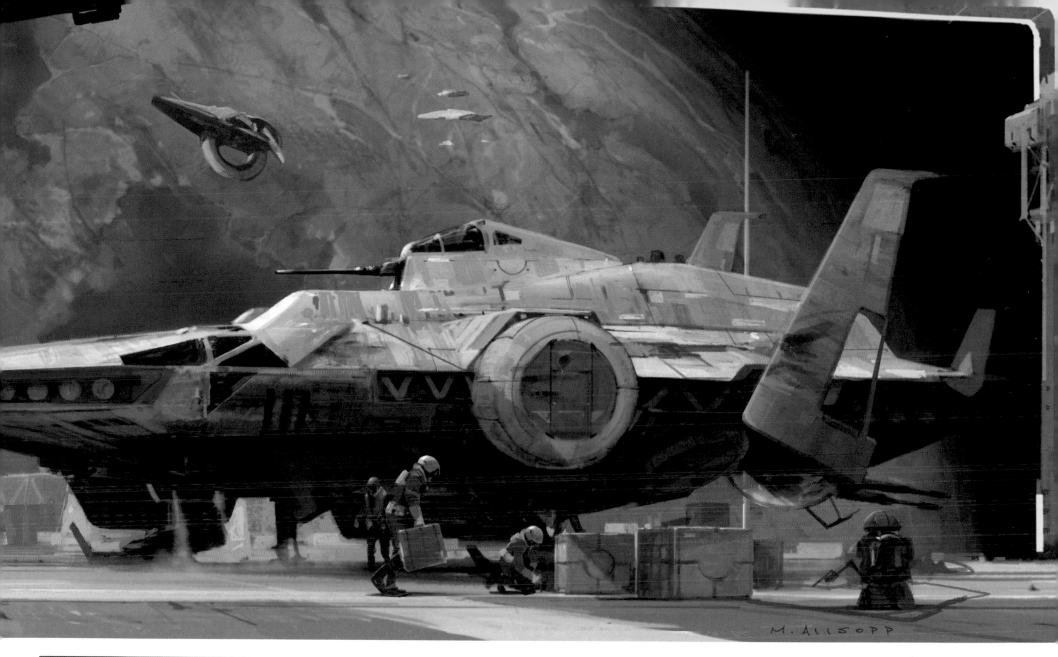

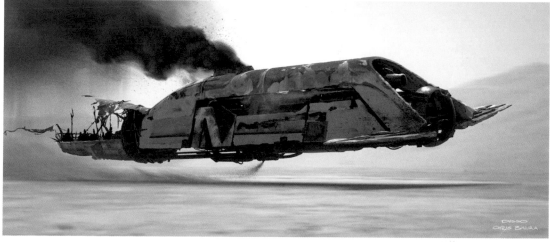

▲ **PIRATE'S SMOKE** Dusseault and Chris Bonura

▲ **PREVIOUSLY KIRA'S (REY'S) RIDE** Thom Tenery

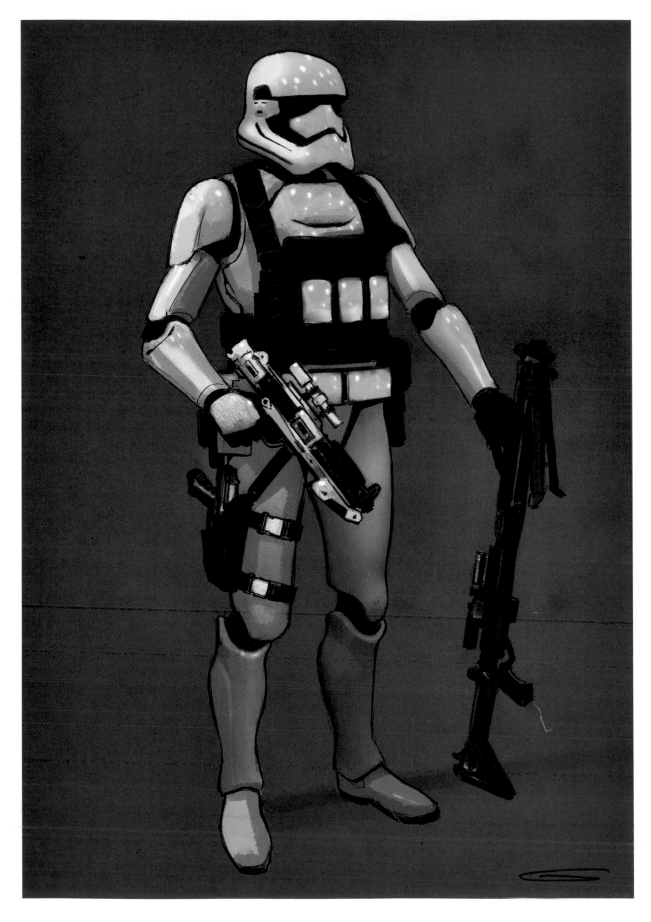

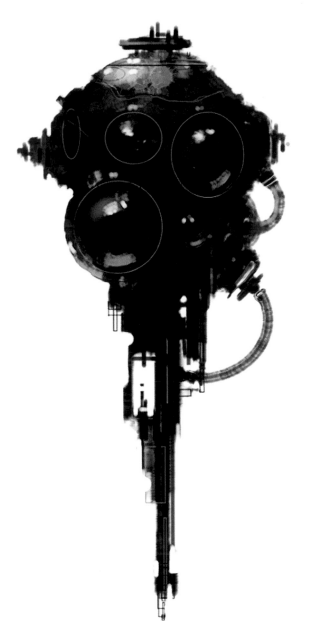

▲ **STAR DESTROYER DROID H016** *"At one point, we were thinking maybe the Jedi Killer had his own droid, whether it's a torture droid or we weren't sure what. You can't really see anything obvious that it can do other than observe you [laughs]. But it's quite an ominous-looking thing."* **Luke Fisher**

◄ **STORMTROOPER Dillon**
"The way George had always described stormtroopers to me was as living skeletons, way, way back, when I was working on The Phantom Menace battle droids. That always stuck with me, because I remember when I was little, seeing them for the first time, they always looked like Halloween costumes of skeletons." **Chiang**

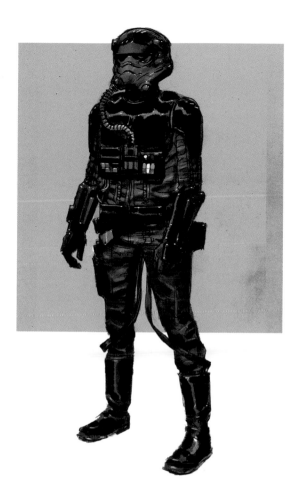

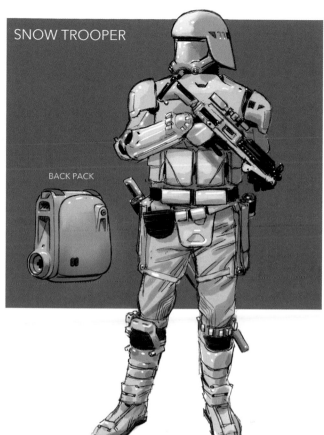

SNOW TROOPER

BACK PACK

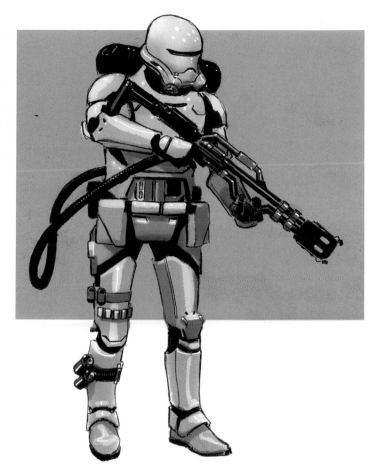

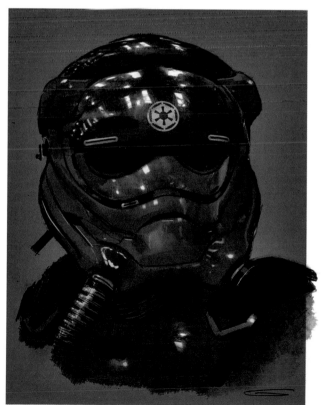

◄ **HELMET** *"When you see the old TIE fighter pilot helmets on screen, not with the rest of the body, they look fantastic. But when you see the pilots running around after Darth Vader in Star Wars, it looks like he's got his little gaggle of children. So we wanted to make them all a little bit closer to the head."* **Dillon**

▲ **TIE PILOT, FLAMETROOPER, AND SNOWTROOPER** *"The TIE pilot, flametrooper, and snowtrooper all share the same jaw piece. You only change out the upper parts. It just felt to me that that would be something that an army would do, design-wise."* **Dillon**

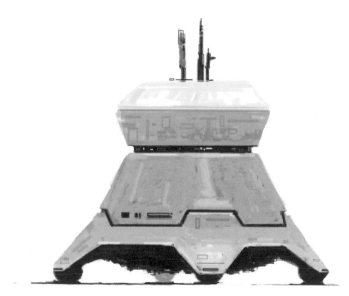

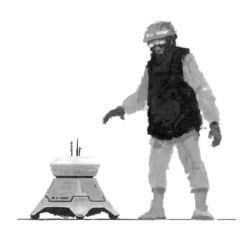

▲ **STAR DESTROYER DROID H015 Fisher**

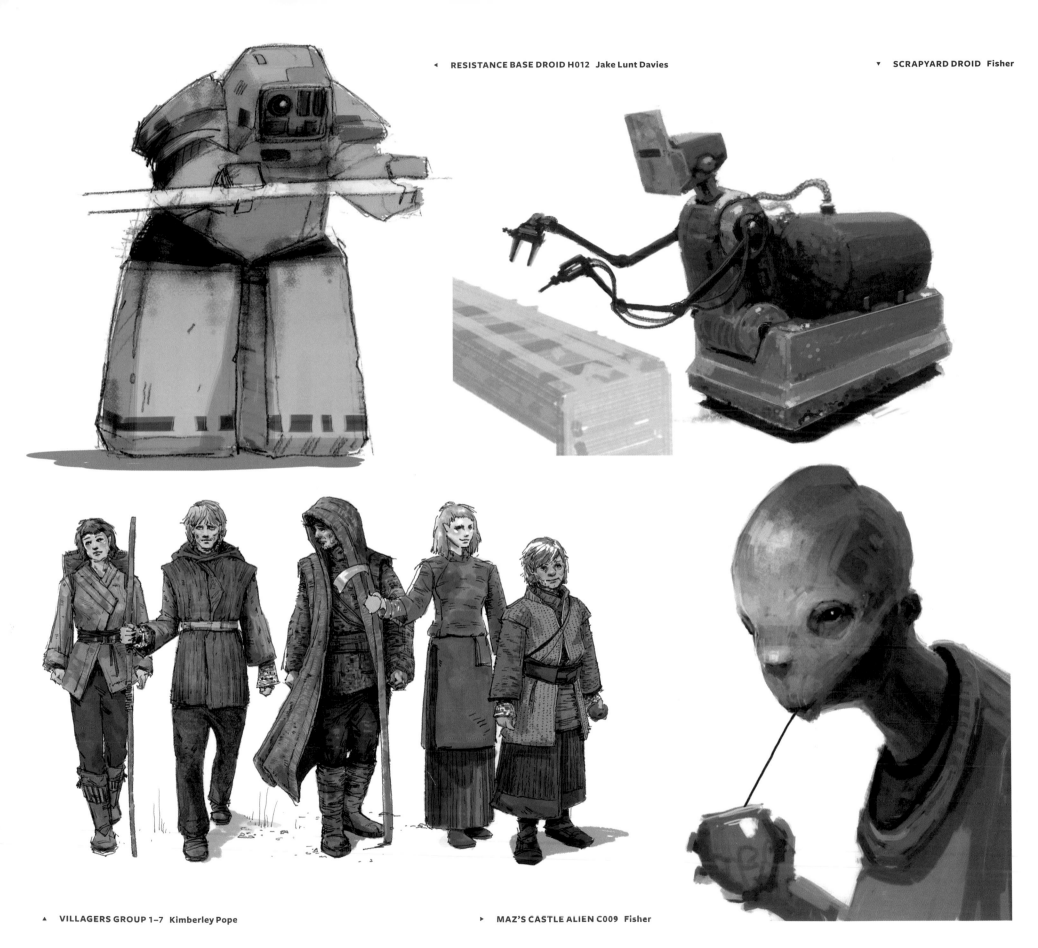

▲ **VILLAGERS GROUP 1–7** Kimberley Pope

► **MAZ'S CASTLE ALIEN C009** Fisher

▲ **TABLE CLEANER C008** *"I was pretty pleased by the alien being all over the film! Roodown is vastly bigger than the other aliens of the same species. I just thought he'd fallen down on his luck, and now he's got these giant JCB-style arms."* **Davies**

▲ **RESISTANCE UNIFORMS GROUP** **Magda Kusowska**

▶ **COLLECTS AND SELLS ITEMS C012** *"I started sketching ways to hide the human body and out of that came this design. 'One-Man-Band' is this sort of glorious combination of everything you can get in a creature: bending the body, animatronic puppets, remote-controlled bits and bobs around the performer."* **Davies**

In October, the Visualists illustrated designs for a castle inspired by Ralph McQuarrie's preliminary drawings for Darth Vader's fortress. At first, it was to be Princess Leia's castle, where our band of heroes seek her after leaving Exotic City.

Roger Christian, Episode IV's set dresser and creator of the very first *Star Wars* lightsaber and blaster (and today a director in his own right), visited Lucasfilm on October 15 and 16 to meet with the Episode VII art department and the *Star Wars Rebels* team.

In late October, Lucasfilm announced the departure of Michael Arndt from the production. After having consulted on the film since January alongside screenwriter and producer Simon Kinberg (*X-Men: Days of Future Past, Star Wars Rebels*), Lawrence Kasdan (screenwriter of *Raiders of the Lost Ark* and co-screenwriter of *The Empire Strikes Back* and *Return of the Jedi*), and J.J. Abrams resumed screenwriting duties in Arndt's stead. Concept artist Christian Alzmann also left the project in October, transitioning to other ILM shows.

The collective US-UK art departments concentrated on the Jakku village attack; Kira's fallen AT-AT home; rebel, Neo-Imperial, and non-aligned vehicles; as well as the still-unapproved Jedi Killer villain.

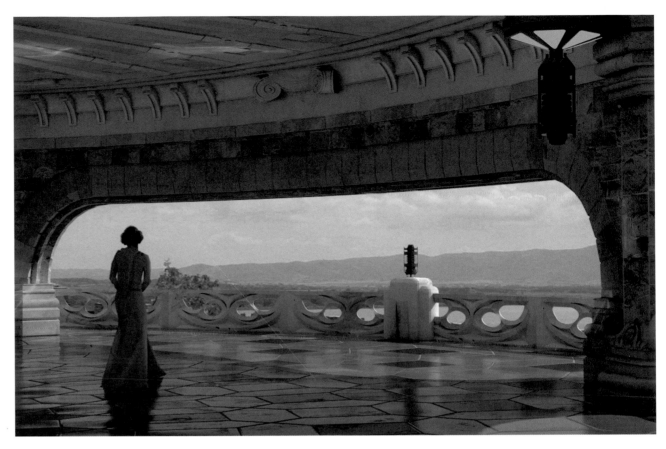

▲ **CASTLE INTERIOR 1.2** Dusseault

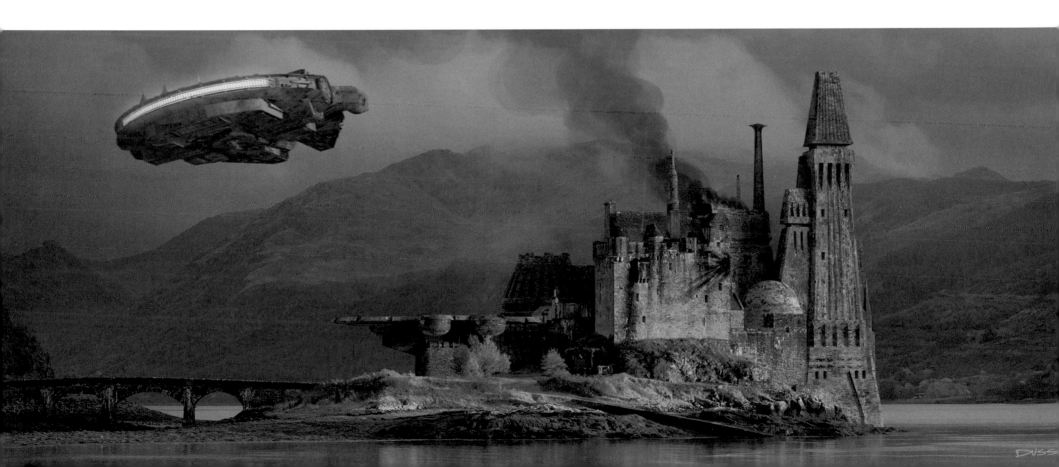

▼ **CASTLE MERGE** *"We eventually made the castle a little more sci-fi. For a while, it was feeling very realistic—a paintover of Eilean Donan Castle in Scotland,"* **Dusseault**

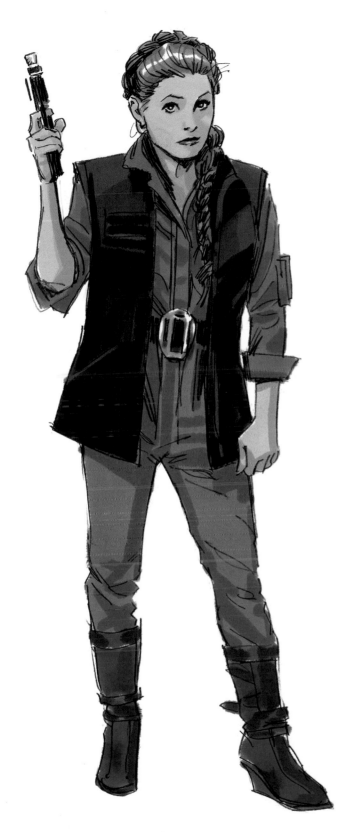

▲ **PRINCESS LEIA FATIGUES** Dillon

▶ **SABER REVEAL** *"That was one of the arguments Ryan Church and I had, over whether the lightsaber actually throws light within the environment. Initially, I thought they should not, because that makes them almost magical in a way."* **Clyne**

▲ **CASTLE INTERIOR 3.3** Dusseault

▼ **RESISTANCE BASE HALLWAY** Wallin

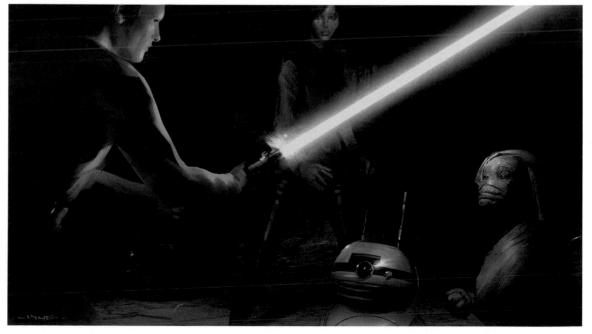

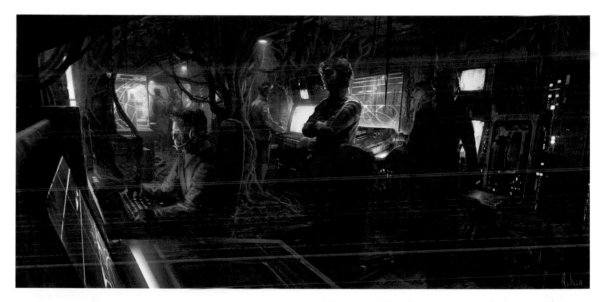

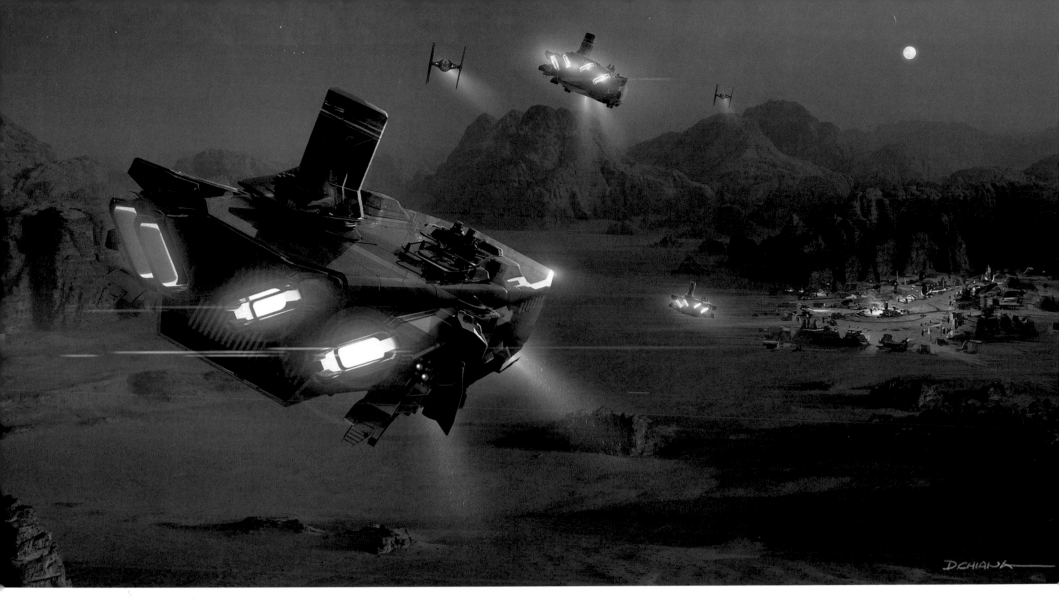

▲ **VILLAGE HIGH WIDE** *"We came up with this new look, focusing on adobe-type architecture with these different eclectic forms found in Africa, specifically Ethiopia."* **Chiang**

◄ **VILLAGE CLOSE-UP** **Allsopp**

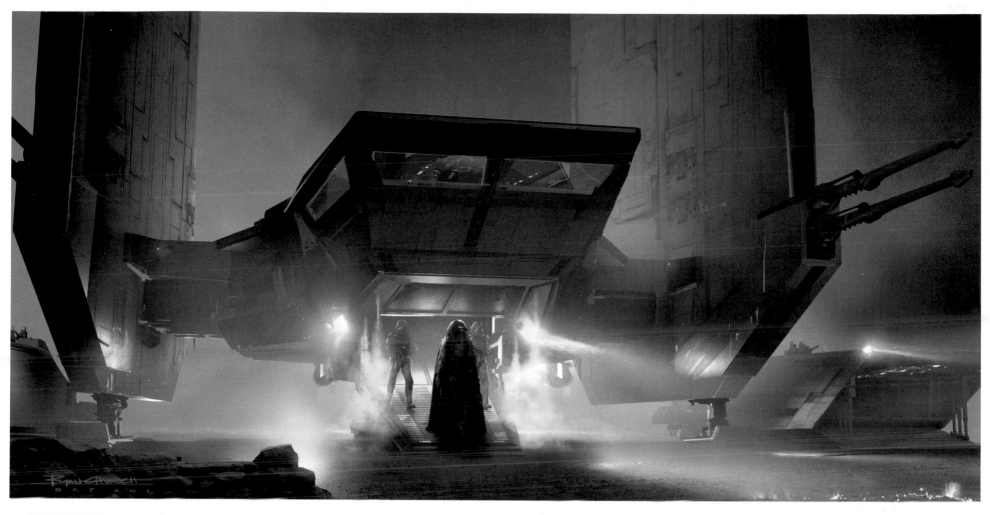

▲ JEDI KILLER LIMO LANDED Church

▼ HUT EXTERIOR Clyne

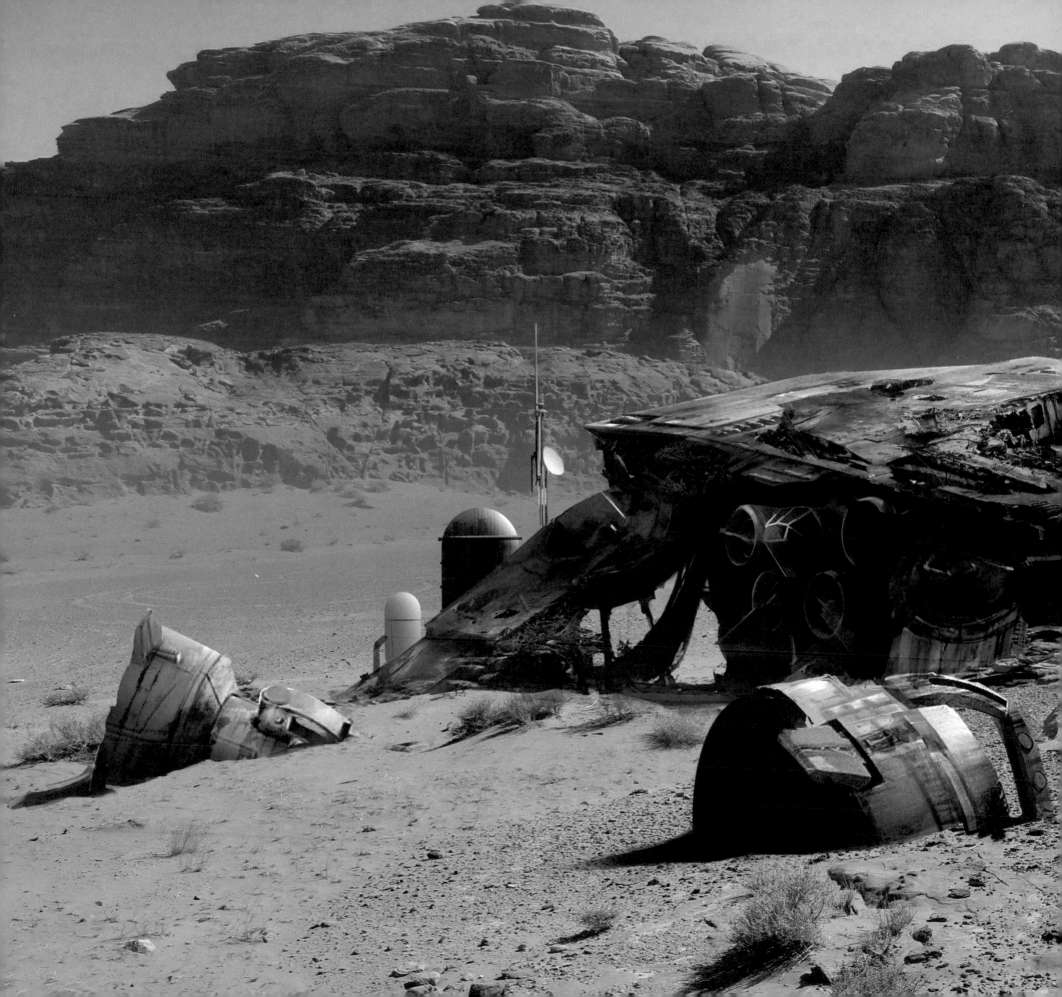

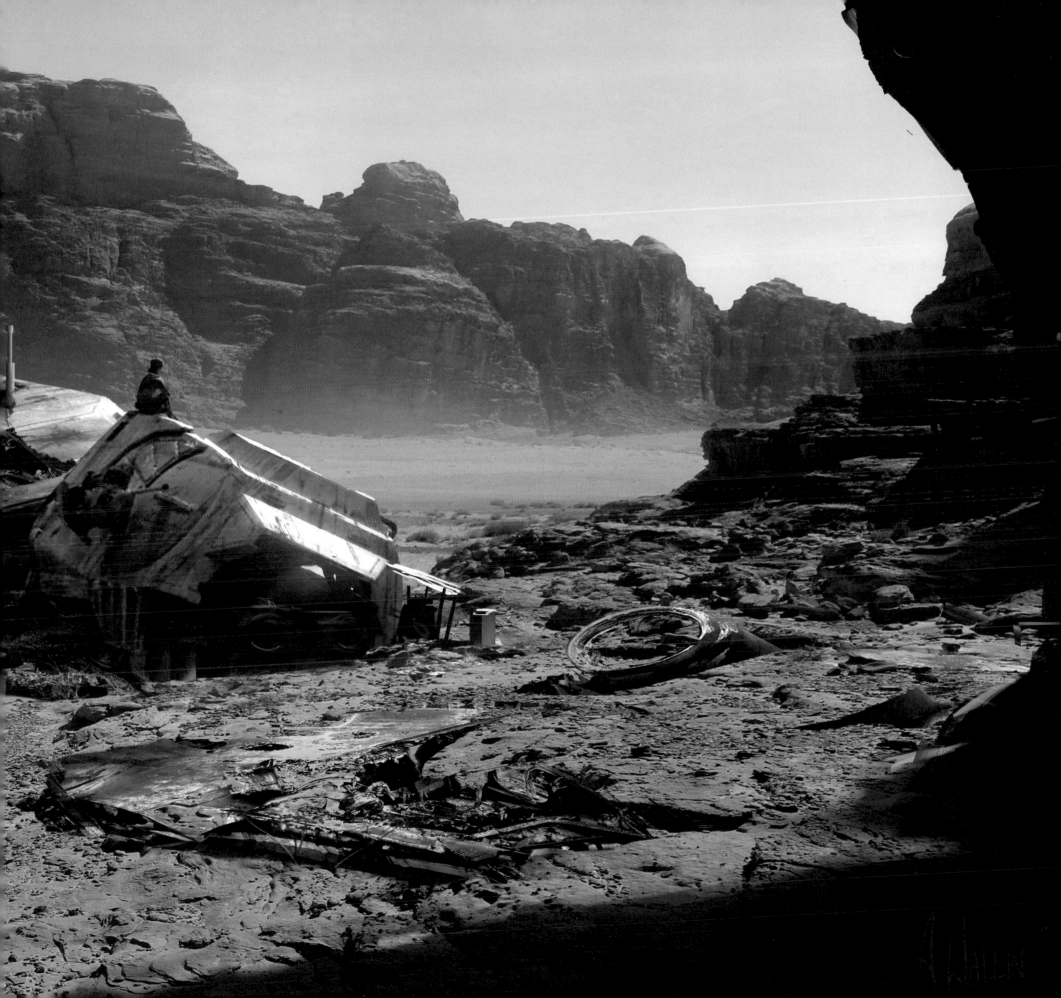

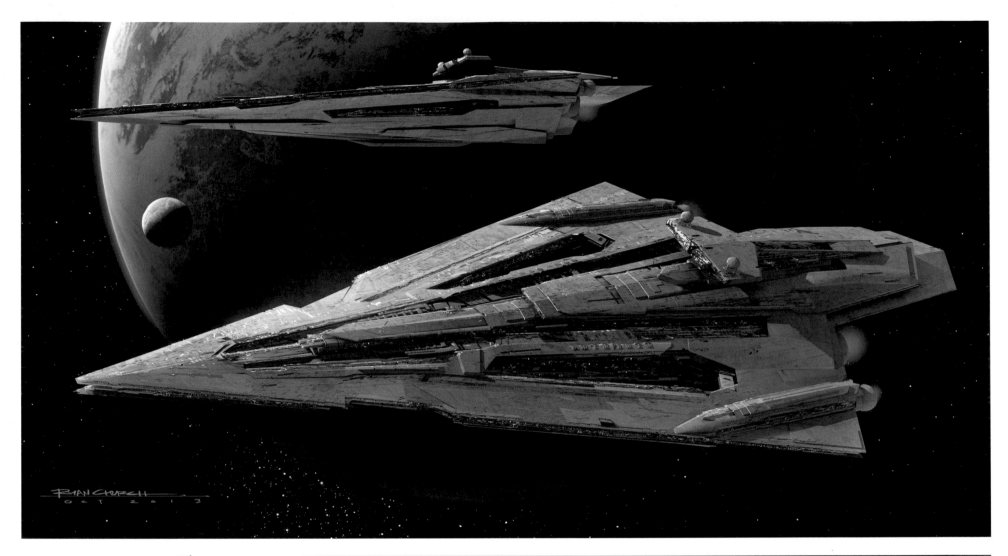

▲ **STAR DESTROYER EXTERIOR** *"That was actually based off a thing that James Clyne had done in Star Trek Into Darkness: He put a bunch of negative spaces in the villain's black ship. I thought, 'Well, let's try it with the Star Destroyer.'"* **Church**

▶ **HUT INTERIOR LOOKING IN** Church

◀◀ **AT-AT IDEA** *"The fallen AT-AT goes nicely with the crashed Star Destroyer—having the remnants from the original movies frozen in time like that."* **Wallin**

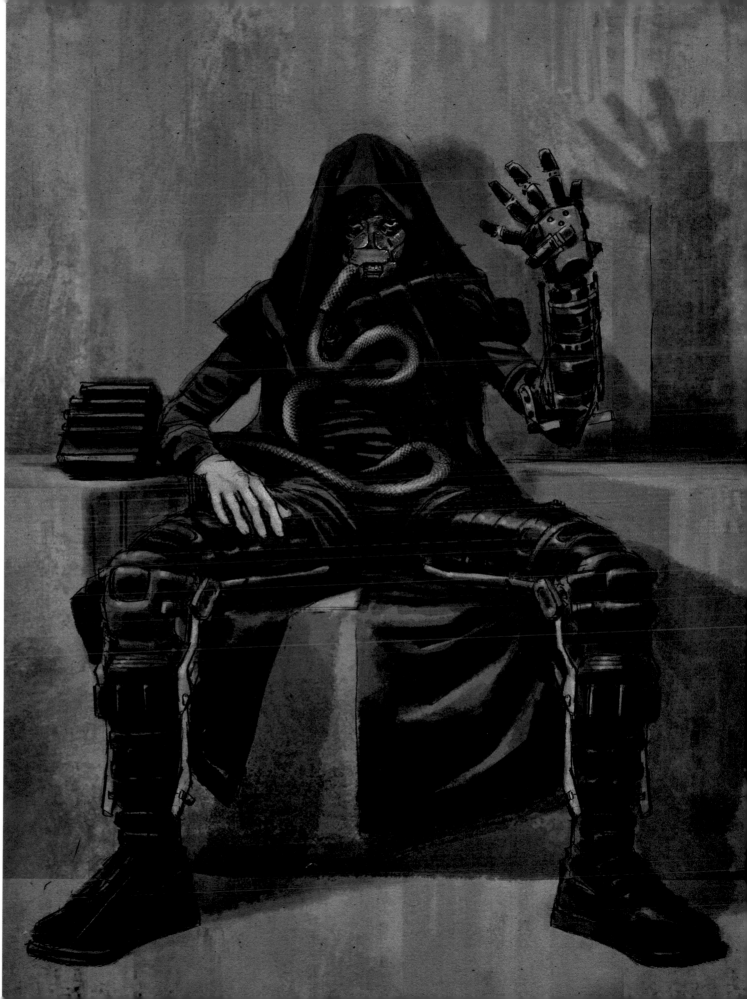

▲ **DARTH VADER'S HELMET** *"I was looking at mummified heads for Vader's helmet. And I thought it was just amazing how the skin sort of stretches down and distorts to look like a screaming face."* **Fisher**

▸ **JEDI KILLER NEW CONCEPT AMENDED** *"The Jedi Killer design was like trying to land a helicopter on a penny. We couldn't be too Vader-ish, but we couldn't reference something else too heavily, either."* **Dillon**

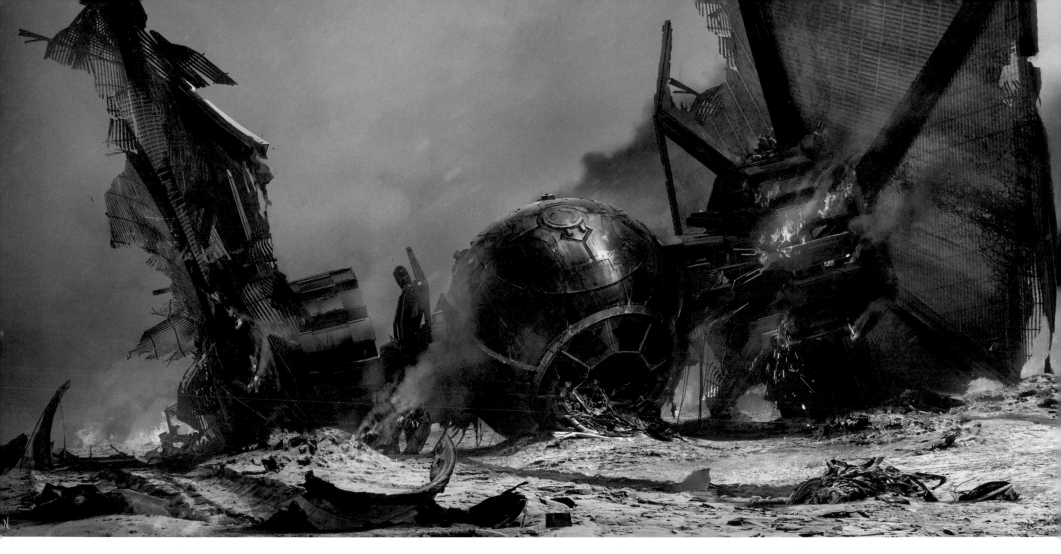

▲ **CRASH SITE ANGLE 2** *"People were talking about how cool the TIE fighter build was. I ran down there, and it had gotten disassembled. It was like my one chance to see it in all its glory, and I missed it [laughs]."* **Wallin**

▶ **TIE FIGHTER SPECIAL OPS** Fausto De Martini

▼ **BLACK OPS FIGHTER** Church

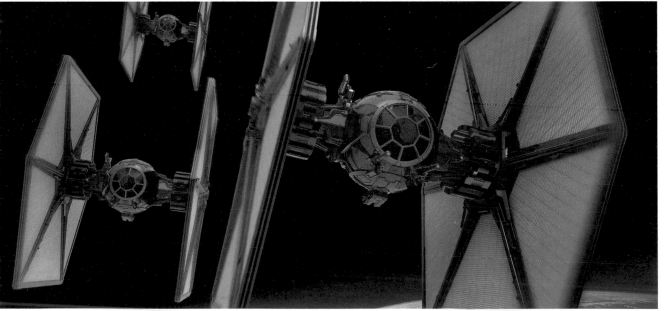

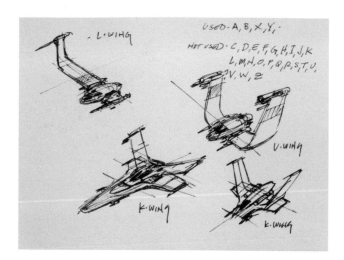

◄ **ALPHABET STARFIGHTERS SKETCH**
"I thought I should just go through the alphabet. So I did these initial, really quick sketches of the L-wing, which was called the J-wing, eventually, and the K-wing." **Clyne**

► **J-WING VARIANT** **Clyne**

▼ **HELMET** *"My job was to shrink down the pilot helmet a bit, closer to the head. But I wanted to keep a lot of those elements from the original in some way; the cutaways and the little design decals."* **Dillon**

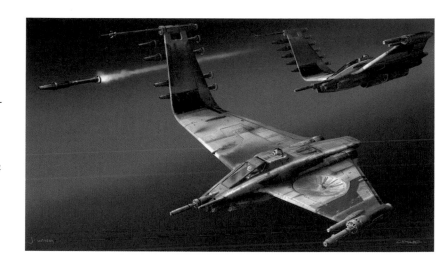

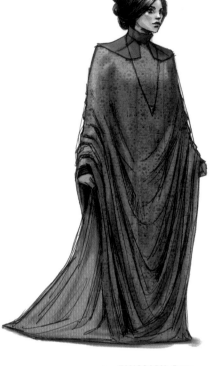

▲ BOUNTY HUNTER SAND MAN C010 Davies

▲ OUTPOST EXTRA 12 Kusowska

▲ EMISSARY Pope

▲ OUTPOST EXTRA 06 Kusowska

▲ OUTPOST EXTRA 09 Kusowska

▲ OUTPOST ALIEN C039 Dillon

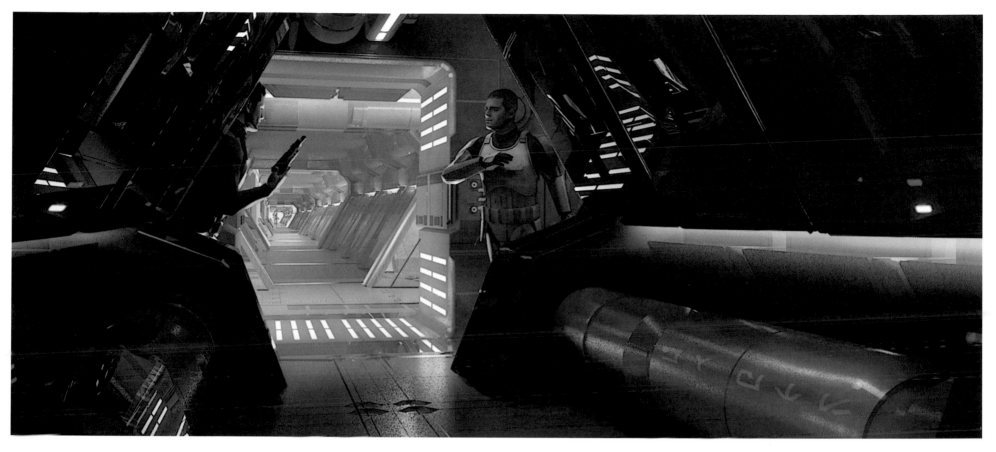

▲ **SERVICE HALLWAY** Clyne

▼ **HANGAR** Dusseault

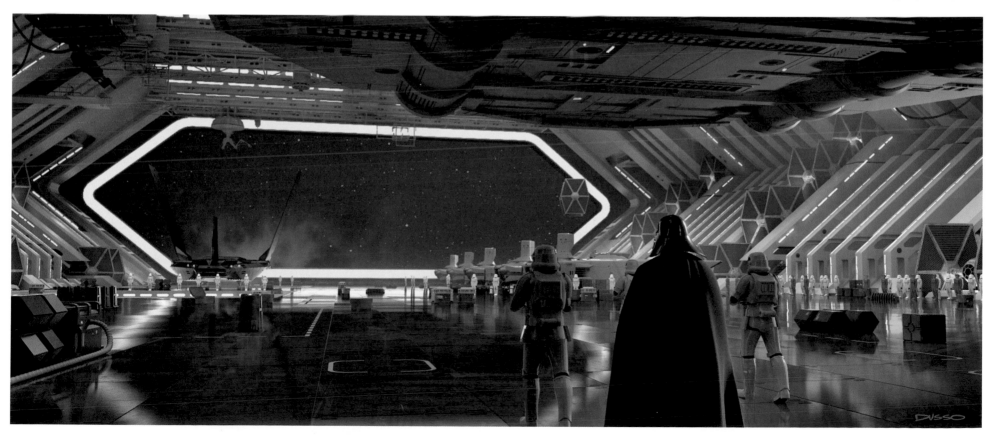

After eleven months of design work, the artists continued to iterate on the pivotal Jedi Killer villain but were still far from an approval. Meanwhile, first drawings emerged from the costume department for the female lead Kira, in response to the pre-visualization department's needs. But a major win was scored with the November 28 full approval of the neo-stormtrooper designed by Michael Kaplan and refined by concept artist Glyn Dillon and ZBrush artist Sam Williams.

The creature department continued to churn out aliens and droids that would eventually find homes in the outpost and castle. And both art departments carried on generating Act III story ideas, while developing film-wide set and vehicle designs, including the first approved blueprint for an updated X-wing starfighter.

Darren Gilford remembers, "J.J. actually said, instead of having the four engines, one on each wing, why not try one big circular form that gets split in a scissor action as the wings open? Something in the back of my head said 'I think I've seen that,' but I couldn't figure out where. Then, of course, going back through all the artwork, the Ralph McQuarrie piece came up. I was like 'Oh my God, it's exactly the same idea!'"

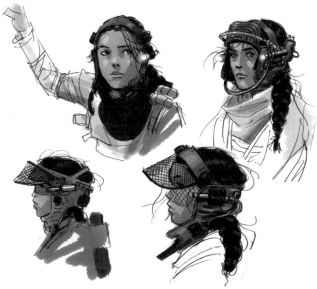

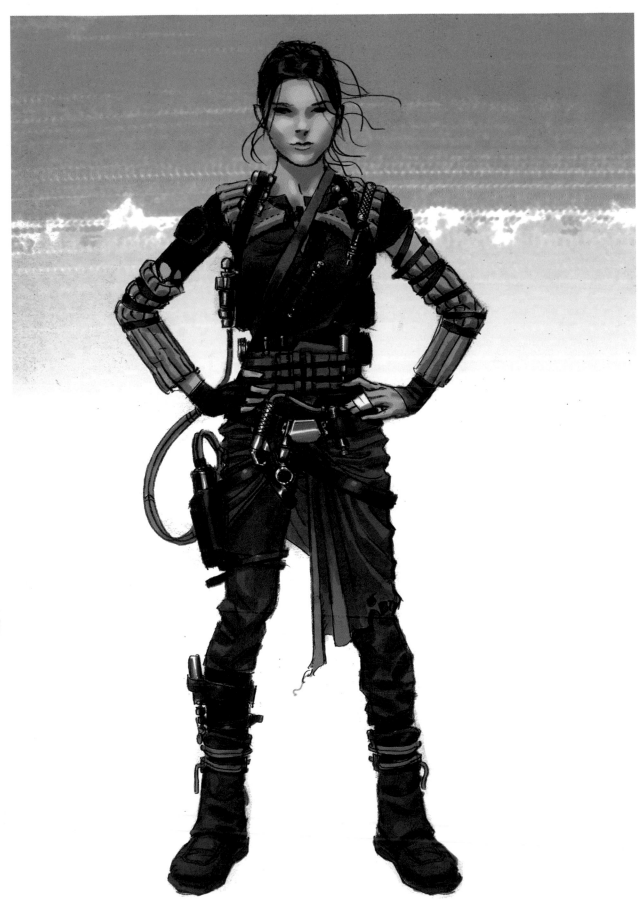

▲ **KIRA (REY) HEADGEAR SKETCHES** Dillon

▶ **KIRA (REY) NEW DESIGN 06** *"There was talk at the beginning that Kira would have quite a lot of gear for climbing, in addition to a lot of tools. Then, as we went on, we thought it should be simpler, pared down."* **Dillon**

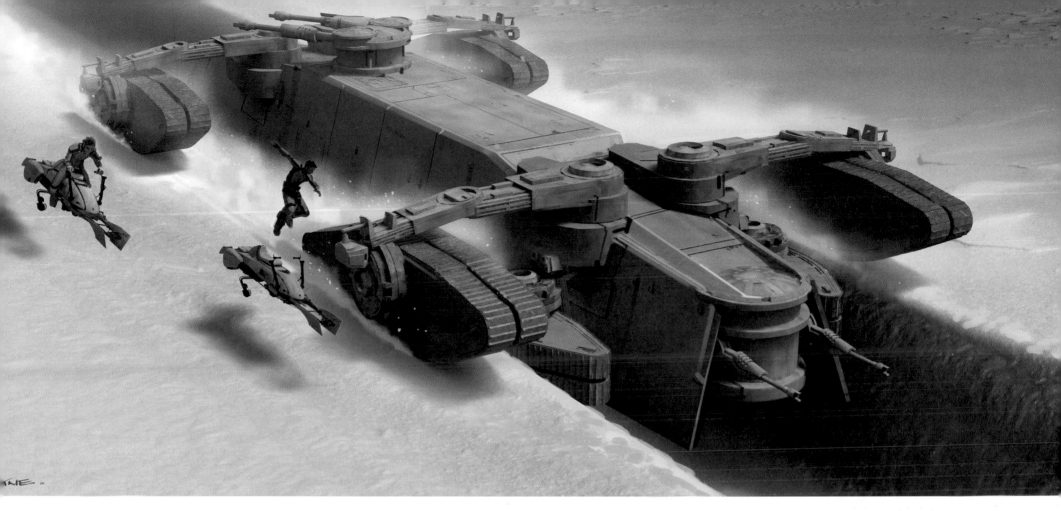

▸ **AT-AT SLED** *"Once in a while, there'd be a day where Rick would say, 'Okay, forget everything I said [laughs], do whatever you want.' This was just a fun idea to have guys on speeders jumping onto another moving vehicle. Maybe some stormtroopers came out and there would be a good ol' fistfight."* **Clyne**

▸ **KIRA (REY) HALLWAY** Chiang and Wallin

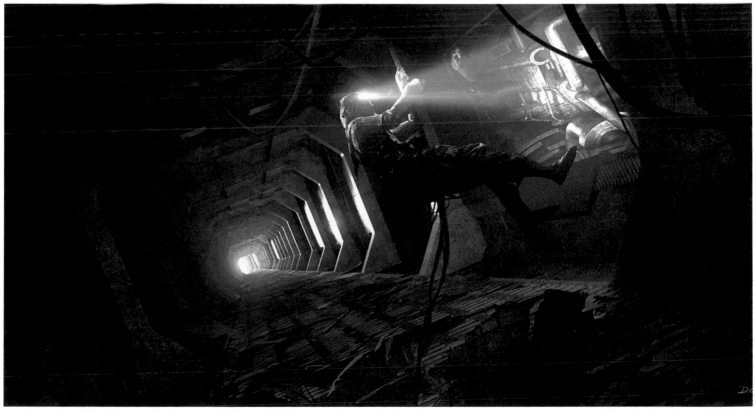

▲ **REPUBLIC PLANET SKETCH** Allsopp

▼ **REPUBLIC PLANET PAINTOVER** Allsopp

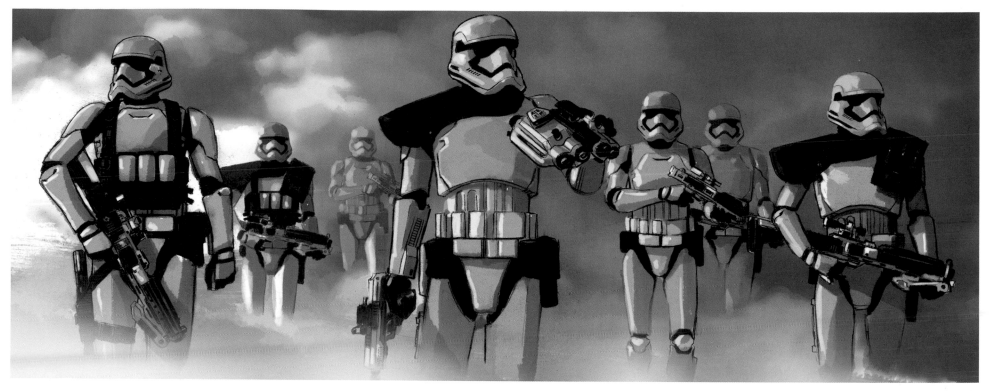

▲ **TROOP SHOT** *"I added the lenses, and the clip bit that goes between the lenses and the grill, and also the one breathing-tube thing. Originally, Michael Kaplan just wanted that to be a black void, because he wanted everything to be completely simple."* **Dillon**

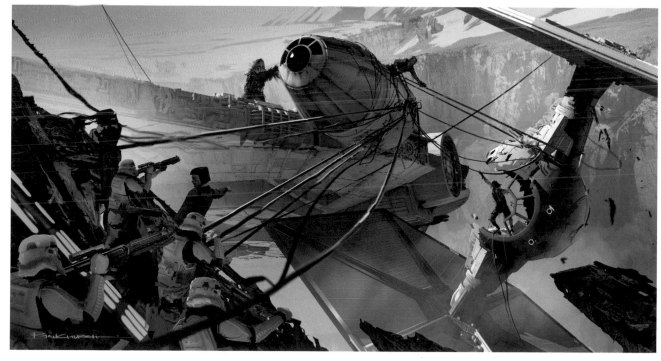

▲ **TIE & *FALCON* ENTWINED** *"We were throwing out third act ideas. This is an entangled skirmish between the Falcon and TIE fighter, where everyone is crawling on the surfaces of their vehicles, which is always so great."* **Church**

▲ **STORMTROOPER BREAKDOWN** Dillon

▲ **CASTLE ALIEN C050** *"C050 was a very simple head. But I designed it with the actor Kiran Shah in mind. It kind of looks like Kiran."* **Ivan Manzella**

◄ **CASTLE DROID H027** *"Neal said, 'Let's put a stilt-walker in it!' I thought he was mad! [Laughs.] Katy Coleman, the stilt-walker/performer, did a great job inside."* **Fisher**

▼ **MAIN STREET EXTRAS 01** **Pope**

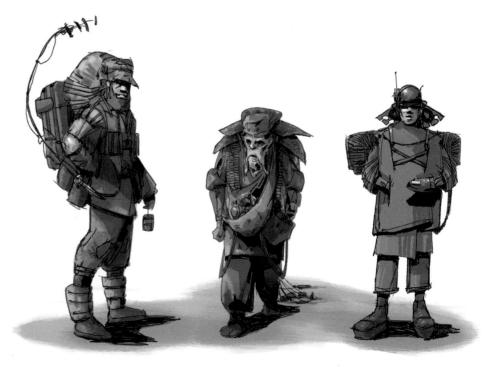

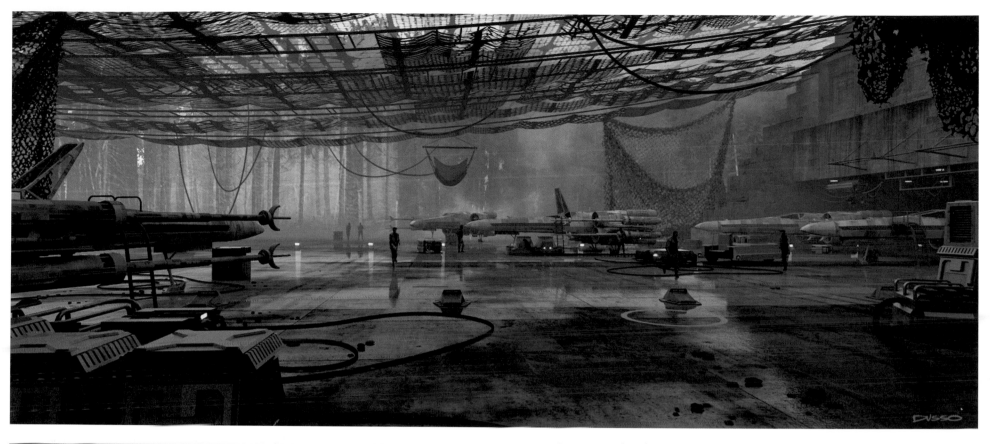

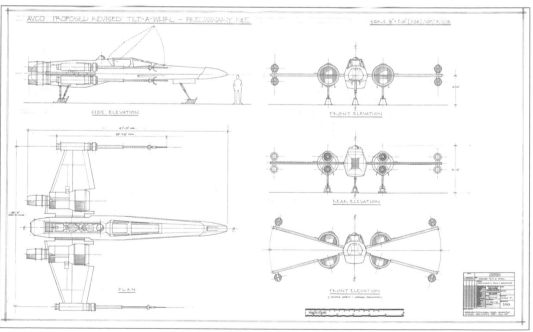

▲ **X-WING BASE** *"This net was taken directly out of World War II German attacks on London. They would span these nets to cover entire blocks."* **Dusseault**

◄ **X-WING PARKING** Church

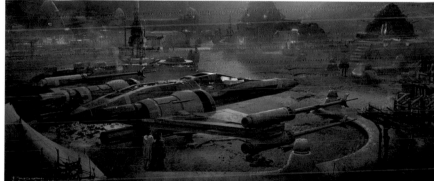

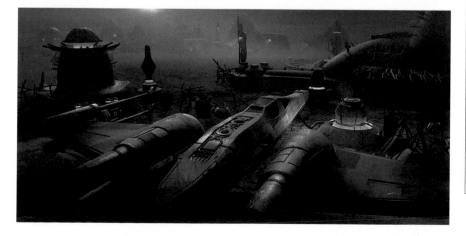

◄ **X-WING HIGH ANGLE** Clyne ▲ **REVISED X-WING PLANS & ELEVATIONS** Gary Tomkins

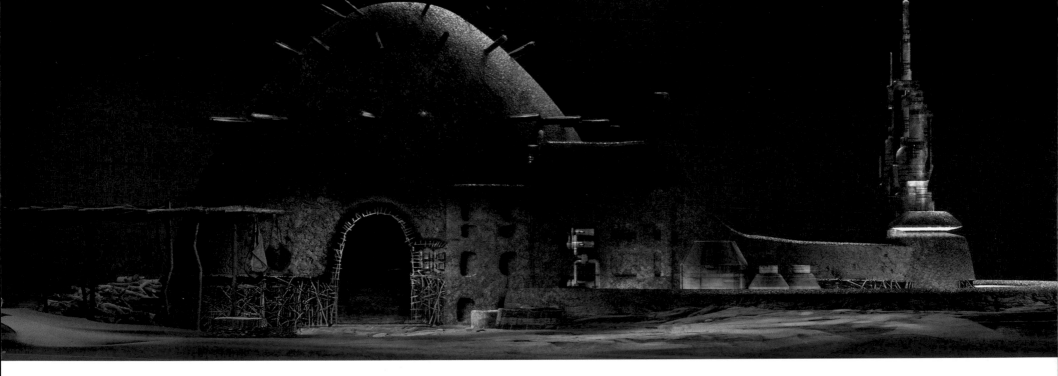

▲ **HUT** *"I developed this architectural incorporated light on the far right. To me, it just feels very Star Wars to have something that looks of Earth culture, but with a little tech inside of it."* **Clyne**

▼ **VILLAGE HIGH ANGLE 2** **Wallin**

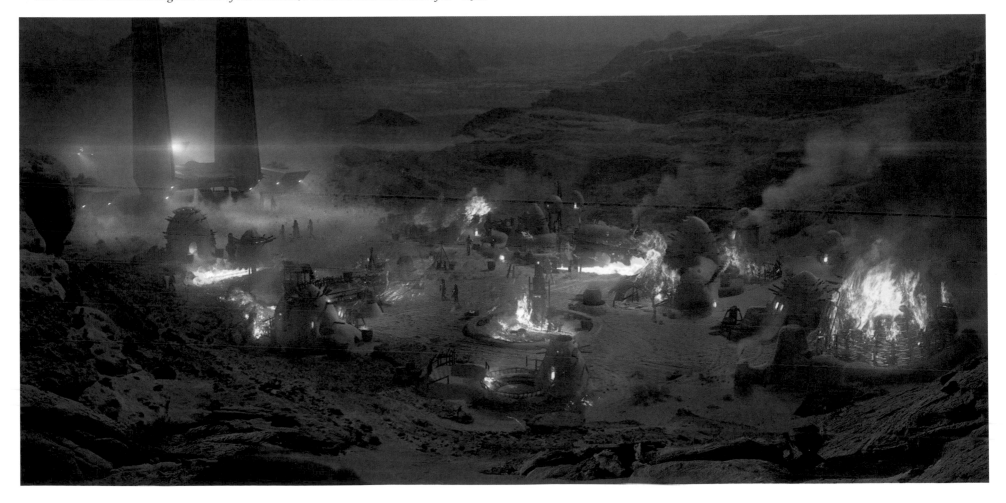

► **JEDI KILLER SNOW SCENE** *"I remember feeling really excited when I first drew that. This could be it; this could be the Jedi Killer [laughs]. And then, when they said they need the Guavian Death Gang, I immediately thought to get that guy's mask in there."* **Dillon**

▼ **JEDI KILLER NEW CONCEPT** Dillon

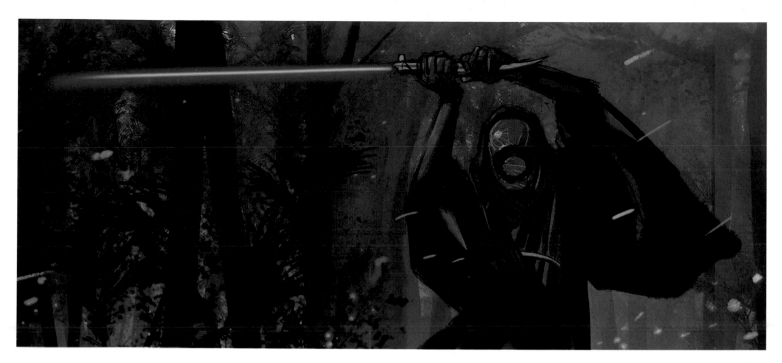

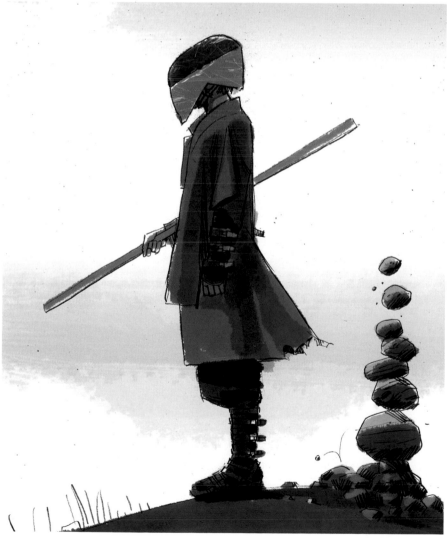

▲ **TIE FIGHTER SPECIAL FORCES INTERIOR 18** De Martini ▼ **THE SEVEN LIGHT** Dillon

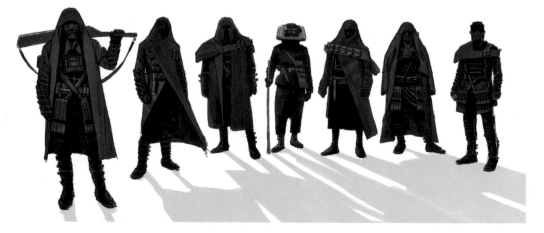

After a scouting visit, Greenham Common, a former Royal Air Force station an hour from Pinewood Studios, became a leading candidate for an Episode VII location shoot. The six aboveground nuclear strike shelters were considered for Exotic City, the home of Maz and her alien-filled pub.

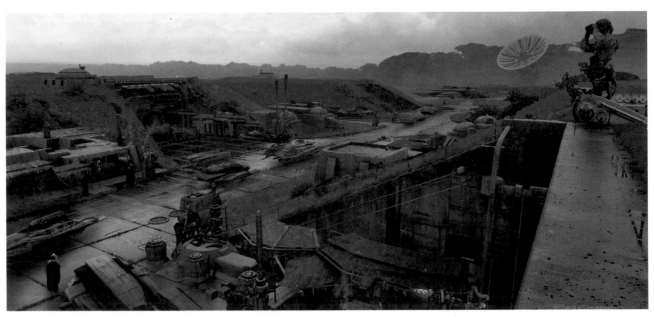

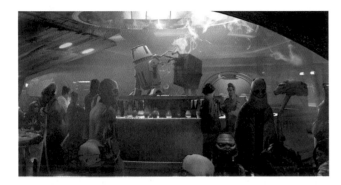

▲ **OLD SKOOL ROBOT FIGHT 01** Church

▲ **VILLAGE EXTERIOR HIGH WIDE** Church

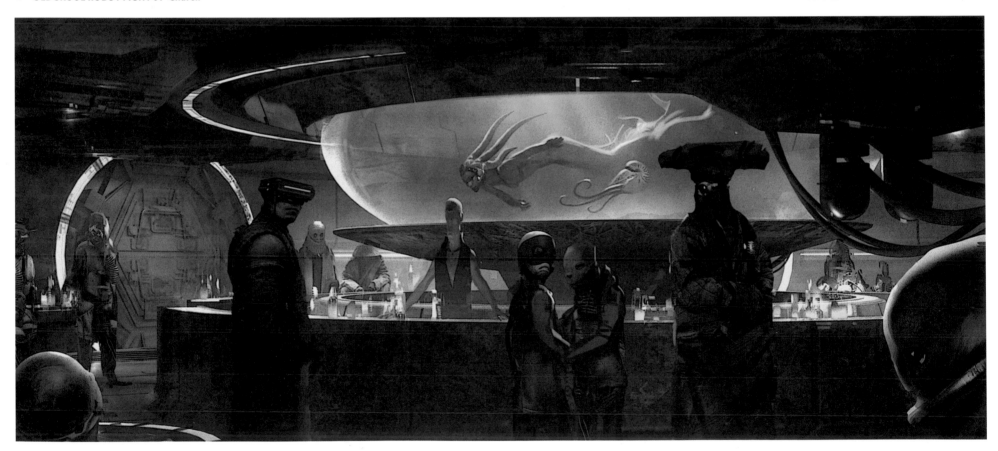

▲ **BAR CENTER** *"One idea I had was, what if there's literally a big fish tank? The idea came from The Right Stuff, where they're all at a tiki bar and this mermaid comes down to flirt with one of the astronauts."* **Clyne**

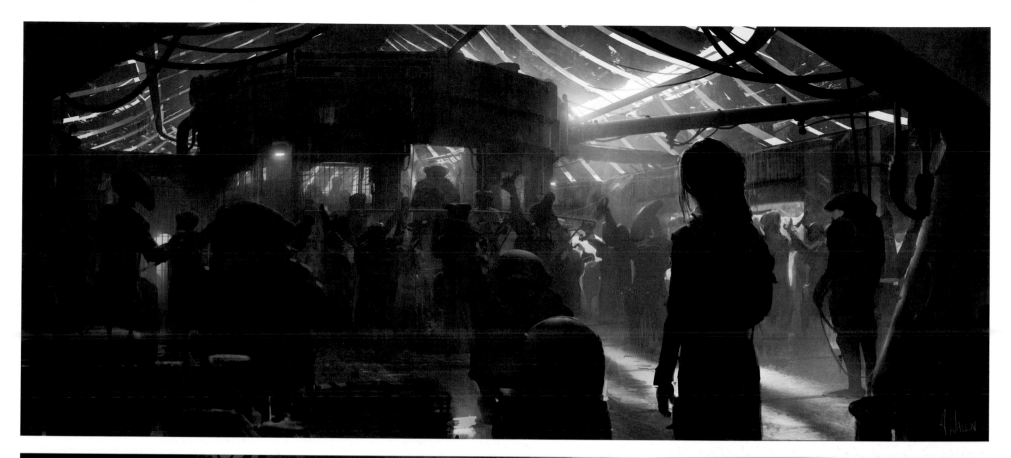

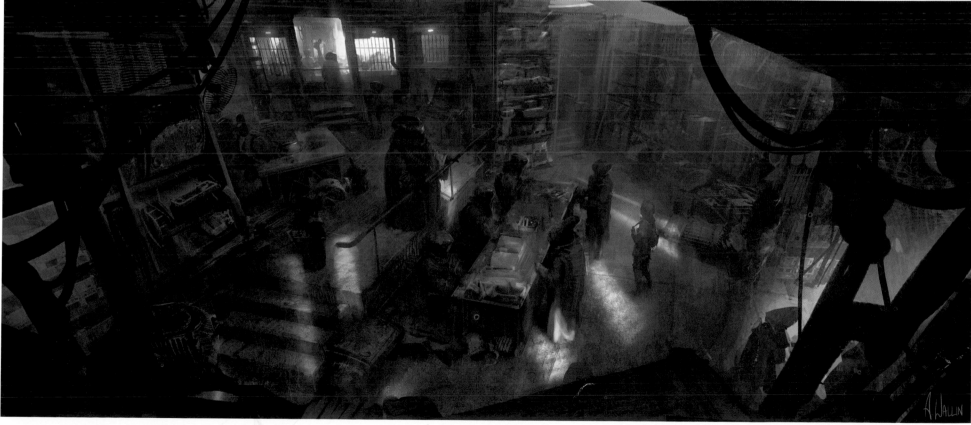

After a frantically paced year of development
and design on Episode VII, the artists had created
tens of thousands of concept pieces. With principal
photography slated to commence in the early sum-
mer of 2014, an even more desperate push was about
to begin, so the art departments breathed a collective
sigh of relief in anticipation of the coming holiday
break. Prior to the respite, however, J.J. Abrams
called a crucial meeting on December 13 at Bad Robot
Productions in Santa Monica to pitch the most recent
version of the Episode VII story, supported by Rick
Carter and the latest concept art.

Darren Gilford remembers, "Episode VII com-
poser John Williams was there, Larry Kasdan was
there, as were all the players from Lucasfilm: Kathleen
Kennedy, ILM. We all broke for Christmas and New
Year's, but I just remember leaving that room feeling
so excited—a childlike feeling of 'wow.' I think it was a
turning point for a lot of people. J.J.'s enthusiasm is so
sincere and endearing, and it was so great to hear."

Days later, Kasdan and Abrams turned in their
first draft of the still-untitled script.

▼ **LITTLE BEAST BIOMECH** *"We were talking to Brian Herring, who is our puppet-performers guy, about the stage play* War Horse. *'What can we do that uses that technology?' Again, with the beauty of digital technology, we do have the potential for rod removal, leg removal. How far can we push it?"* **Davies**

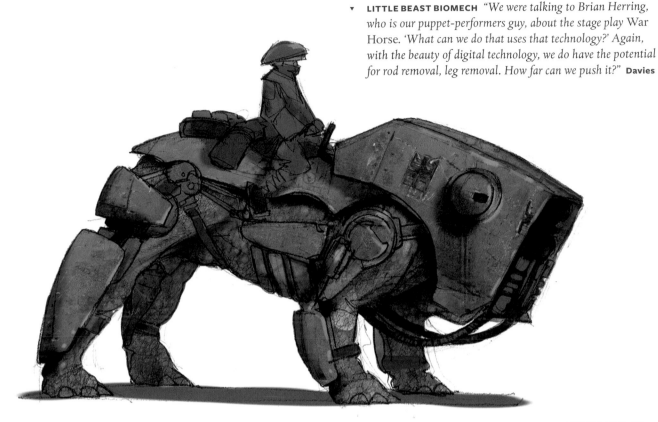

▼ **DEPOT GATE** Allsopp

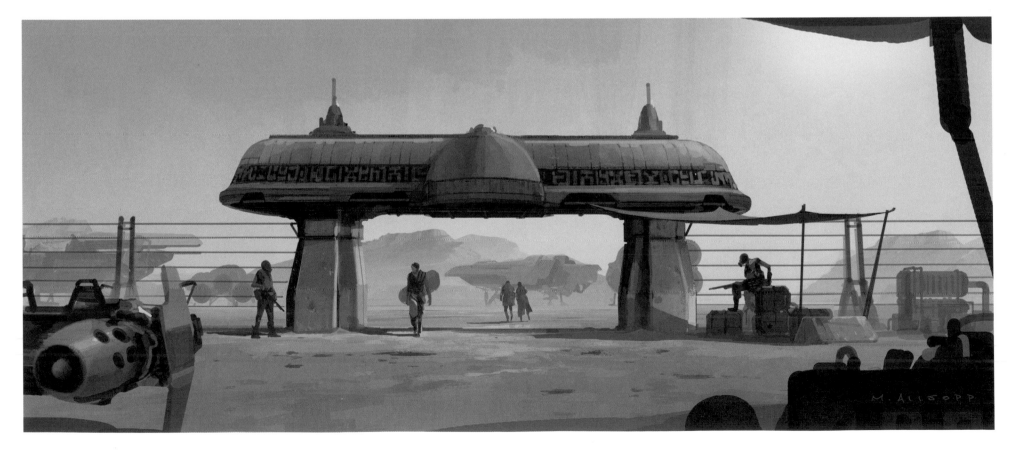

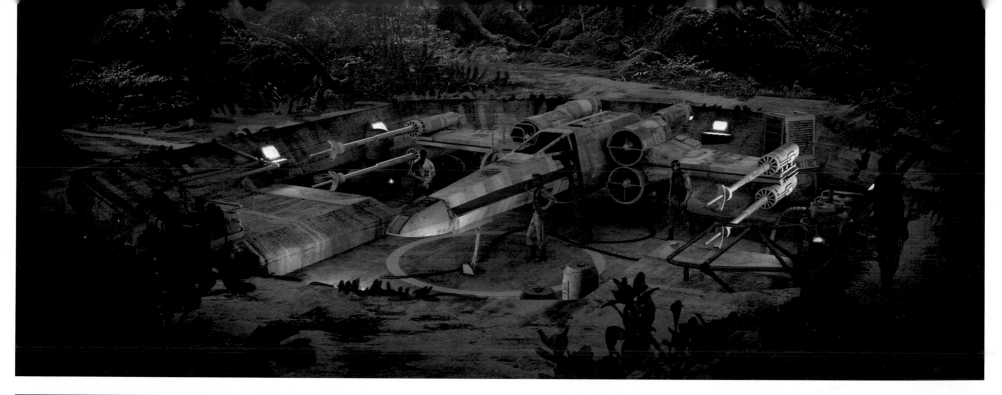

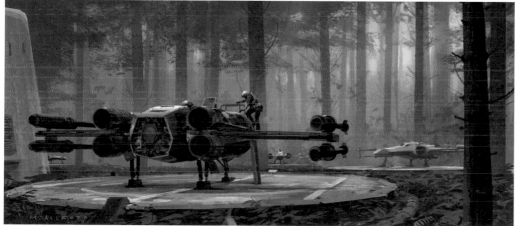

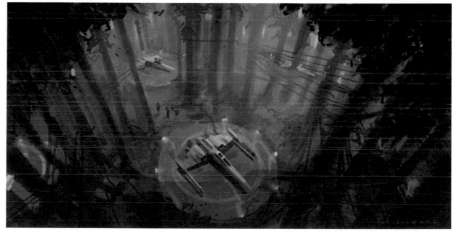

▲▲ **X-WING BASE** Dusseault

▲ **LANDING PADS 03** Allsopp

▲ **LANDING PADS 01** Allsopp

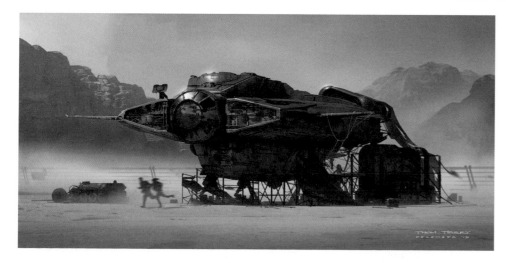

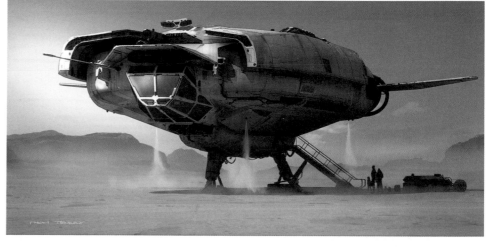

▲ **DOCK VEHICLE 2 SCAFFOLD** Tenery

▲ **FAMILY SHIP SHAPE DEV** Tenery

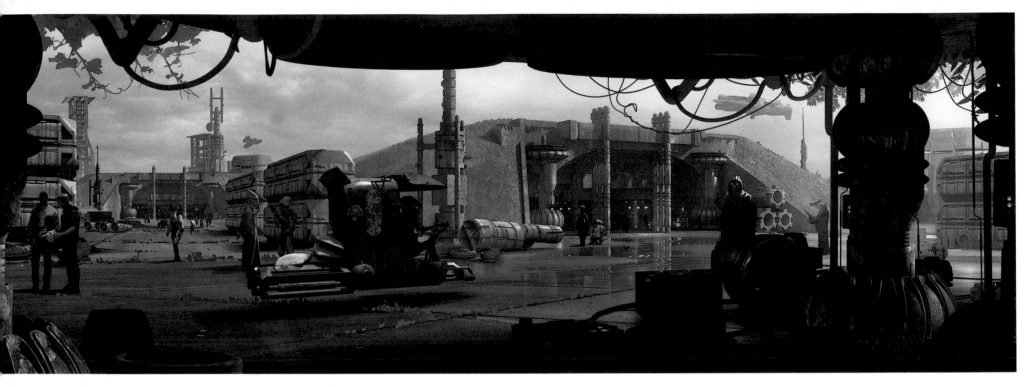

▲ **MAIN STREET ESTABLISHING** *"I think this got pretty close to what the bar town could be. But there were some clashing motifs."* **Clyne**

▼ **BAR ENTRANCE ESTABLISHING** *"We thought it would be interesting if half the city was subterranean. Those were Indian fairy tale designs on the murals, just giving it some texture."* **Clyne**

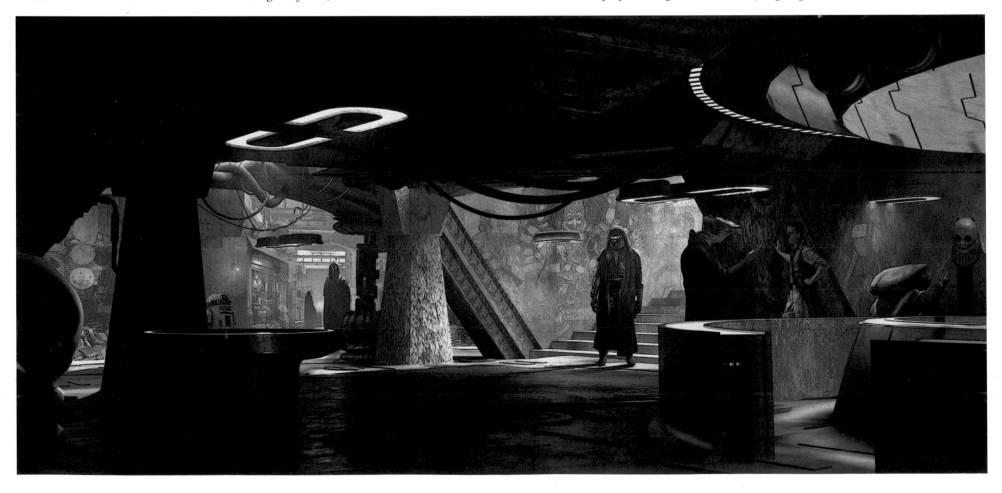

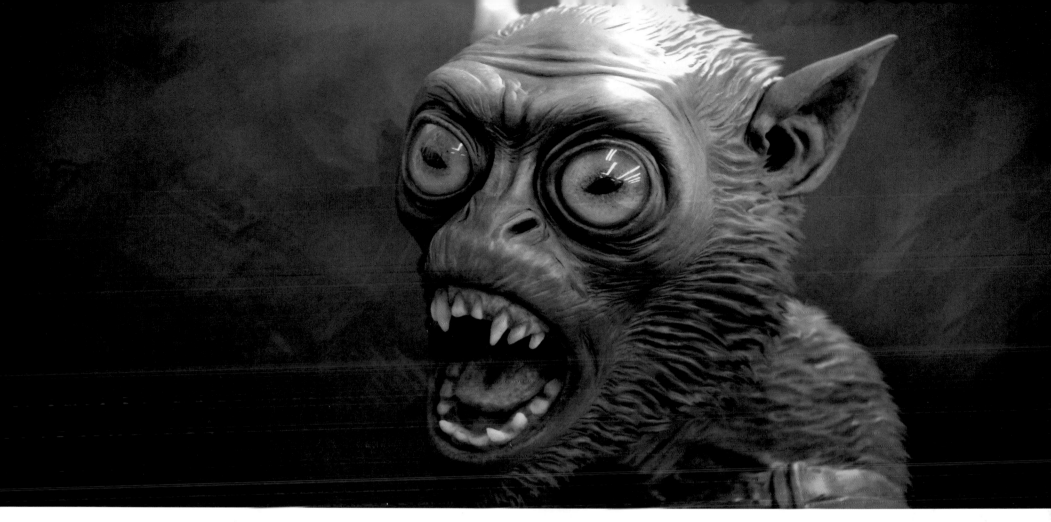

▲ **MAZ'S CASTLE ALIEN C069** *"J.J. always loved that March 1975 Ralph McQuarrie 'Cantina' painting. So I did a maquette based on the creature from that. And I did this maquette based on older Chewbacca illustrations that McQuarrie had done."* **Manzella**

▼ **BAR BUNKER INTERIOR** *"There was a second floor, at the time, that Maz lived in. And she's cooking there or preparing potions."* **Dusseault**

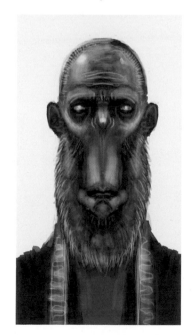

▲ **MAZ'S CASTLE ALIEN C049**
Manzella

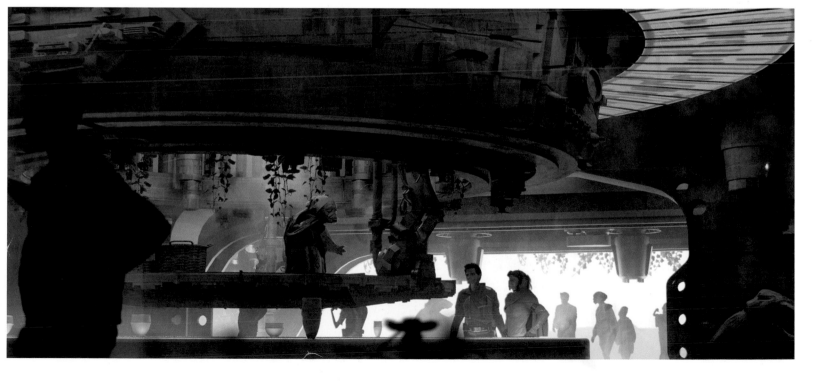

With less than five months until the start of principal photography, the art, creature, and costume departments returned from the holidays with renewed spirits and sense of purpose. In Los Angeles, Thom Tenery and Fausto De Martini refined the look of Han Solo's cargo hauler interior, while the pirate gangs that confront Solo there continued to evolve in the costume department. A new corner of a very familiar room on Solo's other ship, the *Millennium Falcon*, was revealed. Finishing touches were put on another vehicle, the new X-wing starfighter. And a final design for Kira's speeder came from an unexpected source: the creature department.

The creature department polished off designs for Poe's (formerly John Doc's) newly named astromech droid, BB-8. The as-yet-unnamed Jedi Killer and the gang he fell in with as a young man slowly evolved, as well. But an approved design was still months away.

Ryan Church journeyed home to Los Angeles and joined the team at Bad Robot for his final month and a half on the film before returning to ILM in San Francisco for other projects. Art director Kevin Jenkins, who previously worked with Rick Carter on *War Horse* and *Lincoln*, was recruited by ILM and assigned to the Pinewood-based art department. "When I was a kid," Jenkins recalls, "I got *The Art of The Empire Strikes Back*, which switched me on to go into film. The thing I've tried to have in my mind this whole year is: Protect it, protect it, protect it. My love of the late-seventies, early eighties movies has transported me to 1986, and I'm designing this movie with that era in mind."

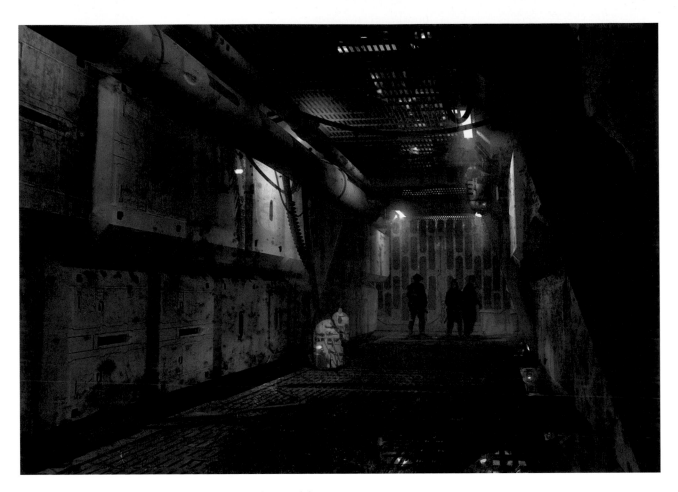

▲ **RED STRUCTURE SMALL CONTAINERS** Tenery and De Martini

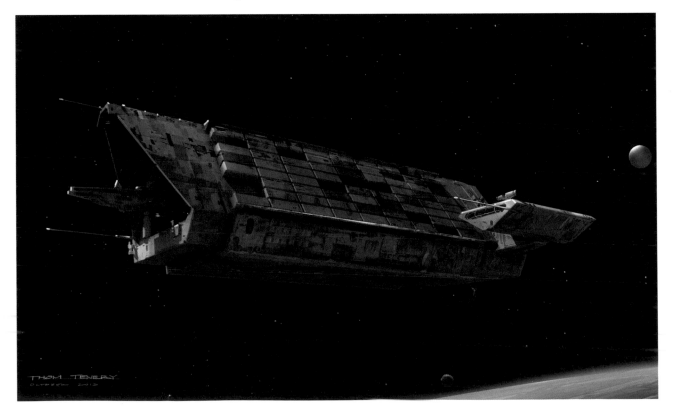

▶ **HAN'S CARGO HAULER BIG MOUTH TRI** *"The idea here was Han and Chewie are truck drivers piloting a big old rusty broken-down big rig. I think the prevailing metaphor was this big huge baleen whale just overwhelming the* Falcon *and swallowing it whole."* **Tenery**

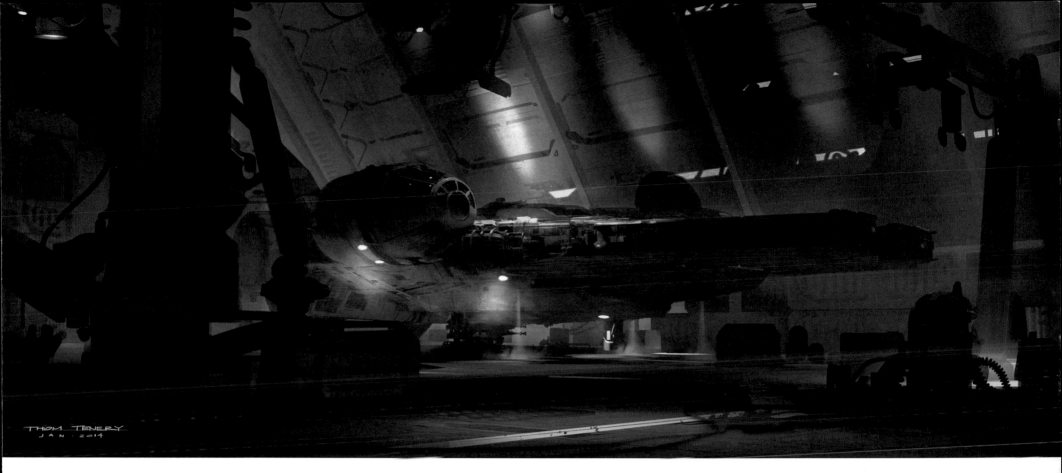

▲ **LANDING BAY** *"This is sort of the classic Star Wars, Millennium Falcon-in-the-hangar moment. Not unlike the Mos Eisley reveal of the Falcon in* A New Hope *and in any number of other shots, like Hoth."* **Tenery**

▶▶ **BUNKER ENTRANCE JUNGLE Allsopp**

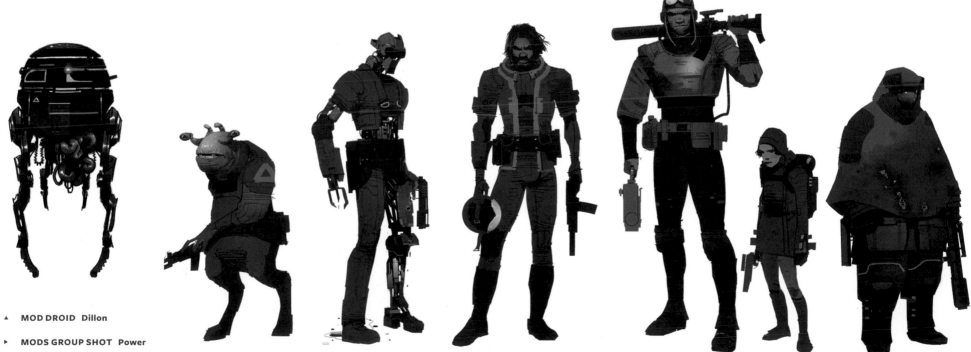

▲ **MOD DROID Dillon**

▶ **MODS GROUP SHOT Power**

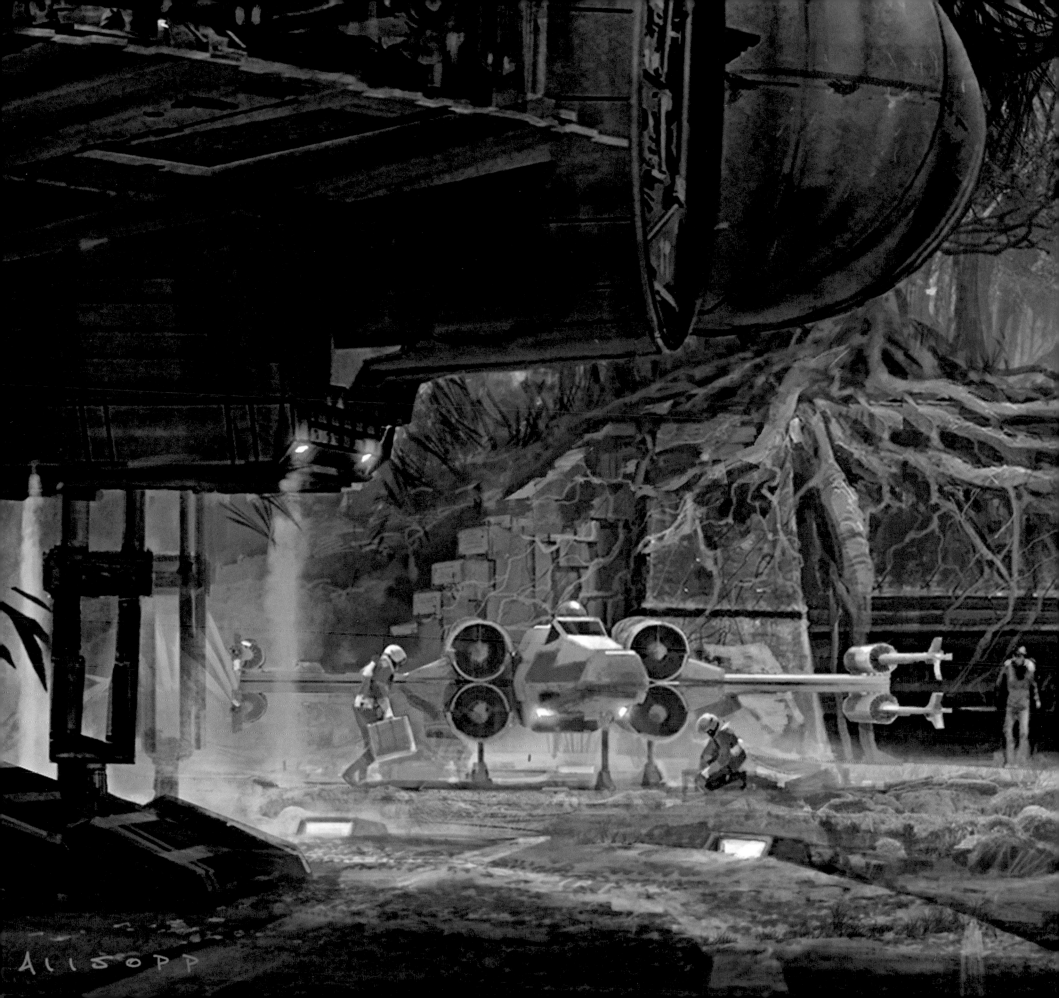

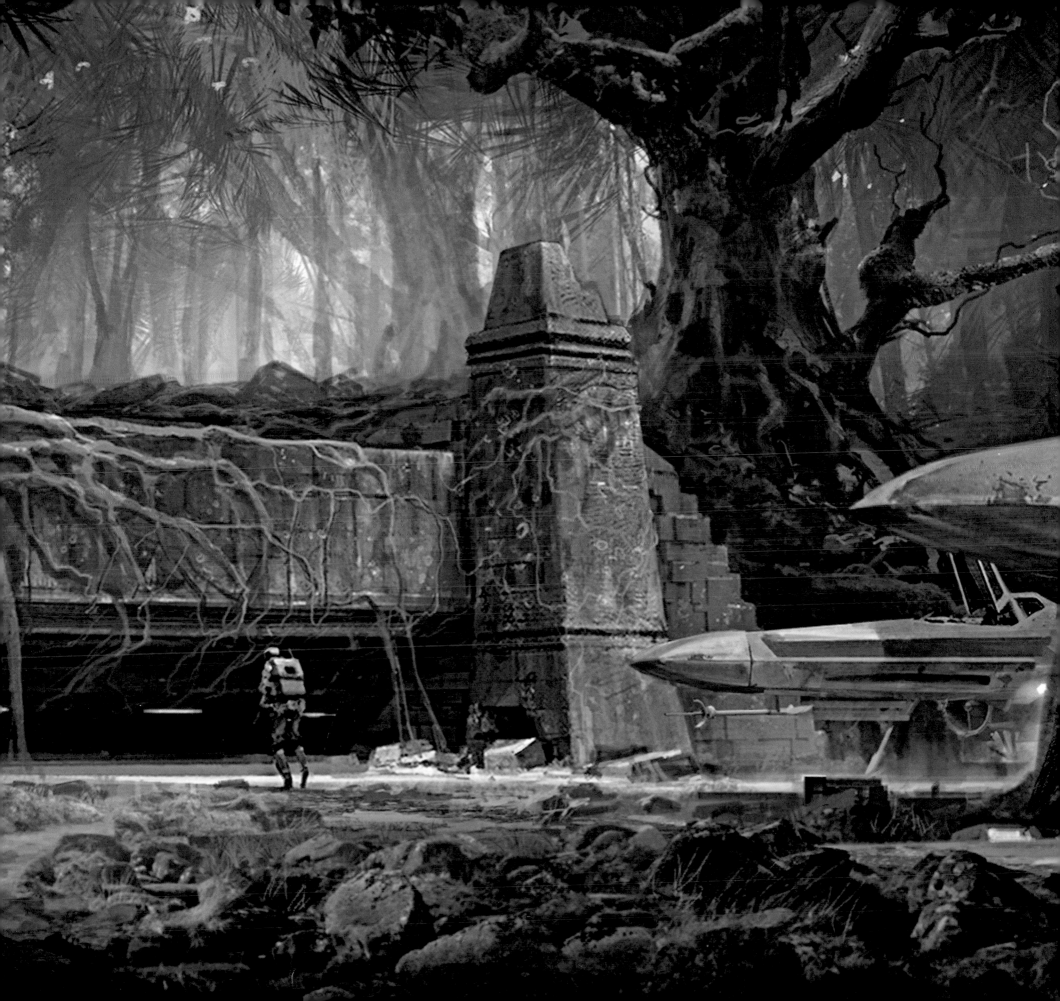

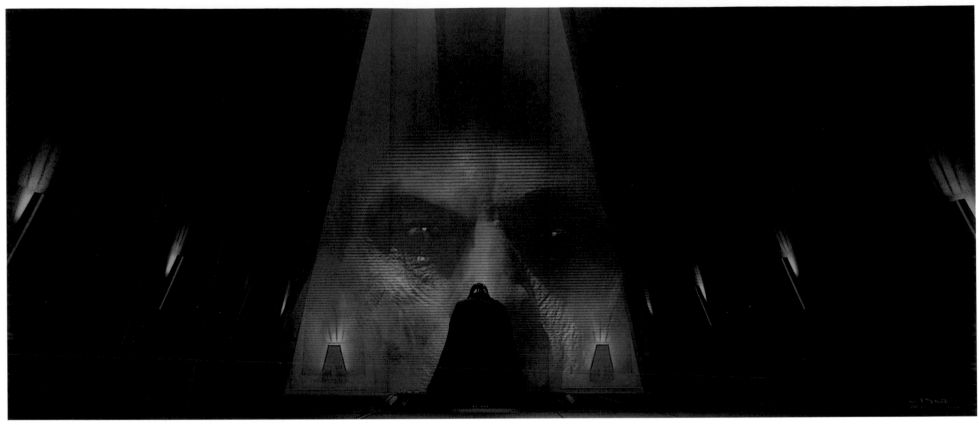

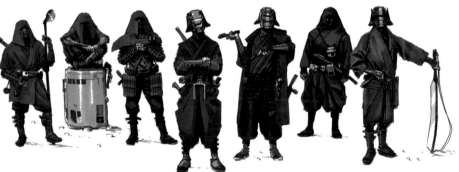

CHAMBER *"This is Boris Karloff's face from The Mummy (1932). The shape of the room echoed some of McQuarrie's past work, specifically these vertical trapezoid rooms."* **Clyne**

GANG GROUP SHOT **Dillon**

CREWMAN PROFILE *"This was an idea for the Jedi Killer. When it didn't get approved, I thought, 'Well, it would be good for the crewman.'"* **Dillon**

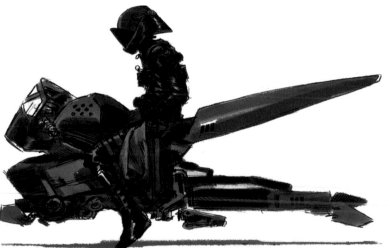

▲ **JEDI KILLER BIKER** **Dillon**

▲ **YOUNG JEDI KILLER NEW CONCEPT** **Dillon**

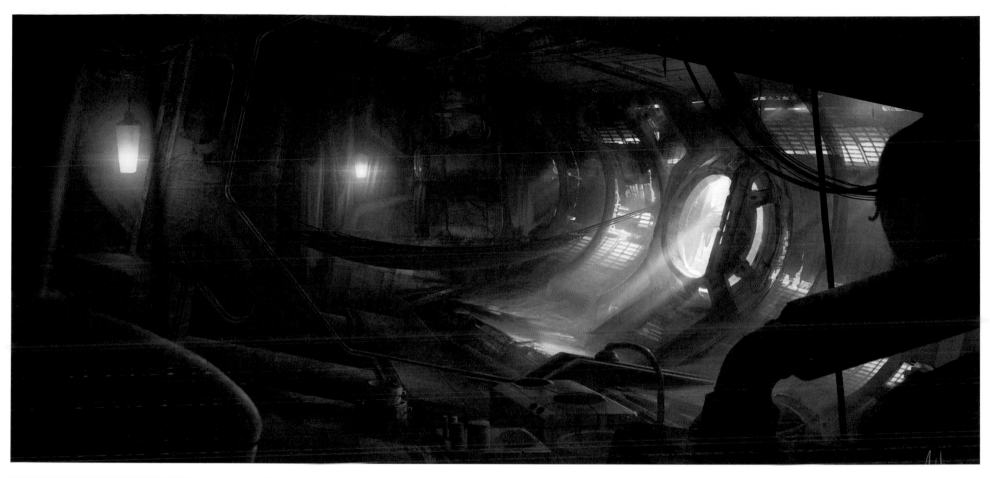

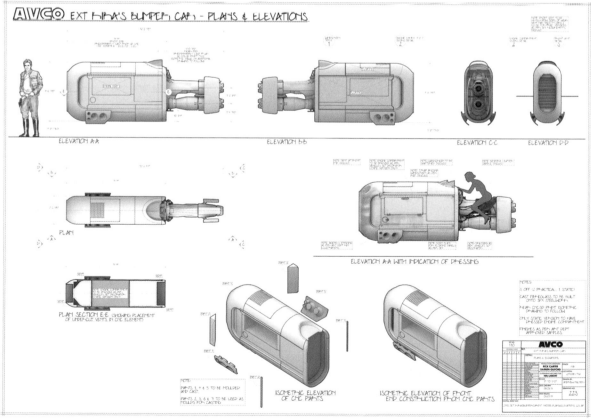

AVCO EXT KIRA'S BUMPER CAR – PLANS & ELEVATIONS

ELEVATION A·A ELEVATION B·B ELEVATION C·C ELEVATION D·D

PLAN

ELEVATION A·A WITH INDICATION OF DRESSING

PLAN SECTION E·E

ISOMETRIC ELEVATION OF CNC PARTS ISOMETRIC ELEVATION OF FRONT END CONSTRUCTION FROM CNC PARTS

▲ **KIRA'S (REY'S) HOME VIEW** *"That was an assignment that I got on a Monday and finished in one day. Then J.J. approved it, straight away. And I nearly fell out of my chair. 'Surely you're just messing with me right now, because designing this was supposed to take months.' [Laughs.]"* **Wallin**

◄ **EXT KIRA'S (REY'S) BUMPER CAR – PLANS & ELEVATIONS** Andrew Proctor

▼ **KIRA (REY'S) SPEEDER FINAL** *"Luke's speeder is a very simple slab, like a big bar of soap. I was thinking that's one silhouette which works very well. I was also looking at industrial vehicles, like tractors."* **Davies**

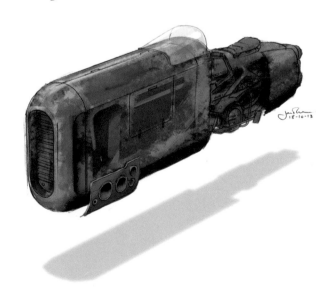

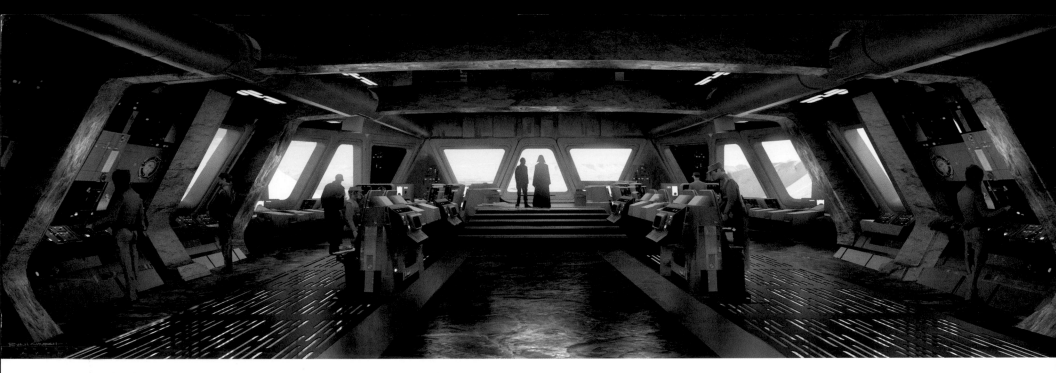

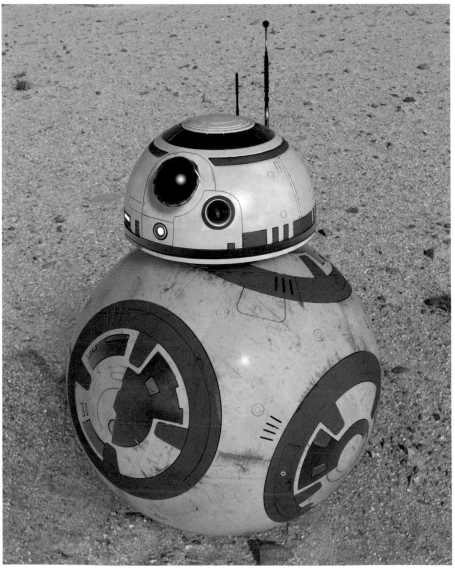

STARKILLER CONTROL ROOM Church

"It was an interesting challenge, that one, because the only time you've ever really seen the Star Destroyer bridge before was when it was framed in space. This time, we were going to reuse that set for a couple different spaces, one being the control room for the Starkiller base on the surface of that planet. So that's inherently going to flip the set's contrast from dark space outside with the bridge's lighter interior to a blown-out, almost white-snow environment outside with a darker control room interior." **Gilford**

BB-8 FACE DESIGN "We needed to create this illusion that BB-8 was freer rolling than he actually appeared. We came up with this solution that he would be divided in six, like dice. So when it actually rolls, the pattern goes haywire. We also infused BB-8 with little references to the Artoo-Detoo designs. We gave him this asymmetric, three-eyed sort of look, with one prominent Cyclops eye." **Davies**

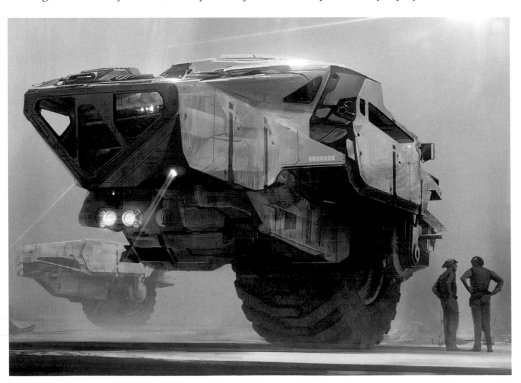

VEHICLE DESIGNS Chiang

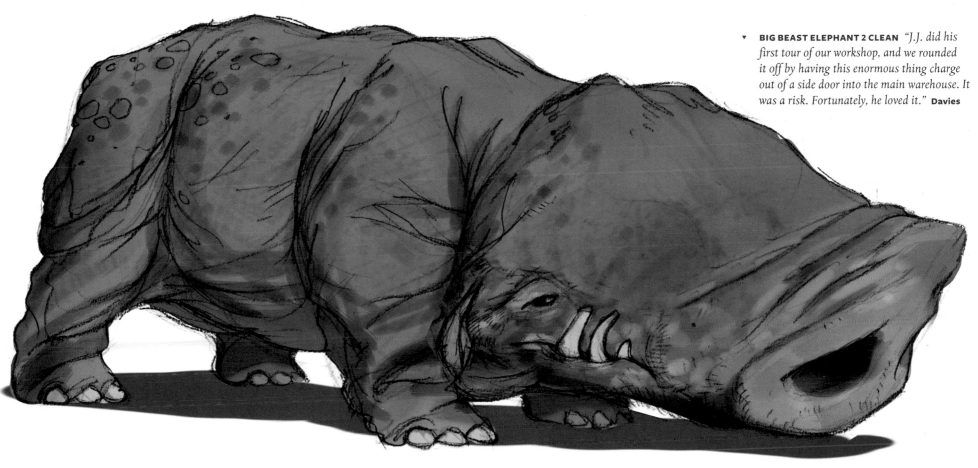

▼ **BIG BEAST ELEPHANT 2 CLEAN** *"J.J. did his first tour of our workshop, and we rounded it off by having this enormous thing charge out of a side door into the main warehouse. It was a risk. Fortunately, he loved it."* **Davies**

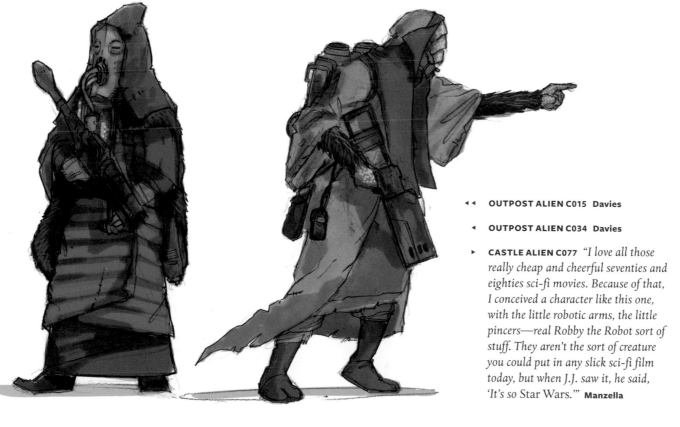

◄◄ **OUTPOST ALIEN C015** **Davies**

◄ **OUTPOST ALIEN C034** **Davies**

► **CASTLE ALIEN C077** *"I love all those really cheap and cheerful seventies and eighties sci-fi movies. Because of that, I conceived a character like this one, with the little robotic arms, the little pincers—real Robby the Robot sort of stuff. They aren't the sort of creature you could put in any slick sci-fi film today, but when J.J. saw it, he said, 'It's so Star Wars.'"* **Manzella**

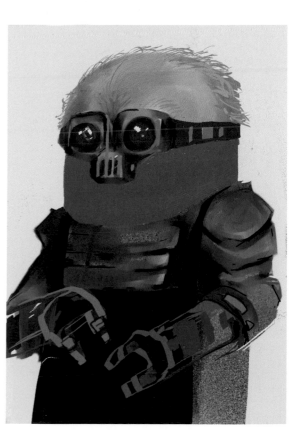

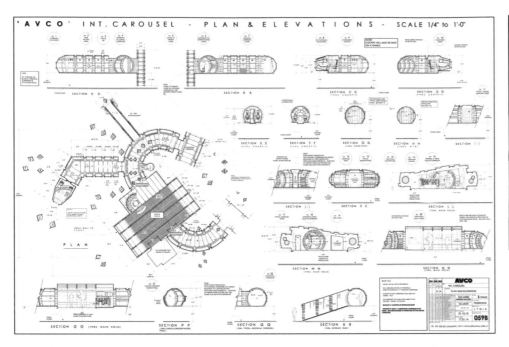

'AVCO' INT. CAROUSEL - PLAN & ELEVATIONS - SCALE 1/4" to 1'-0"

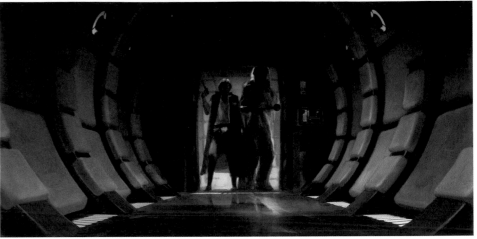

◀ **MILLENNIUM FALCON CORRIDORS PLANS & ELEVATIONS** Lydia Fry

"You walked onto that Falcon set, and you just felt like a child again. Watching other people walk in was one of my favorite things. 'Oh my God. Here we are. We're back in the Falcon.'" **Gilford**

▲ **FALCON CORRIDOR** Allsopp

▼ **INFIRMARY** Allsopp

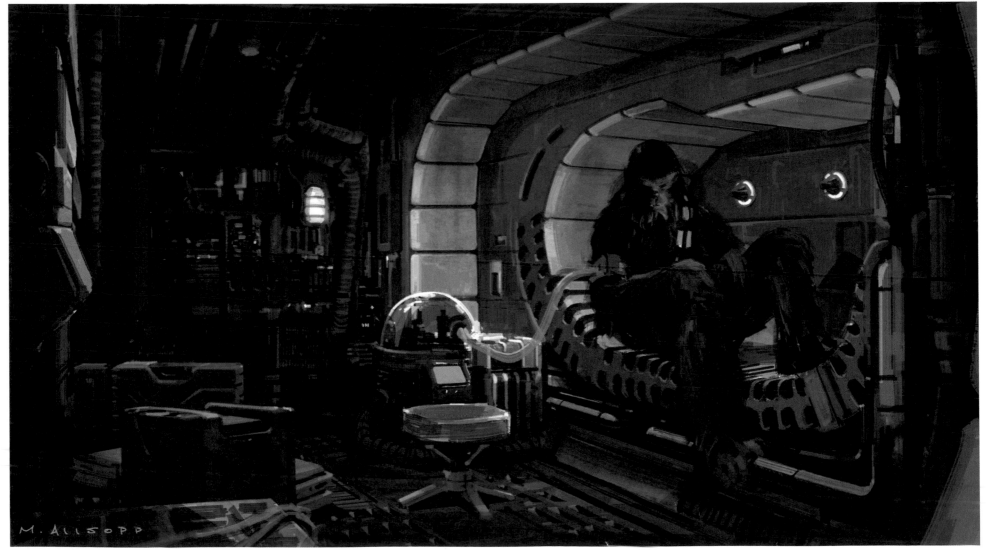

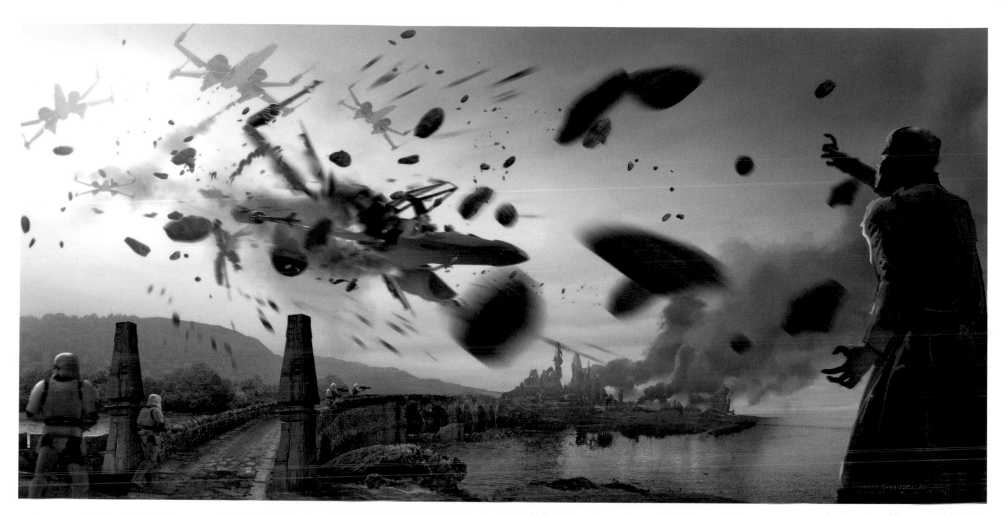

▲ **JEDI KILLER ROCK THROWING**
"*This was the Jedi Killer throwing rocks at the X-wings. It was a quick morning of doing this at Bad Robot before a meeting with Rick.*"
Church

▶ **X-WING SHOT** De Martini and Church

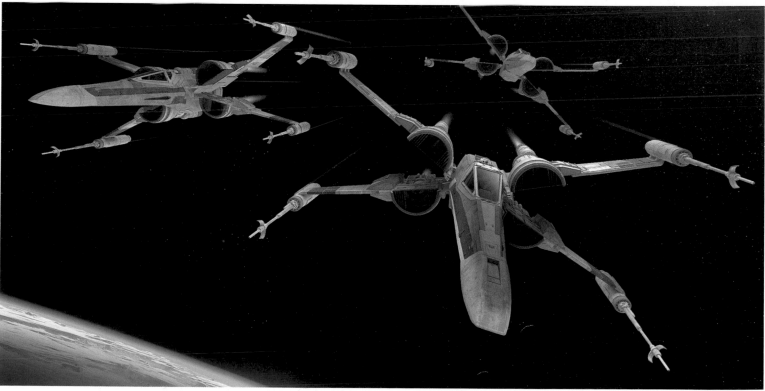

Ireland's Skellig Islands and the larger island's sixth-century monastery were chosen by Abrams and the production designers to stand in for Luke Skywalker's homestead; the concept artists got their first crack at integrating location photos into their designs. Artists from both sides of the Atlantic contributed to a big design push for the interior of Maz's castle, as it was finally decided to blend the long-gestating Exotic City idea with McQuarrie's early castle concepts. With that decision, the Greenham Common RAF base location was freed up to become what it was perhaps always meant to be: Leia's resistance base.

James Clyne relocated to Pinewood Studios for a month to help supervise the initial construction of the Star Destroyer hangar, along with the newly approved interrogation room and First Order troop transporter sets. Across the lot in the costume and creature departments, approved designs for Kira and her junk boss, Unkar Plutt, were locked in. "I think that the blobfish concept for Unkar came from J.J.'s daughter," Ivan Manzella recalls. "We all had a stab at it, and J.J. picked up on that one."

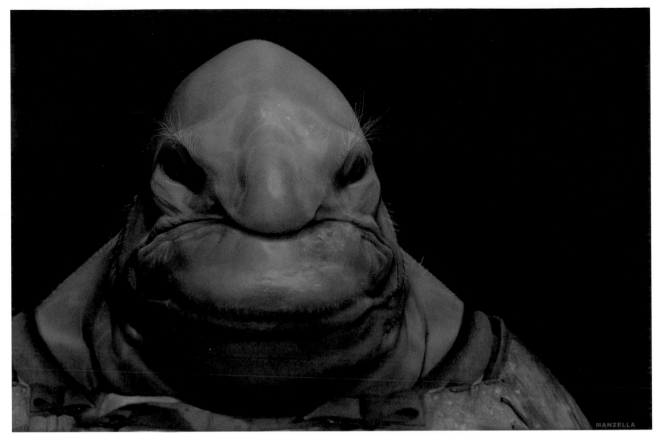

▲ **JUNK DEALER BLOB** Manzella

▼ **MARKET** Kevin Jenkins

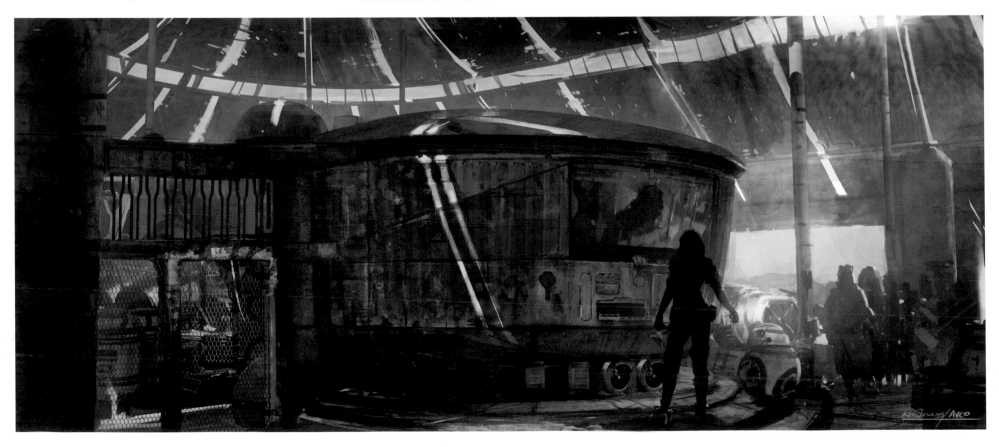

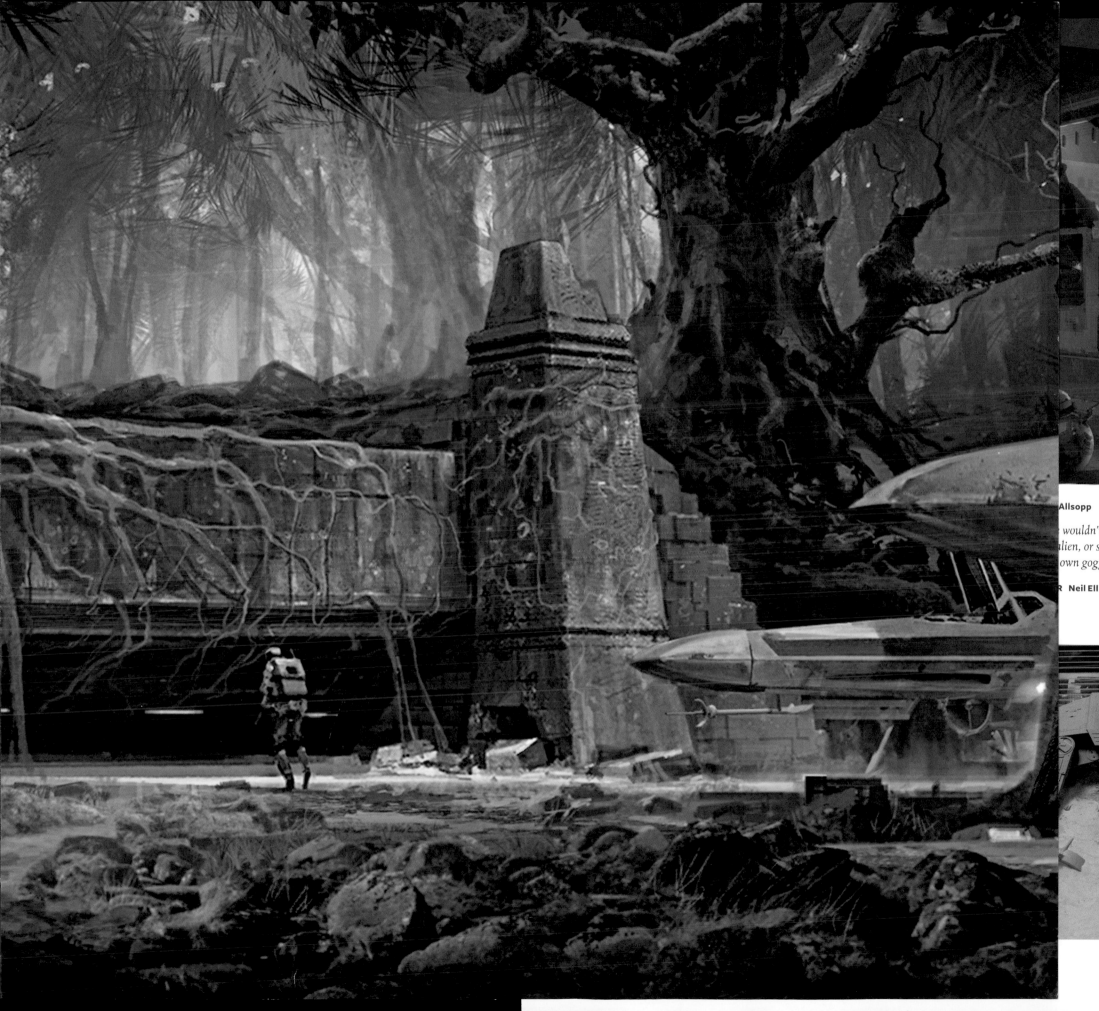

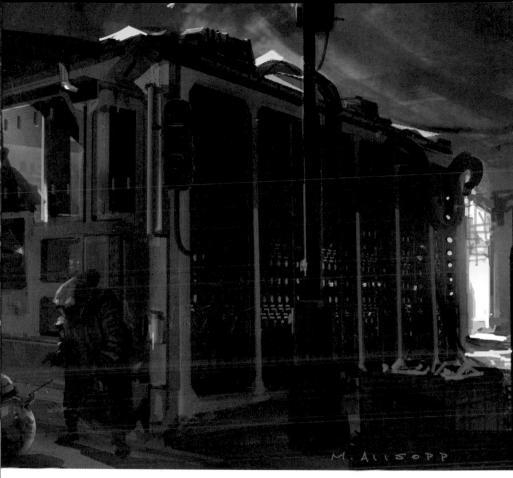

Allsopp

wouldn't be able to see who Kira was; we wouldn't know
alien, or something else entirely. And I thought it would be
own goggles out of scavenged stormtrooper lenses." **Dillon**

R **Neil Ellis**

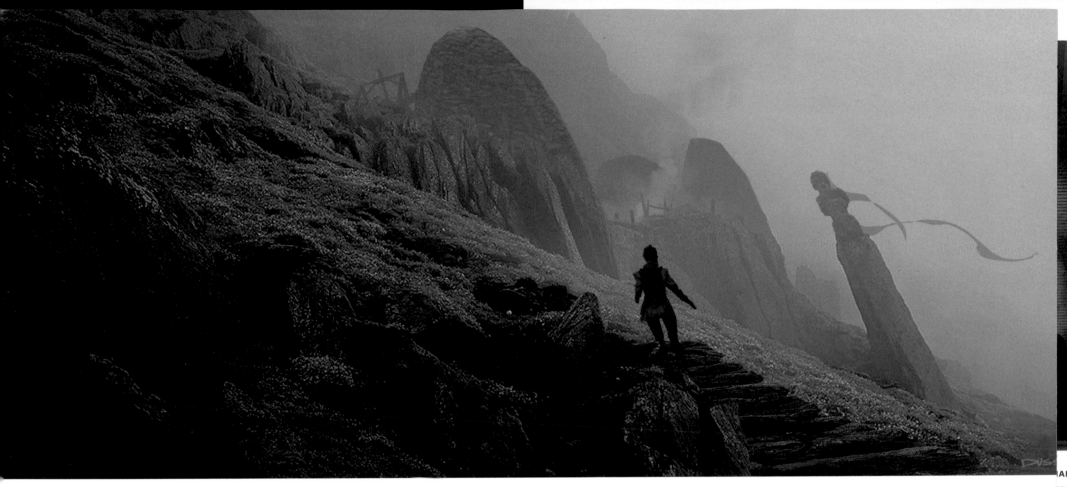

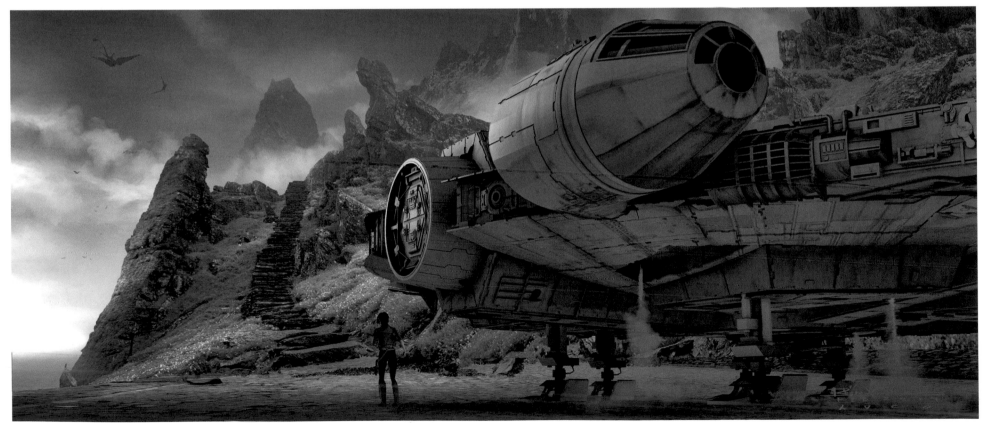

▲▲ SKELLIG **Dusseault** ▲ UNDER *FALCON* *"The location needs nothing done to it. It's an amazing place; just putting the Falcon in is enough."* **Church**

▲ YOUNG JEDI KILLER NEW CONCEPT **Dillon**

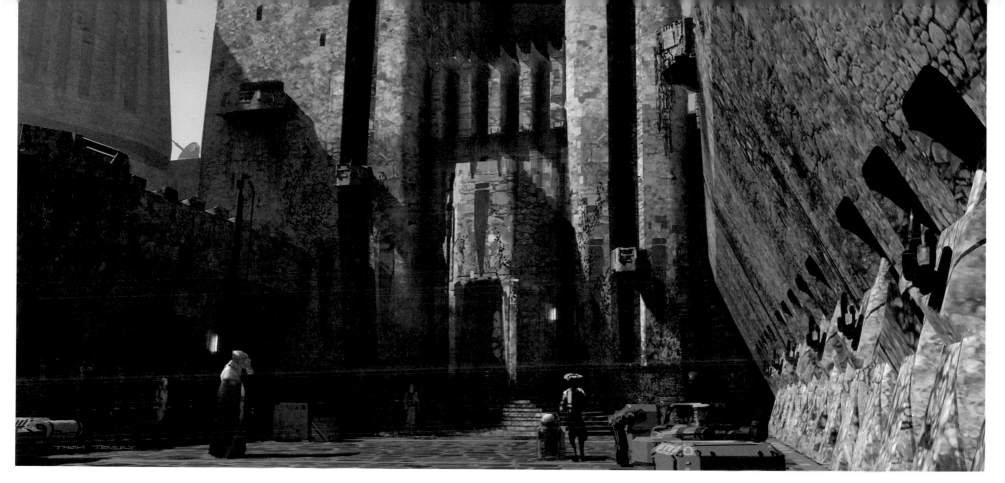

▲ **COURTYARD DEV** Tenery

▼ **CASTLE SKETCH 01** Allsopp

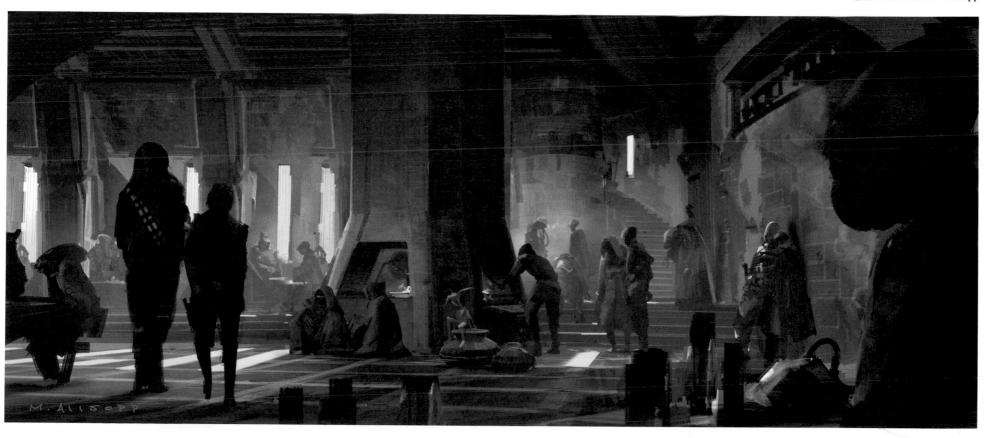

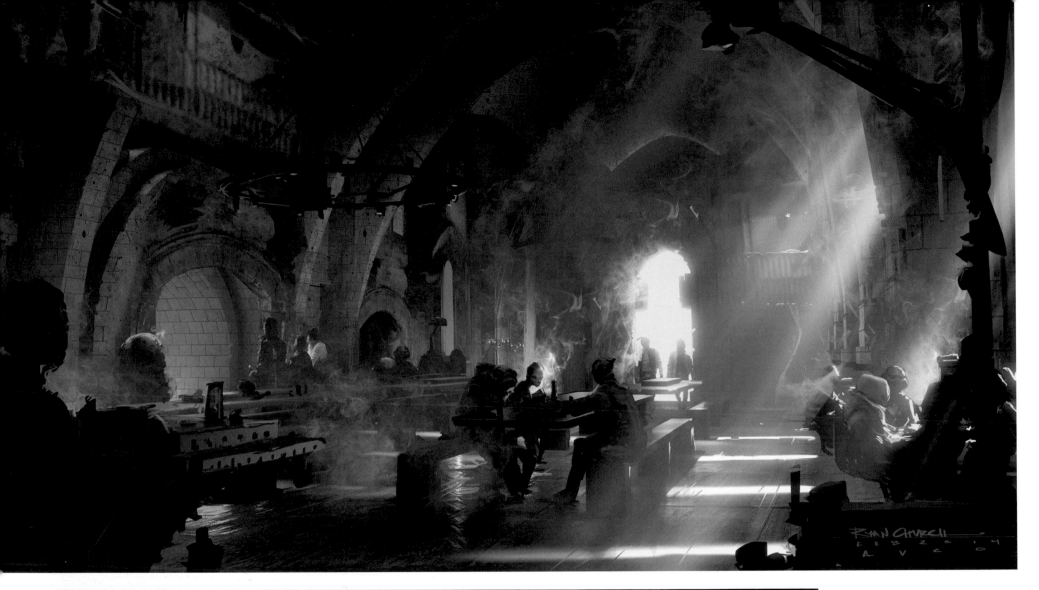

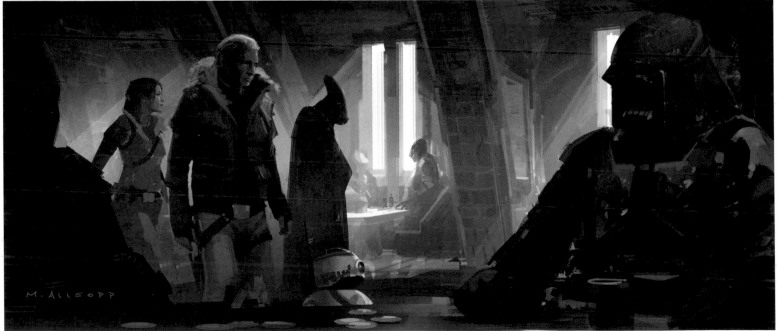

▲ **CASTLE HALL TOWARD DOOR**
Church

◄ **CASTLE SKETCH 04** Allsopp

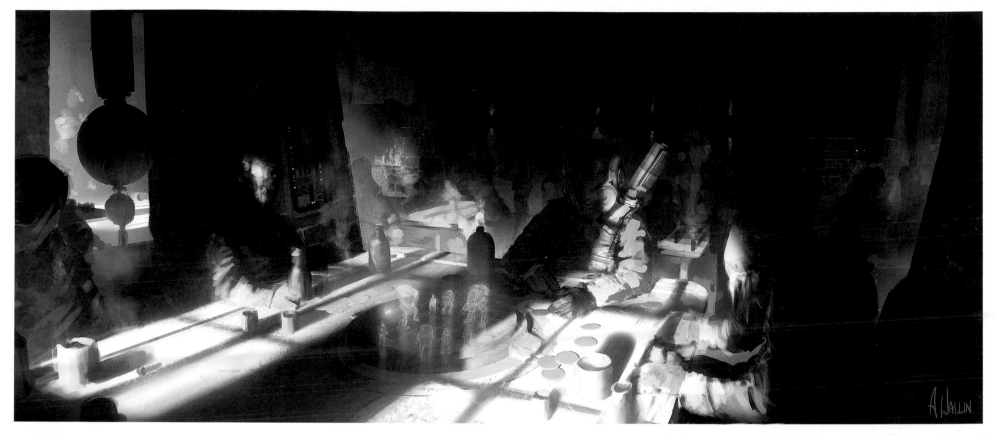

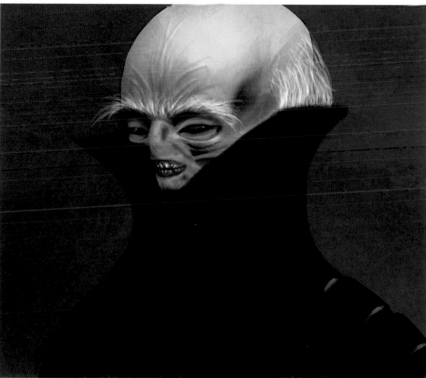

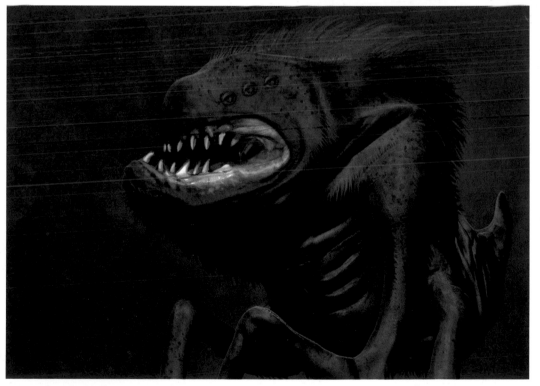

▲▲ **DINING ROOM ANGLE** *"That's probably one of my favorite pieces, because I was allowed to just sit there and take my time on it. I think it's important to sit down and put your whole heart into at least a couple of pieces, every once in a while."* **Wallin**

▲ **CASTLE ALIEN C078** *"C078's my favorite! I don't know why he's my favorite. Maybe it has more to do with me. He's got my design sensibility."* **Manzella**

▲ **CASTLE ALIEN C081** *"The teeth in the final creature are really sharp. They're made of dental acrylic. I like the contrast between the gums and the black skin."* **Manzella**

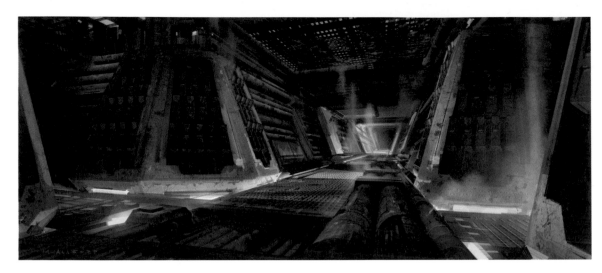

▲ **CRAWL SPACE INTERIOR** Allsopp

▼ **MODDER** Dillon

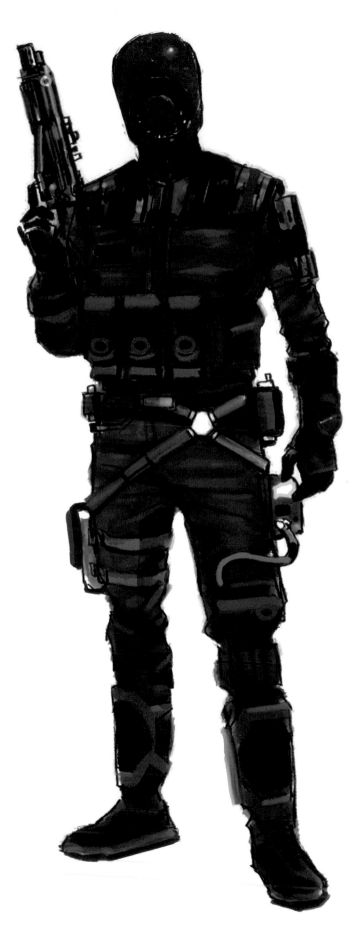

▲ **REBEL GROUND CREW** Dillon

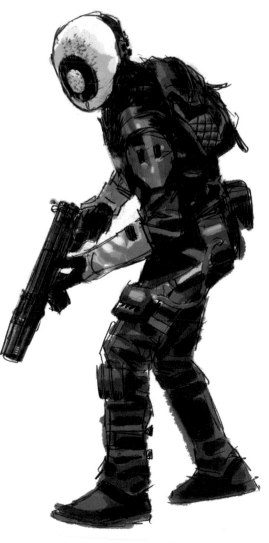

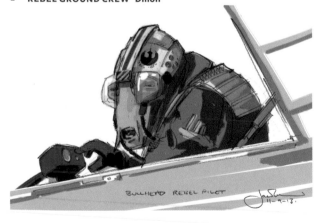

▲ **BULLHEAD REBEL PILOT C030** Davies

▶ **RED SUIT HEAD** *"I was really pleased the Guavian Death Gang helmet moved on, somewhere between paramilitary and Boba Fett. My original idea was for them to have little jackets. But that turned into a boiler suit/jumpsuit hybrid."* **Dillon**

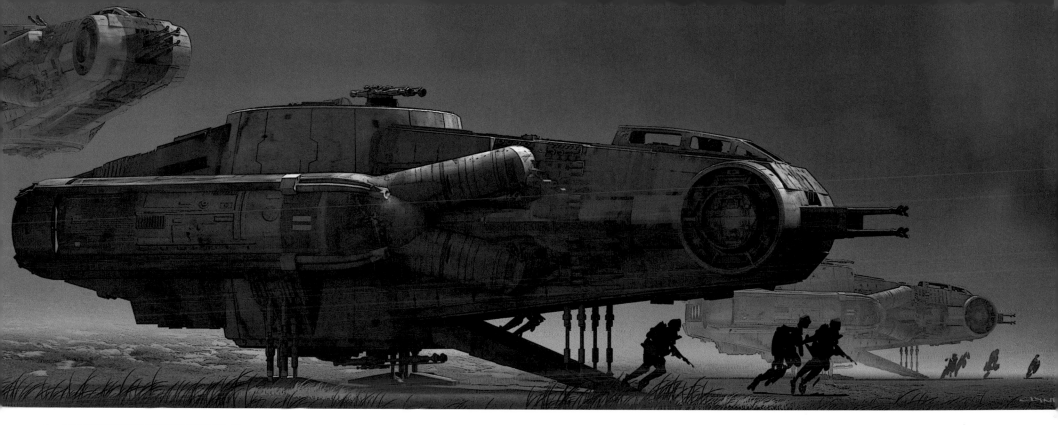

▲ **RESISTANCE TRANSPORT LANDING** Clyne

▼ **GREENHAM COMMON** Allsopp

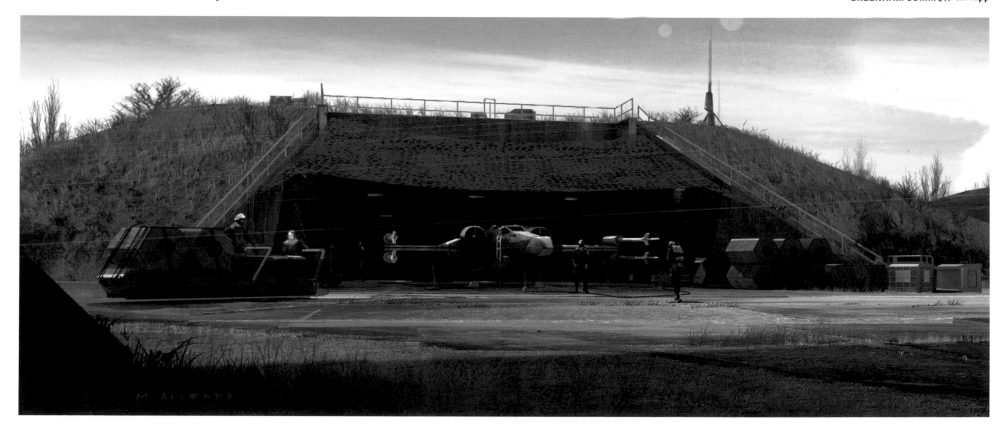

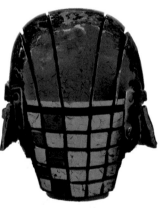

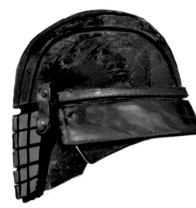

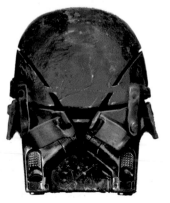

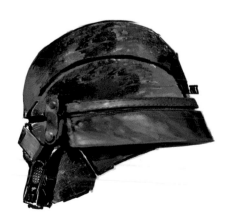

▲▲ **FILTER CYLINDER MODEL ACROSS** Church

▲ **JEDI KILLER SWORD** Lee Oliver

▶ **GRENADE HEAD & X HEAD** *"I really liked the grenade head one. This was another one of my designs for the Jedi Killer that never worked out."* **Dillon**

▲ **TORTURE ROOM FROM ENTRY** *"The torture room was a triangle—they liked the idea of a very simple geometrical shape. There was also a Hitchcock-inspired element to the forced perspective of the torture chamber."* **Clyne**

▶ **JEDI KILLER IN WOODS** Power

In a major milestone for the production, Glyn Dillon's design for the Jedi Killer—soon to be known as Kylo Ren—was finally locked and approved on March 11. March was a big month for several other reasons, as well. Big-screen icon Han Solo, as played by the legendary Harrison Ford, got an approved costume update.

In the art department, three new vehicles were drafted, only one of which would make it into the final film. Concept art for the castle ruins set was also first painted by the designers. Lastly, Thom Tenery's castle interior became the prototype for the set, as the resistance transport, resistance base, and Starkiller base sets saw further refinement.

Deadlines for the Jakku exterior location shoot in Abu Dhabi loomed in the back of everyone's minds. The production's quick return to Pinewood to shoot Star Destroyer interiors, including the hallways, hangar, and torture room sets; *Millennium Falcon* interiors; and Jakku village backlot night shoots were also of pressing concern.

Darren Gilford recalls, "We decided to build the outpost in Abu Dhabi at the end of the mangrove swamp—the only place we could find that had a clear horizon, where it was desolate, flat as a pancake. J.J. wanted the location to be a really unappealing, horrible place for her to exist. Kira's life is just miserable, and this miserable place echoes that."

▲ **BAR CREATURE C024 Davies and Fisher**

▶ **STORMTROOPER CLOAK FRONT RED STRIPE Power**

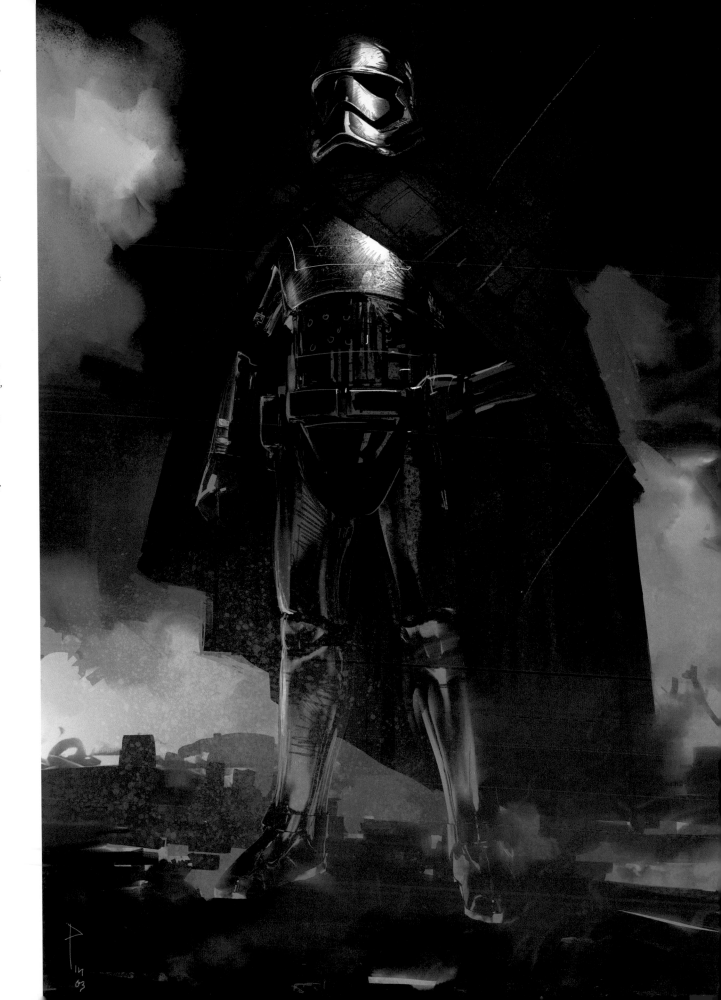

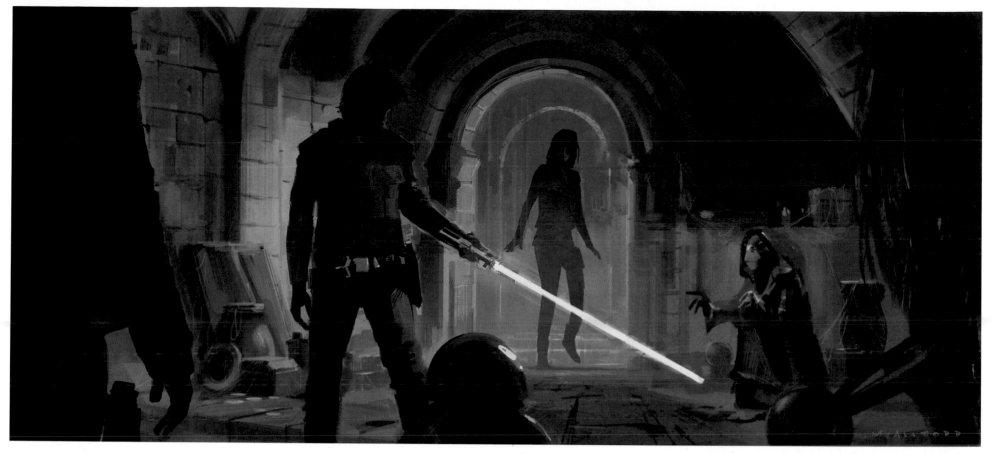

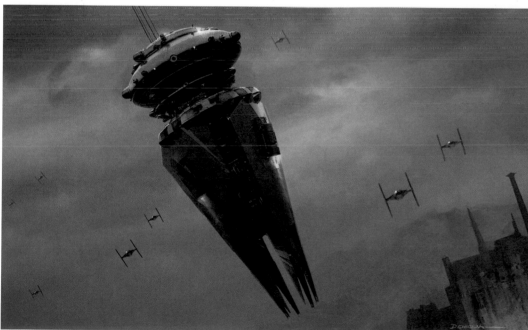

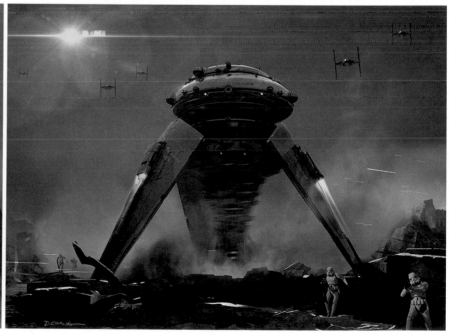

▲▲ **CATACOMBS FINN** Allsopp

▲ **LANDING & DRILLING** *"J.J. wanted this very specific machine to drill into the catacombs when the Empire attacks Maz's castle. I wanted to put in elements of the probe droid because that's such an exotic, threatening shape."* **Chiang**

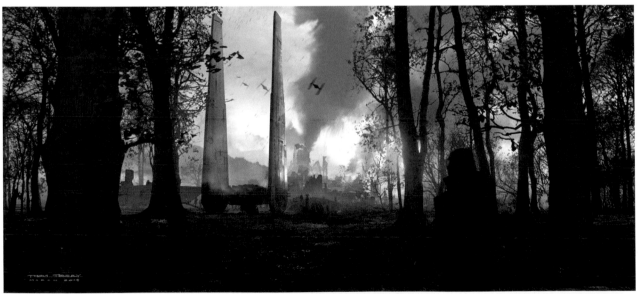

CASTLE INTERIOR PANO WIDE *"There was a running joke/wager that Rick put out there, that whoever cracked this one, everyone's got to buy him a drink. I was the last to work on it, so I ended up winning—but I should point out that there was so much development done on this before me that I can't, in good conscience, take credit for it."* **Tenery**

"We finally came up with that design around the fire pit. The spoked headers are always a great way to hide the fact that you want to be able to light from above, but we didn't want to give away the fact that we weren't creating a ceiling." **Gilford**

◄ **BATTLE KIRA (REY) WOODS** **Tenery**

◄ **NEW COLOR SCHEME 01, 03 & 10** **De Martini**

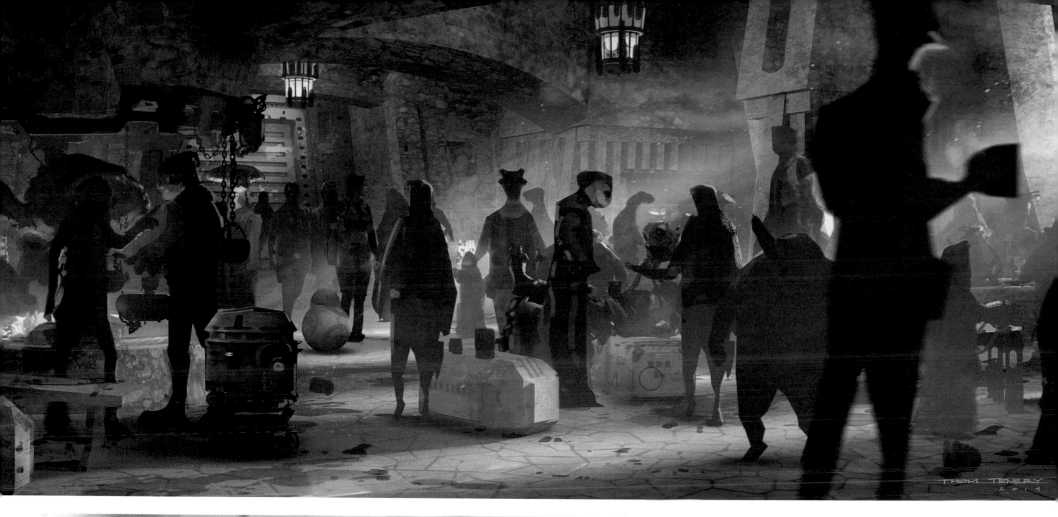

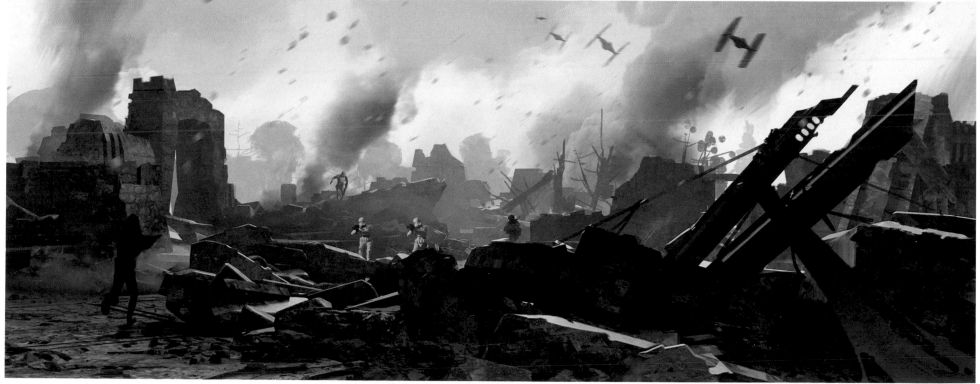

▲ RUIN BATTLE Tenery

▲ **STARKILLER BASE MOUNTAIN FORTRESS** *"You don't want to crowd a battle scene with 75,000 types of ships. In Return of the Jedi, you could tell who the good guy and bad guy were: They weren't just a random mass of colors and shapes."* **Jenkins**

▶ **TIE FIGHTER RUINED EXTERIOR** Ellis
"The crashed TIE fighter was the biggest and hardest set we had to make in Al Qasr. We had to do almost a 1,000-foot trough of how it would have come in on the soft landing and dive into the sand." **Gilford**

▼ **STARKILLER *FALCON*** Allsopp

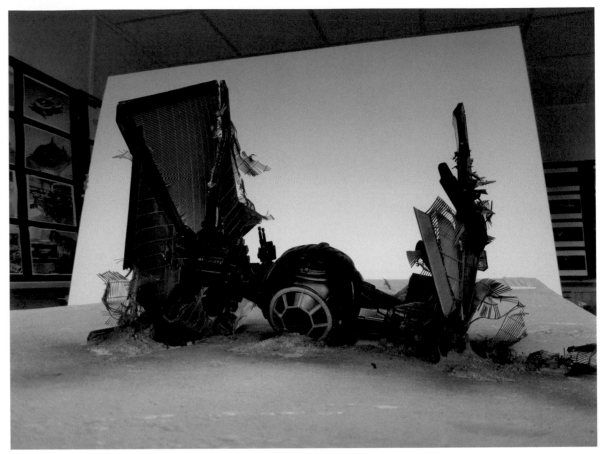

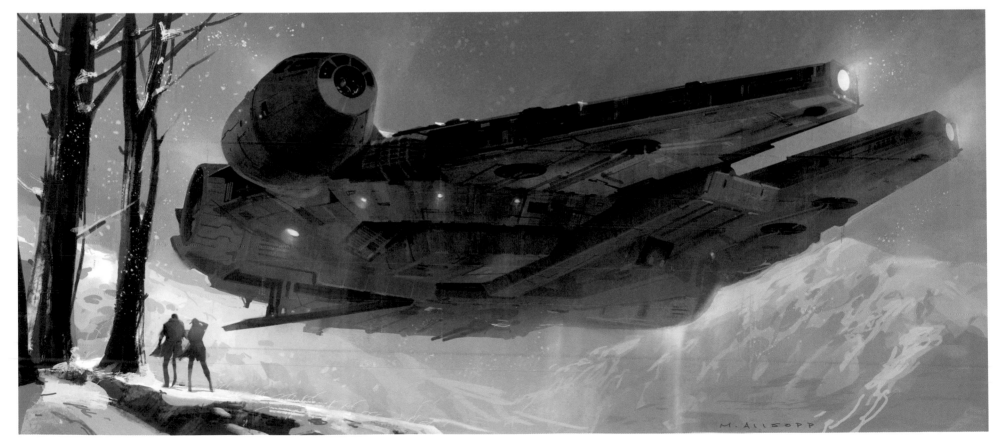

▲ **ELEVATION (CHROME DETAIL)** Dillon ▼ **FLAMES CLOSE-UP** Dillon

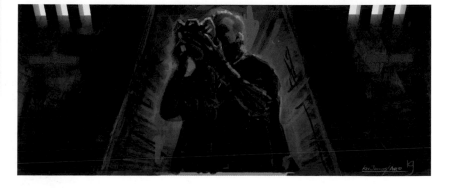

▲ **POSTER** *"I was thinking, 'What is it that blew me away when I was a kid?' And do you know the science fiction book cover and film concept artist Chris Foss? He would do this stripe effect of black-and-yellow camouflage for the Dune ships. And when J.J. saw that, he was like 'Oh, that's cool.' None of us could quite believe it, because it had been such a long process, that he actually thought something was cool [laughs]. It might have been J.J. that said, 'Maybe it would be better if it was reflective.' He liked the yellow, but he wasn't sure about it being on there all the time."* **Dillon**

▲ **KYLO'S CHAMBER** Jenkins

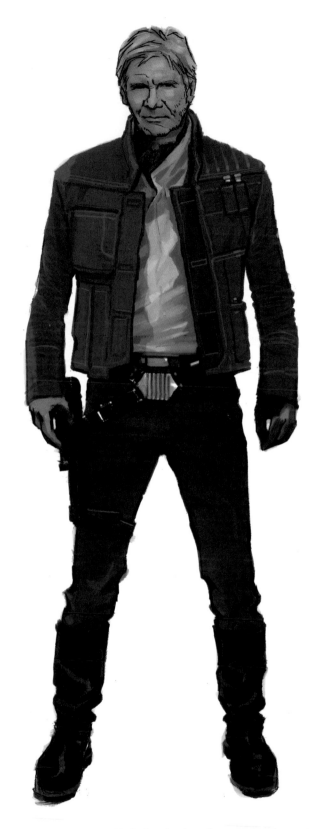

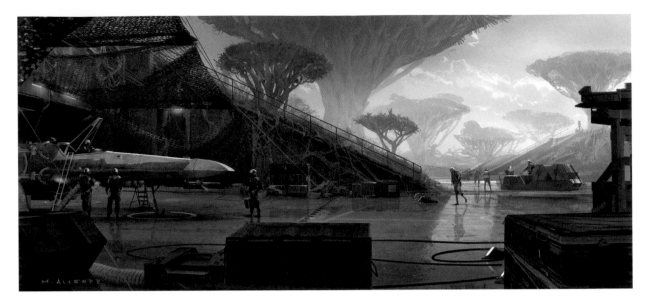

▼ RESISTANCE BASE INTERIOR 01 Wallin

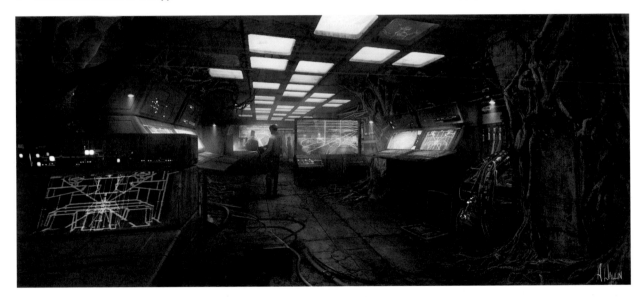

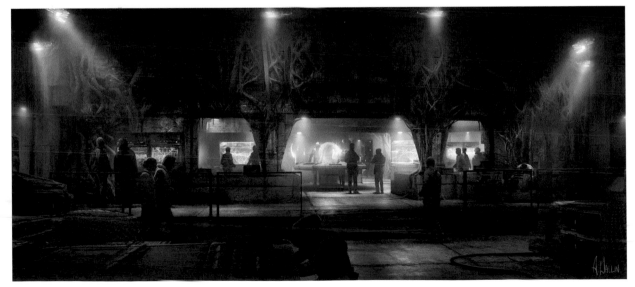

▲ COCKPIT JACKET *"We designed quite a few costumes, but again, Han Solo only ended up wearing the short brown jacket. But he had a duster coat, and for a while J.J. and Michael Kaplan wanted the original vest."* **Dillon**

▶ RESISTANCE BASE INTERIOR 02 Wallin

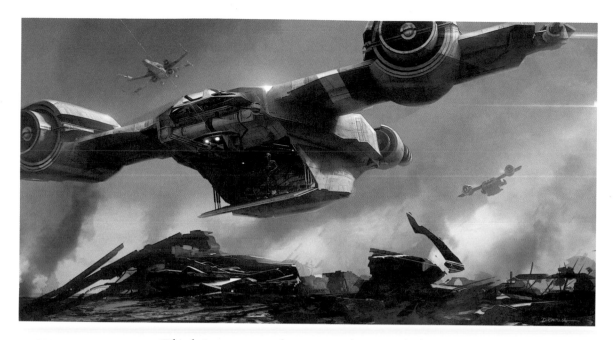

▲ **RESISTANCE TRANSPORT** "*This design was supposed to repurpose the First Order landing ship—turn it into a rebel ship. And I've always loved big outboard engines, because to me, they capture the essence of Star Wars.*" **Chiang**

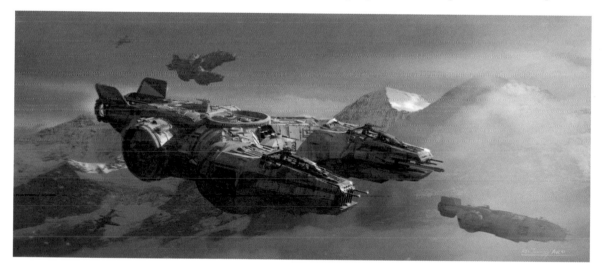

▲ **TRANSPORT IDEA** Jenkins

▶ **FULL LENGTH** Dillon

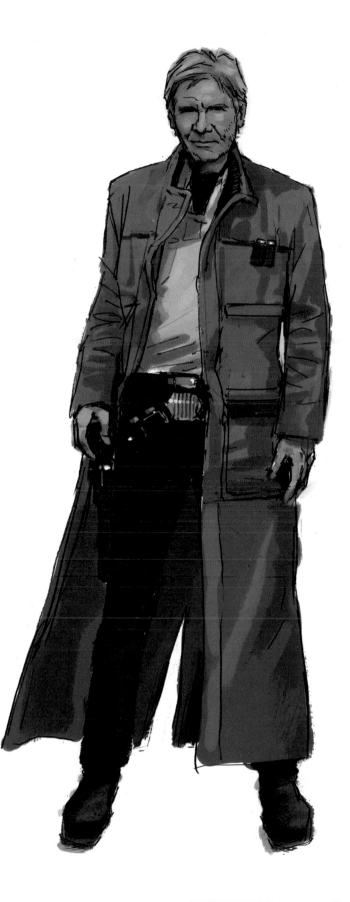

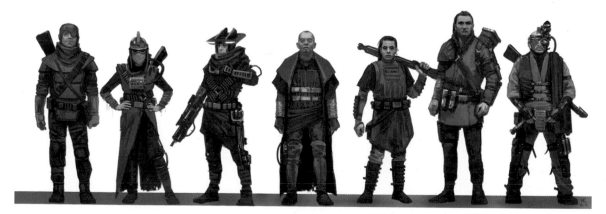

▲ **ROCKERS GROUP SHOT** Kusowska

▶▶ **RALLY SITE TROOPS VIEW** Jenkins

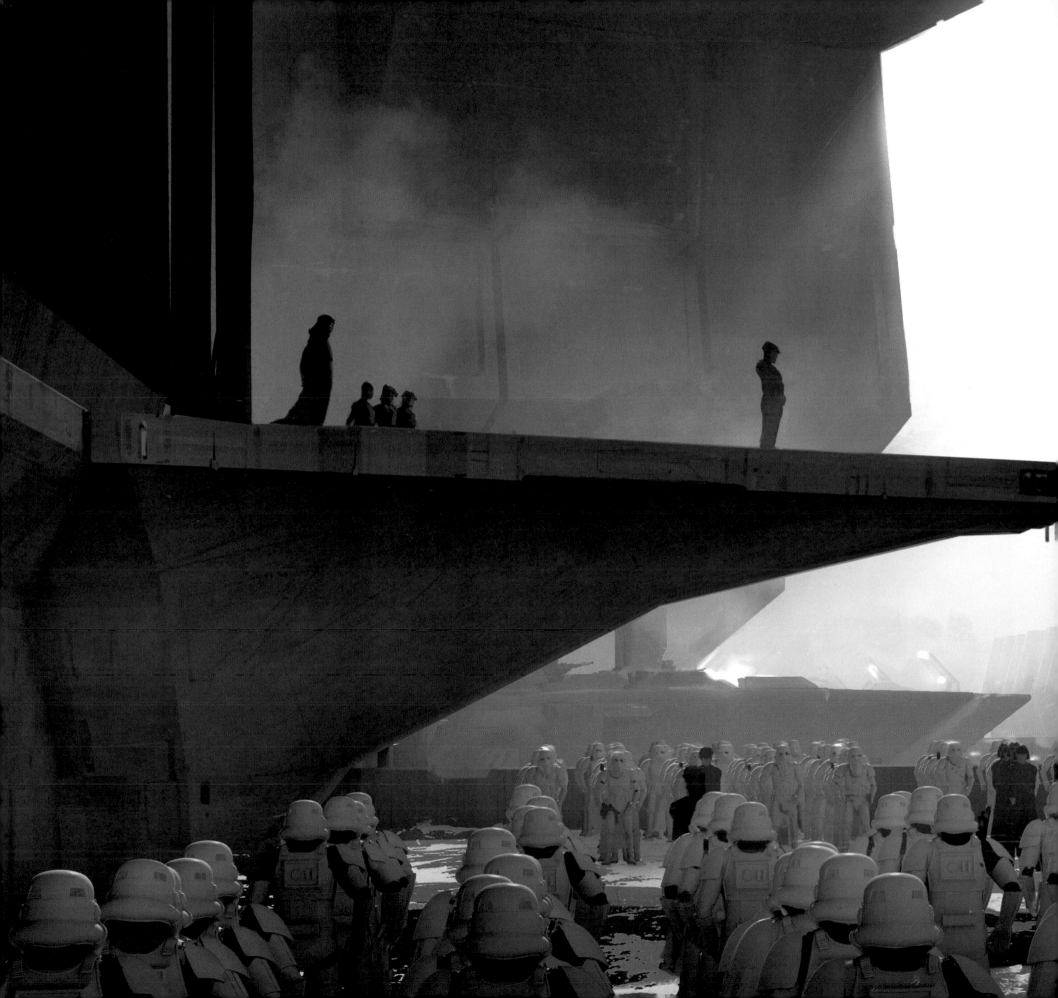

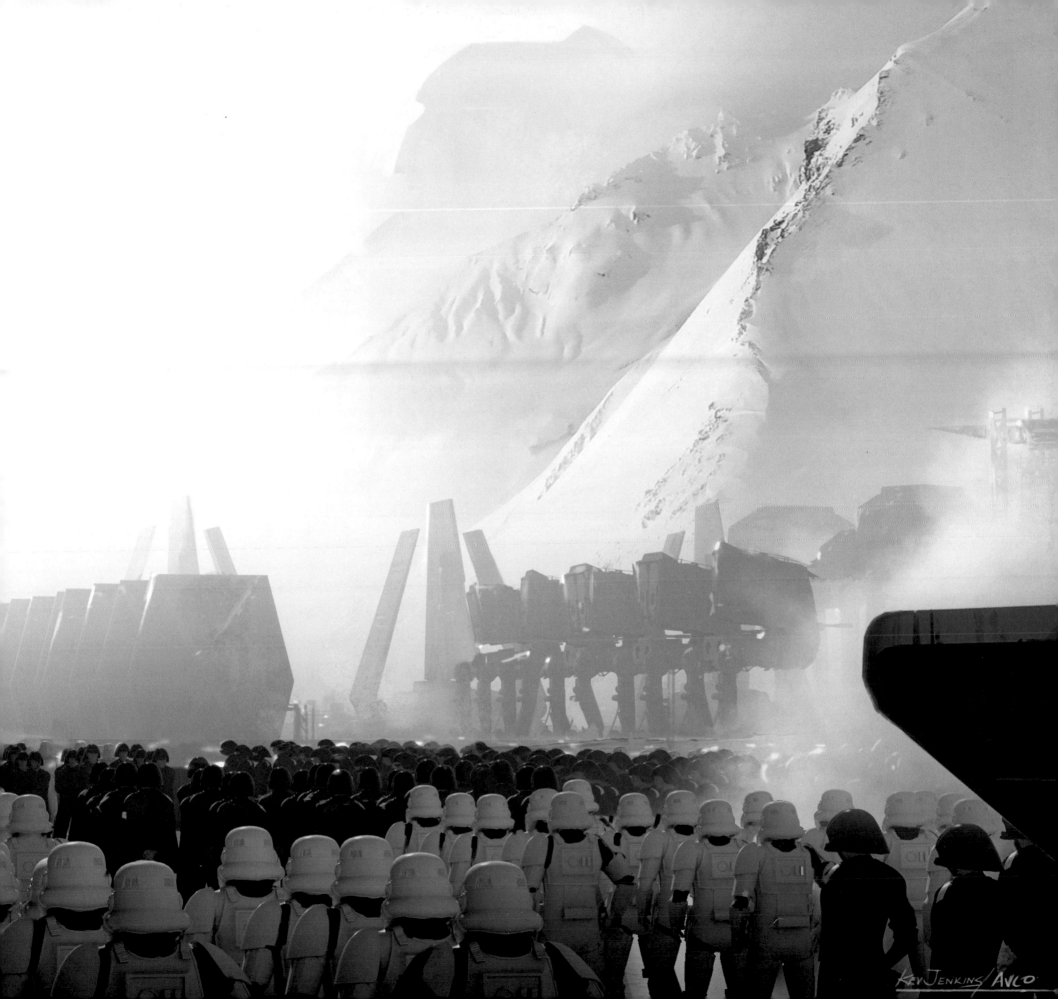

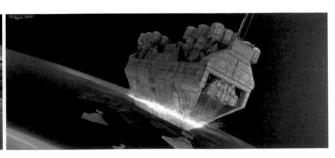

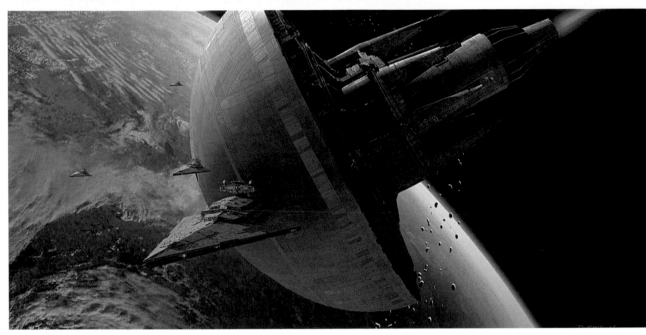

▲ **WARHAMMER BLOCKOUT 02, 03 & 05** *"The resistance War-hammer was crazy. Imagine this huge ship that has this really strong front that could actually penetrate a shield and then deploy ships through it."* **De Martini**

◄ **WARHAMMER ATTACK Chiang**

▼ **SNOWSPEEDER SKETCH 05 Clyne**

"At first, we were going for things that were a little bit too slick and a little bit too sci-fi for J.J. And again, he described this vehicle like a stormtrooper utility maintenance vehicle [laughs]. Everybody was trying to tackle it, and nobody quite got there." **Gilford**

"Then J.J. said, 'Well, what if we flip the snowspeeder?' We rotated it 180 degrees, and the windows become headrests. It was a true 'What if . . .' moment." **Clyne**

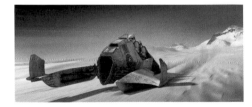

▲ **SPEEDER** Jenkins ▼ **SPEEDER** Dusseault

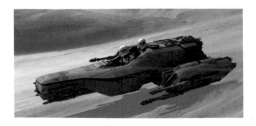

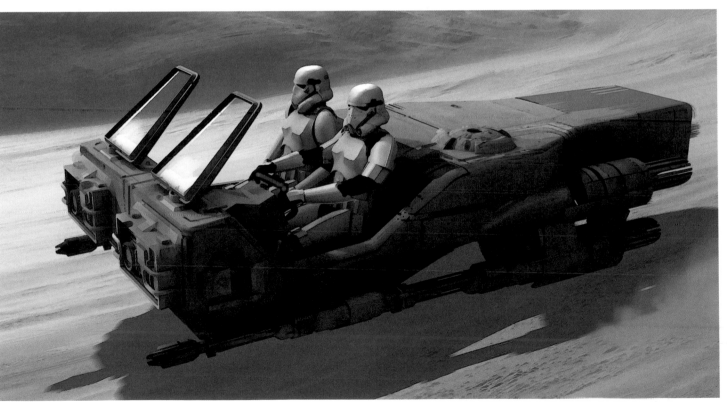

▲ **SNOWSPEEDER SKETCH 03 Clyne**

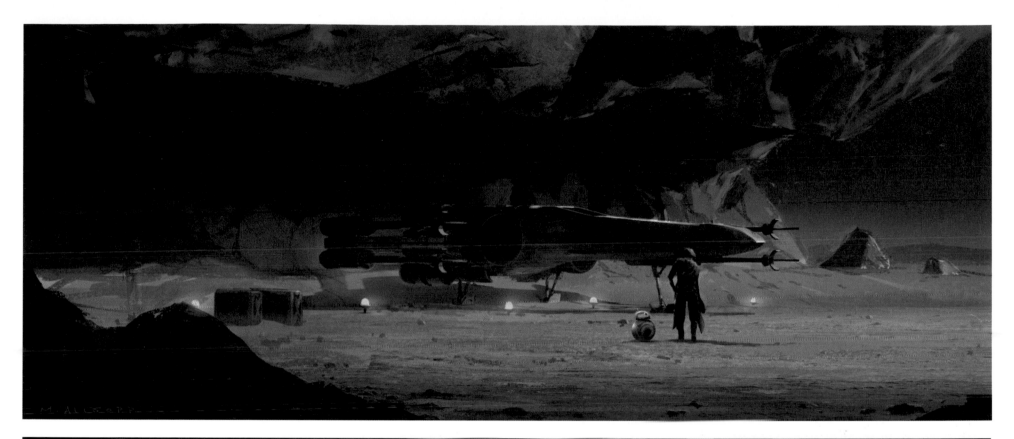

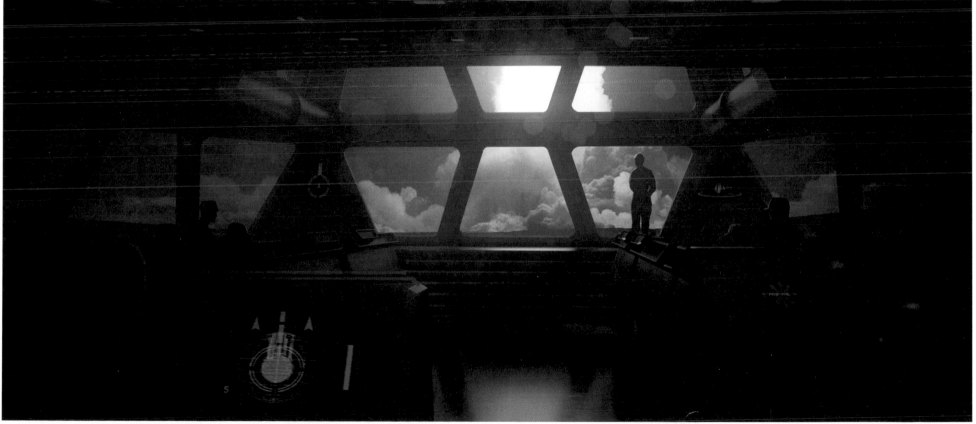

▲▲ **VILLAGE X-WING SET EXTENSION** Allsopp and Haley Easton-Street

▲ **FIRE SEQUENCE** *"An exposure treatment is a much more realistic effect for this scene. Being in an atmosphere adds a lot, and it's all to our favor."* **Dusseault**

To take the helm, director J.J. Abrams moved from Paris to Pinewood Studios on April 4, where he would remain for the duration of the shoot. As the resident expert on Imperial design, concept artist James Clyne also relocated to Pinewood in early April to work with art director Kevin Jenkins on Starkiller base designs as they related to the script's Act III story beats.

Jenkins says, "I spent a lot of time with James Clyne going through a lot of Brutalist architecture. Brutalism influenced Norman Reynolds, John Barry, and the original *Star Wars* design team for the Empire."

The creature and costume departments combined forces to fill out Maz Kanata's castle with aliens, beasts, and humanoid denizens. Ivan Manzella's Wollivan character, as played by long-running *Star Wars* actor Warwick Davis, ended up at the castle's ball-droid fighting table, in one of the last sequences shot for the film.

Meanwhile, the remaining Pinewood crew scrambled to prep for the start of principal photography in Abu Dhabi on June 16. "I was going back and forth a bit, but I think I arrived in Abu Dhabi maybe two or three weeks before photography," Darren Gilford recalls. "It all came together, but it was massive amounts of dressing, massive amounts of construction, huge logistical planning—the set was huge."

▲ **RESISTANCE BASE, SET** Photograph by David James

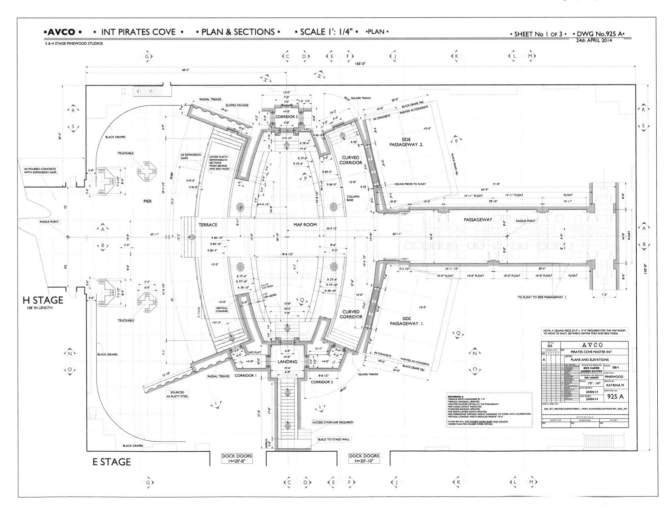

▶ **RESISTANCE BASE PLANS & ELEVATIONS** Katrina Mackay
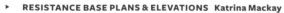
"*On Pinewood's E Stage, there's a projection hallway that was used for rear projection techniques probably back in the forties or fifties. When you're looking out from the rebel base map room into the darkness and those lights fading off into nothing, the physical lights are getting smaller and lower, so it gives you a forced perspective linear angle. It creates an incredible amount of depth. That was J.J.'s dream: to really try the old-school techniques.*" **Gilford**

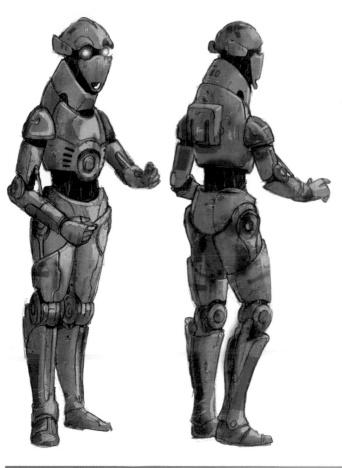

▶ **RESISTANCE DROID H001** *"In* Empire, *there's a bounty hunter lineup and one of them is named Zuckuss, who has a head like a fly; there's 4-LOM, who's a protocol droid with Zuckuss's head. I thought: There it is—an example of a protocol droid that doesn't necessarily have a human head.'"* **Davies**

▶ **WOLLIVAN** Manzella

▼ **WOLLIVAN** Davies

▲ **SAND VEHICLE** Tenery

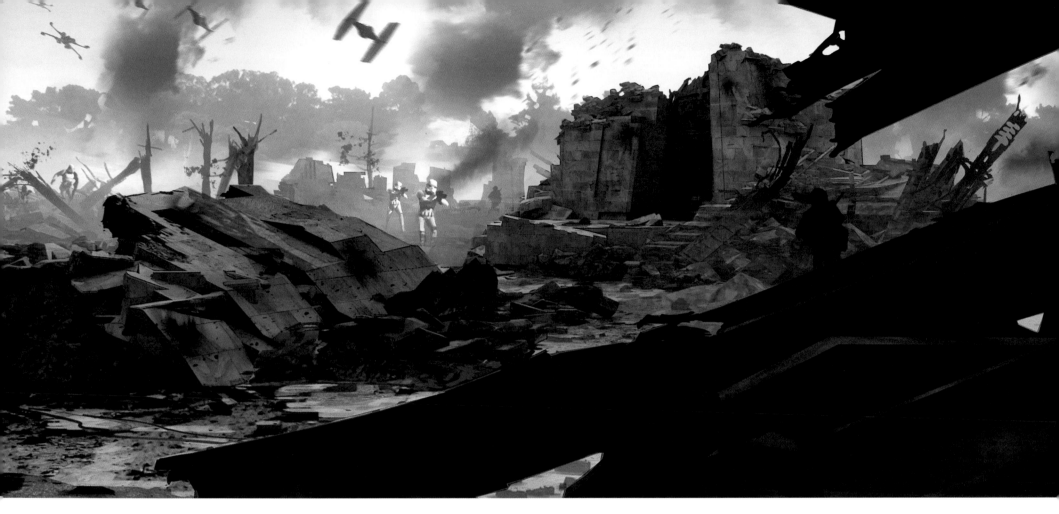

RUIN SET PAINTOVERS *"It seems like all of these Star Wars movies are going to have so many contemporary flavors and concepts that arose in a post-9/11 world. In some ways, this ruins set feels like it's more and more out of that sensibility."* **Tenery**

MAZ'S CASTLE PLANS & ELEVATIONS Sam Leake

MAZ'S CASTLE, SET Photograph by David James

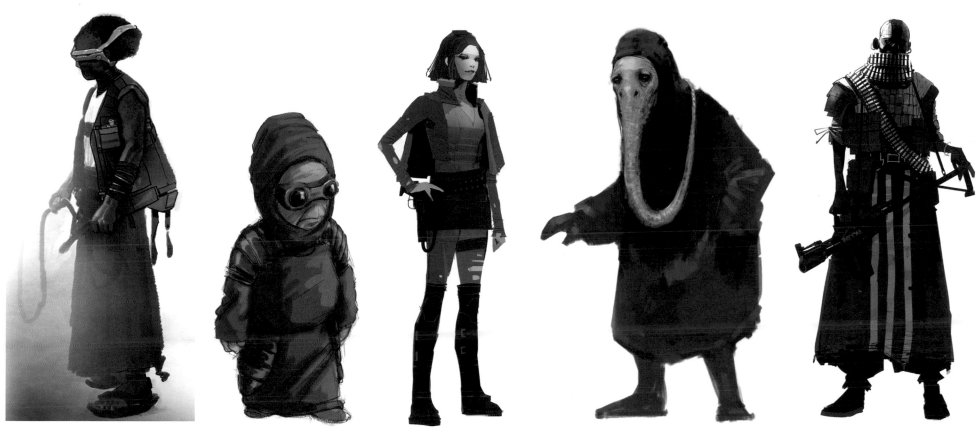

▲ **BEAST HANDLER** Dillon ▲ **TEETO BLACK GOGGLES** Davies ▲ **BAR CHARACTER** Davies ▲ **ELEMAN** Fisher ▲ **BAR CHARACTER 20** Power

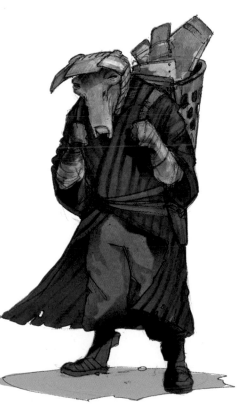

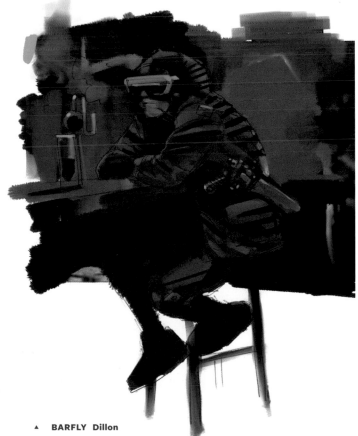

▲ **SPACESUIT WOMAN** Dillon ▲ **SCAVENGER C030** Davies ▲ **BARFLY** Dillon

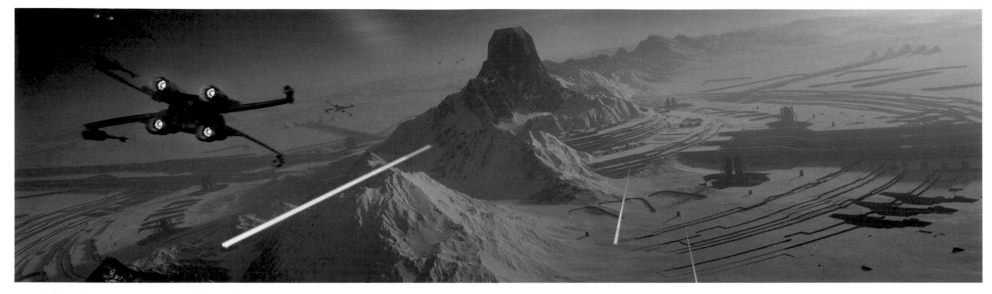

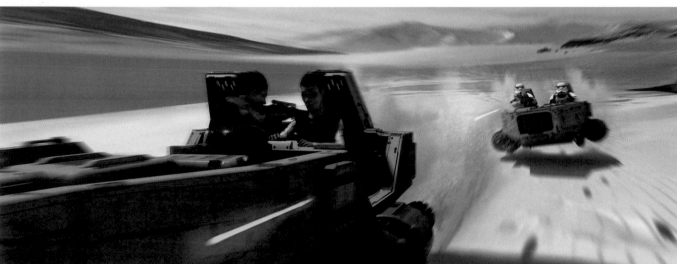

ICE PLANET *"This piece utilizes planetary software. It's all fractal, so you can go from pebbles that look real and zoom out, zoom out, zoom out to the moon and still see a planet with the clouds and everything that still looks real [laughs]."* **Dusseault**

◄ **CHASE** Tenery

◄ **HOLDING CELL ROUGH LAYOUT** Clyne

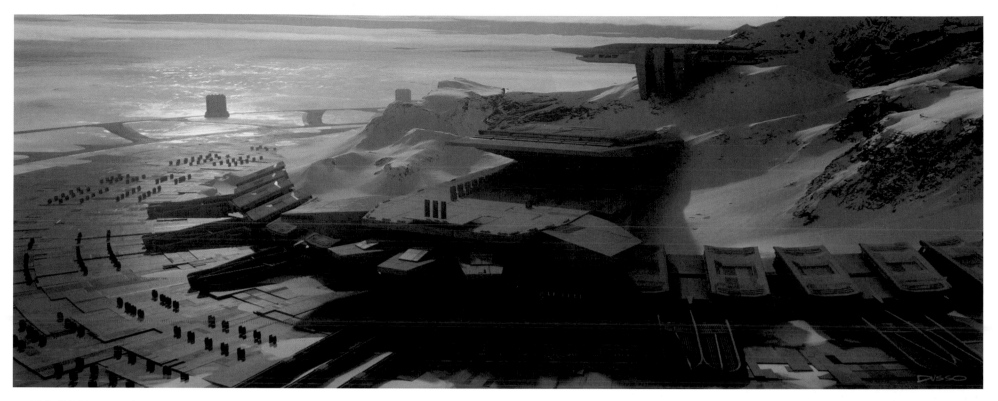

▲ THOR'S PICS Dusseault

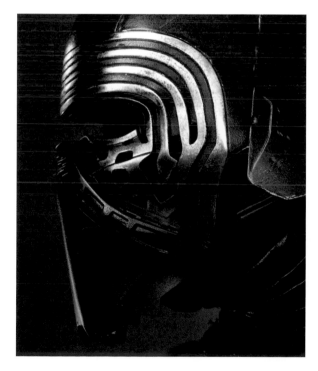

▲ KYLO REN (ADAM DRIVER) Photograph by Jules Heath

▲ OSCILLATOR—007 STAGE Allsopp

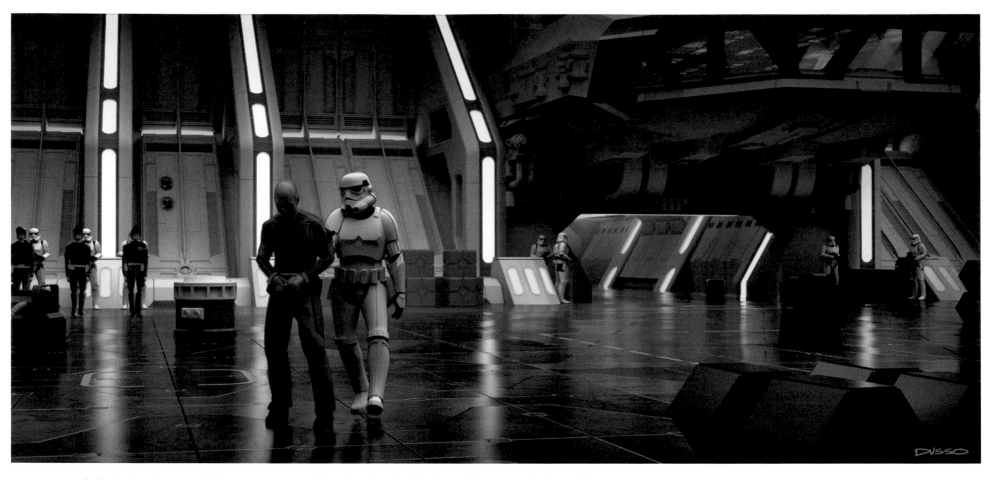

▲ **WALL** *"We had to look at the set and address the question of where the cobra-head bridge would sit. That will obviously be CG extension."* **Dusseault**

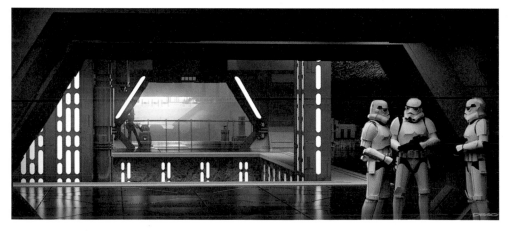

▲ **PIT Dusseault**

"We were originally going to put Starkiller-base hallways on E Stage once we struck the resistance base. We were trying to figure out how we were going to incorporate a pit into that set and then also use the projection hallway. J.J. kept on going back to the original Death Star set from A New Hope and the genius of its design." **Gilford**

▶ **FIRST ORDER STORMTROOPER OFFICER Photograph by Jules Heath**

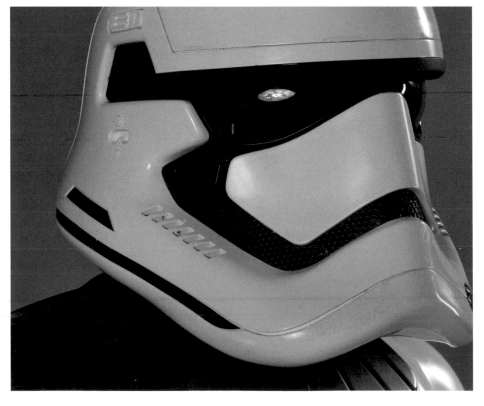

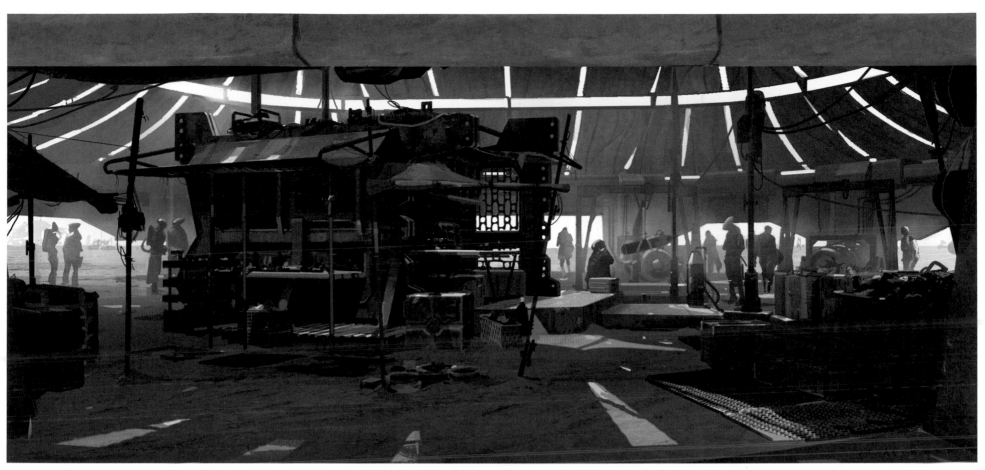

▲ **GANG BOSS STRUCTURE** Allsopp

▲ **STEELPECKER** *"Somehow Steven Spielberg and J.J. had had a conversation that led to the idea of a bird eating metal. It would be poking around the innards of a machine and come out all oily and dirty and crumbly—old filthy rust all over its feathers— which I found quite exciting."* **Davies**

▶ **IN HIS HUT** *"These were some of the most pleasurable things to create because Max von Sydow's face was so easy to draw, in a way, because it's so characterful and he has such distinctive facial features. McQuarrie's Boba Fett has a cape that falls down in front, over the shoulder, which I really loved and tried to emulate.* **Dillon**

▲ **JUNK BOSS FULL BODY** Davies

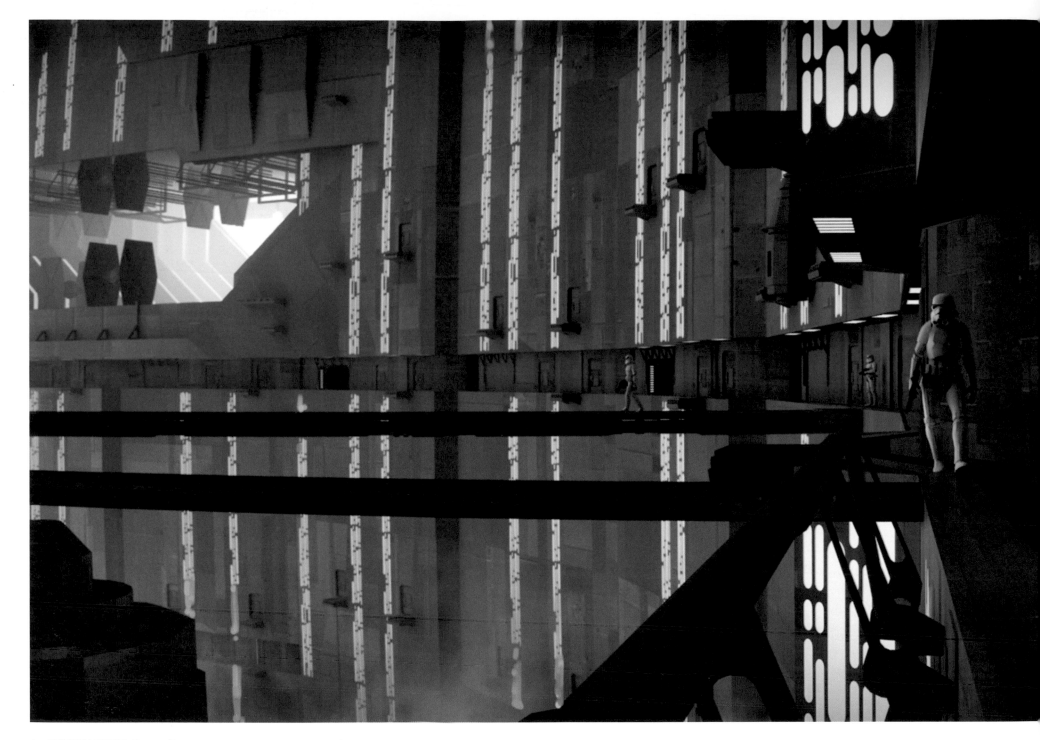

▲ **TRENCH LAYOUT** Dusseault

PRODUCTION

The production phase of the design of *Star Wars: The Force Awakens* officially kicked off on May 17, 2014, with the first day of principal photography on location in the United Arab Emirates. The company remained in Abu Dhabi for a week and a half before returning to Pinewood Studios for the remainder of the production, outside of two relatively local and one distant location shoot on the Skellig Islands off the coast of County Kerry, southwest Ireland. "Rick and I were able to divide and conquer," co-production designer Darren Gilford recollects. "Certain things I'd ask his opinion on, he'd ask my opinion on, or we'd evaluate them together. It was a very fluid relationship, and we threw our resources, time, and effort where they were needed."

The production ran smoothly until a June 11 on-set accident involving Harrison Ford. This led to a complete re-working of the shooting schedule and a two-week cast-and-crew hiatus in August, to allow Ford time to recover. The end of principal photography shifted from mid-September to early November. Soundstage sets, such as the *Millennium Falcon*, resistance base, and Maz's castle interiors, which were intended to be struck and, in some cases, replaced with other sets, had to, instead, remain standing until Ford's return. In the case of the crucial Starkiller base hallway interior, the relocation to Pinewood's smaller Richard Attenborough (R.A.) Stage, where the Star Destroyer hangar wall once stood, necessitated a complete rethink and redesign.

"I don't know what the final count was, but I think if you add everything up—vehicles, cockpits, etc.—I think we were at 125 or 130 sets, which is a ridiculous amount. Some of them were huge, full soundstages, and some of them were just tiny closets of the *Millennium Falcon*. Paul Hayes and his construction team handled it without batting an eye," Gilford says.

Following a full travel day, prep day, and pre-shoot day from May 14 to 16, principal photography began in Abu Dhabi on Saturday, May 17. The subsequent week of desert shooting covered the First Order attack on the outpost, moving into Al Qasr's orange sand dunes for the TIE fighter crash landing and Kira's fallen AT-AT dwelling sequences. "We painted it exactly in that classic primer gray that the AT-ATs were rendered in the snow," Gilford says. "It looked great in the snow, but out in the bright sun of the desert, it just didn't look right. So we shipped our lead scenic painter, Paul Wescott, out there and he ended up making the whole thing metallic—but not too shiny or fake-looking."

Back at Pinewood Studios, the crew prepared for the company's return on May 30 and 31. Design work remained focused on Starkiller base sets and story points, placing the final details on costumes and filling out the resistance base and castle sets with creatures.

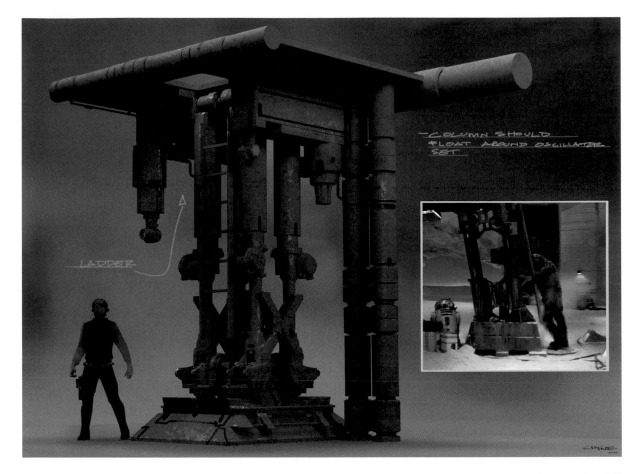

▶ **COLUMN DETAIL** Clyne

▲ **SMOKE SHADOW** *"They were trying to get it very atmospheric, almost Chinese shadow puppetry, with the screens."* **Dusseault**

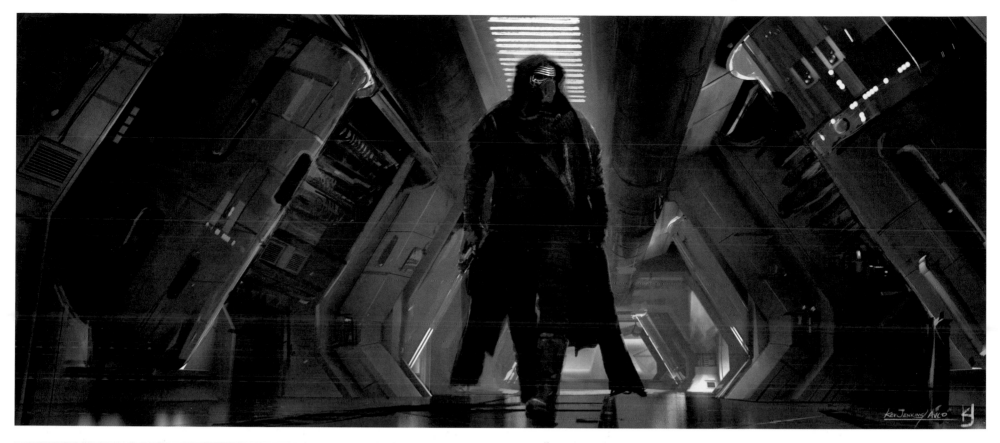

▲▲ **OSCILLATOR** Jenkins ▲ **MAIN CORRIDOR TO OSCILLATOR** Jenkins ▲ **STORMTROOPER UPSTAIRS** Clyne

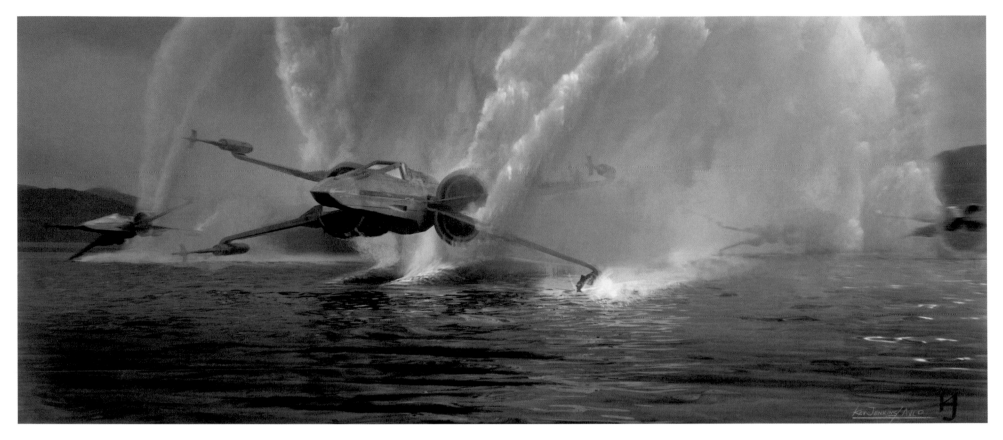

▲ **X-WING ON WATER** *"I think producer Bryan Burk had this idea, a bit like the movie Firefox, of the X-wings just skimming across the water."* **Jenkins**　　　　　　▼ **X-WING APPROACH** **Allsopp**

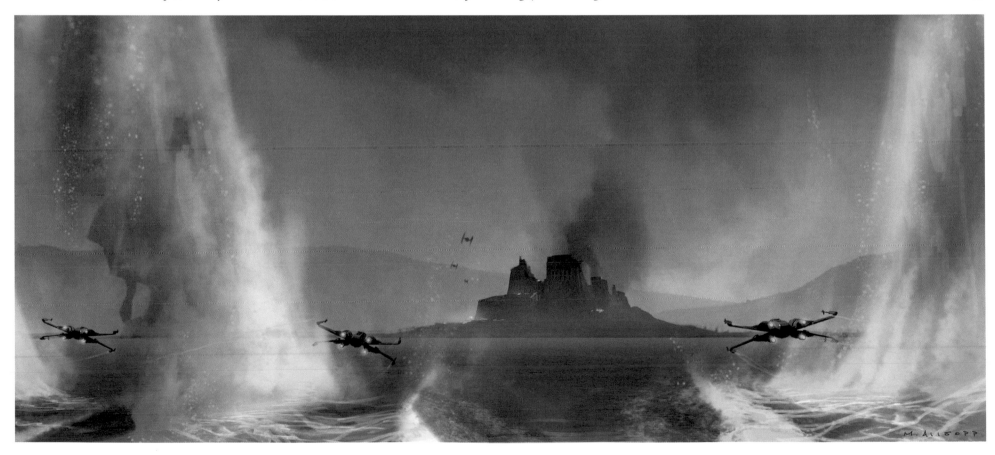

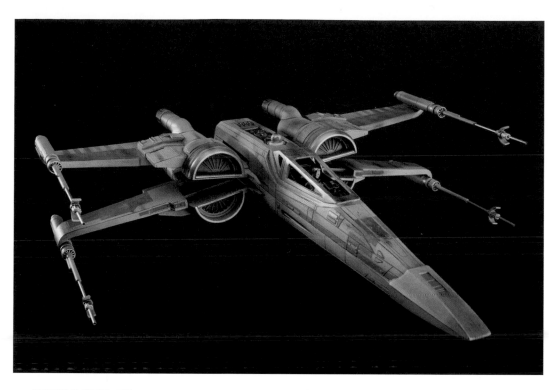

▲ X-WING FIGHTER Ellis

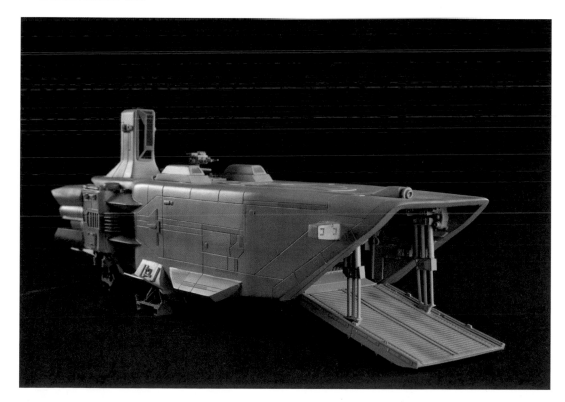

▲ FIRST ORDER TROOP TRANSPORTER Ellis

▶ POE FLIGHTSUIT Dillon

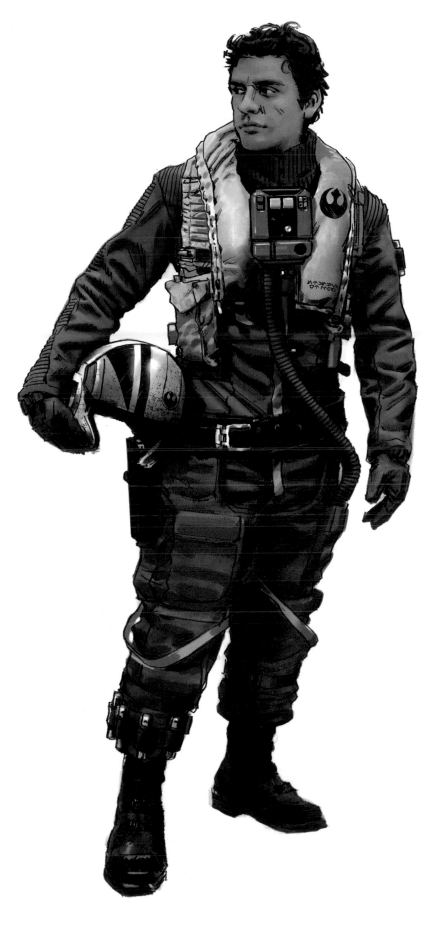

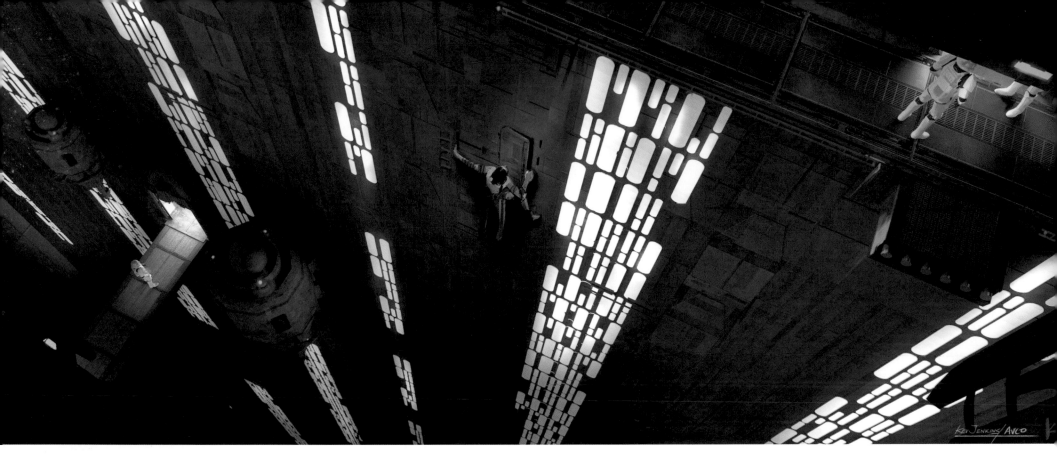

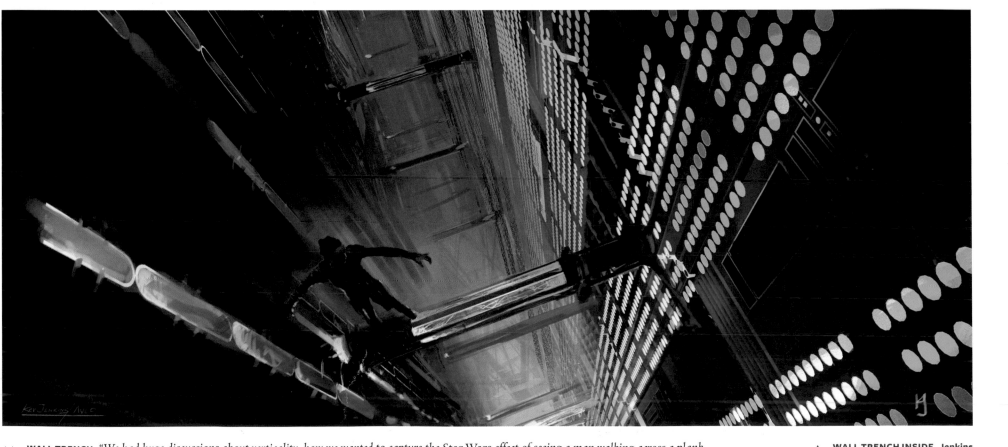

▲▲ **WALL TRENCH** *"We had huge discussions about verticality, how we wanted to capture the Star Wars effect of seeing a man walking across a plank above you—panning down and seeing the drop go on. These pieces were about trying to create that basic seventies Star Wars look."* **Jenkins**

▲ **WALL TRENCH INSIDE** Jenkins

JAKKU SACRED VILLAGE, SET Photograph by David James

"Once we got to the backlot and started sculpting the huts, we had to create our own sand berms and dunes to help create a horseshoe around the village. It was one of the first sets we did, and I was a little nervous about it. But once we got out there at night, lit 'em up, and saw the environment, it worked really, really well." **Gilford**

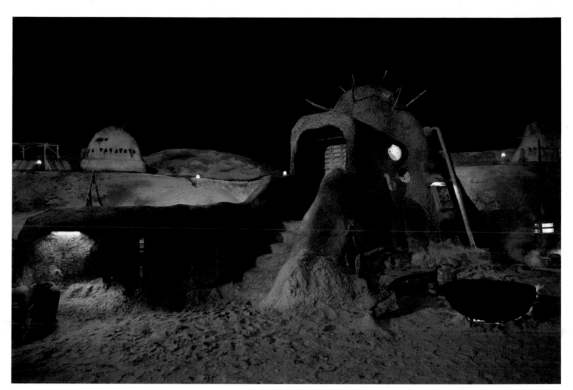

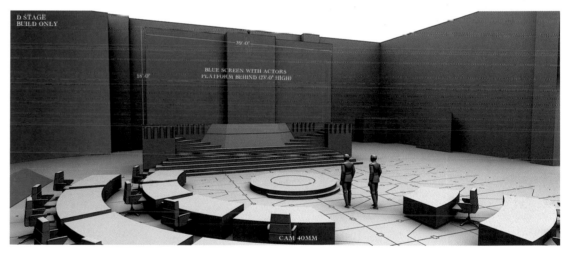

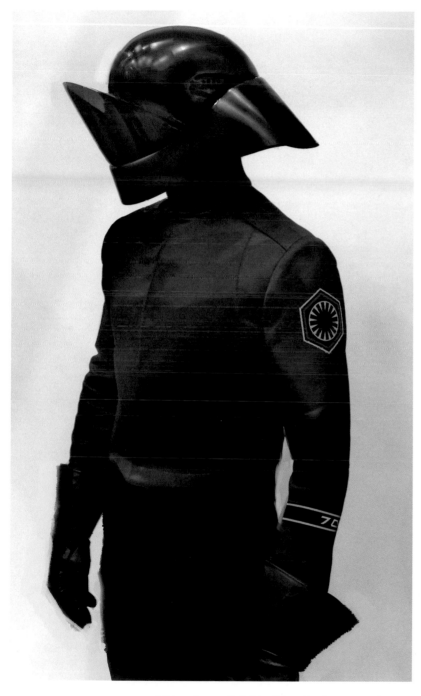

CONFERENCE ROOM WIDE *"This reflects a little bit of the Lincoln Memorial. Supreme Leader Snoke was going to have this ambient occlusion, shaded gray. So he would be a solid mass, but at the end we would realize Snoke was just a hologram all along."* **Clyne**

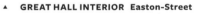

◄ **SQUAD LEADER** Dillon ▲ **GREAT HALL INTERIOR** Easton-Street

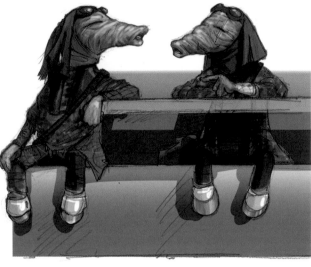

▲ **MAZ'S CASTLE ALIENS C056** Davies

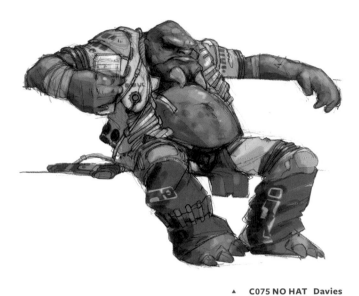

▲ **C075 NO HAT** Davies

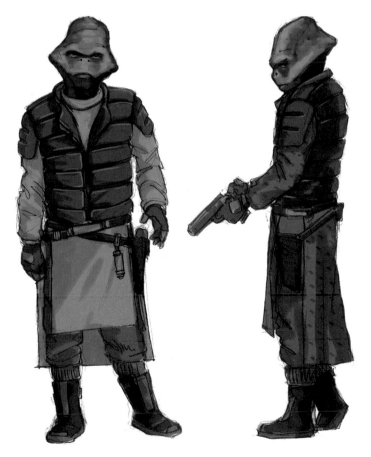

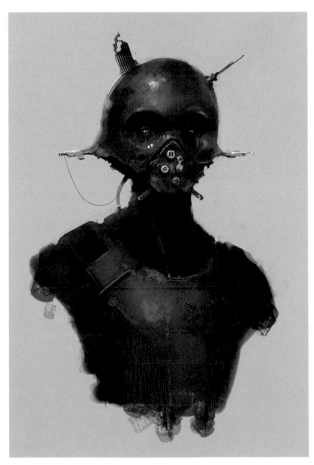

▲ **MAZ'S CASTLE ALIENS C020** Davies

◄ **BROWN TATTOO C058** Davies

▲ **MAZ'S CASTLE DROID ORIGINAL** *"I envisaged this character as a bounty hunter–type. In adding the costume, Jake Lunt Davies turned it into a female droid! It ended up becoming quite sexy. [Laughs.]"* **Fisher**

► **GRUMMGAR AND BAZINE NETAL** **Photograph by David James**

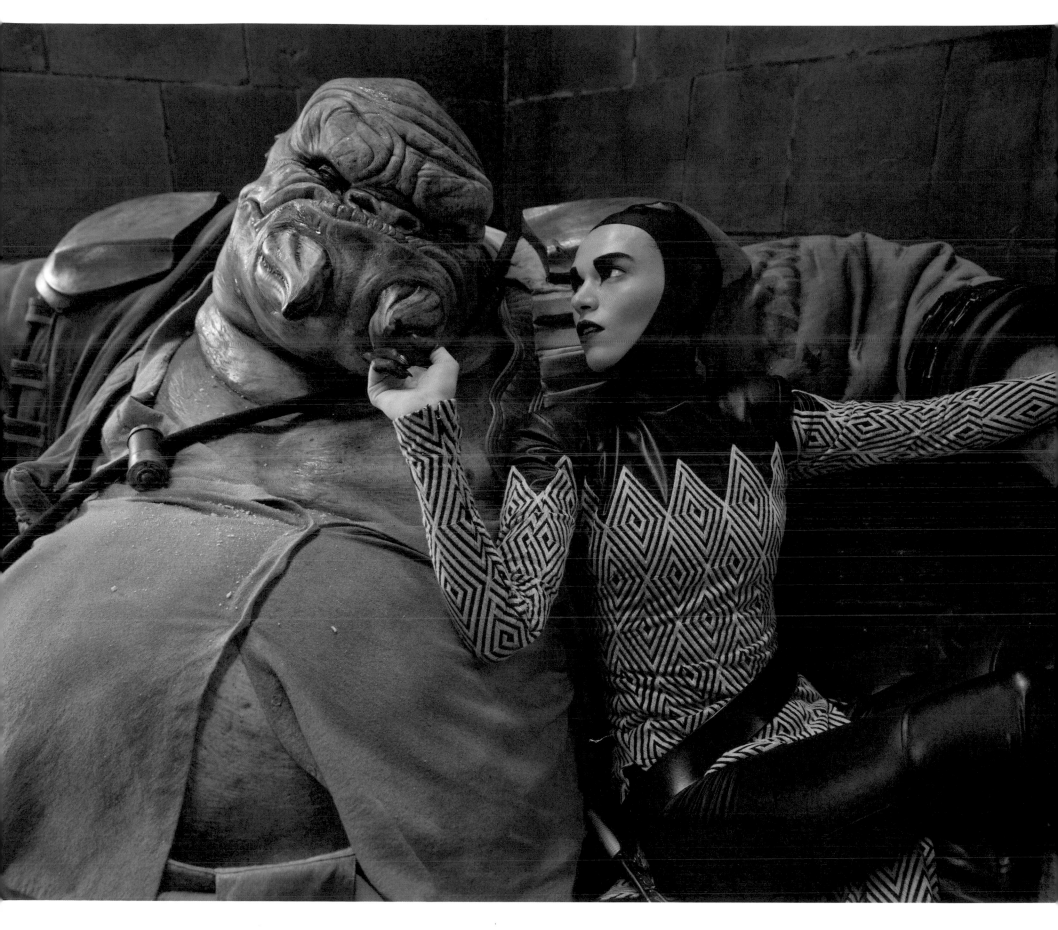

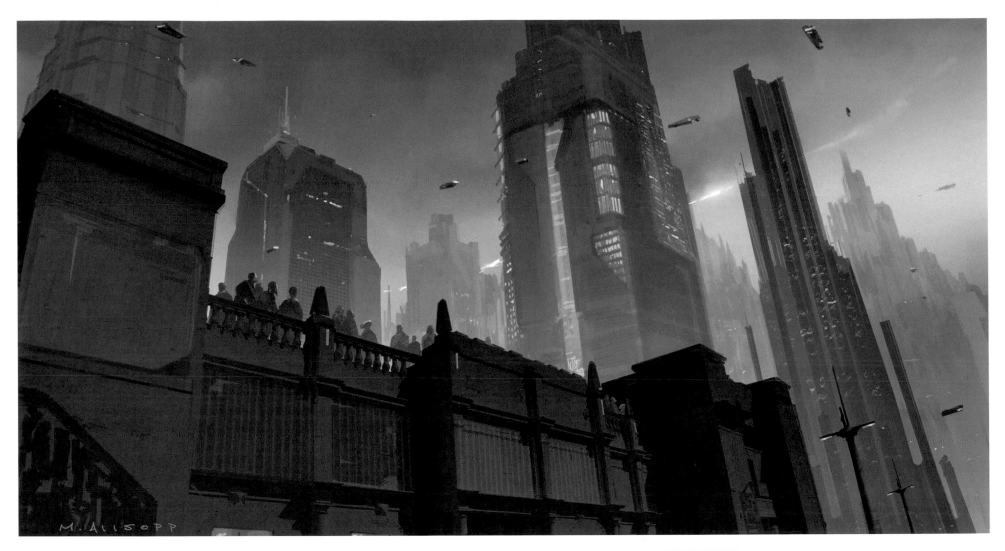

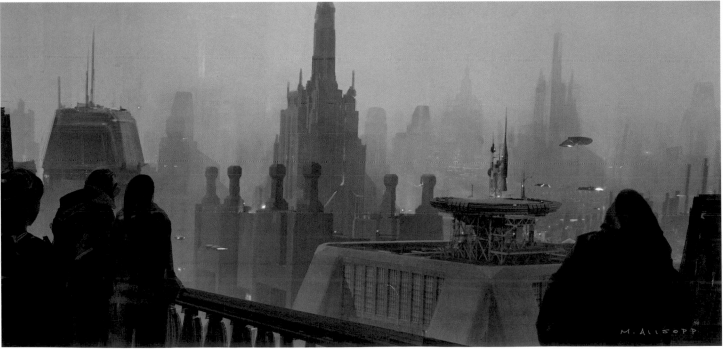

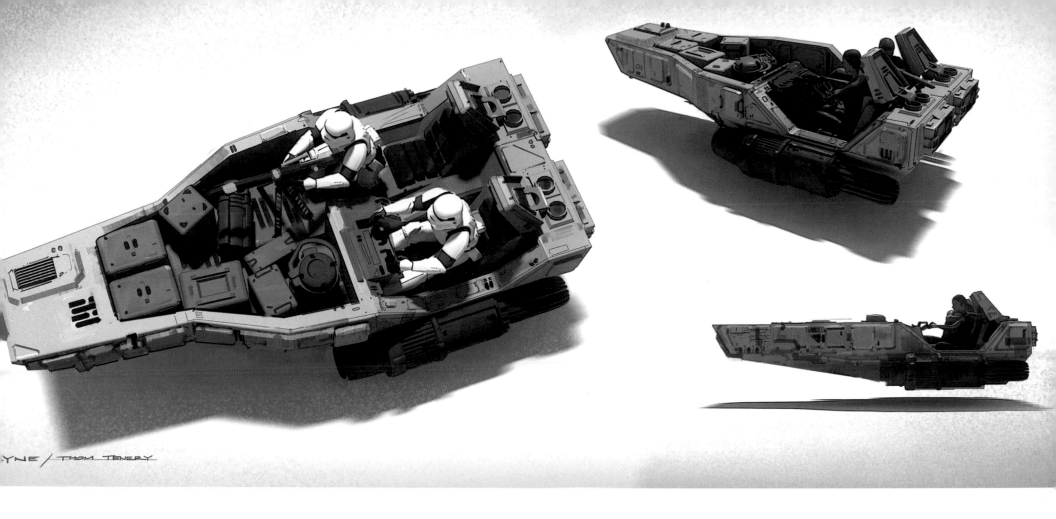

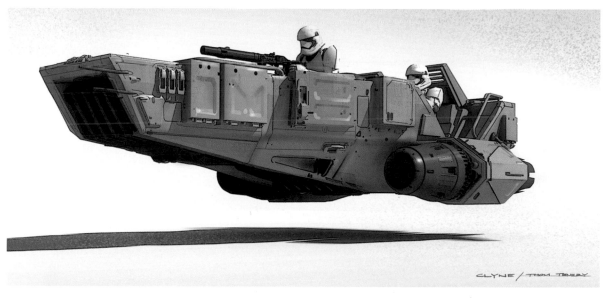

TOP CORNER
OF HEADREST
BLOWN OFF

THESE PARTS OF FINS
TO BE BLOWN OFF

SCORCH MARKS ON
BODYWORK (PAINTED ON)

▲ ▲ **SPEEDER DEVELOPMENT** Clyne and Tenery

"J.J. really liked the silhouette that James blocked out, but he suggested we try reversing
it. And so I flipped that design, made the front the back and vice versa." **Tenery**

▲ **TAPERED HULL 04** Clyne and Tenery

"The snowspeeder started to feel like a swamp buggy, or a bayou swamp-boat.
It almost has a skiff nature to it, sliding over the snow, which I liked very much." **Gilford**

▲ **DAMAGE AREA** Stuart Rose

Buoyed by the success of the Abu Dhabi loca- tion shoot, the filming crew returned to Pinewood in high spirits. Shooting resumed on the Star Destroyer sets starting May 30, transitioning to the *Millennium Falcon* interior sets during the day and the Jakku village backlot set at night on June 3. Then, the unthinkable occurred. On June 11, Harrison Ford was injured on the *Falcon* set only days after starting *The Force Awakens.* "Harrison's accident was horrible on every level," Darren Gilford recalls. "It complicated things a lot, too. There was a lot of redesign and improvised logistical planning, very quickly."

Photography resumed at the *Falcon* sets on June 13, shifting to the resistance base on E Stage and the reset backlot ruins set the following week. But without Ford, those sets, as well as Han's under-construction cargo hauler and Maz's castle set, would have to hold until his recovery and return. The Starkiller base and Maz's castle exterior continued to dominate the concept artists' work in June, as design started at ILM on purely digital shots, such as the resistance X-wings skimming the water and the Starkiller base starfighter battle.

▲ **MAZ CONCEPT** *"When they ran out of time to create a puppet, Luke Fisher, Jake Lunt Davies, me, and Dermot Power were called in to create some designs for Maz. They wanted her to have more of a fortuneteller vibe. That's where the bangles and big giant sequins come from."* **Dillon**

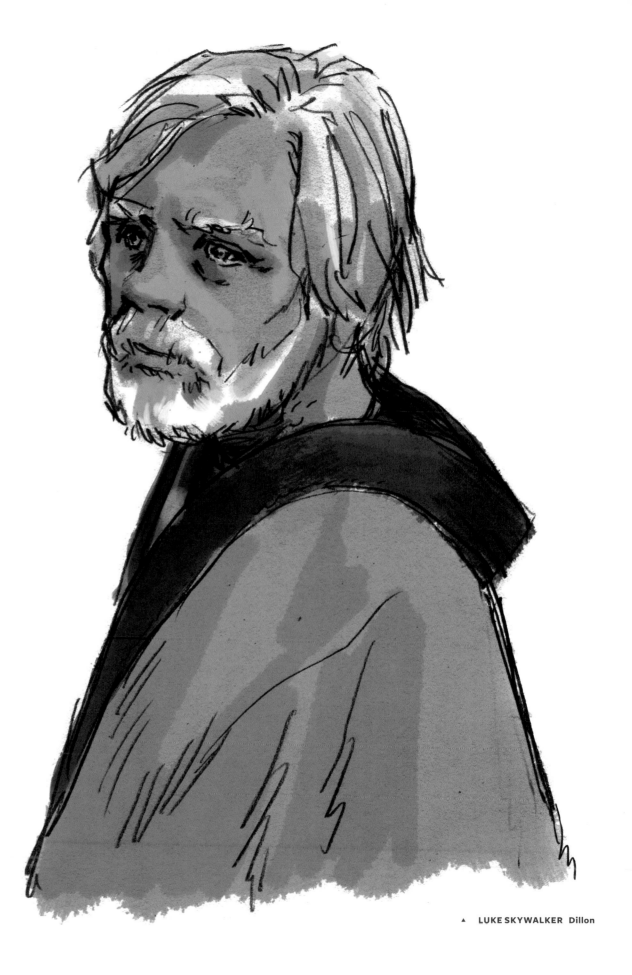

▲ **LUKE SKYWALKER** Dillon

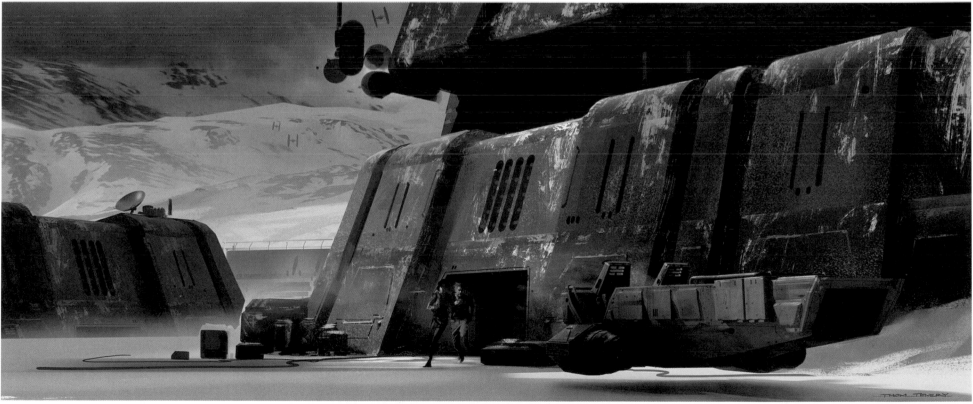

▲▲ **STARKILLER PLANET** *"You put an atmosphere on the Starkiller, and it nearly takes away all the things that make the planet even look believable. And so I tried this idea of breaking through the surface with the gun."* **Jenkins**

▲ **PARKING LOT DOOR** Tenery

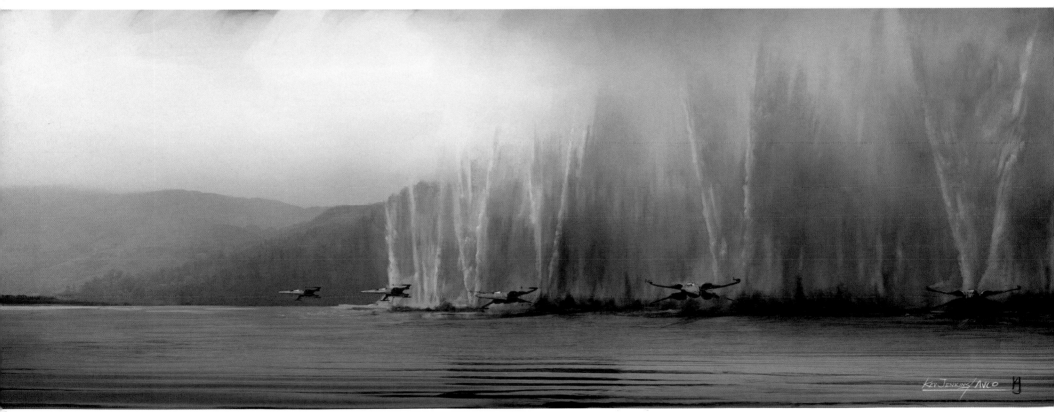

▲▲ **X-WING APPROACH** *"J.J. wanted this super-vertical rooster tail of water, which was fun to create."* **Clyne**

▲ **X-WING ON WATER** Jenkins

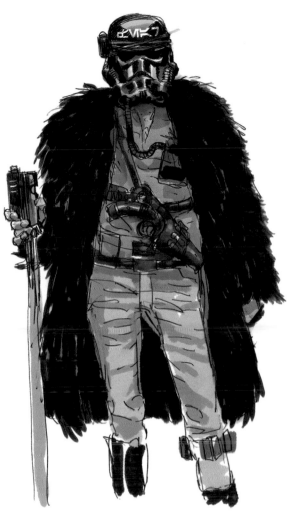

▲ **OLD TROOPER BARFLY** Dillon

▶ **C024 ORIGINAL** *"When we started off, it really was just a big pool of characters. C024 (Sidon Ithano) was from that pool. Colin Jackman ended up sculpting his helmet and did a lovely job."* **Fisher**

▼ **OVERLAY C079** Davies

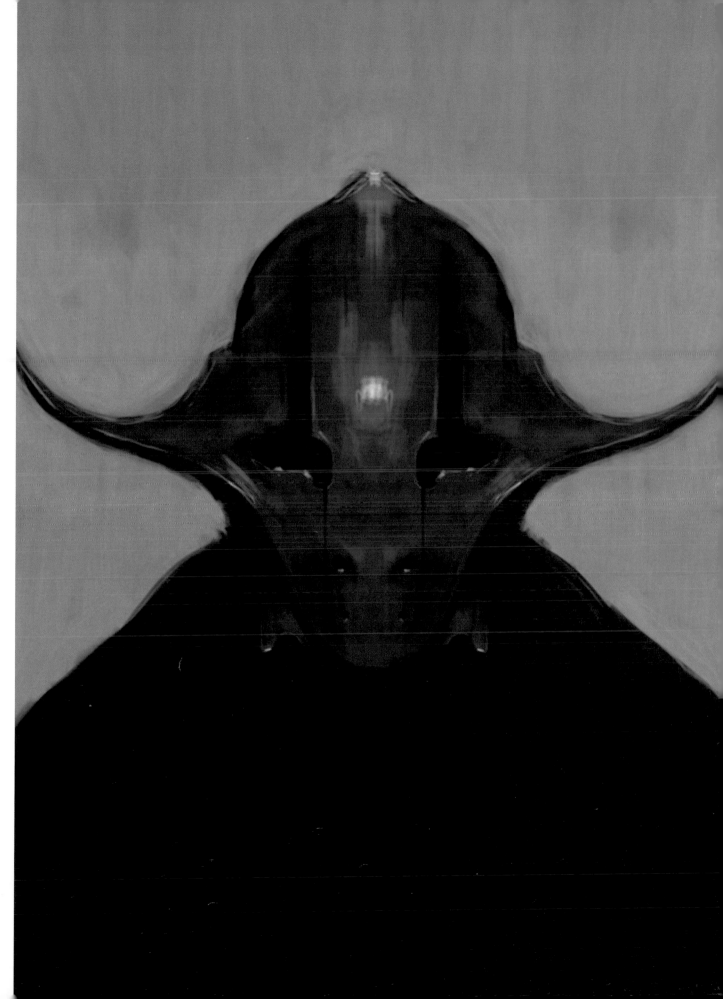

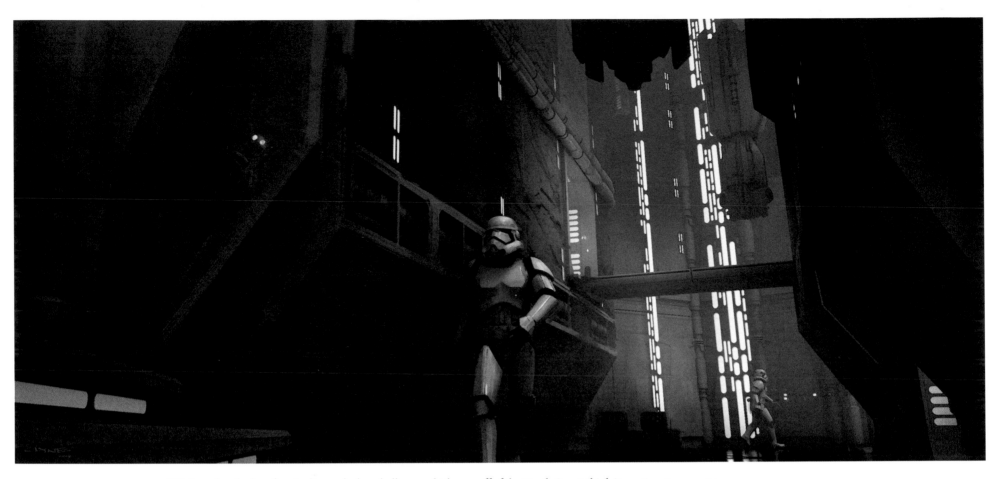

▲ **MAIN CORRIDOR LAYOUT 06** *"We introduced a lot of verticality to the base hallways, which cues off of the Death Star. I think it was twenty-seven to thirty feet to the perms, the ceiling of the actual set, and they just let it go to black. J.J. tried to push, in-camera, as much as possible."* **Clyne**

▼ **PILLS** Dusseault

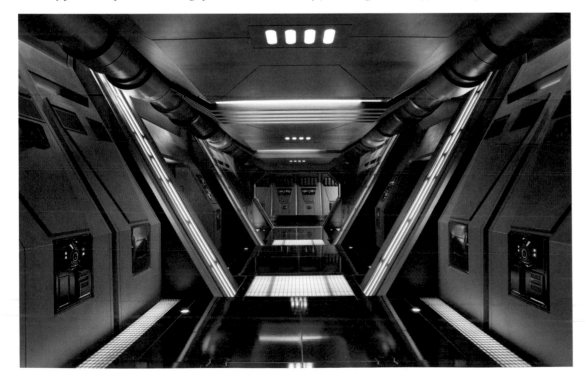

▲ **FIRST ORDER STAR DESTROYER HALLWAY** Photograph by John Wilson

▲ **MAIN CORRIDOR LAYOUT 05** Clyne

▲ **CONTROL ACCESS POINT CONSOLE REVISED** Mark Harris

"When Mark Harris, one of our local art directors in London, was sixteen or seventeen, he was working directly with art director and set decorator Harry Lange on The Empire Strikes Back and literally was doing the tape application with Harry, knew his process and knew his background. So I immediately said, 'All the graphic applications on physical sets are going through Mark.'" **Gilford**

▶ **KIRA (REY) FINALE** "I didn't know Rey was going to have a second outfit until about a week before it had to be made [laughs]. I wanted the outfit to look Han Solo-inspired." **Dillon**

▼ **STRUCTURE ON FIRE** Tenery

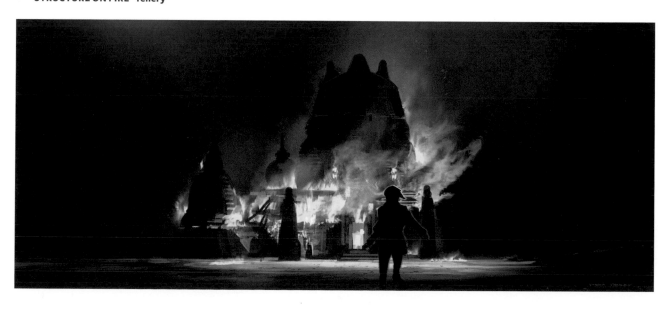

▶▶ **HALLWAY** Dusseault

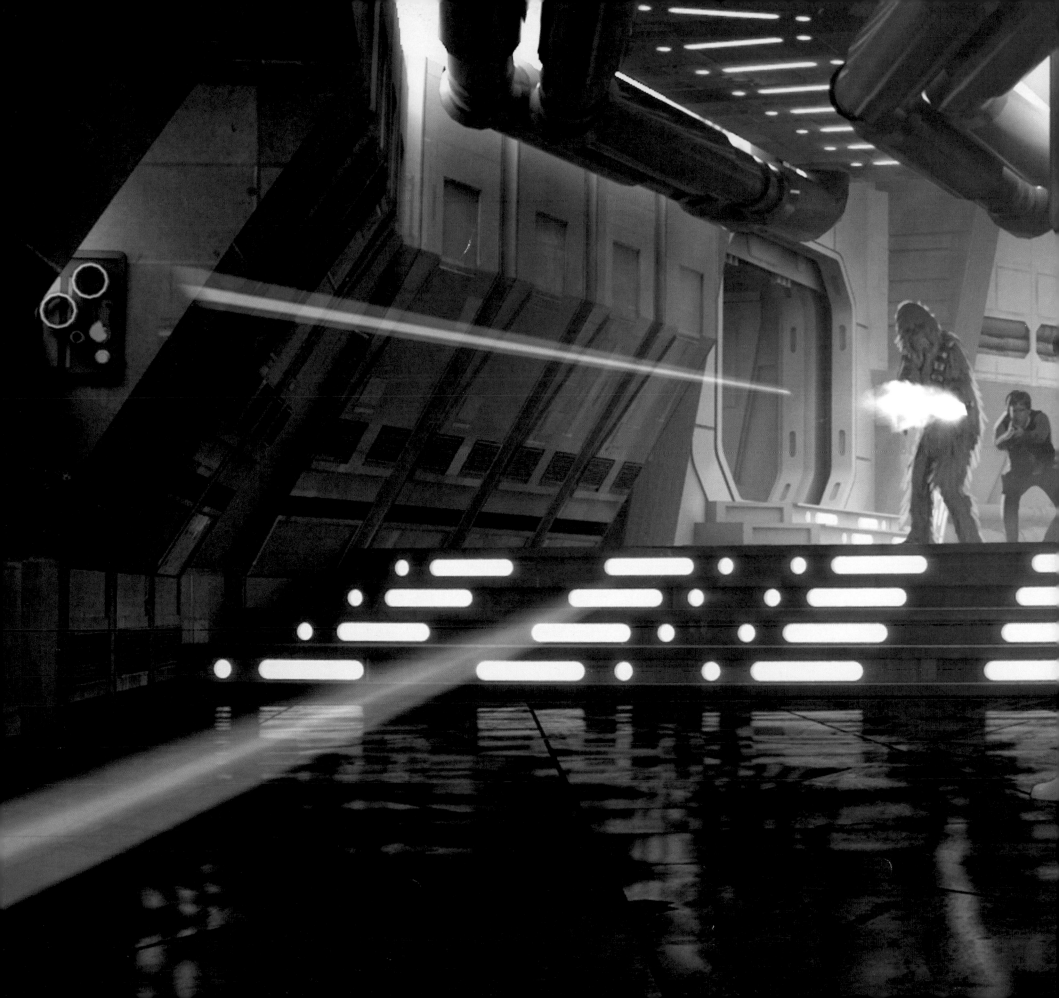

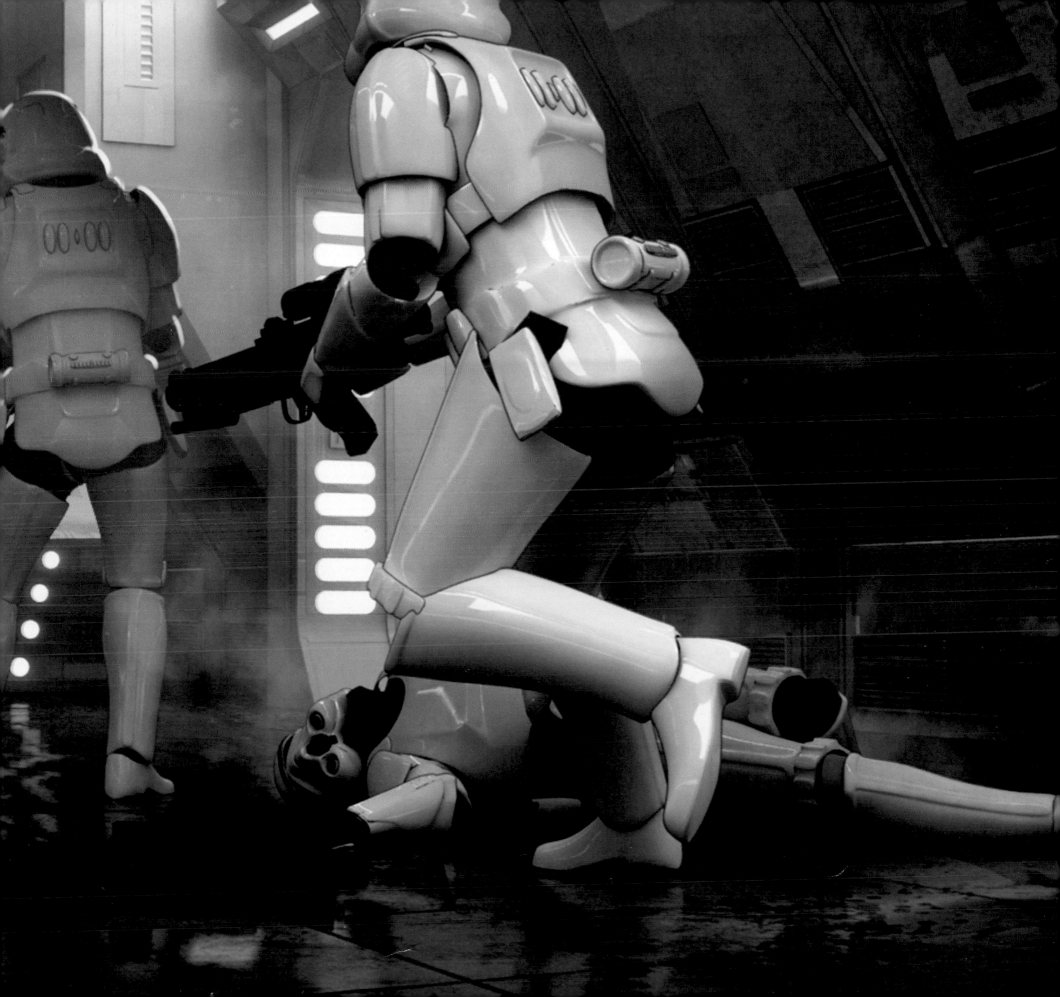

JULY 2014

The main unit continued to shoot whatever cargo hauler and Maz's castle scenes they could without injured lead actor Harrison Ford, including moving up two location shoots originally scheduled for mid-September to July. Designs for the Star Destroyer exterior, to be digitally modeled by ILM, and Luke Skywalker's costume were approved, while progress crawled forward on the resistance troop transporter vehicle. Digital characters Supreme Leader Snoke and the rathtar monster that attacks the gangs in Han Solo's freighter were also addressed but not yet approved.

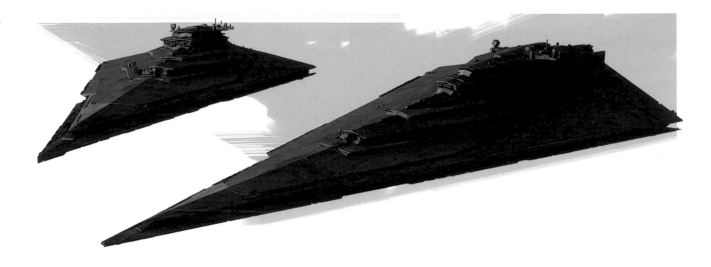

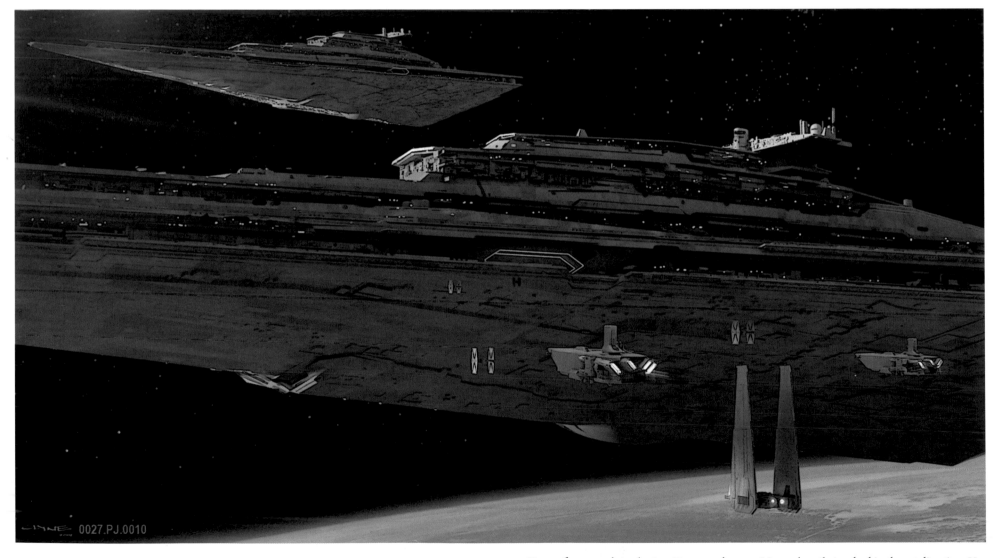

▲ **RETURN** Clyne

▲▲ **STAR DESTROYER VIEWS** *"It was fun to work on the Star Destroyer because J.J. was heavily involved in the art direction. He threw out all these ideas: 'What if we have negative spaces? What if the top tower was asymmetrical?'"* **Clyne**

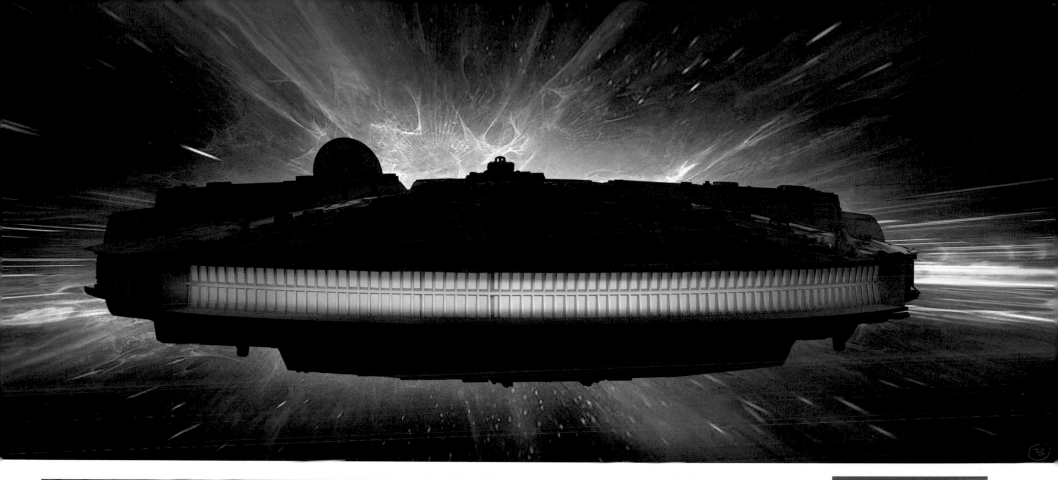

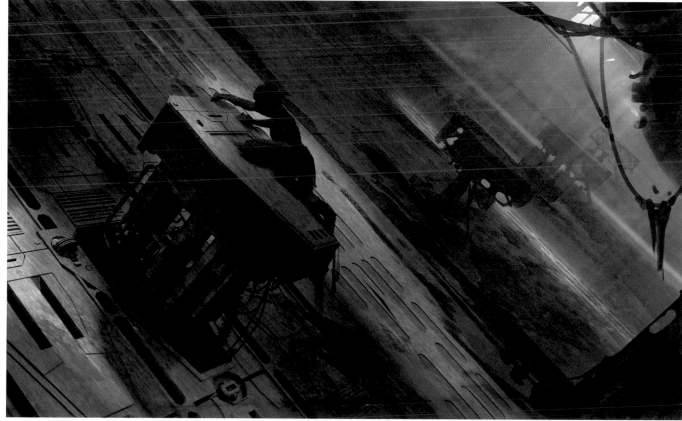

▲▲ HYPERSPACE Clyne

▲ HATCH DEVELOPMENT Tenery

▲ DESCENT PILLAR DETAIL Jenkins

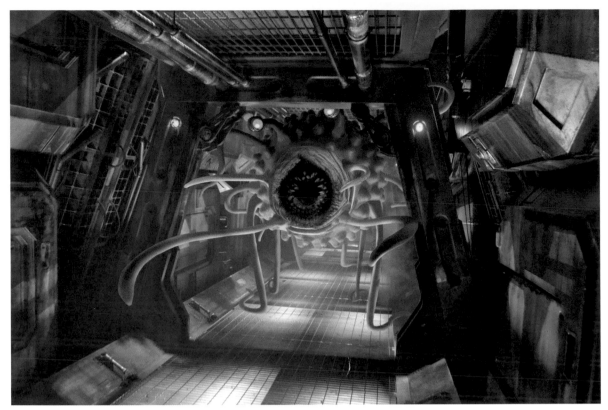

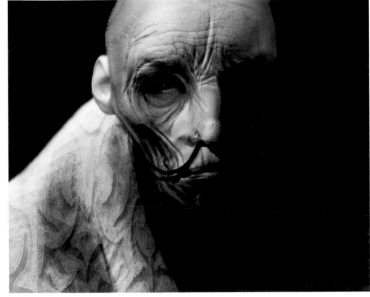

▲ SNOKE 01 *"Snoke almost became a female at one point. J.J. picked out a maquette he liked and then we took it to a full-size version, sculpted in plasteline. J.J. and Neal didn't want him to be old and decrepit, like the Emperor."* **Manzella**

◄ RATHTAR PINK Davies

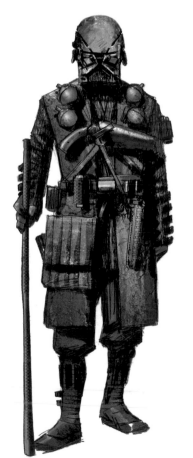
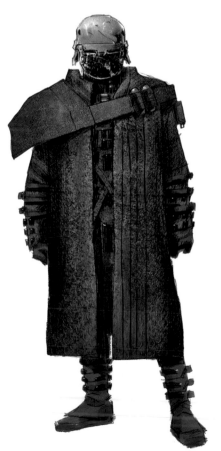
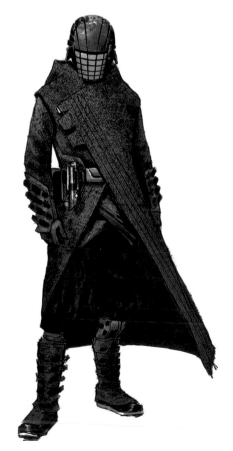
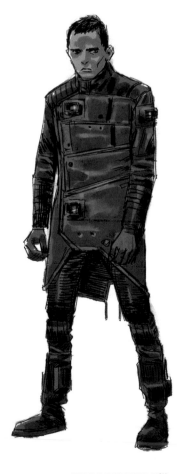

▲ KNIGHTS DESIGNS 01, 02 & 03 Dillon

▲ MOD BOSS MAN Dillon

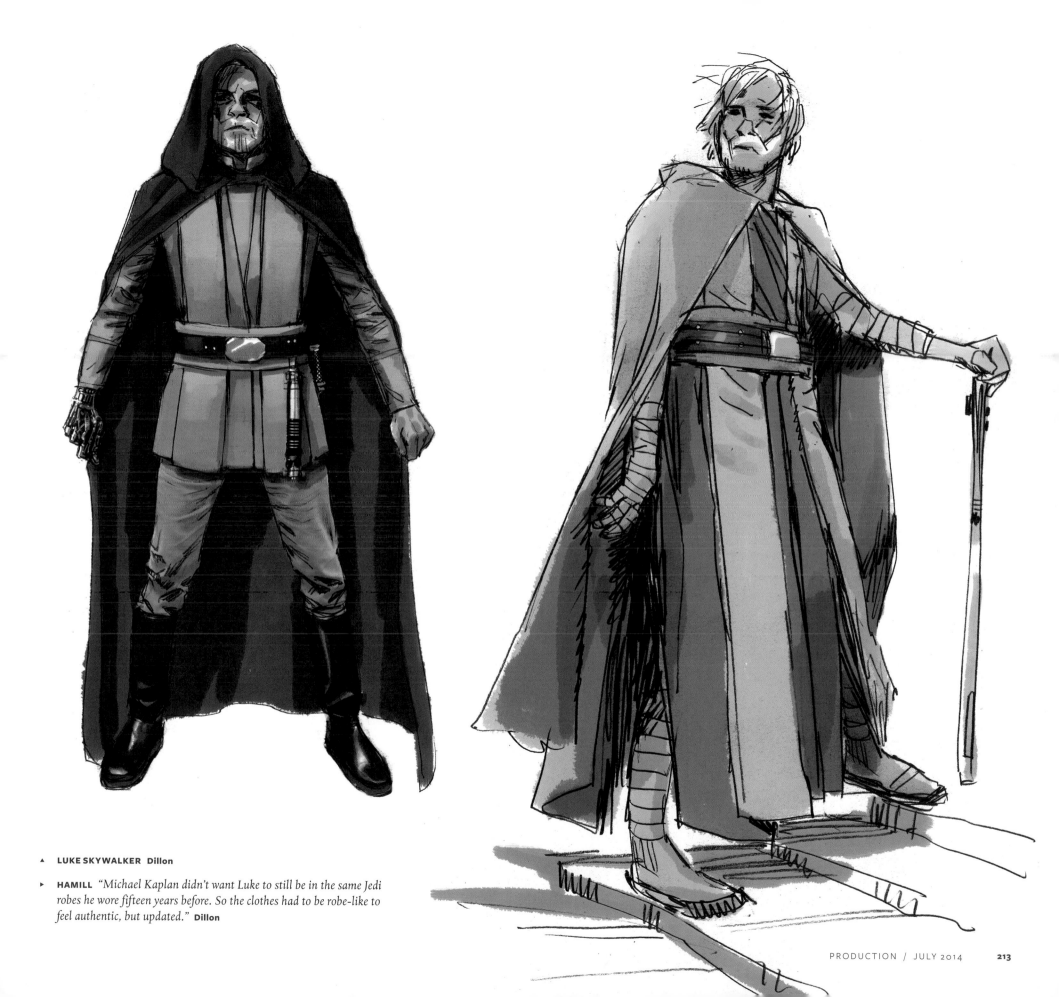

▲ **LUKE SKYWALKER** Dillon

▸ **HAMILL** *"Michael Kaplan didn't want Luke to still be in the same Jedi robes he wore fifteen years before. So the clothes had to be robe-like to feel authentic, but updated."* **Dillon**

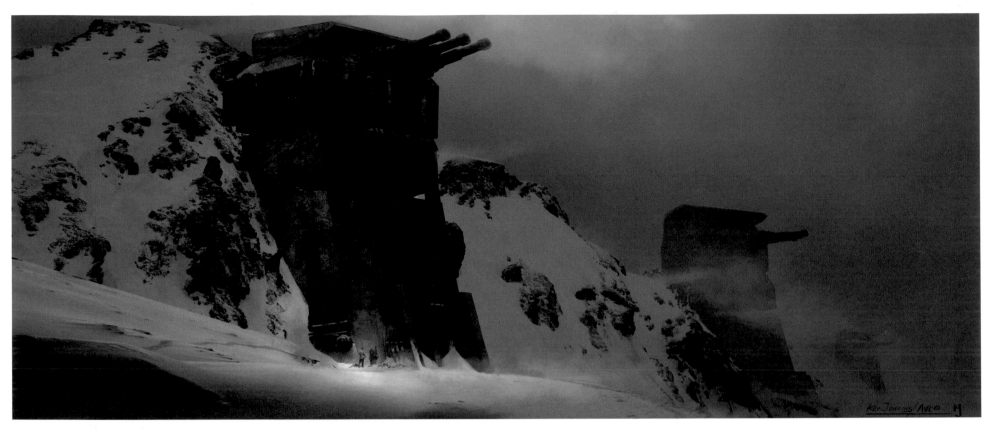

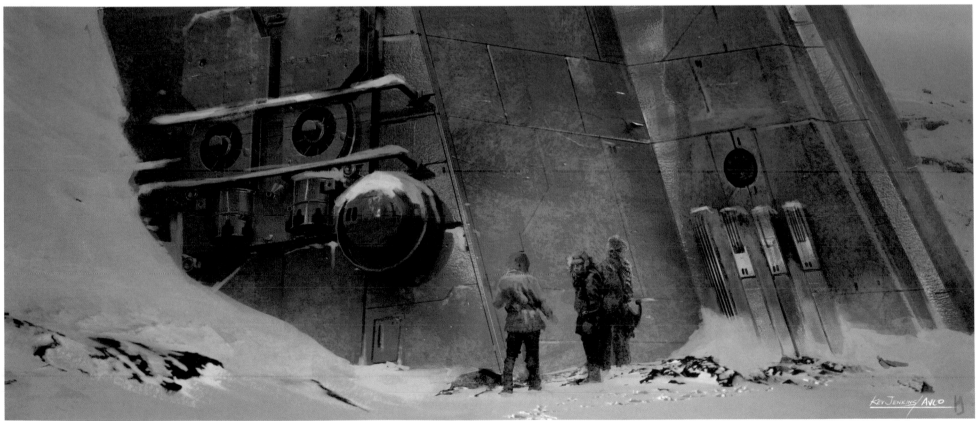

▲▲ **GUN EMPLACEMENT 02** *"I can just see so much of World War II in many aspects of Star Wars, Empire, and Jedi. I'm a big World War II nut, so I threw in references to it as much as I could. This is basically a German battleship gun turret stuck on a Star Wars pedestal."* **Jenkins**

▲ **GUN EMPLACEMENT 01** Jenkins

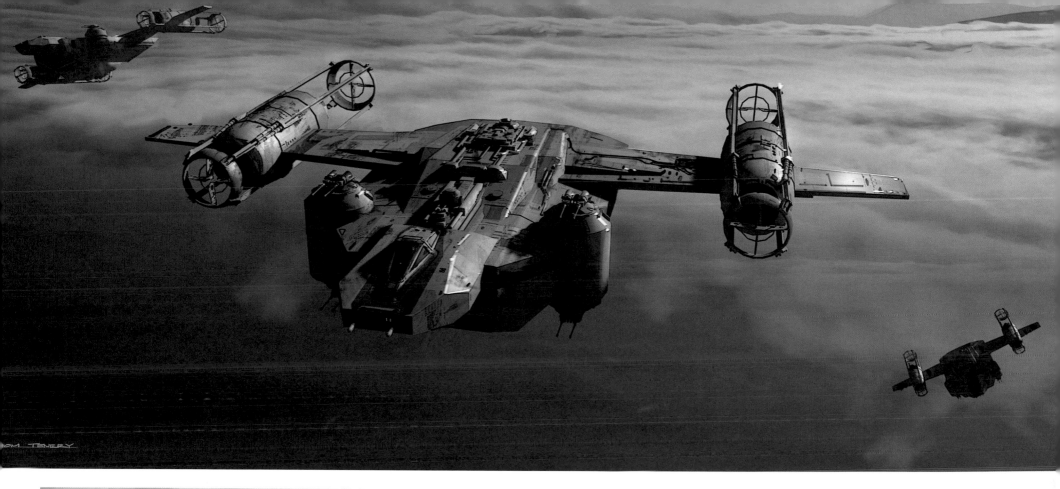

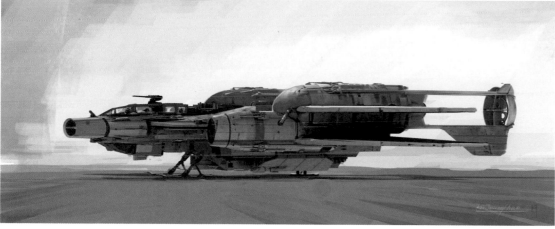

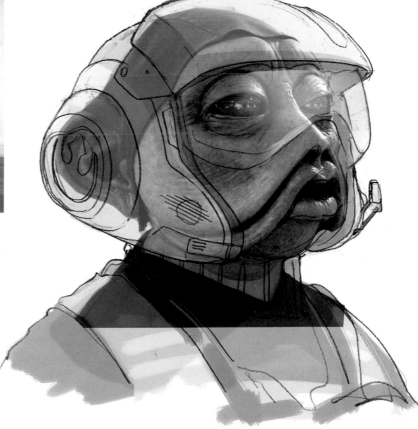

▲▲ **RESISTANCE TRANSPORT FORM DEVELOPMENT** Tenery

▲ **TROOP CARRIER 03** *"When we were getting stuck on the rebel troop transport, I had lots of fun creating the most retro-heavy Y-wing I could."* **Jenkins**

▶ **X-WING HELMET OVERLAY** Davies

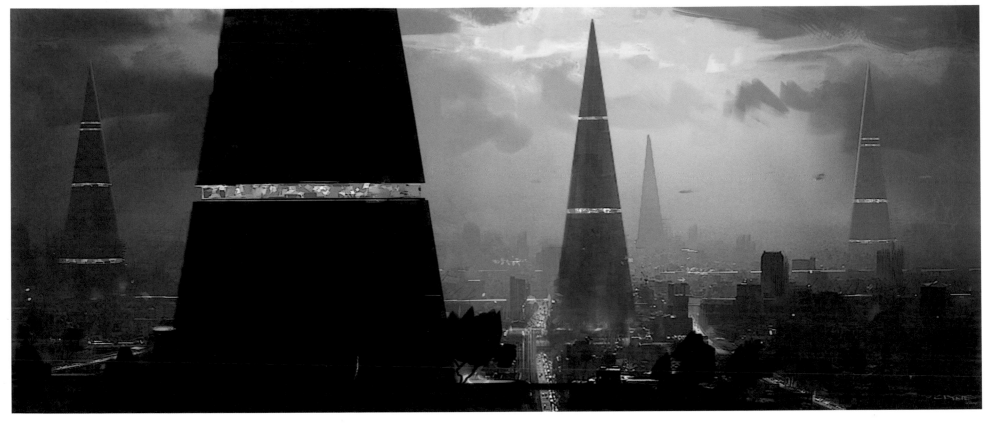

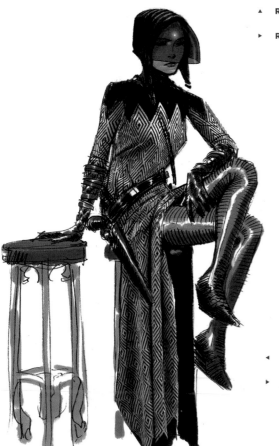

▲ **REPUBLIC CITY** Clyne

▶ **REPUBLIC CITY SENATE** Dusseault

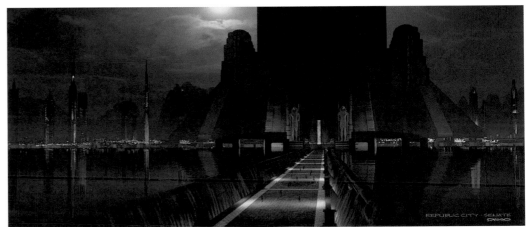

◀ **MAZ BARFLY** Dillon

▶ **WEAPON FIRE** *"This is a series depicting how this gun fires. Everything frozen around the gun turns into water. It knocks down trees. It's a massive planetary scale event."* Dusseault

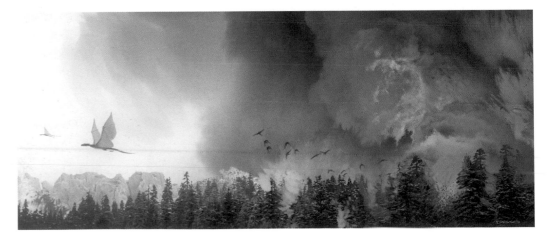

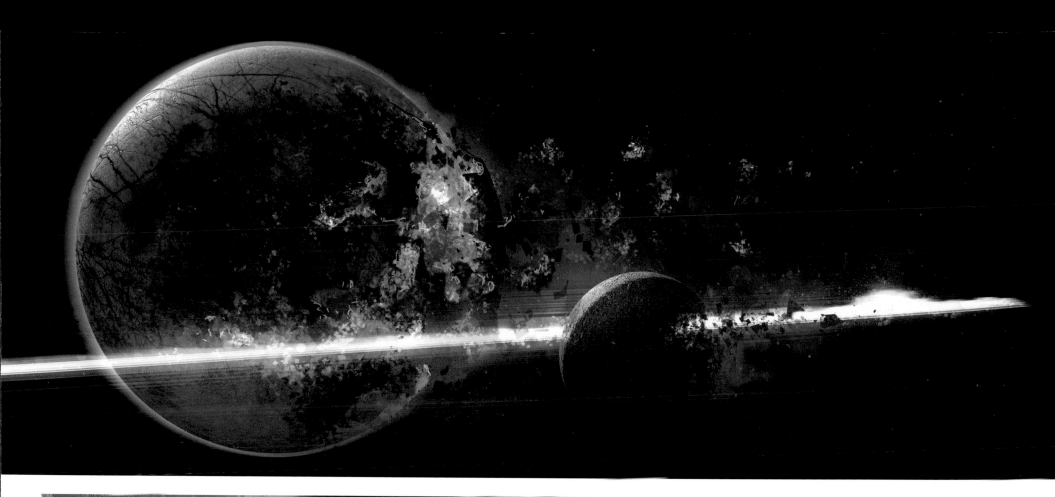

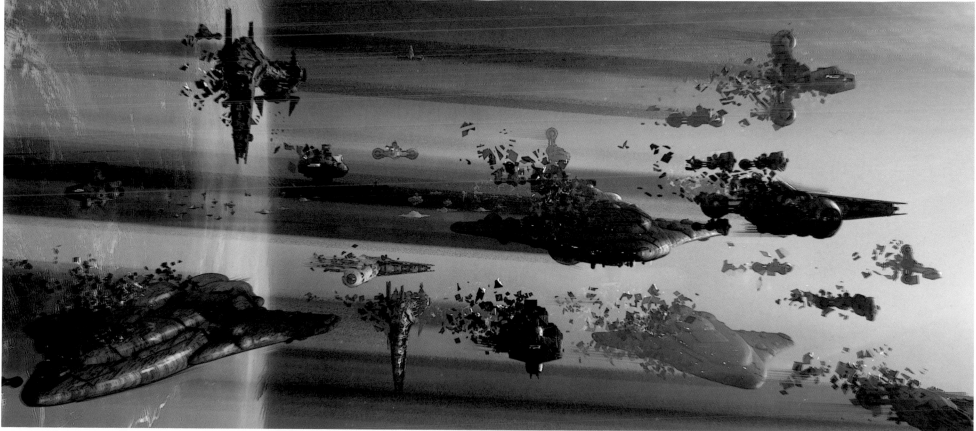

▲▲ **PLANET DESTRUCTION** Clyne

▲ **FLEET DESTRUCTION** Clyne

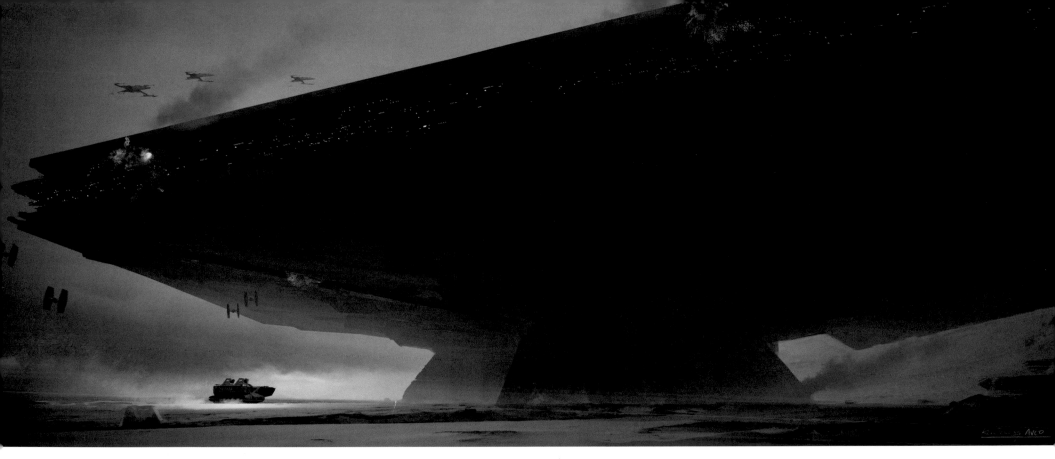

▲ **OSCILLATOR ENTRANCE APPROACH** Jenkins

▼ **ENTRANCE FROM ABOVE** Jenkins

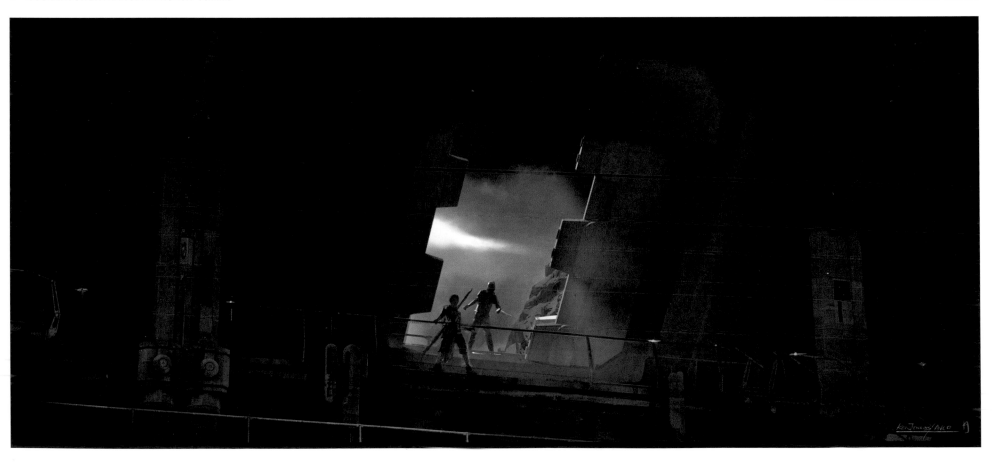

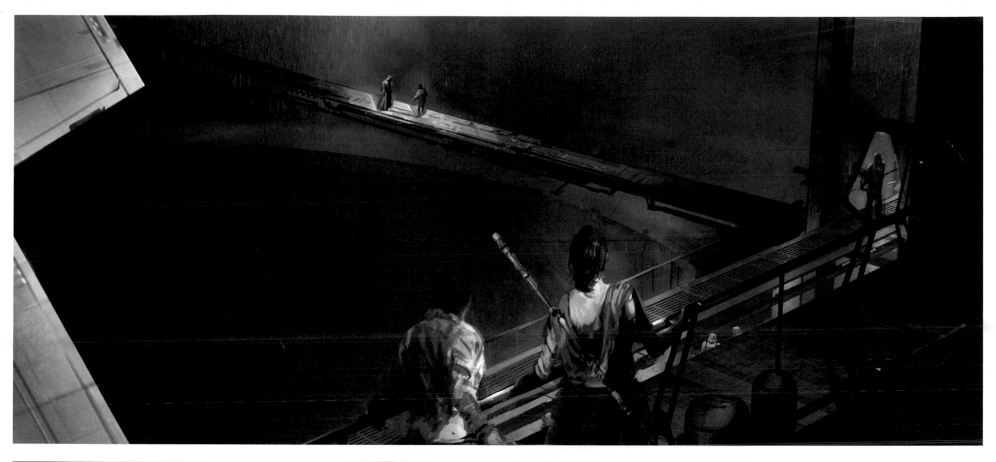

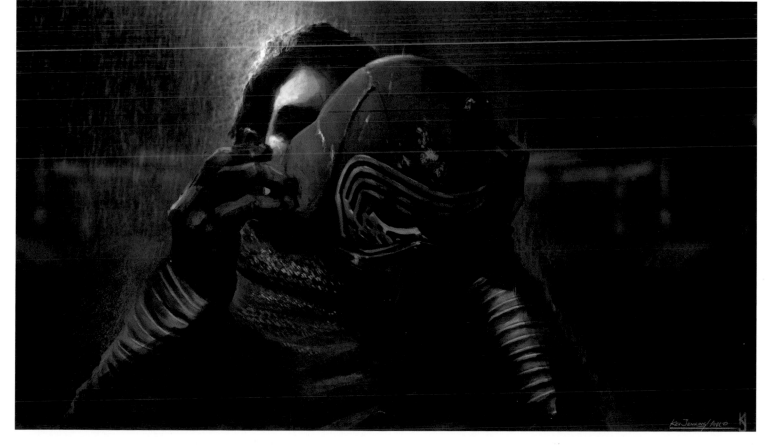

▲ **LOOKING DOWN** Jenkins

◀ **REVEAL** Jenkins

▸▸ **SPOTLIGHT** *"These images are a huge metaphoric exploration about the light and the dark side of the Force, which I had long discussions with Rick about. The wide shot of the light glimmer just hitting the two of them—that's the Force essentially making its decision."* **Jenkins**

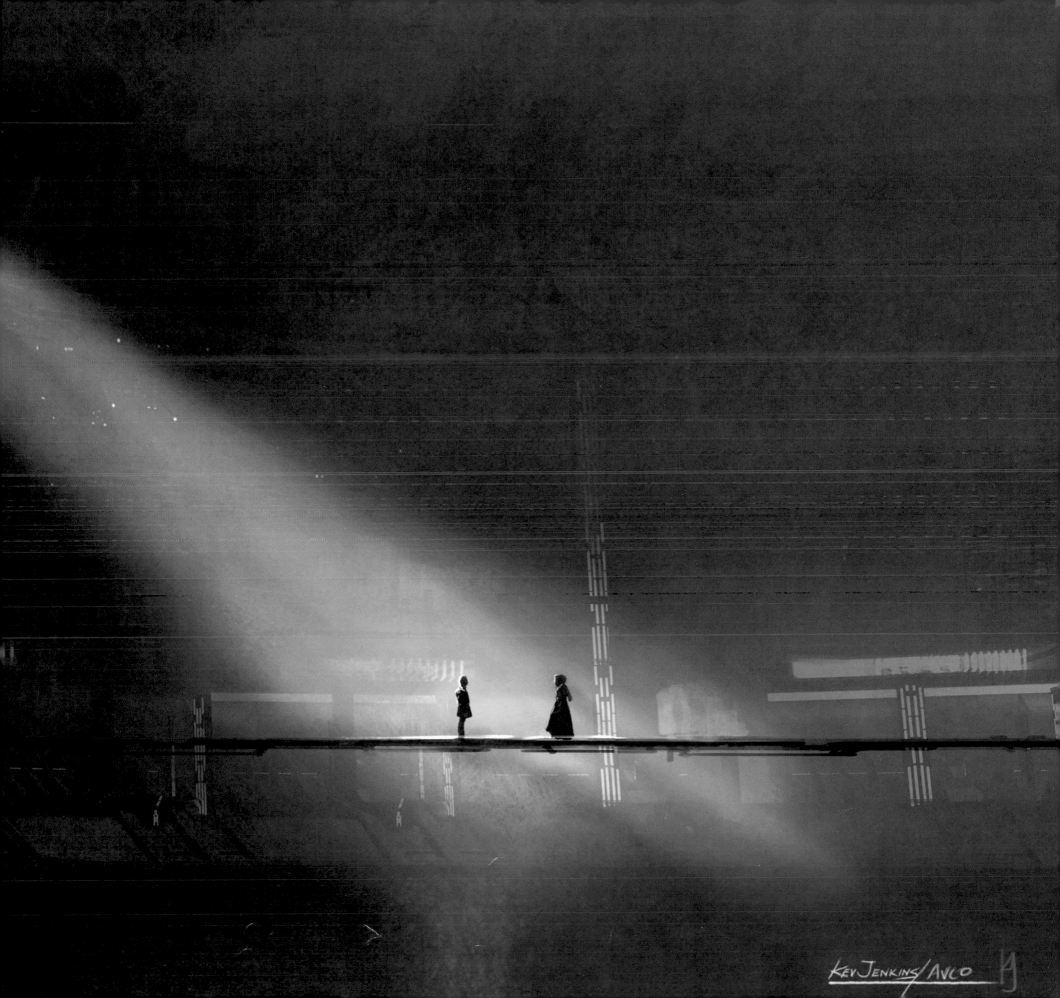

The entire *The Force Awakens* production went on a two-week hiatus in August to give Harrison Ford time to heal. "We were able to recover and get back up to speed, making the back end of the shoot so much easier in so many ways," Darren Gilford recalls.

After twenty months, the Lucasfilm-based Visualist art department turned in final pieces on August 27. James Clyne and Yanick Dusseault moved on to look development for ILM's Roger Guyett–led digital effects team. Doug Chiang transitioned into co-production designing Gareth Edwards's *Star Wars Anthology: Rogue One*, alongside *The Force Awakens* supervising art director Neil Lamont. Ryan Church, Christian Alzmann, and Erik Tiemens also returned for *Rogue One*.

Back in Pinewood, shooting resumed without Ford on August 26 with the interior Star Destroyer bridge, followed by the film's climactic lightsaber duel on Q Stage, where a snowy forest had been brilliantly realized by the Pinewood crew.

▲ **Q STAGE SCENIC PAINTING Matt Walker**

"We had an incredible scenic painter, Matt Walker. He did the 360-degree background on Q Stage, two football fields of scenic forest, a crazy amount of linear footage. Literally, he's on a scissor lift, up fifty feet, bucket of paint, going down the backing with a roller, getting the trunks of the trees. His eye . . . to be able to paint like that, that loosely, and know what it looks like across the stage from a hundred feet away and to know it looks photo-real? It's a lost talent." **Gilford**

▼ **REY'S HOUSE Clyne**

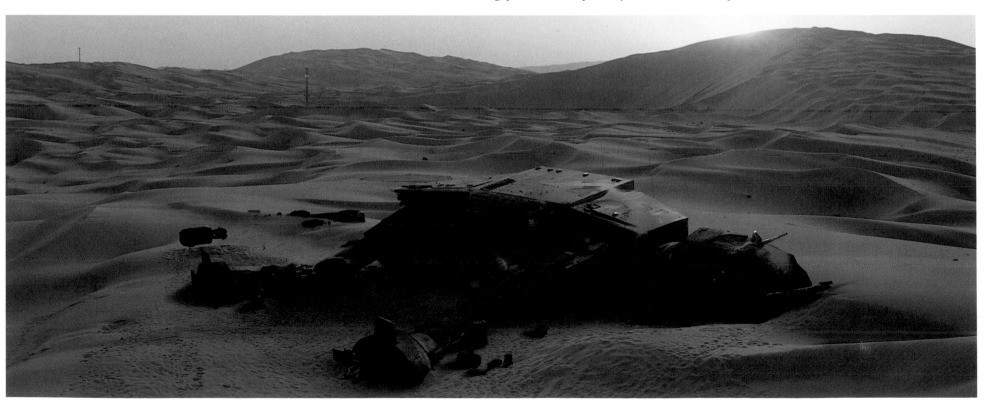

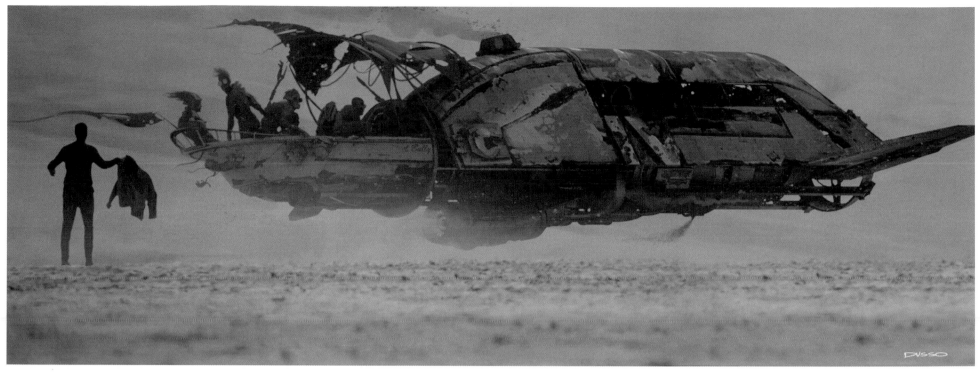

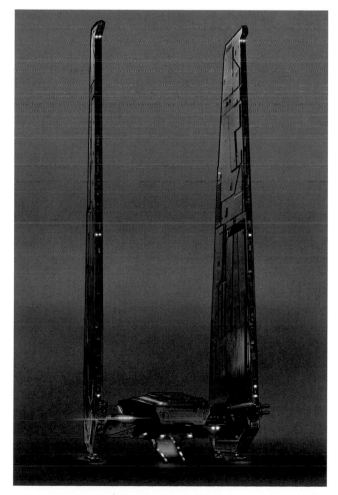

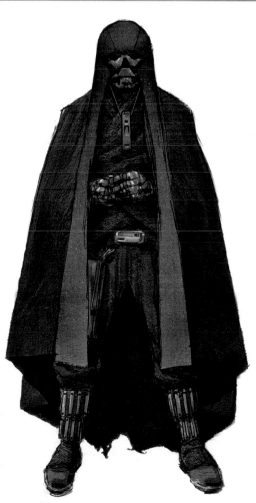

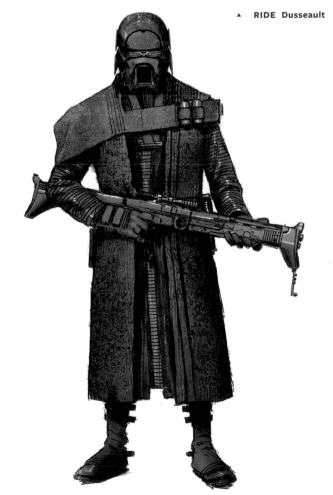

▲ RIDE Dusseault

▲ **KYLO REN SHIP LIGHTING DESIGN** David Fogler

▲ **KNIGHT 23** Dillon and Pope

▲ **KNIGHT 13** Dillon

▲ STARKILLER LAND 05 Andrew Booth and BLIND LTD.

▼ RESISTANCE BASE HERO ATTACK Booth and BLIND LTD.

▲ STARKILLER HOLDING CELL PANEL, DETAIL
Photograph by Jules Heath

▲ TIE MONITOR INSERT Booth and BLIND LTD.

"J.J. really wanted to go back to the simplicity of the graphics that were established in Star Wars, without being dated. This was largely J.J.'s response to modern motion graphics that create overly complex layers of content. It was incredibly difficult determining what we felt was the right level of homage to the original three films versus the level of updated visuals. Andrew Booth and BLIND LTD. did a really nice job walking that line." **Gilford**

▶ STARKILLER PORT
Booth and BLIND LTD.

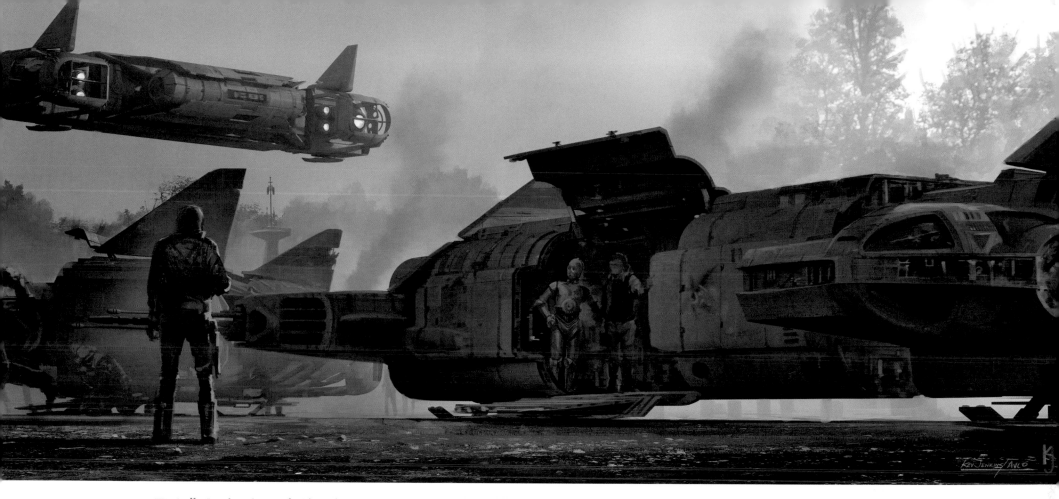

▲ TROOP CARRIER 12 *"Basically, I took a picture of a Chinook, a troop transport helicopter, and turned it on its side. Where the two helicopter engine bits go, I replaced one with a cockpit and the other with a gun. The troops come out of the middle."* **Jenkins**

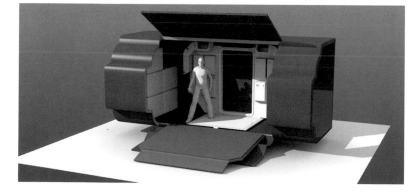

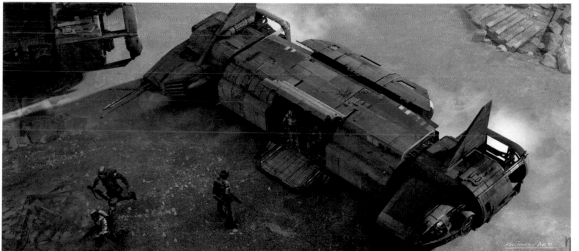

▲ INSIDE TROOP CARRIER BUILD Jenkins

▲ TROOP CARRIER 13 Jenkins

▼ TRANSPORTER LANDING Clyne

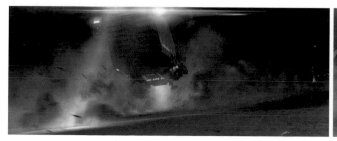

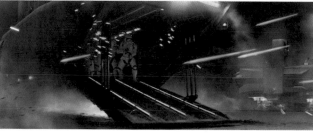

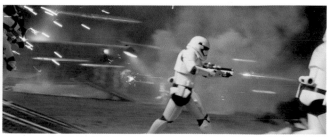

Principal photography on *The Force Awakens* continued on the Pinewood Studios lot with a healed and reinvigorated Harrison Ford rejoining the production on September 15. ILM look-development, the visual effects equivalent of early concept development for CG models and shots, also continued in September, with Yanick Dusseault and James Clyne tackling the starship graveyard chase and *Falcon* crash sequences, respectively.

Meanwhile, in the Pinewood art department, Starkiller base set and shot designs remained the primary focus. In the creature and costume shops, the designers and builders began wrapping up the few remaining characters left to be shot in the doomed Republic City scenes, the "Force-back" flashback sequence, and Ford's return to Maz's castle.

▸ **GRAVEYARD SET PIECES 01 & 02** Bonura

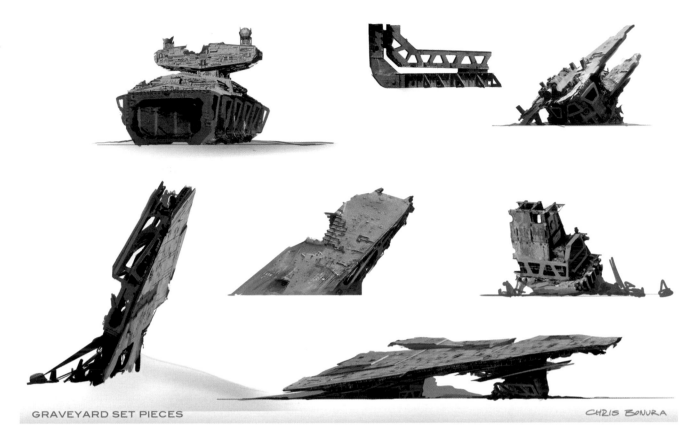

GRAVEYARD SET PIECES CHRIS BONURA

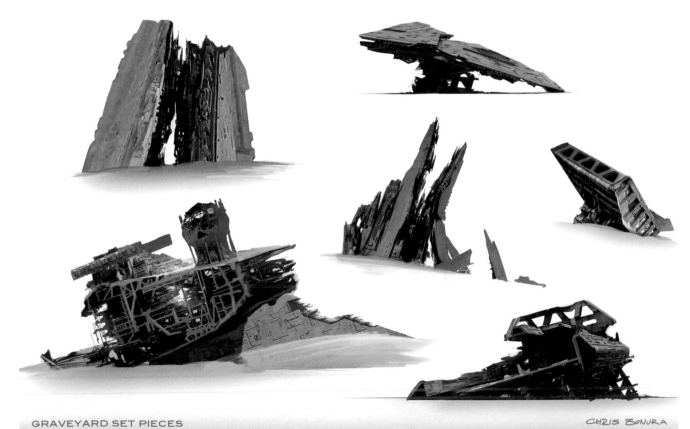

GRAVEYARD SET PIECES CHRIS BONURA

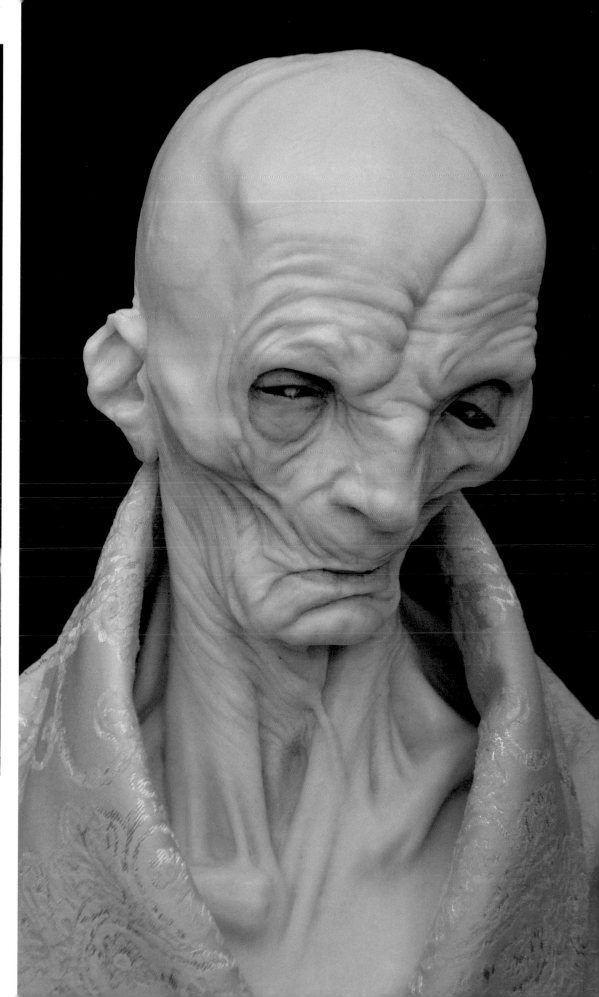

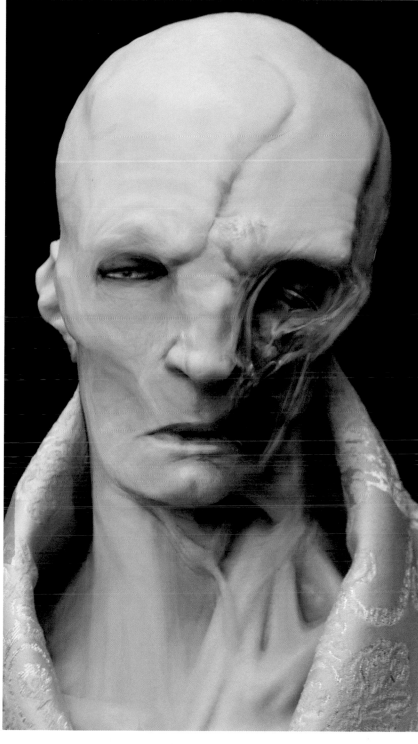

▲ **SNOKE 02** *"J.J. wanted to base Snoke on the Hammer Films horror movies, giving the design a ghoulish look. We made a bust out of marble powder, because we talked about him being very pale. And I imagined him to be a beautiful marble sculpture, so dark and menacing, but actually quite beautiful to look at."* **Manzella**

▶ **SNOKE 06** *"It's almost like Snoke was quite handsome when he was younger. And in my mind, the more powerful he's become, the more the Dark Side consumes him. We made his eyes really pale, pale blue so the whites of his eyes are almost the same color as his skin and costume. Piercing."* **Manzella**

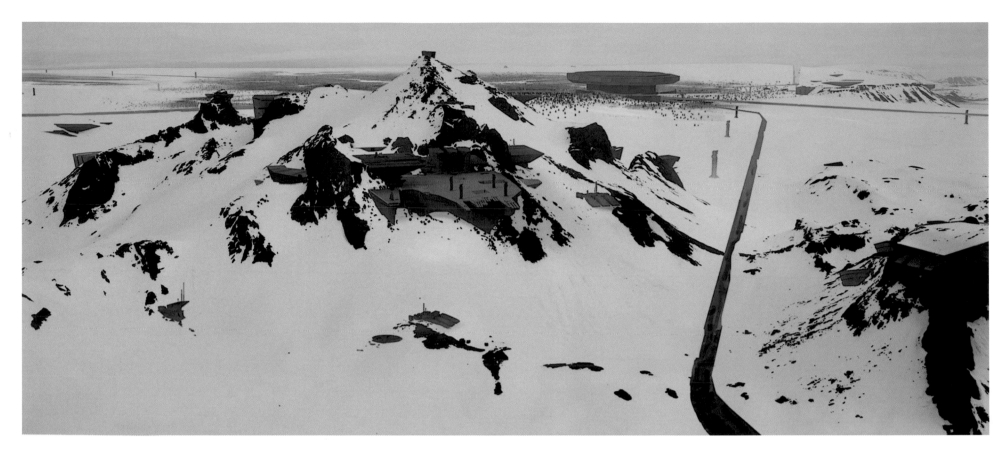

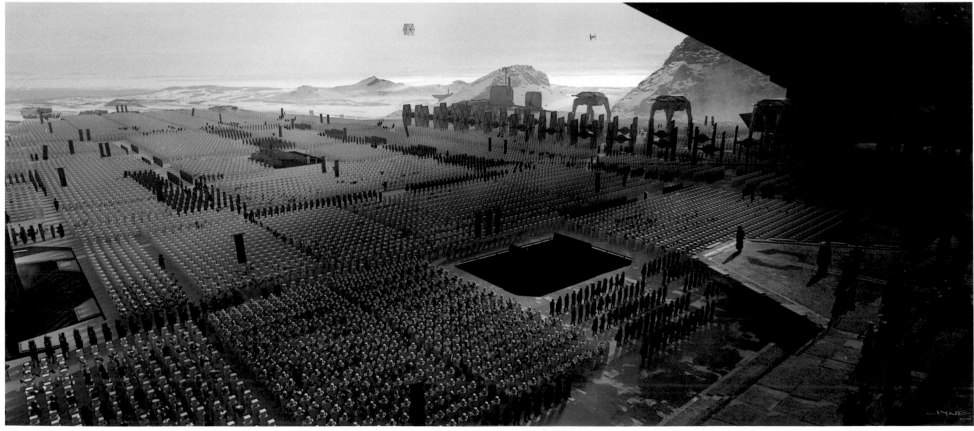

▲▲ RALLY SITE MASTER LAYOUT Clyne

▲ RALLY SITE WIDE Clyne

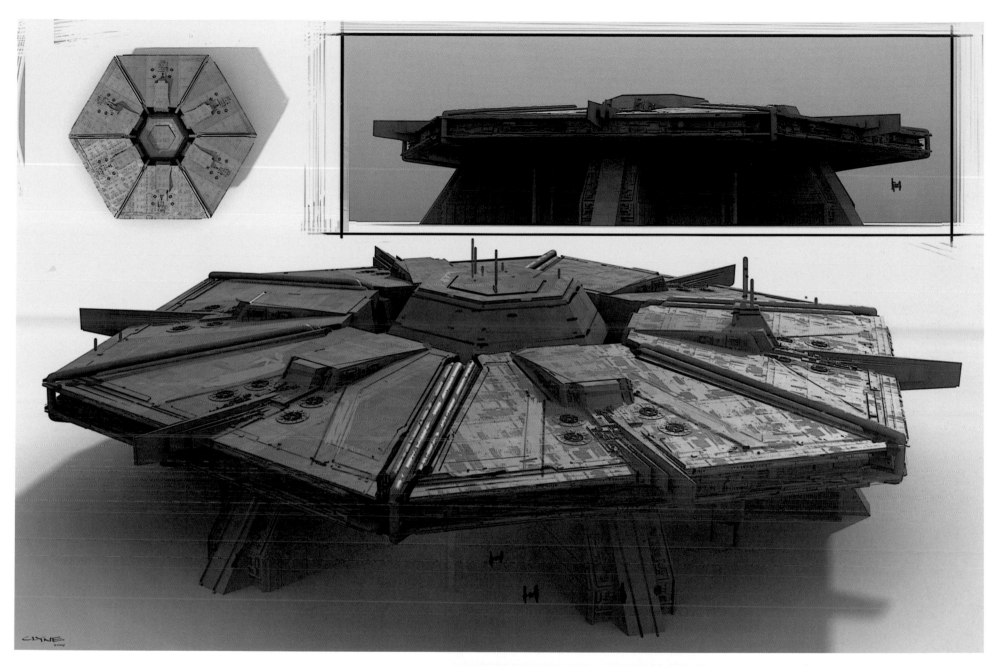

▲ **BOLT DETAILS** *"I do think you have to be careful in the Star Wars universe to not be too fancy with designs, to keep it kind of brutal and simple. The oscillator is literally a big mushroom bolt shape."* **Clyne**

▶ **OSCILLATOR PAINT LIGHT** *"We wanted to create a 'blood on your hands' kind of mood on this oscillator set. So the blue is Imperial navy, very much reminiscent of The Empire Strikes Back. And I pumped the blood red everywhere to create that contrasting mood."* **Jenkins**

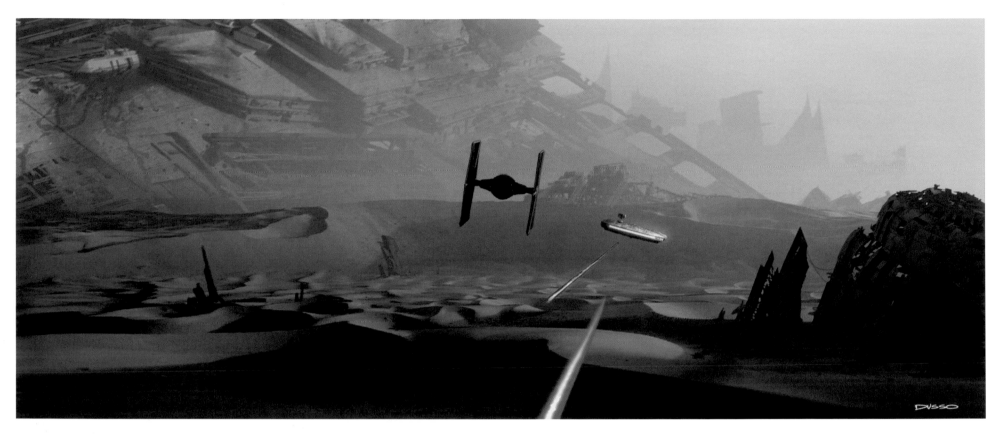

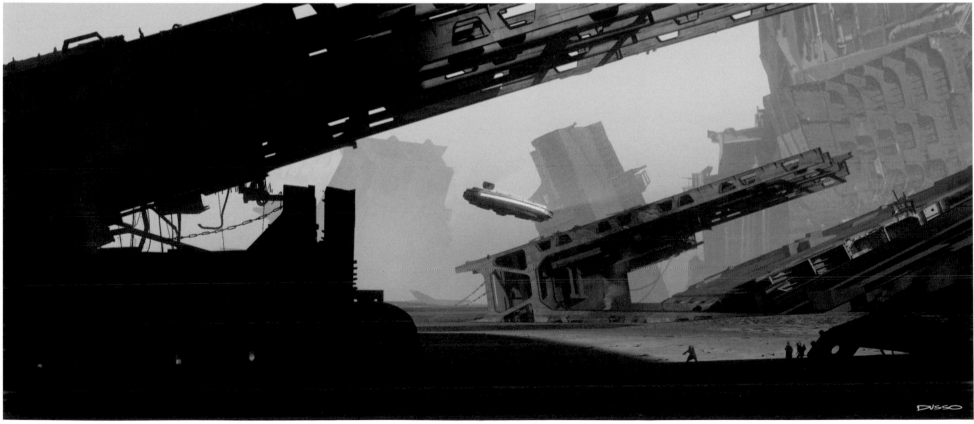

▲▲ **GRAVEYARD 3.1** Dusseault

▲ **CHASE 1.6** *"All of the elements we put out into a shot have to maintain a certain relationship. There will be foreground pieces that fly by, small-detail complex layers, etc. It's about layering things."* **Dusseault**

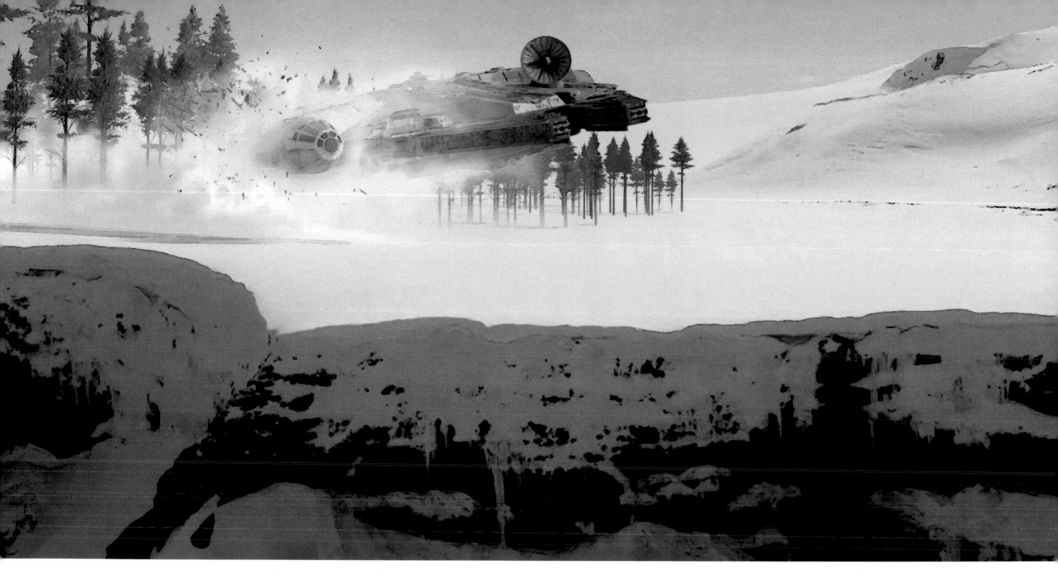

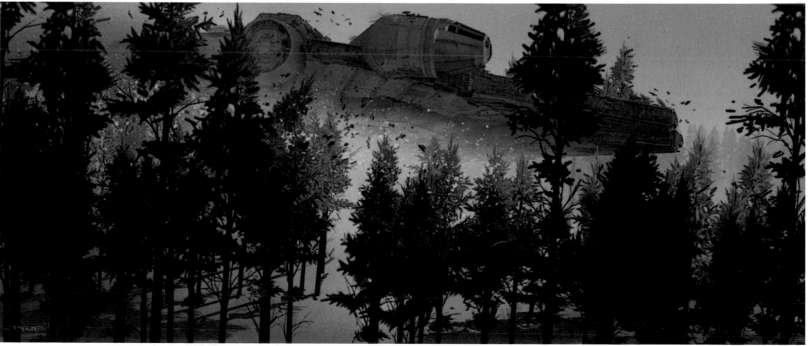

▲ **SNOW CRASH 01** Clyne

▶ **SNOW CRASH 03** Clyne

On October 3, original *Star Wars* trilogy producer Robert Watts and production designer Norman Reynolds visited the set of *The Force Awakens* at Pinewood. "As a kid, Norman Reynolds was the first name I ever associated with production design: *Raiders of the Lost Ark, Star Wars, Empire, Jedi,*" Darren Gilford recalls. "His work was such a ground zero and a point of departure for so many elements of our film. I had a whole day with him to walk him around everything. He was such a gentleman, and I think he had a wonderful time."

The final designs for *The Force Awakens*'s two primary digital characters, Maz Kanata and Supreme Leader Snoke, were confirmed in October as well. The Maz maquette received a finishing paint, costume, and accessory pass. The shadowy Snoke shifted in a more youthful direction before garnering director approval, moving even further away from the previous six *Star Wars* films' "big baddie" Emperor Palpatine.

▶ **TAKODANA PLANET** *"Because planets can be pretty simple, I like trying to give a little bit of character without getting too fantastical. There's a single river that goes around the equator—I like that."* **Dusseault**

▲ **CASTLE** Dusseault

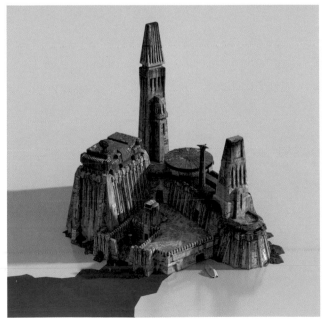

▲ **CASTLE** Dusseault

Normally on a film this size, there is a pros-thetic character-painting department with upward of twenty artists. But for *The Force Awakens*, creature department creative supervisor Neal Scanlan entrusted paint finish designer Henrik Svensson (*Prometheus*, *Guardians of the Galaxy*) with the task of single-handedly painting more than eighty aliens and droids in his ten months on the project. He only left five unfinished due to time constraints.

"When it comes to Maz, BB-8—all these charac-ters that I thought might be tricky—I thought, 'Oh God, this is going to be such a challenge,'" Svensson recalls. "I would show the designs to J.J. and was met, almost instantly, with support. I've never worked on a project where I've gotten such good support and feed-back from everyone, from the director downward."

"Lupita Nyong'o, the actress playing Maz, came into the workshop to have a look at the head sculpt, which was a lovely treat. She got very close to it; she was quite tactile with it. It reminded her of her grandmother, strangely. I thought it was really nice that she had a connection with the sculpt." **Fisher**

▸ **MAZ SCULPT BY FISHER; PAINT FINISH BY HENRIK SVENSSON** **Photograph by Jules Heath**

"J.J.'s brief, from reading the script, described Maz Kanata with these goggles. I was thinking, you see elderly people wearing glasses, and even for a long while after they take the glasses away, you see imprints on the bridge of the nose." **Fisher**

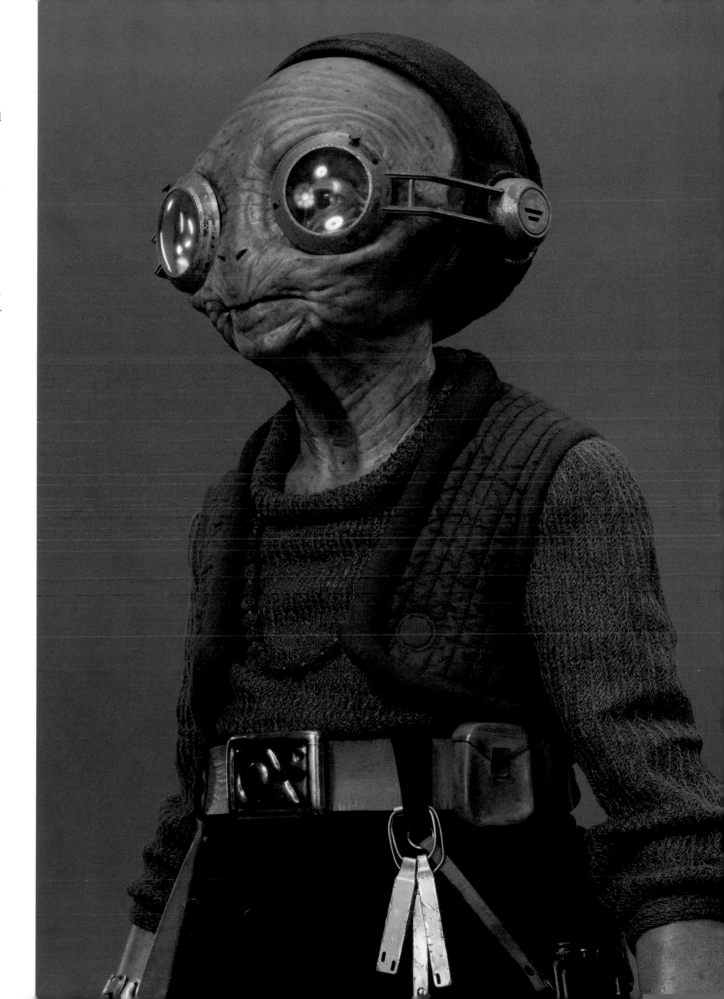

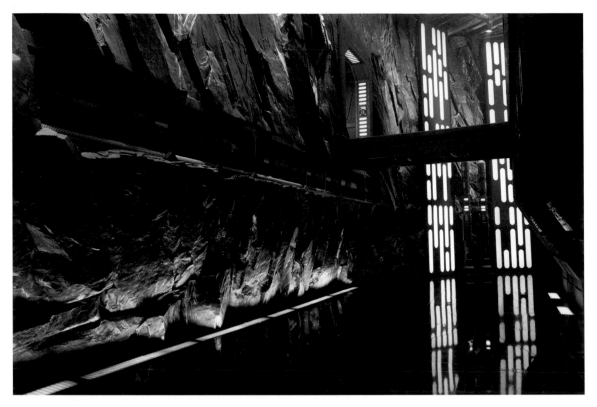

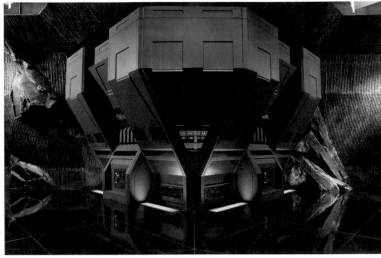

◄ **STARKILLER HALLWAY** Photograph by David James

▲ **STARKILLER HALLWAY JUNCTION** Photograph by Jules Heath

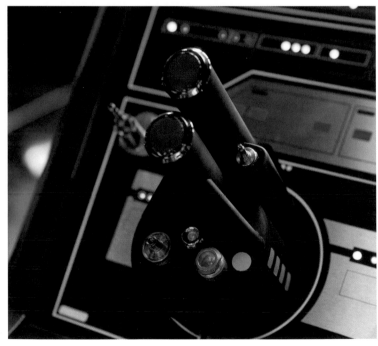

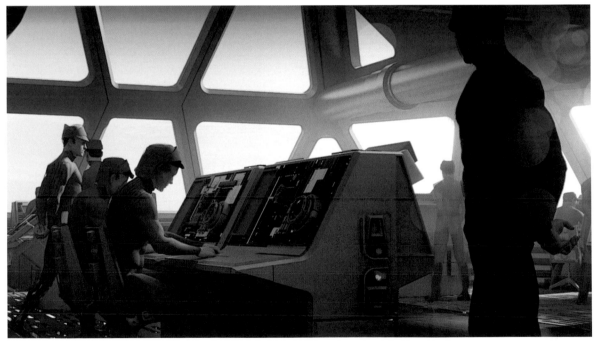

▲ **STARKILLER CONTROL ROOM PANEL** Photograph by John Wilson

▲ **COMMAND POST** Dusseault

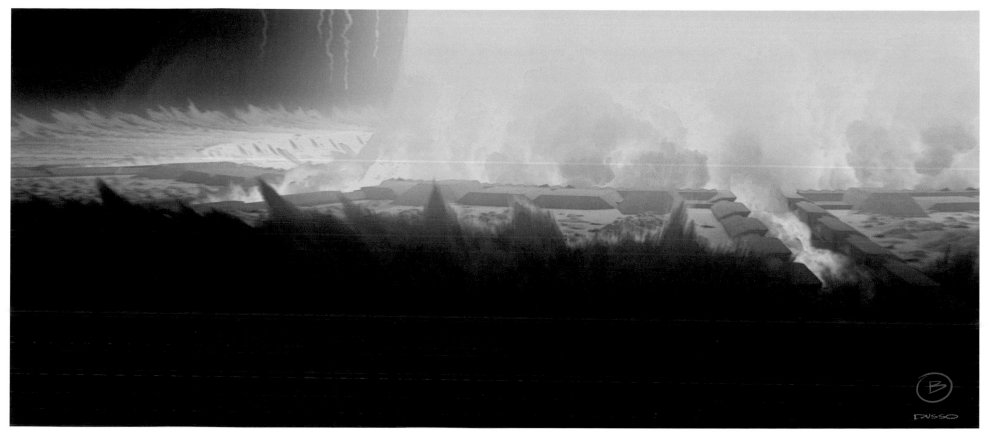

▲ FIRING Dusseault

▼ FLEET Dusseault

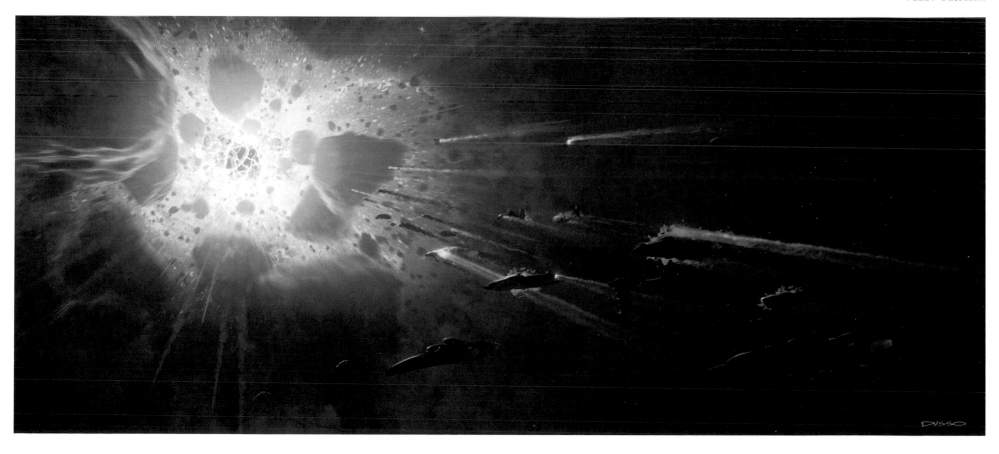

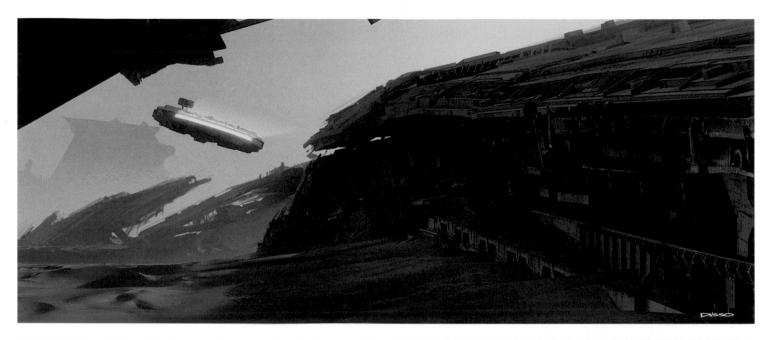

◄ **CHASE 4.2** Dusseault

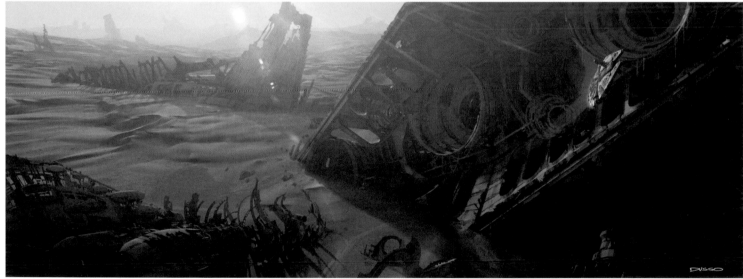

◄ **DEBRIS FIELD** Dusseault

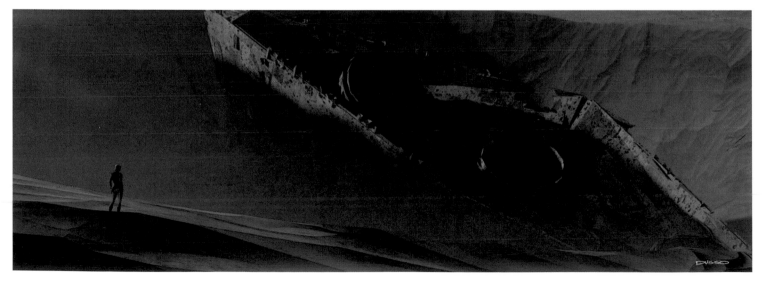

◄ **GRAVEYARD 1.1** *"Was it a battle? Did the starships fall from space? And if so, are we trying to be realistic about what a satellite does when it comes through the atmosphere, or not? Star Wars can be selective—which option would best serve the story, emotionally and visually?"* **Dusseault**

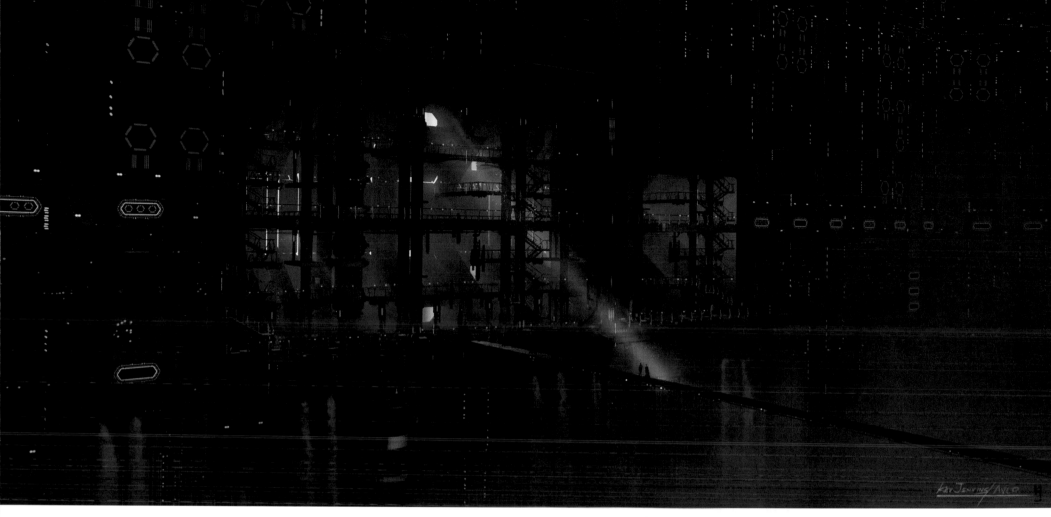

OSCILLATOR WIDE DIAGONAL *"We have this oscillator mechanical oil refinery bit in the middle, to the left and right and above will be this Empire-version of Bespin light patterns. The pattern I've designed is based around hexagons."* **Jenkins**

"We must have designed that set a hundred times, in so many different ways. J.J. kept on going back to the original Death Star set from A New Hope because it was so genius. When you really start to study that movie, whether they were swinging across the chasm or Obi-Wan is going around disabling the tractor beam or going down the hallways to the elevator shaft or Han chasing the stormtroopers down one way, it is amazing to realize how versatile they made that set. J.J. rode us really hard to come up with designs that he could use the same way." **Gilford**

▲ **EPISODE IV DEATH STAR HALLWAYS PLANS & ELEVATIONS** Peter Childs

▲ **STARKILLER HALLWAYS PLANS & ELEVATIONS** Peter Dorme ▶▶ **BOLT ATTACK** Clyne

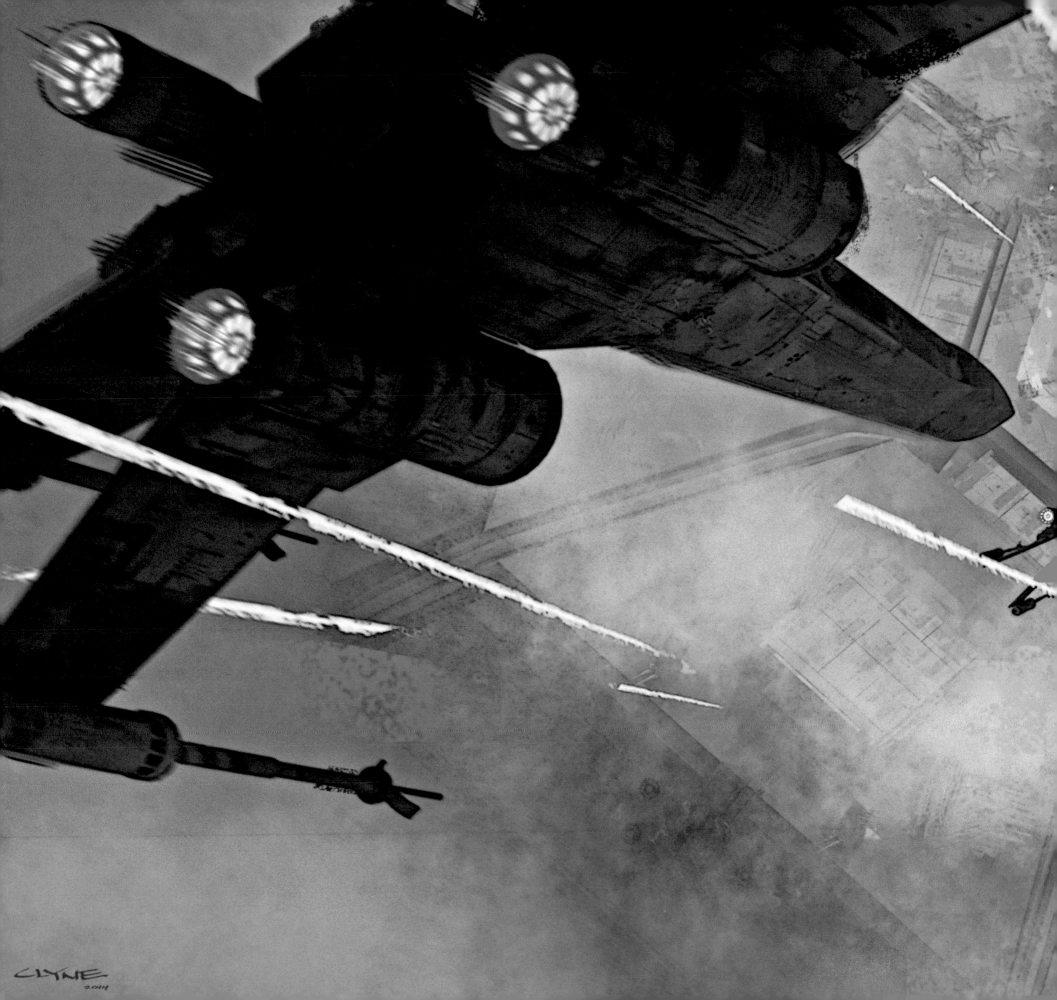

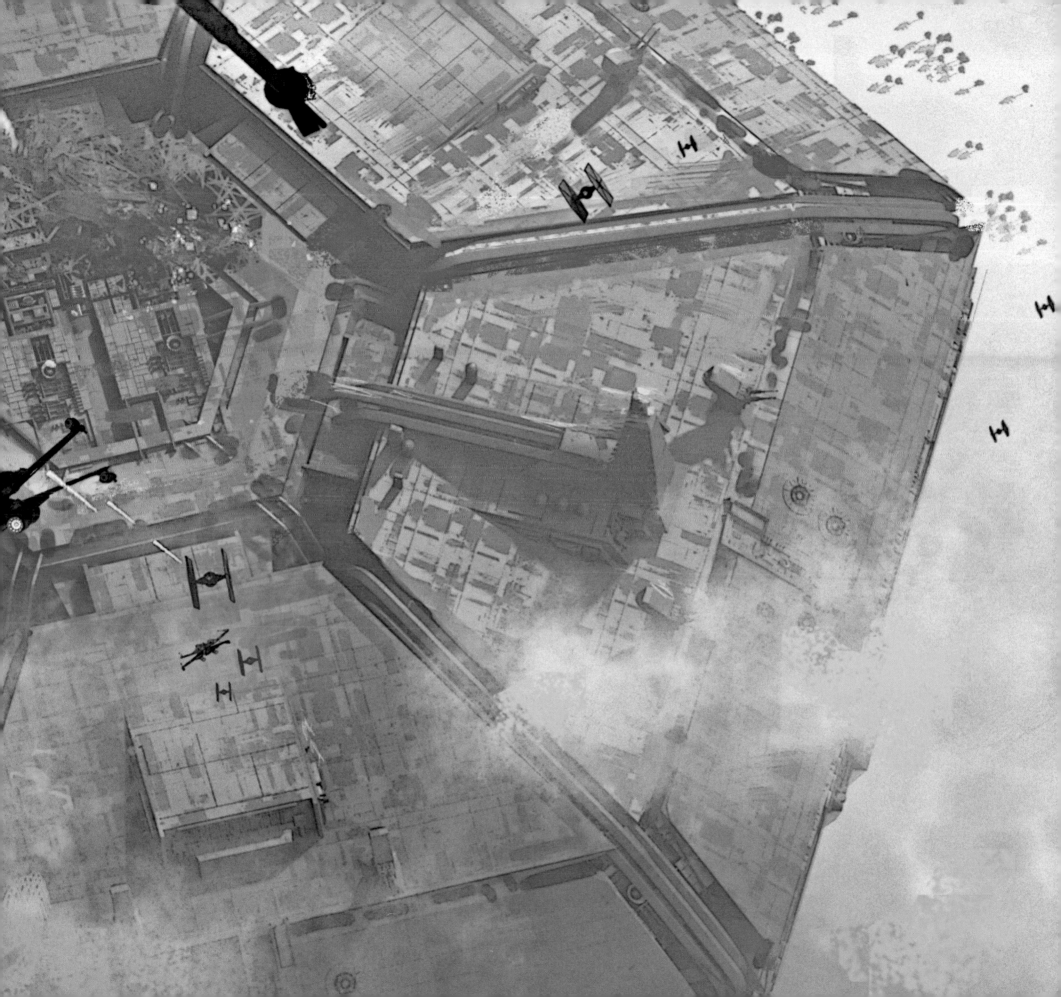

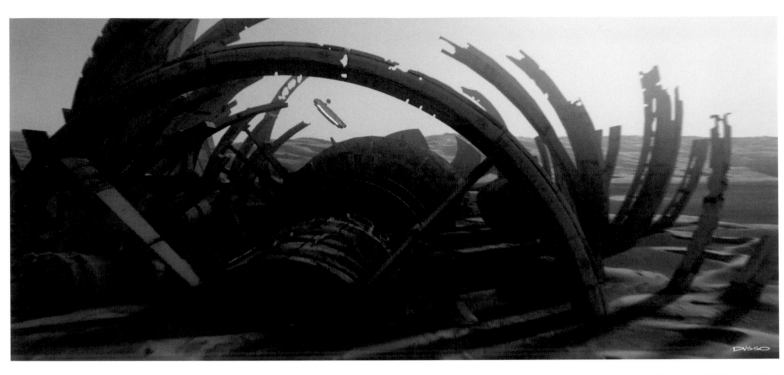

◄ **ENGINES** *"In the movies, anyway, you've got the classic arch that you go through in every graveyard. That idea is mimicked here. I'm trying to push the skeleton in the desert idea a lot—the animal, structural . . . that's a lot of fun to work with."* **Dusseault**

▼ **ENTER FOREST** Clyne

► **BULLET HOLE DEV** Timothy Mueller

► **PLANET JAKKU (INSET)** Mueller

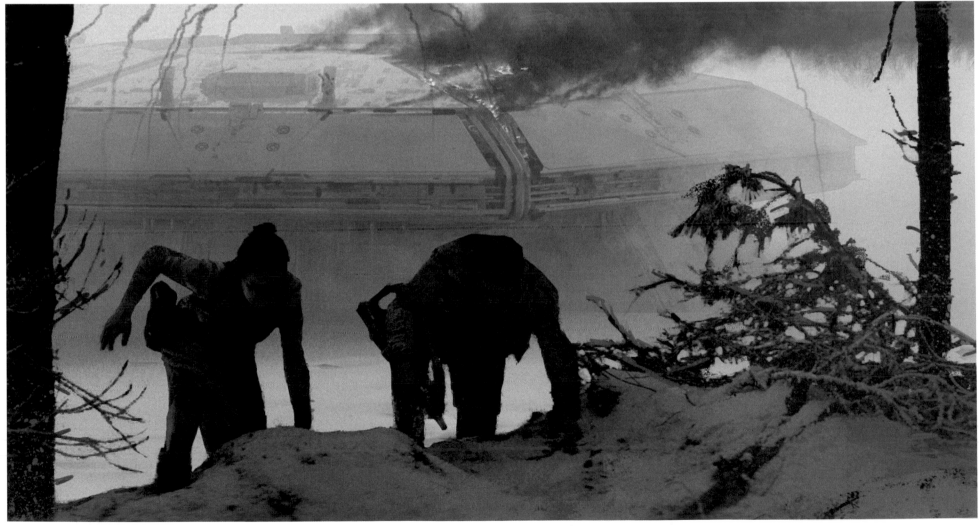

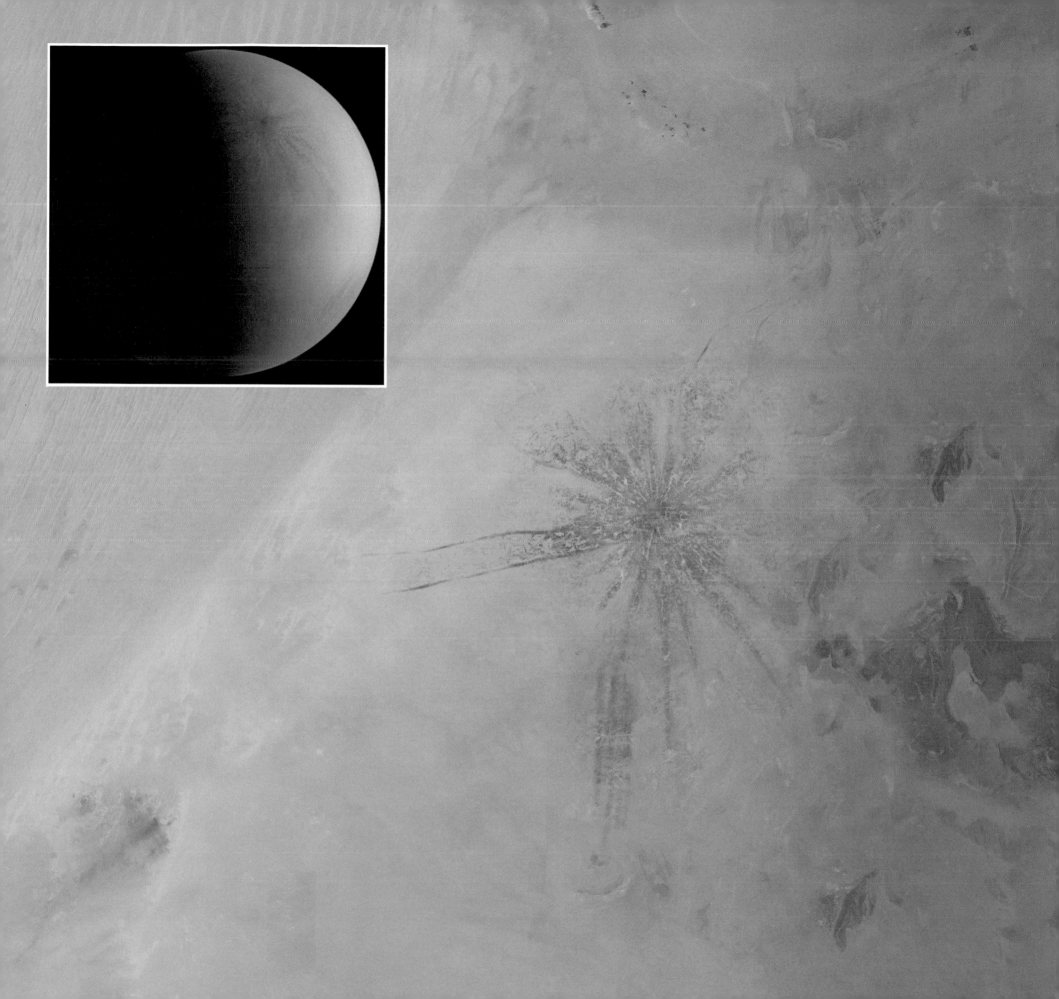

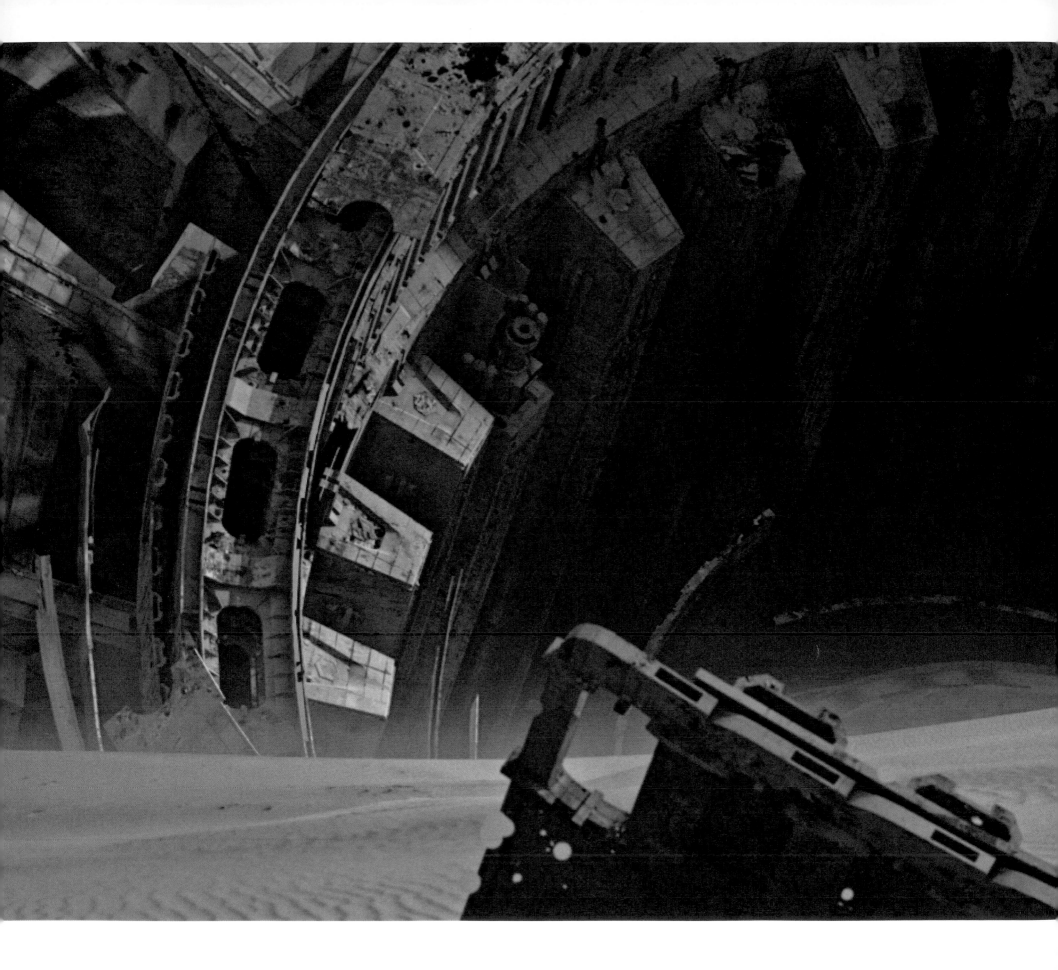

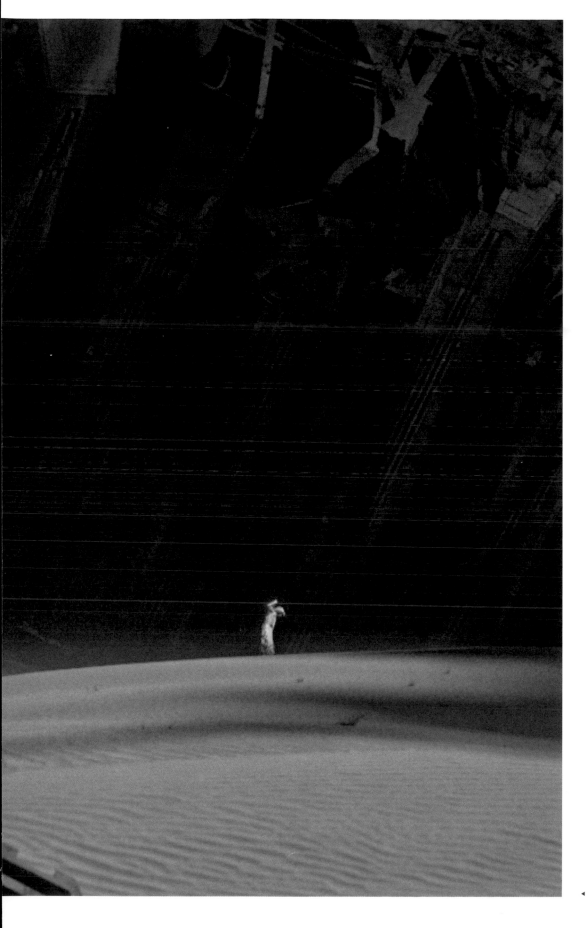

POST-PRODUCTION

In late summer, the four art departments slowly started wrap-ping, beginning August 27 with the San Francisco–based Visualists, the longest-standing group. All three Pinewood-based art departments wrapped in early November, with final UK art dailies turnover on November 3.

The final week of principal photography at Pinewood focused on the maze-like Starkiller base hallway set on R.A. Stage. Kevin Jenkins recalls, "It's a massive homage to the Death Star set. I don't think the audience will realize that everything happening on screen was shot within four feet of each other." November 6 denoted the final first-unit shooting day on *The Force Awakens*, encompassing flashback sequences. A massive fireworks display over Pinewood studios that same evening celebrated the end of a two-year journey. "I think the work is a testament to how strong the team is," Jenkins says. "As Rick Carter said, this is the best art team he's ever had on a film, purely because of the speed at which projects were thrown at us, all of which were exceptionally tough to tackle."

In concert with the end of principal photography, the UK art departments, including the creature effects and costume teams, transitioned onto the next film in the franchise, Gareth Edwards's (*Monsters, Godzilla* [2014]) *Star Wars Anthology: Rogue One*, due for release in December 2016.

November 6 also marked the public reveal of the film's long-awaited title, *Star Wars: The Force Awakens*.

◄ **REY EMERGES** Dusseault

NOVEMBER 2014– JANUARY 2015

The winter of 2014 was a transitional time. At Industrial Light & Magic in San Francisco, the post-production shot turnover and delivery process officially began on November 7, with the first turnover of shots from Bad Robot Productions. The ongoing digital shot creation process by Roger Guyett's team was slated to carry on deep into 2015, close to the December 18 release date of *Star Wars: The Force Awakens*.

Visualist Yanick Dusseault continued to work on the Jakku graveyard sequence, while James Clyne designed shots for the Starkiller base assault. Clyne's design for Han Solo's cargo hauler was the last major vehicle approval for the film.

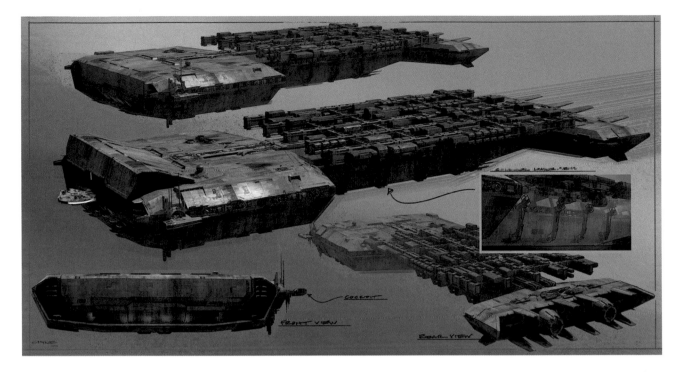

▲ **FREIGHTER ESTABLISHING SHOT 12** Clyne

▼ **FREIGHTER ESTABLISHING SHOT 14** Clyne

▲▲ **DESTROYER INTERIOR** Dusseault

▲ **SHIP CRASH** *"They shot all the Abu Dhabi plates—the desert plates—pretty much at sunset. It looks like midday in the outpost, then Rey and Finn take the Falcon, they fly a mile, and it's sunset. Those creative licenses are completely acceptable."* **Dusseault**

▲ **RED PIPE DETAIL** Clyne

▲ **BOMB PLANT PIPE** *"The red pipes were our idea to make that location shift inside the base a little more apparent. But also this big red pipe saying, 'Plant bombs here' [laughs], which was a Rick idea . . . a production design comment. It gives the audience something to focus on."* Clyne

"WHO IS LUKE SKYWALKER?"

"I learned more working on this project than in any other aspect of my life, in any education I've ever had, whether it was college, internships, or anything else," Darren Gilford recalls. "Working with Rick was an amazing opportunity. It started as a mentor-mentee relationship; by the end, we felt like equals, because of Rick. In this business, there are so many egos, there's so much involved . . . so his willingness to share something as big as this was incredible. He's at the point in his career where that's what he wants to do: collaborate and share with young up-and-coming designers."

In summation, Rick Carter said, "I have told Kathleen Kennedy that my job is to really pay attention to the Force and what I feel the Force is as it represents itself in the story and the visuals of the movie—so that it has a presence. What is the Force? It's when you recognize that it was always there, like Kansas for Dorothy. But that doesn't mean that every aspect of the Force is known yet. So when we get to this third act in the *Star Wars* series, there's more to be revealed. And that reveal is going to involve things from the past that were right in front of us all along. We didn't understand all that those things meant, and now we have to let them play themselves out. To me, that's the Force."

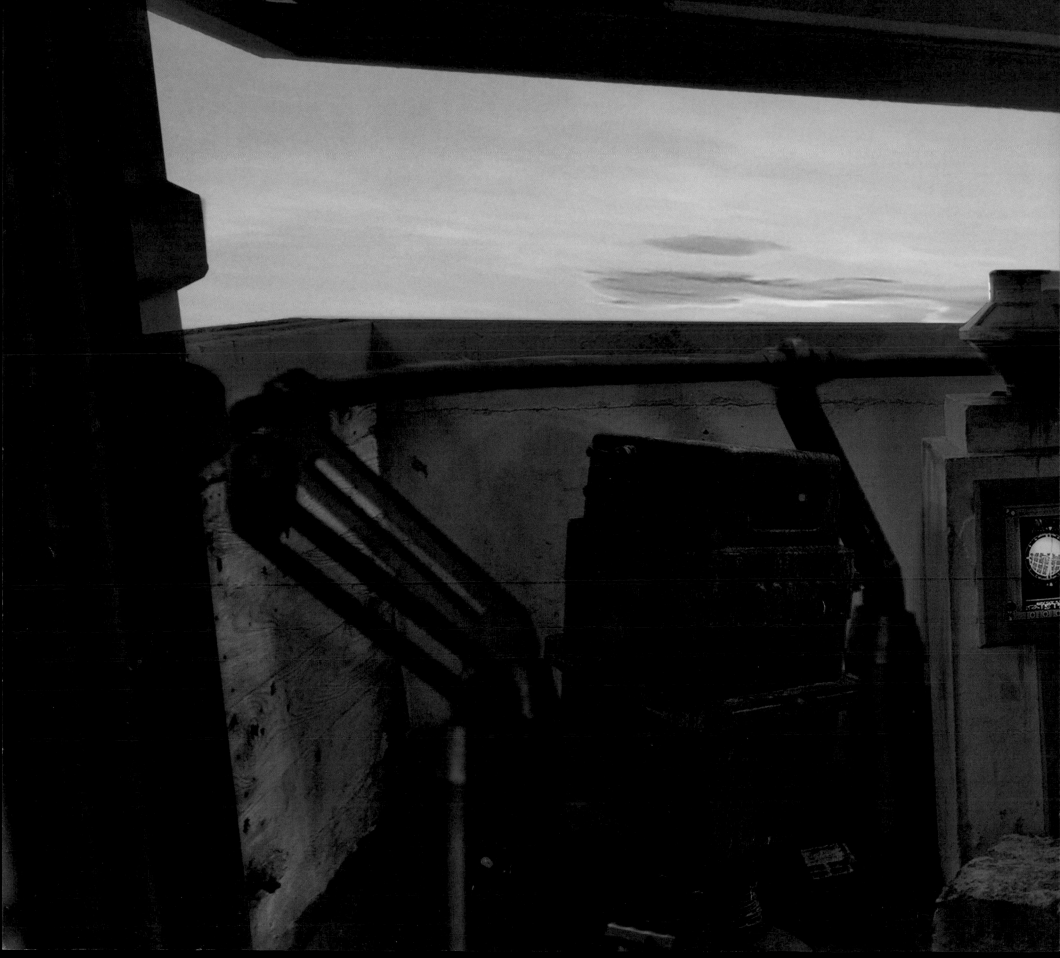

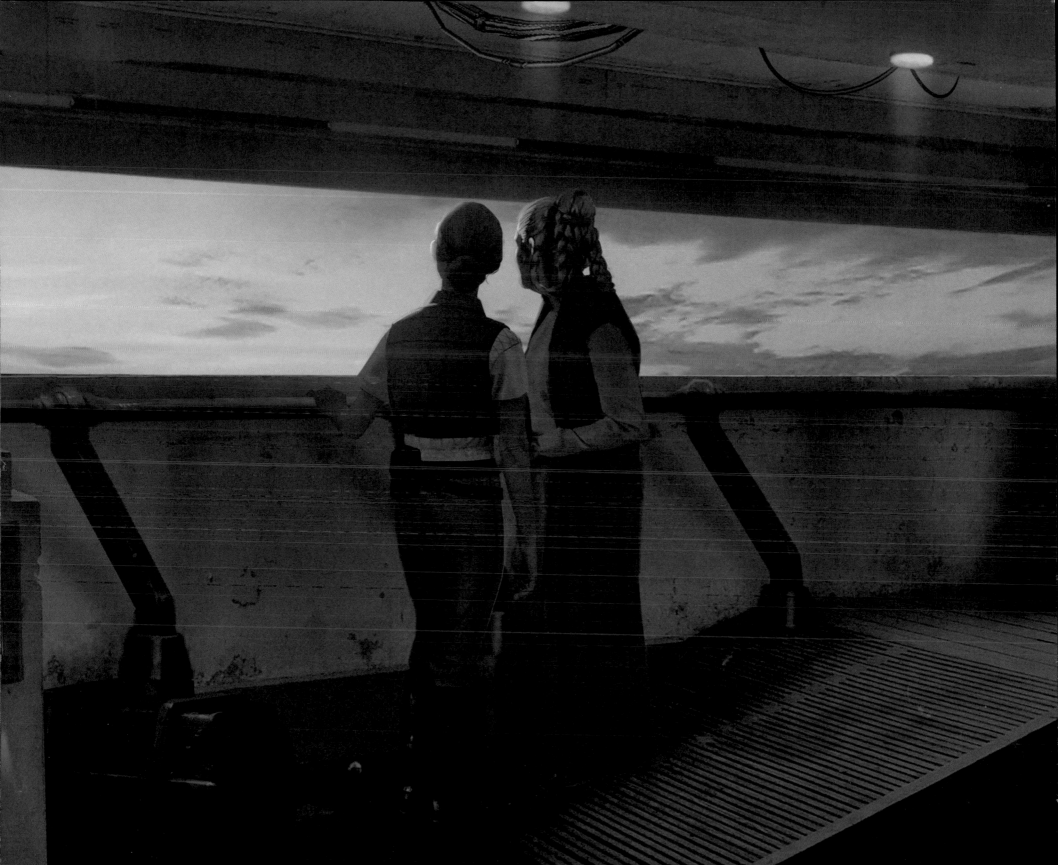

INDEX

◄ Yoda Fountain, Lucasfilm Ltd., San Francisco, California. Left to right: James Clyne, Doug Chiang, Mark Hamill, Christian Alzmann, Nicole Letaw, Iain McCaig, and Phil Szostak. Photograph by Liz Hanks Chiang

For Lucasfilm Ltd.

EXECUTIVE EDITOR J. W. Rinzler
ART DIRECTOR Troy Alders
IMAGE ARCHIVES Stacey Leong, Matthew Azeveda
STORY GROUP Pablo Hidalgo, Leland Chee, Rayne Roberts

For Abrams

SENIOR EDITOR Eric Klopfer
DESIGNER Liam Flanagan
PRODUCTION MANAGER Denise LaCongo

Library of Congress Control Number: 2014959560

ISBN: 978-1-4197-1780-2

(WRAP-AROUND CASE) FALCON CHASE VERSION 03 Chiang

Printed and bound in the United States
10 9 8 7 6 5 4 3 2 1

Abrams books are available at special discounts when purchased in quantity for premiums and promotions as well as fundraising or educational use. Special editions can also be created to specification. For details, contact specialsales@abramsbooks.com or the address below.

115 West 18th Street
New York, NY 10011
www.abramsbooks.com

www.starwars.com

Acknowledgments

First and foremost, special thanks to Jonathan Rinzler: for his friendship, guidance, and for asking me to be a part of this incredible book series. And to George Lucas, without whom none of this would be possible, for his patience and humor; J.J. Abrams and Kathleen Kennedy, for continuing to carry the *Star Wars* torch so brilliantly. Special thanks to Rick Carter and Darren Gilford, for allowing me to contribute to their art department and for giving so much of their time to this book.

Thanks to friends and supporters Ron Gall, Sean and Sarah Dicken, Mike Bates, Meredith Higdon, Shawn Hunter, Matt Davis, Chris Wales, and especially Tina Fossella.

At Abrams Books: Eric Klopfer, Liam Flanagan, Gabriel Levinson, and Denise LaCongo.

At Lucasfilm: Brian Miller, Doug Chiang, Nicole Letaw, Genna Elkin, Tyler Scarlet, Stacy Bissell, Luke O'Byrne, Troy Alders, Rayne Roberts, Sammy Holland, James Erskine, Howard Roffman, Lynne Hale, Kiri Hart, Pablo Hidalgo, Leland Chee, Simon Kinberg, Michael Siglain, Stacey Leong, Matt Azeveda, Gabrielle Levenson, Becca Friedman, and Newell Todd.

At Pinewood: Kyle Wetton and Pollyanna Seath; in the costume department: Michael Kaplan, Dave Crossman, and Henrietta Sylvester; in the creature shop: Neal Scanlan and Katie Newitt.

At Skywalker Ranch: Connie Wethington, Kristine Kolton, Jo Donaldson, Robyn Stanley, Laela French, Joanee Honour, Kathy Smeaton, and the entire Skywalker Archives team.

At Bad Robot Productions: Cory Bennett Lewis, Michelle Rejwan, and Robby Stambler.

Massive thanks to all of the *Force Awakens* artists who so thoughtfully spoke about their work.

And to all of those who lifted me up when I needed it: Robert Pollard, Nick Petrulakis, Denis Morella, George Evelyn, Rick McCallum, Kathryn Ramos, Dominic Robilliard, Jason McGatlin, and Tina Mills.

Love and gratitude to my parents Joseph Szostak and Barbara Armbruster, for unconditionally supporting my dreams and for pulling me out of school early in 1983 to see a matinee of *Return of the Jedi*. To my brothers Martin and Dave, for always being there. And to the next generation of *Star Wars* fans, my niece and nephew, Grace and Leo.

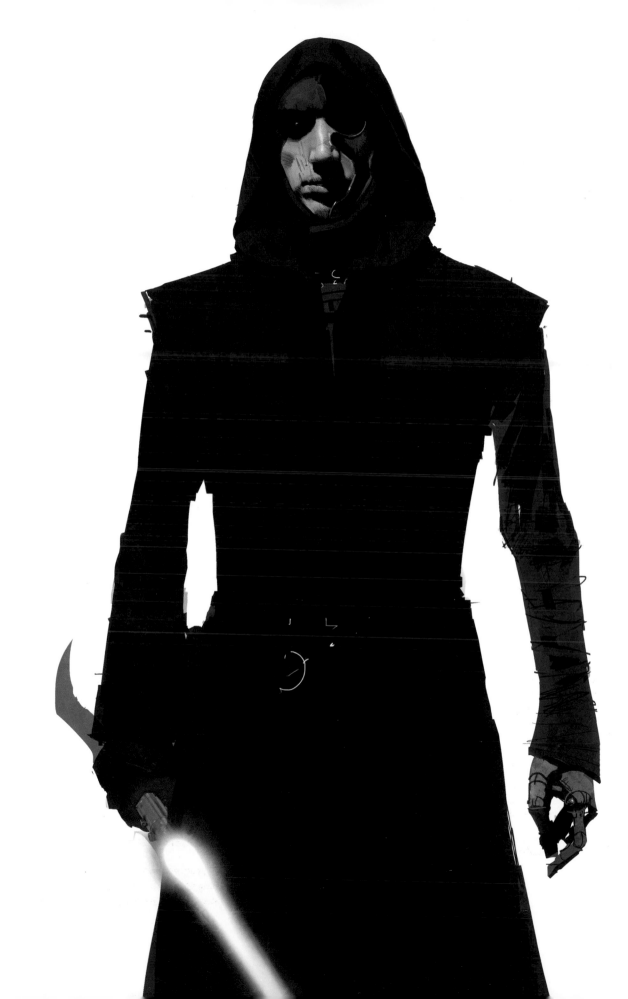

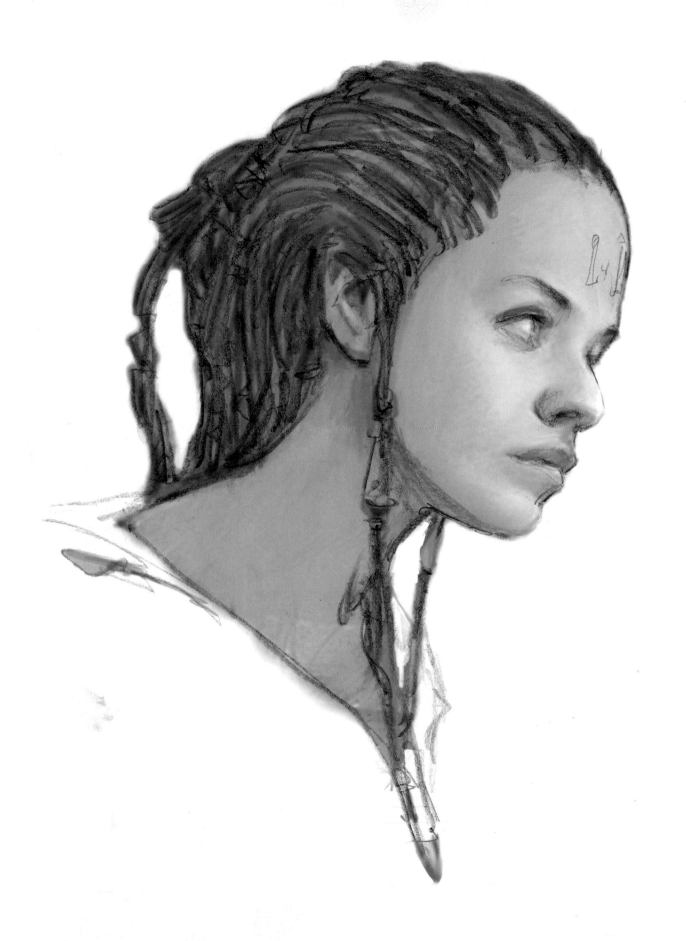